THE END
OF FASHION

MARION COUNTY PUBLIC
LIBRARY SYSTEM
321 Monroe Street
Fairmont, WV 26554
(304) 366-1210

D0024307

MARION COUNTY PUBLIC
LIBRARY SYSTEM
321 MONROE STREET
FAIRMONT, WV 26554
(304) 366-1210

THE END
OF FASHION

Clothing and Dress in the
Age of Globalization

EDITED BY
ADAM GECZY AND
VICKI KARAMINAS

BLOOMSBURY VISUAL ARTS

LONDON · NEW YORK · OXFORD · NEW DELHI · SYDNEY

BLOOMSBURY VISUAL ARTS
Bloomsbury Publishing Plc
50 Bedford Square, London, WC1B 3DP, UK
1385 Broadway, New York, NY 10018, USA

BLOOMSBURY, BLOOMSBURY VISUAL ARTS and the Diana logo are trademarks of
Bloomsbury Publishing Plc

First published in Great Britain 2019

Selection and Editorial Matter Copyright © Adam Geczy and Vicki Karaminas, 2019
Individual chapters © their authors, 2019

Adam Geczy and Vicki Karaminas have asserted their rights under the Copyright, Designs
and Patents Act, 1988, to be identified as Editors of this work.

For legal purposes the Acknowledgments on p. xiii constitute an extension of this
copyright page.

Cover design: Adriana Brioso
Cover image: XIAO LI presentation during the London Fashion Week
in London, England, 2017 (© Victor Virgile/Gamma-Rapho/Getty Images)

All rights reserved. No part of this publication may be reproduced or transmitted
in any form or by any means, electronic or mechanical, including photocopying,
recording, or any information storage or retrieval system, without prior
permission in writing from the publishers.

Bloomsbury Publishing Plc does not have any control over, or responsibility for,
any third-party websites referred to or in this book. All internet addresses given
in this book were correct at the time of going to press. The author and publisher
regret any inconvenience caused if addresses have changed or sites have ceased
to exist, but can accept no responsibility for any such changes.

A catalogue record for this book is available from the British Library.

A catalog record for this book is available from the Library of Congress.

ISBN: HB: 978-1-3500-4504-0
 PB: 978-1-3500-4912-3
 ePDF: 978-1-3500-4505-7
 eBook: 978-1-3500-4506-4

Typeset by Integra Software Services Pvt. Ltd.
Printed and bound in India

To find out more about our authors and books visit www.bloomsbury.com
and sign up for our newsletters.

CONTENTS

LIST OF ILLUSTRATIONS

Figures

Plates

NOTES ON THE CONTRIBUTORS

Sandy Black is Professor of Fashion and Textiles Design and Technology in the Centre for Sustainable Fashion, London College of Fashion, University of the Arts London, UK, and has extensive experience in both academia and the fashion industry, formerly running the Sandy Black Knitwear company selling internationally. Her current inter-disciplinary research is into the role of design and new business models in addressing issues of sustainability in the fashion sector. In 2005, she initiated the *Interrogating Fashion* network to create a research agenda for future fashion, and led the project *Considerate Design for Personalised Fashion Products*. Recent funded research into the designer fashion sector bridges research, innovation, business models, and sustainability under the umbrella F.I.R.E. (Fashion, Innovation, Research, Evolution). Sandy has published widely on sustainable fashion including *Eco Chic the Fashion Paradox* (2008); *The Sustainable Fashion Handbook* (2012); *The Handbook of Fashion Studies* (2013); and also on knitwear including *Knitting: Fashion, Industry, Craft* with the V&A Museum. She is founder and co-editor of the journal *Fashion Practice: Design, Creative Process and the Fashion Industry*, published since 2009.

Patrizia Calefato teaches Sociology of Culture and Communication at Università degli studi di Bari Aldo Moro, Italy. Her main fields of research are fashion theory, socio-semiotics, and cultural studies. She is a member of the Advisory Boards of international journals, among them *Fashion Theory*, *Journal of Asia Pacific Pop Culture*, *Semiotica* and *Jomec Journal*. Among her latest works are *Paesaggi di moda: corpo rivestito e flussi culturali* (2016); *Il giubbotto e il foulard: studi culturali, corpo, comunicazione* (2016); "Italian fashion in the latest decades: From its original features to the 'new vocabulary'", *Journal of Asia Pacific Pop Culture* (2016); "Il corpo e l'essere umani oggi: protesi, macchine, moda", *Comunicazioni Sociali* (2015); *Fashion Journalism* (2015); *Luxury, Lifestyles and Excess* (2014).

Pamela Church Gibson is Reader in Historical and Cultural Studies at the London College of Fashion, UK. She has published extensively on film and fashion, gender, history, and heritage. She is the author of *Fashion and Celebrity Culture* (2013) and has published essays in various journals, including *Fashion Theory*, and the

Journal of British Film and Television Studies, while also contributing articles to various anthologies on fashion and on cinema. She has co-edited several books, including *Dirty Looks* (1993); *Fashion Cultures: Theories, Explorations, Analysis* (2000); *More Dirty Looks* (2004); and *Fashion Cultures Revisited* (2012). She is the founder and Principal Editor of the journal *Film, Fashion and Consumption*. In 2012 she co-founded the European Popular Culture Association and was its first President. She is on the editorial board of several international journals and various book series; she is also the founding Editor for Edinburgh University Press of the new book series *Films, Fashion and Design*.

Hazel Clark is Professor of Design Studies and Fashion Studies at Parsons School of Design, The New School, New York, USA. Building on a degree in fine arts and a PhD in design history, her scholarship has focused on uncovering new perspectives, cultures, and geographies for the study of fashion and design internationally. She has taught in the United States, UK, Europe, Australia, Hong Kong, and China. Her collaborative publications include *Old Clothes, New Looks: Second Hand Fashion* (2005), with Alexandra Palmer; *The Fabric of Cultures: Fashion, Identity, and Globalization* (2009), with Eugenia Paulicelli; *Design Studies: A Reader* (2009), with David Brody; *Fashion and Everyday Life: London and New York* (2017), with Cheryl Buckley; and *Fashion Curating: Critical Practice in the Museum and Beyond* (2017), with Annamari Vanska. In 2017 she co-curated, with Ilari Laamanen, the exhibition *fashion after Fashion* at the Museum of Arts and Design, New York.

Jennifer Craik is Professor of Fashion at the Queensland University of Technology, Brisbane, Australia. She is author of several books on fashion and arts and cultural policy, including *The Face of Fashion: Cultural Studies in Fashion* (1994), *Uniforms Exposed from Conformity to Transgression* (2005), and *Fashion: The Key Concepts* (2009), and has mostly edited (with M. Angela Jansen) *Modern Fashion Traditions: Negotiating Tradition and Modernity in Fashion* (2016). Her current research projects include fashion in the Asia Pacific region, including contemporary Indigenous fashion design and contemporary Chinese fashion design.

Adam Geczy is an artist and writer who teaches at Sydney College of the Arts, the University of Sydney, Australia. With twenty-five years of artistic practice, his video installations and performance-based works have been exhibited throughout Australasia, Asia, and Europe to considerable critical acclaim. He has produced numerous books, including *Fashion and Orientalism* (2013), *Fashion's Double: Representations of Fashion in Painting, Photography and Film* (with Vicki Karaminas, 2015), and *Artificial Bodies: Models, Mannequins and Marionettes* (2017). He is editor (with Vicki Karaminas) of the *Journal of Asia-Pacific Pop*

Culture (Penn State University Press) and editor (with Jakelin Troy and Lorena Fontaine) of *ab-Original: Journal of Indigenous Studies and First Nations' and First Peoples' Cultures* (Penn State University Press). His most recent titles include (with Vicki Karaminas) *Fashion and Masculinities in Popular Culture* (2017).

Vicki Karaminas is Professor of Fashion and Director of Doctoral Studies for the School of Design at the College of Creative Arts, Massey University, Wellington New Zealand. With Adam Geczy she has co-edited *Fashion and Art* (2012), co-written *Queer Style* (2013), *Fashion's Double: Representations of Fashion in Painting, Photography and Film* (2015), *Critical Fashion Practice from Westwood to Van Beirendonck* (2017), and *Fashion and Masculinities in Popular Culture* (2017). Other book projects include *Shanghai Street Style* (2013), *Sydney Street Style* (2014), *Fashion in Popular Culture* (2010), *The Men's Fashion Reader* (2009), and *Fashion in Fiction: Text and Clothing in Literature, Film and Television* (2009). She is founding editor of *The Australasian Journal of Popular Culture* and the founding editor (with Adam Geczy) of the *Journal of Asia-Pacific Pop Culture*. She is a member of advisory and editorial boards of a number of international journals, including *Fashion Theory: The Journal of Dress and the Body*.

Véronique Pouillard is Associate Professor in the History of Modern Europe at the Department of Archaeology, Conservation, and History, University of Oslo, Norway. Prior to this, she held posts and fellowships at the Université Libre de Bruxelles and at Columbia University, and was a Newcomen Fellow at the Harvard Business School. Véronique's research focuses on the history of international business, especially in the fields of fashion, advertising, and intellectual property. Véronique was Principal Investigator with the HERA II Enterprise of Culture Project financed by the European Science Foundation. She is now the Humanities coordinator of the Nordic Branding research project, a multidisciplinary initiative at the University of Oslo. She is the co-editor (with R. L. Blaczszyk) of the book *European Fashion: The Creation of a Global Industry* (2018).

Hilary Radner is Emeritus Professor of Film and Media Studies at the University of Otago, New Zealand, and author of three monographs that form a trilogy addressing the formation of feminine identity at the end of the twentieth century and the beginning of the twenty-first century: *Shopping Around: Consumer Culture and the Pursuit of Pleasure* (1995), *Neo-Feminist Cinema: Girly Films, Chick Flicks and Consumer Culture* (2011), *The New Woman's Film: Femme-Centric Movies for Smart Chicks* (2017). Her recent publications include a co-edited special issue of *Fashion Theory* (2017), with Vicki Karaminas, and *Raymond Bellour: Cinema and the Moving Image* (2018) with Alistair Fox.

Agnès Rocamora is Reader in Social and Cultural Studies at the London College of Fashion, University of the Arts London, UK. She is the author of *Fashioning the City: Paris, Fashion and the Media* (2009). Her writing on the field of fashion and on the fashion media has appeared in various journals, including *Fashion Theory, Journalism Practice, Sociology, Sociétés*, and the *Journal of Consumer Culture*. She is a co-editor of *Thinking Through Fashion: A Guide to Key Theorists* (2016), *The Handbook of Fashion Studies* (2013), and *Fashion Media: Past and Present* (2013). She is also a founder and co-editor of the *International Journal of Fashion Studies* and is on the editorial board of *Cultural Sociology* and of *Fashion Studies*.

Valerie Steele is Director and Chief Curator of The Museum at the Fashion Institute of Technology, New York, USA, where she has organized more than twenty-five exhibitions since 1997. A prolific author, she is also the founder and editor in chief of *Fashion Theory: The Journal of Dress, Body and Culture*, the first peer-reviewed journal of Fashion Studies.

Olga Vainshtein is Senior Researcher at the Institute for Advanced Studies in the Humanities at the Russian State University for the Humanities in Moscow, Russia. She has taught courses on Fashion Studies in Moscow, at the University of Michigan, and at Stockholm University. Her current research interests include the cultural history of fashion, European dandyism, fashion and the body, fashion and beauty. She has written for *The Fashion History Reader* and *Men's Fashion Reader; Fashion Theory Journal; Fashion, Style & Popular Culture.* She is the author of the book *Dandy: Fashion, Literature, Life Style* (2006, 2012) and the editor of *Smells and Perfumes in the History of Culture* (in two volumes, 2003, 2010) and the book series *Library of Fashion Theory* (in Russian). She is a member of editorial boards of the journals *Fashion Theory: Journal on Dress, Body and Culture*; *Critical Studies in Men's Fashion*; *International Journal of Fashion Studies*; and the Russian version of *Fashion Theory Journal.*

ACKNOWLEDGMENTS

We would like to thank Lauren Beasley for all her editorial contribution to this project. Our gratitude goes to our editor Frances Arnold and to Pari Thompson at Bloomsbury Publishing for their unwavering support and enthusiasm. We would like to acknowledge and thank the College of Creative Arts at Massey University for awarding a Massey University Research Grant (MURF), which supported the international conference and associated exhibition, The End of Fashion, which was held on December 8–9, 2016, at the Wellington campus and cosponsored by the University of Otago. Many of the chapters in this book were first presented as keynote papers and later developed for publication. Vicki Karaminas would like to thank Emeritus Professor Hilary Radner for her support in co-convening *The End of Fashion* conference and Adam Geczy and Sue Prescott for curating the associated exhibition. She would also like to thank Professor Claire Robinson, Professor Tony Parker, and Distinguished Professor Sally Morgan for their creative and intellectual energy. Adam Geczy would like to thank Sydney College of the Arts, the University of Sydney. Most important, we are indebted to the contributors themselves who saw the value of this project.

INTRODUCTION

One of the cultural aftereffects of postmodernism is that any pronouncement of a phenomenon's death is not necessarily cause for alarm. On the contrary, it can provoke excitement. This is not to be perverse, but rather to acknowledge that former paradigms have been exhausted, or re-oriented. It can mark the end of a canon or a doxology. The end of history, the end of painting, the end of art, and the end of man are among the many proclamations toward the end of the last century. The historicity that underpinned postmodernism entailed a strong consciousness of memory, resonance, and historical signification, especially in the way that narratives, styles, and traditions lived on, or how they were reconfigured into new forms and under different conditions. Culturally speaking, to consign something to death is to open a door to an afterlife, which can be as cliché, or as reinvention. The "end of fashion" is the result of a number of forces caused by the redistributed networks of communication and of global economies. The chapters in this book explore the causes of this end and its many ramifications, critically situating fashion within our vertiginous present.

This present is what Slavoj Žižek has recently identified as the "End Times." Noting that this term is in the plural, these "End Times" are endemic of radical changes in consumption and communication against the backdrop of overpopulation, the strain on resources, and the threat of impending ecological disaster. Announce to any average educated consumer that we are now living in an era of the end of fashion, and you might be surprised to witness a lack of dissent—not that they will explain why—that betrays the temperature of the times. It is an intuition that is arrived at from the now immeasurable immensity of the consumer market, that the dizzyingly heterogeneity of commodities, and the many ways—virtual as well as physical—that these commodities are transacted. "End Times" is not only the backdrop of impending doom but the end of the old myths and beliefs, the end of Communism, and the age of "post-democracy," where the so-called new order is just another fragile order for a deeper disorder. As Žižek concludes, the predicament of "End Times" is that, in the twentieth century, the Left thought it knew what to do, and simply had to wait for the right occasion to do so. Yet today, in these times, "we do not know what we have to do." Yet we know that nonetheless something needs to be done.[1] In other words, in the wake of ends, there is still call for new strategy and invention.

For fashion these new conditions are reflected in a number of ways, in how fashion is designed, received, worn, and represented. There is no longer a universal canon as say, Dior's "New Look" became a ubiquitous standard in the years after the Second World War. Rather, dress is increasingly approached as a mode of personal expression, rather than as a signifier of status or profession, with, of course, notable exceptions. To date little research has been done on the causes and implications of this shift, which has had significant consequences in terms of fashion design and its place in society, the mandate of fashion scholarship and our general attitude toward clothing. Designers are increasingly treated as "artists" and their designs as "art," while fashion encroaches ever more frequently into the museum space. Arguably, these shifts are a manifestation of important evolutions in perspective on a global scale tied not only to technological innovation but also to new ethical modalities emerging in response to what Canadian scholar Marshall McLuhan termed in the twentieth century "the global village," promoted initially by television and intensified with the growth of the Internet.

The "end of fashion" is therefore not to be taken literally but rather in terms of the way fashion and the fashion system, as we have understood it to be in the nineteenth and twentieth centuries, have radically changed. For mass mediation and digitalization have broadened the way that contemporary fashion is now perceived and consumed. Such changes are allied to those in industries such as music, where we have witnessed the demise of record and CD shops, and where now consumption is conducted online. Similarly, "to go shopping" need no longer mean a physical outing and visit to a store; it can just as much mean visiting an Internet site: one can shop between sets in a gym, or while distracted in the workplace. The fact that people are feeling increasingly at home with online shopping has enormous consequences for the fashion industry, which includes the trajectories of its visibility. Its ramifications are also for the phenomenality of fashion, from the physical display of a boutique to the tactile experience itself.

When designer Yves Saint Laurent departed from the fashion industry in 2002 declaring "I have nothing in common with this new world of fashion," it was not just a valedictory announcement and far more of an indication of the changes that lay ahead. At the end of Laurent's career, fashion had reached its apogee, or its end time depending on one's viewpoint, in the ways that it was being produced, manufactured, and consumed. Yes, the cognoscenti of Paris still had the capacity to influence direction, but they were not alone, as there were more than one set of judges and gatekeepers, and these in the most unpredictable of places. Bloggers emerged as power elites shifting the terrain of traditional fashion reporting and dramatically altering the ways in which fashion is disseminated. Commerce and media have united to create new ways of experiencing designer's collections as runway shows now compete with Internet live streaming, digital fashion films, Instagram, and Pinterest. Similarly, concept stores have also replaced the department stores and traditional forms of retailing.

It is worth returning to the rhetoric of ends as it has traditionally been leveled at culture, and in particular, art with its effect on fashion. It is an important concept to consider, as the "end of art thesis," as it has come to be known, occurs together with the shaping of art history (and fashion) in particular with the thought of philosopher G.W.F. Hegel. Working on J.J. Winckelmann's *History of Ancient Art* (*Geschichte der Kunst des Altertums*, 1776), Hegel placed his work within a topology that was justified according to historical progress. Art was viewed by Hegel as a receptacle of the all-pervading Spirit, which slowly disclosed itself over time and with greater degrees of force and lucidity according to the different media—architecture, sculpture, painting, and music—that enshrined it. Eventually, Spirit would have developed to a degree of self-awareness and sophistication that would prove inadequate to art, whereupon it would need to move elsewhere (from religion then to philosophy). At this point, art would be just a spent husk, expended and otiose. Taking up Hegel's declaration of the end of art, Arthur Danto claimed that because of pop art, art's attainment of self-consciousness by the 1960s meant that "history was finished." "Artists, liberated from the burden of history, were free to make art in whatever way they wished, for any purposes they wished, or for no purposes as at all."[2] For Danto, art had progressed through three linear phases: the imitation of reality up until the late nineteenth century, the fracturing of art into manifestos claiming its motives and intentions, and, finally, art's awareness of itself. In other words, art no longer imitated life, but it represented representation itself; its content and form were irrelevant. Danto's "end of art" proclamation, much like Hegel's, was more about the end of art's narrative than the end of art itself. The same linear schema can be applied to the "end of fashion" trajectory as it has progressed since the nineteenth century: the setting of styles and trends by the aristocratic elite that "tricked-down" and were imitated by the masses, the breakdown of social class differentiations through manufacturing and production, and the collapse of geographical style distinctions via mediation and digitalization. Like art that no longer imitates life, fashion is no longer about class distinctions, but it represents representation itself. Despite fashion being an embodied practice, embedded in life and inextricable from life's performance, it is stalked by its representation in the image. And as Danto effectively argued, that end of art is not about the end of art per se but the end of a narrative, so too have we come to the end of a fashion system.

This short itinerary is useful not only to remind us of the historical and theoretical background of ends as they are seen to appear in art and aesthetics. It supplies important historical points that herald "ends" in contemporary fashion. Fashion "ends" after Dior's "New Look," which not only set a universal standard but was the last overarching style that physically manipulated the body (Dior died in 1957). Following this, DIY approaches, the re-use of clothing, stressing and marring material, particularly by designers such as Westwood and Kawakubo,

caused to shatter the notion that high fashion was of fine materials and good tailoring. Wear and dilapidation were fashionable at that time, which also had extraordinary consequences for fashion's relationship to class. Finally, fashion's end is decisive at roughly the same time when "contemporary art" takes over as a moniker from "postmodern art," that is, around the new millennium. Yet one more of the many manifestations of the breadth of approach and the elusiveness of definition as noted by Danto is the way that many fashion designers identify themselves as artists, fashion just happens to be their medium. And just as contemporary artists no longer need to draw in the academic sense, the mandate of that designers know that traditional tailoring techniques continue to alter as a result of outsourcing, global markets, and 3D printing technology. Ironically enough, contemporary fashion remains relatively insulated from charges of frippery and triviality, especially in comparison as how they have been leveled against contemporary art, not least because fashion has always lived under the shadow of such claims. If anything, the technical invention and conceptual sophistication are greater in fashion than ever before. So perhaps another way of reading "the end of fashion" is with the demise of the old binary of art and fashion, and to acknowledge that the equation frivolity and fashion is more of an anachronism that now calls for very different perspectives.

1
FASHION FUTURES

Valerie Steele

"The End of Fashion" is a phrase, it seems to me, with at least three possible implications. First, it could be an imperative: "End fashion!" Second, it could be a statement of fact: "Fashion has ended." Third, it could be a warning: "Fashion is about to end." The discourse surrounding the "end" of fashion also calls to mind debates about the end of, say, art, religion, or printed books. Announcements of their demise have proved to be premature, and the same may be true of fashion. Nevertheless, it is striking that fashion has attracted such hostility or, at least, ambivalence. Anti-fashion sentiment has a long history, composed of a number of different critiques. The idea that fashion is "vanity" and a source of immorality goes back to the dawn of Christianity. By the nineteenth century, when industrialization made it possible for many more people to follow fashion, a variety of groups emerged that positioned themselves "against fashion," including both dress reformers and advocates of "clothing as art." Dress reformers, some of whom were feminists, argued that fashion was a tyrant and women its victims. Fashion was also criticized from a utilitarian point of view as a waste of time and money. For aesthetes, on the other hand, contemporary fashion was ugly. As Oscar Wilde quipped, fashion was "a form of ugliness so intolerable that we have to alter it every six months."[1] For leftists, fashion was and remains "capitalism's favorite child." Tansy E. Hoskins's *Stitched Up: The Anti-Capitalist Book of Fashion* (2014) is an example of activist discourse on fashion as an exploitative, racist, sexist industry, which supports hierarchical distinctions in society, promotes the beauty myth, and destroys the planet. Many of her criticisms of the capitalist fashion system are widely shared, and her book, as a whole, is a call to end fashion, although she does propose a vague, utopian vision of revolutionary, "post-capitalist" fashion, reassuring readers that they will not be forced to wear uniforms like people during the Chinese Cultural Revolution.[2]

Barbara Vinken's *Fashion Zeitgeist: Trends and Cycles in the Fashion System* (English translation, 2005) exemplifies the statement that fashion has ended. A German scholar, Vinken argues that "the century of fashion is over: the very idea

of Paris fashion is at an end—even an anti-fashion could not save it."[3] According to Vinken, the modern fashion system developed in the 1860s with the rise of the haute couture in Paris, and ended about a century later, when fashion no longer filtered downward from the elite, but rather moved up from street and subcultural styles. Although prestigious designers quickly appropriated such demotic styles, this was not enough to maintain the fashion system as it had long existed. Vinken goes on to argue, however, that after a century of fashion, there came something she called "fashion after Fashion" or "postfashion." In a series of chapters, she analyzes its various typologies, from Karl Lagerfeld at Chanel, with the transformation of the *griffe*, to Martin Margiela, whose work was characterized by the registrations of time. Whereas fashion had previously rejected the *démodé* in favor of a ceaseless search for the new, postfashion incorporates the old into a new process of time. Vinken's approach to fashion was similar in some ways to that of certain art critics, who discussed the status of art after "the end of art," a discourse which was related to critical theory about "postmodernism."

Teri Agins's book *The End of Fashion*, published in 1999, is perhaps the most famous example in recent years of a warning that fashion is in danger of ending. An experienced fashion journalist, specializing in the business of fashion, Agins observes some ominous long-term trends, which could be summarized as "nobody's dressing up and everybody loves a bargain." The demise of Christian Lacroix's couture house and the growing importance of mass-marketing and brand image seemed to provide evidence that the fashion system, especially the subset of high fashion, was entering a difficult economic period. For many consumers, Agins warned, designer fashion had begun to seem like a "rip-off."[4] I spoke with Agins in 2017, almost twenty years after she published *The End of Fashion*. "I deliberately chose a provocative title," Agins recalled. "The publishers didn't like it. They thought it was too negative. Back then people kept saying 'Oh, fashion will come back.' Now people tell me, 'Your book was ahead of its time.' A big game changer was the disappearance of dress codes. A whole generation saw the captains of Silicon Valley wearing T-shirts and sneakers—and these are their role models."

A $700 iPhone is most people's clothing budget for two years, continued Agins. "The phone is indispensable. New clothes are not. Of course, people still want trendy stuff, they just want to get it cheaply. Already in the 1990s, Target's slogan was 'It's fashionable to pay less.' This is capitalism. Some people will still make money. I didn't anticipate on-line shopping in 1996. There is an emerging middle-class in Asia, and there is also white space in plus-size clothes. But the mystique of fashion is gone."[5]

In 2015, the eminent trend forecaster Lidewij Edelkoort published her *Anti-Fashion Manifesto*, proclaiming that "fashion is obsolete" and has become "a ridiculous and pathetic parody" of itself. According to Edelkoort, "Marketing … killed

the whole thing … It's governed by greed and not by vision." In interviews, she reiterated: "This is the end of fashion as we know it."[6] The last clause is the key, because she also suggested, counter-intuitively, that couture, the most exclusive and expensive component of fashion, will be coming back, along with an emphasis on clothing rather than "fashion."

In contrast to Agins's business-oriented analysis of problems in the contemporary fashion system, Vinkens's theoretical analysis of historical changes in fashion, and Hoskins's activist analysis of injustices in the fashion industry, Eidelkoort's *Anti-Fashion Manifesto* is a hybrid of warning, statement, and call to action. Fashion is simultaneously described as dying, dead, and about to be resurrected in a new form. It is a bit like the medieval philosophy of the King's two bodies, whereby the court announces: "The King is dead! Long live the King!" Eidelkoort's manifesto has been greeted with considerable enthusiasm within academia, more in the liberal arts than in fashion design, however. Members of the fashion industry have been respectful, but there is also considerable disagreement with her analysis and proposed improvements to the fashion system.

Any discussion of the "end" of fashion also inevitably evokes the idea of the "beginning" of fashion—and, indeed, the definition of "fashion" itself. While the majority of dress historians tend to believe that fashion began in fourteenth-century Europe, as part of the gradual rise of capitalism, there are also scholars who identify the beginning of fashion with nineteenth-century modernity, as well as those who focus on the eighteenth-century beginnings of the Industrial Revolution and the consumer economy. In addition, there has recently been a movement toward looking globally at the rise of fashion, with special attention paid to eleventh-century Japan and to the T'ang, M'ing, and Q'ing dynasties in China.

These differences of opinion are obviously directly related to differing definitions of "fashion," as opposed to "dress" or "costume." Although fashion is often defined as a regular pattern of style change, there is little agreement about the required rate and degree of change, and whether fashion necessarily involves changes in silhouette, as opposed to, say, color or decoration. Another unresolved question is to what extent it matters if changing styles of dress are restricted to members of a tiny elite. Fashion in Heian Japan, if we can call it fashion, was restricted to members of the court, as, indeed, it mostly was in fourteenth-century Burgundy.

As an historian, I am inclined to think that fashion did not "begin" abruptly in one time and place, but rather gradually developed in different places, following different trajectories. Similarly, rather than trying to identify the "end" of fashion, or the rise of "postfashion," it seems more useful to think in terms of changes within an evolving fashion system.

In this chapter, I will look at how fashion "as we know it" has changed and where it may be going. I will make no attempt to go back to the "origin" of

fashion, focusing instead on the past few centuries. My own research indicates that ever since the late seventeenth century, Paris was the center of fashion in the Western world, setting new styles that were adopted in many other countries. Significant changes in the fashion industry began in the mid-nineteenth century, with the rise of the *grande couture* (now called the haute couture). At the same time, developments in mass production, together with a retail revolution and inventions such as the paper pattern and the sewing machine, led to fashion becoming a genuinely popular phenomenon. For approximately 100 years—from the mid-nineteenth century to the mid-twentieth century—Parisian haute couture was at the pinnacle of the Western fashion system, and couturiers were widely regarded as "dictators" or "geniuses" (although this was always a misleading stereotype). When Dior launched his 1947 New Look, it was copied throughout much of the world, including Japan. Increasingly, most people thought of fashion as a phenomenon relating to women's clothing. Men's clothing appeared to follow a different trajectory, changing much more slowly. However, the fashion system changed dramatically in the subsequent decades. No longer can a single designer like Dior create a collection that women everywhere adopt. Already by the 1960s, the empire of fashion had begun to break up into multiple style tribes. Some women wore Chanel couture suits (which cost about $500) and others wore licensed copies (which cost about $25), others wore youth styles by English designers like Mary Quant or futuristic fashions by designers like Pierre Cardin and Andre Courrèges. Young men also increasingly adopted new styles of their own, which were collectively characterized as "the Peacock Revolution."

Increasingly, Paris was challenged by new fashion cities, such as London, Milan, and New York. Haute couture diminished in influence, as designer ready-to-wear, youth styles, and sports clothes emerged as vital components of the fashion system. London, in particular, spawned new youth styles, from Mod to punk, which embraced menswear as much if not more than womenswear. The young British people who identified as Mods were often working class. They were not anti-fashion. Indeed, they were extremely interested in fashion—as long as it was *their* fashion. "The original Mods had their clothes made, hunting down tailors and shoe-makers prepared to bend to their fantasies or, if they did admit something mass-produced they either modified it, took it out of context or insisted on certain stringent qualifications—their jeans, for instance, had to be American."[7] Gradually, designers emerged to cater to the new market. As the self-taught designer Mary Quant put it, "To me, adult appearance was very unattractive …. I had always wanted the young to have a fashion of their own."[8] Many London boutiques, such as Quant's Bazaar, Barbara Hulanicki's Biba, and John Stephen's eponymous menswear shops, accommodated young people's tastes for "modern" styles associated with popular culture and music. Miniskirts and tights for young women and brightly colored trousers and shirts for men were among the most important new styles, which soon spread from London around

the world. Eventually, the new styles took root in the Paris system, becoming transformed into more stylized futuristic looks.[9]

As the Mods gave way to the hippies in the late 1960s, attitudes toward fashion changed radically, as the hippies proclaimed themselves to be adamantly anti-fashion. Positioning themselves as anti-conformity, anti-consumption, and anti-hierarchy, they rejected the changing styles promoted by the fashion industry. The long ago (Victorian petticoats found in thrift stores) and the far away (Chinese workers' jackets) provided inspiration for individualized ensembles. Anti-war sentiment was ironically expressed through the wearing of cheap and tough garments from army and navy surplus stores. But hippy style was epitomized above all by blue jeans.

A book published in New York in 1970, *The Greening of America: How the Youth Revolution is Trying to Make America Livable*, explained the new "consciousness" among young people, whose first "commandment is: to be true to oneself." As the author, Charles Reich, explained: "A good place to begin is clothes, for the dress of the new generation expresses a number of the major themes of Consciousness III in a very vivid and immediate way. The first impression the clothes give is of uniformity and conformity—as if everyone felt obliged to adopt the same style." But this was "an erroneous impression." "[T]here is agreement on certain principles, but great individuality within these principles." Young people, Reich explained, favored "inexpensive clothes," because they believed that "neither individuality nor distinction can be bought in a clothing store." They wore "earthy, sensual" clothes, such as blue jeans, which give the wearer "freedom to do anything he wants," in a "deliberate rejection of the neon colors and plastic, artificial look of the affluent society" and the socially mandated need to "dress up." Young people's clothes might look uniform, but they are not, because "they are extremely expressive of the human body, and each body is different and unique." Whereas "men's suits really *are* uniform, … jeans make one conscious of the body."[10]

Formerly a working-class man's garment, blue jeans were now adopted by young men and women of the middle class. While ceasing to be vernacular workwear, jeans also seemed to be outside of the fashion system, and therefore "authentic," especially when hand-embroidered, or otherwise individualized (Plate 1). "The new clothes express profoundly democratic values. There are no distinctions of wealth or status; people confront one another shorn of these distinctions."[11] In fact, of course, jeans were rapidly incorporated into an evolving fashion system. Manufacturers machine-embroidered and otherwise embellished jeans, and new brands appeared. Jeans became fashion.

The punk subculture notoriously rejected hippy love and peace in favor of sex and anarchy, but they inherited at least some of the hippies' sentiments against fashion. They refused to accept social rules governing appropriate dress and behavior, and they were uninterested in following trends set by

the fashion industry. However, they were very interested in creating their own transgressive styles. Because their styles were often deliberately shocking, punk was initially rejected with horror by a fashion industry that had easily assimilated mod and hippy styles. Punk would therefore appear to be the poster child of anti-fashion. Yet almost immediately, creative entrepreneurs began to cater to the new punk subculture, and remarkably rapidly punk style infiltrated the fashion system.

Vivienne Westwood became the first and most important punk fashion designer. She and Malcolm McClaren began designing and selling clothes in the early 1970s, frequently renaming their store as their styles changed. McClaren also promoted punk bands like the Sex Pistols. Punk also became a part of the fashion system when designers such as Zandra Rhodes and later Gianni Versace created garments that visually referenced punk tropes, such as safety pins and rips. Indeed, virtually all street and/or subcultural styles, no matter how outré, have proved relatively easy to assimilate into the fashion system. Every few years, high-fashion designers and fashion stylists resurrect elements of past styles. Although members of the various subcultures often complain about the loss of "authenticity" that results from the incorporation of subcultural styles, this has no effect on the process of fashionization.

Avant-garde Japanese designers, such as Rei Kawakubo of Comme des Garçons, had a huge affect on international fashion, beginning in the mid-1980s. Many people today believe that the "Japanese fashion revolution" was the last really significant challenge to the fashion system. Yet although they helped "brand" Japan as a fashion-forward country, once they had begun to be successful, avant-garde Japanese designers almost always moved their runway shows from Tokyo to Paris. Indeed, instead of competing with Paris, Japanese designers confirmed Paris as the world capital of fashion. More significantly, many of the design innovations pioneered by the Japanese avant-garde, such as the use of frayed edges, were also incorporated into both high fashion and mass fashion. Essentially the same thing happened with avant-garde designers from Belgium, such as Martin Margiela. Thus, avant-garde fashion, like subcultural style, was never effectively or for long a form of anti-fashion.

Whether avant-garde, high fashion, or mainstream, designers have traditionally presented their collections at fashion shows, attended by buyers and journalists. The buyers placed their orders and journalists featured their choice of dresses in daily newspapers and monthly magazines. Then clothes arrived in stores a few months later. People waited and then they bought garments, usually at full price. Not anymore. There have always been copyists, but things really changed when fashion shows started appearing online, where everyone could see the latest looks from the runway almost immediately, including consumers and fast fashion companies. Fast fashion companies knocked them off instantly and shipped cheap copies to stores months before the high-fashion originals got there.

There are good aspects to this "democratization" of fashion—ordinary people can afford trendy clothes. But there is also exploitation of workers and theft of creative ideas from designers. The clothes are cheap and poorly made, so consumers tend to throw them out quickly and buy more. This is obviously environmentally unsustainable. The Rana Plaza factory disaster in Bangladesh in 2013 also demonstrates how dangerous and unfair this system is for the workers. Today, issues of sustainability and social justice are among the most important criticisms leveled at the fashion system, with activists asking whether it is even possible for fashion to become sustainable.

Fast fashion was the result of both technology (especially the internet) and globalization (with most textile and clothing production going to Asia). Obviously, both technology and globalization have long influenced fashion, but they have been ramped up to new levels in the twenty-first century. Moreover, the speed of *all* fashion accelerated as a direct result of the impact of fast fashion. Consumers grew accustomed to getting new merchandise every few weeks through fast fashion retailers, such as H&M and Zara. They no longer wanted to wait months after they had seen the Fall or Spring fashion shows online before they could buy the clothes in stores.

High fashion designers responded by producing two additional collections, usually referred to as the Resort and Pre-Fall collections, which were supposed to help fill in the gaps between the "real" Fall and spring collections (which gets the lion's share of media coverage). From creating two collections a year, designers started doing four, or six if they also did couture, or eight if they also did menswear—not to mention overseeing accessory design.

The veteran fashion journalist Suzy Menkes was one of many to comment on the frantic pace of fashion: "A couple of promotional shows in Asia, Brazil, Dubai, or Moscow can bring the count to ten. Ten shows a year!" notes Menkes, "that means a show nearly every month." After the suicide of Alexander McQueen and the drug-and-alcohol-fuelled public meltdown of John Galliano, even more people started talking about the stress under which designers worked. As Menkes writes: "If we accept that the pace of fashion was part of the problem behind the decline of John Galliano, the demise of Alexander McQueen and the cause of other well-known rehab cleanups, nonstop shows seem a high price to pay for the endless 'newness' demanded of fashion now. The strain on both budgets and designers is heavy."[12]

Meanwhile, in October 2015, Raf Simons left Dior, Alber Elbaz left Lanvin, and Alexander Wang left Balenciaga—triggering more anxious press. Actually only Raf Simons left because the speed with which he had to design was incompatible with his creative process. Stress was apparently not an issue, but he did say that he was frustrated by the lack of time to create: "You have no incubation time for ideas, and incubation time is very important …. I'm not the kind of person who likes to do things so fast."[13] Raf Simons's departure from Dior was, for many

observers, a kind of wake-up call. People began talking more about the fashion system as being broken or unsustainable. Asked if fashion moves too fast now, Karl Lagerfeld said, that is just the way it is: fashion moves fast. "If you are not a good bullfighter, don't enter the arena," he says. "I have no problem, but not everybody may have dream teams to do all that work. It goes with the times we live in. There is no way to look back. For some people and smaller companies, it could become too much, but big companies like Chanel, Dior, Vuitton, etc. are organized to face speed…. The thing I hate most are designers who accept those very well-paid jobs and then think the demand is too strong, that they are afraid of burn-out, etc…. Fashion is a sport now. You have to run."[14] Lagerfeld, of course, is a notorious workaholic, who also, as he admits, has the money of Chanel behind him to hire teams of assistants. But most other designers interviewed by *WWD* magazine also seemed reluctant to complain about the speed of fashion, perhaps fearing that it would make them look uncompetitive. Only Alber Elbaz did say: "Are we turning into an entertainment business? Is that the fashion business? I'm questioning, I'm not criticizing." And he observes, "I ask editors 'how are you?' and they say 'I cannot see 60 shows in one week.'"[15]

Fashion editors and retailers increasingly complained that they were deluged with too many collections, too many brands, and too many products. Although Paris held the line at 90 shows for their fashion week, at last count New York Fashion Week had more than 200 fashion shows. Consumers, too, began to suffer from fashion fatigue. They shopped less, and tended to look for sales—or special collaborations. For example, when the expensive, high fashion company Balmain collaborated with H&M on a special "capsule" collection, it triggered frenzies among shoppers—in part because Balmain's designer, Olivier Rousteing has so many followers on social media.

Some observers argued that consumer indifference was also related to scheduling problems in the fashion system. For example, the main Fall and Winter collections arrive in stores in July, when in most countries in the northern hemisphere it is really hot. Then the clothes are only in the stores for about eight short weeks, before going on sale. Fashion pundits argued in favor of a new idea—"show now, buy now." It was, of course, recognized that there were real problems with logistics. How could designers get the clothes made and shipped right after the shows? Should there be closed shows only for buyers, followed a few months later by big public shows (when things are in the stores)? How could you keep the closed shows secret? Some designers in New York and London expressed interest in the Show Now, Sell Now concept, but representatives of the fashion associations in Paris and Milan insisted that real creative fashion was worth waiting for. In practice, only a handful of items from any given collection were available immediately for sale. Thus, the initial attempts to capitalize on "Show Now, Buy Now" proved less successful than anticipated. The litany of complaints about overworked designers also dwindled. When Raf Simons became creative director at Calvin Klein, replacing both the designers

for womenswear and menswear, and taking on an even larger role than he had had at Dior, the fashion press treated his move to Calvin Klein as entirely positive,

One of the biggest issues in the fashion system, of course, is globalization. Within the global fashion system, the main actors with decision-making power—the creative and operational heads of big companies, specialist producers, flagship stores, and so on—are concentrated in a few world cities, like Paris and New York. However, the center-to-periphery framework has been complicated, by the rise of fashion pluralism and new fashion centers. Today these are four major fashion capitals—Paris, New York, Milan, and London—but many up-and-coming fashion cities. The map of fashion has changed. Today, there are hundreds of fashion shows around the world, testifying to growing numbers of designers and consumers. In East Asia alone, there are fashion weeks in Tokyo, Seoul, Shanghai, and Beijing, while South and Southeast Asia hosts fashion weeks in New Delhi, Mumbai, Bangkok, and Jakarta, to name only a few.

Most independent designers are trapped between the big luxury companies (like LVMH) and the big fast-fashion companies (like H&M). But it is even harder if the independent designers are not based in one of the big fashion capitals. Some cities, such as Berlin, have a certain stylistic influence, while others such as Mumbai or Shanghai occupy an important economic position, which they are trying to transform into a better symbolic position in the global media.

It is clear that local designers will never dress everyone—Zara and H&M do that. But local designers can represent their nation or community, and local fashion shows can definitely improve the local economy. Because of the structure of the global fashion industry, designers in peripheral cities need to take a two-pronged approach—simultaneously building local fashion centers and making an effort to penetrate world fashion capitals.

What are the factors that contribute to building both economic and symbolic capital and creating a viable fashion identity? A good fashion school, like Central Saint Martins in London or the Royal Academy of Art in Antwerp, seems to be important. So is the development of intermediate institutions, such as independent fashion boutiques and local fashion weeks, which help local designers and retailers. The presence of skilled and specialized subcontractors is crucially important, as are links between fashion and other cultural institutions, such as museums. Fashion cities also benefit if they have access to technology and science. Los Angeles has become something of a regional fashion center, in part because of cheap real estate and a pool of labor. But technology is also an issue. The LA-based company Skincraft, for example, utilizes body-scanning technology as well as laser-cutting for a customized fit.

All evidence indicates that the future of fashion will be closely connected to advances in textile technology. The Dutch designer Iris Van Herpen is known for sculptural silhouettes, new materials and construction techniques, and use of digital technology. Unusual as her work is, it also reflects fashion's obsession with new materials, techniques, and silhouettes that extend or otherwise alter the shape

of the body. New materials can add volume without undue weight, for example, while new technologies, such as computer-aided design tools, can create new and complex shapes in clothing—just as they do in architecture. 3D printing is especially fascinating because it could potentially end up transforming the entire way we manufacture clothes, eliminating the need for low-skilled, out-sourced labor.

But discussions of technology lead back to one of the most mysterious and critical issues in fashion—creativity. Creativity is a phenomenon whereby something new is created—be it an idea, a work of art, or an invention. In the fashion world, creativity is usually attributed primarily to the individual fashion designer, who is popularly seen as a unique "genius." Obviously individual designers have their own inner lives and personal histories. However, even the greatest fashion designers, such as Lee Alexander McQueen, do not create new fashions in isolation. Like all individuals, McQueen also worked within the context of a particular culture and society. He grew up gay in an era of AIDS and overt homophobia, and he identified with victims of prejudice, such as Joan of Arc. He apprenticed on Saville Row, worked in fashion in Italy, and attended Central Saint Martins, thus acquiring a deep body of knowledge of fashion techniques and fashion history. It was not just a matter of acquiring knowledge, but also being encouraged to put ideas together and determine which ideas were better and thus worth pursuing.

In his groundbreaking book, *Creativity*, Mihaly Csikszentmihalyi emphasizes that creative ideas and products arise "from the synergy of many sources and not only from the mind of a unique genius." Moreover, "The level of creativity in a given place at a given time does not only depend on the amount of individual creativity. It depends just as much on how well suited the respective domains and fields are to the recognition and diffusion of novel ideas." A domain, he explains, is "a set of symbolic rules and practices." For example, fashion is a domain. So is mathematics. A field comprises "all the individuals who act as gatekeepers to the domain," the ones who judge the value of a new creation.[16] Thus, if creativity is to flourish, there must be a critical mass of knowledgeable people who come together to share ideas and judge which new ideas are best. Consider the Italian Renaissance—were there suddenly more creative people born in and around Florence, Italy? Or was there something about the situation at that place and time that encouraged the creation and acceptance of new ideas and new types of painting?

Paris has long been considered the ultimate site of creativity. Less than two years after the Nazi Occupation of Paris ended, Christian Dior presented his first collection. Dubbed the New Look, its extravagant luxury and femininity revolutionized fashion. This was not only due to Dior's "genius." After the war ended, the domain of fashion and the field of fashion journalists, buyers, and consumers were receptive to a new, highly feminine, luxurious style. Decades later, even prickly individuals like McQueen were able to acquire allies and supporters, a network of gatekeepers—who collectively produce the A list/B

list rankings which help establish which designers become most respected and successful.

Creativity studies show that a diversity of people, cultures, and domains increases the chances of coming up with creative new ideas. As Czikszentmihalyi writes: "Centers of creativity tend to be at the intersections of different cultures, where beliefs, lifestyles, and knowledge mingle and allow individuals to see new combinations of ideas with greater ease. In cultures that are uniform and rigid, it takes a greater investment of attention to achieve new ways of thinking."[17]

In creating exhibitions, I have certainly discovered that the intersection between domains is a fertile place for creative discoveries. Thus, for example, last year I organized an exhibition on *Dance and Fashion*, exploring how these two art forms have influenced each other. Another MFIT exhibition, *A Queer History of Fashion: From the Closet to the Catwalk* also explored how the experiences of LGBTQ people has enriched fashion.

Iris Van Herpen has been especially interested in the intersection of fashion and science. She graduated from the ArtEZ School in Holland; like Central Saint Martins, it is an art-oriented design school. After working with Alexander McQueen, she started her own label in 2007 in London. She showed her collections at Amsterdam Fashion Week before moving on to Paris. Her *Capriole* collection of July 2011, when she made her debut in Paris as a member of the Chambre Syndicale de la Haute Couture, was a collaboration with the architect Isaie Bloch and with the 3D print company Materialise.

Iris Van Herpen has said that "Technology creates new design possibilities and innovative materials." In the future, she says, "I hope … there will be a totally new generation of 'super' materials that do not exist today …. Future fashions could include ways to dress in substances that are not touchable or stable, but actually move and change with the wearers' moods and expressions. Rather than wearing clothes made of solid substances, in future people could be dressed in such things as smoke, drops of water, colored vapor or radio waves."[18] However, technology, per se, is not, perhaps, the central aspect of Iris Van Herpen's work. It is, rather, a means she uses to explore feelings and ideas. Her *Capriole* collection, for example, included five looks inspired by her experiences of free-fall parachute jumping (Capriole is French for "a leap into the air"). One look, for example, recalls the moment of free fall, when, she says, "The adrenalin surges through my body, I can feel every fiber of my frame, my mind is not thinking anymore, and all my energy is concentrated in my body …. Once I'm safely on the ground, I am reborn."[19]

How different Iris's creative system is from the non-stop production of most fashion workers, including the so-called creative workers, like designers. Fashion has become more and more like factory farming. Already, in the early 1990s, the Italian designer Franco Moschino launched an advertising campaign and

window displays urging viewers to "STOP THE FASHION SYSTEM!" Moschino, who founded his company in 1983 and died of AIDS in 1994, was known for his witty designs, such as jackets embroidered with slogans like "Expensive jacket" (Figure 1.1). But the campaign to "STOP THE FASHION SYSTEM!" with its striking image of a vampiric female figure was not just a joke (Figure 1.2).

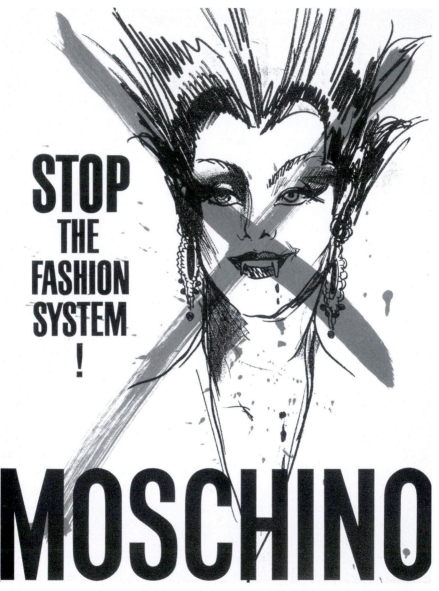

Figure 1.1 ART MOSCHINO—Advertising Campaign Spring/Summer 1990. Courtesy Moschino

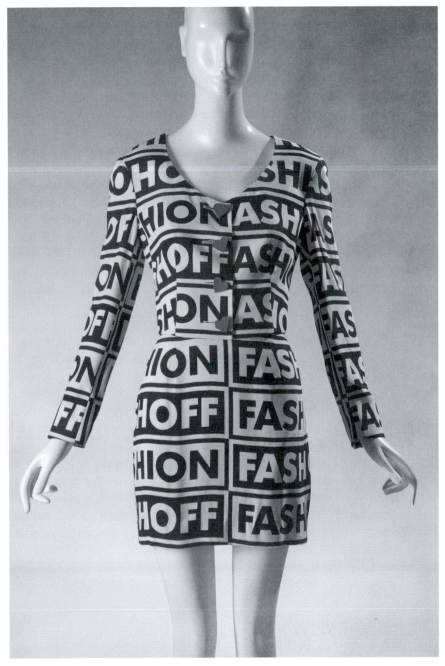

Figure 1.2 Franco Moschino. Suit, 1990, Italy. Museum Purchase. Photograph copyright The Museum FIT

Elizabeth Wilson once wrote, "the thesis is that fashion is oppressive, the antithesis that we find it pleasurable." As she further observes, dress "is never primarily functional" and human beings "are not natural."[20] To which I would add, it is precisely the artificiality and "pointlessness" of fashion that make it valuable as an aesthetic and expressive vehicle.[21] So how do we keep the best of fashion while minimizing those parts of the fashion system that are dehumanizing? One venue for thinking about fashion is the museum, and in recent years curators have increasingly begun to explore possible futures for fashion. The Museum of Art and Design recently presented *fashion after Fashion* (2017), curated by Hazel Clark and Ilari Laamanen, in collaboration with the Finnish Cultural Institute in New York and Parsons School of Design, The New School. The exhibition argues that "the term 'fashion' itself demands redefinition" in order to accommodate "a wider range of practices and ideologies." The exhibition title uses "fashion" (in the lowercase) to signal "a more reflective, … creative process that is not determined solely by commerce, the market, and trends." According to information provided by the museum, the participants in the exhibition "call into question the state of Fashion (in the uppercase) and challenge some of its main constructs, including the myth of the individual star designer, short-lived and commodity-driven products, gendered dressing, ideal bodies, and waste."[22] *Utopian Bodies—Fashion Looks Forward*, curated by Sofia Hedman and Serge Martynov, at Liljevalchs, Sweden, is another recent exhibition with an excellent catalog, which identifies key issues, including sustainability, change, technology, and craft, as well as more intangible ideas, such as community, resistance, memory, gender identity, love, and utopia. The exhibition and book explore "fashion's possibilities and human creativity," asking: "How can fashion be harnessed to create a better future?"[23]

In conclusion, it may be useful to remember that fashion is not only an economic and material entity but also a cultural and symbolic one. Long dismissed as superficial, fashion is, in fact, profoundly linked to our sense of individuality—and even our humanity. To enhance the symbolic value of fashion, or to use fashion to make a better future, it is necessary to foster an environment within which everyone's creativity can flourish. Finally, it is important to remember that fashion is not just about clothes, but about new ways of seeing and thinking.

2

TIME AND MEMORY

Adam Geczy and Vicki Karaminas

Fashion has always had problems with origins, starting with the beginnings of clothing itself, with the transition from bodily covering to dress. This is a transmutation that is linguistic in structure, analogous to the mythic transition from speech to language, or from raw to cooked. Clothing holds a special place within the linguistic conscience of civilization, since it comes into being "as such"—after the Fall, after leaving paradise—where it is a signifier of shame and lack. Clothing both covers and compensates what it is we "truly" and "only" have. From the beginning, then, fashion and dress are haunted by an end, namely the end of a particular condition, a state of being and consciousness, that subsequently necessitated clothing. Fashion is haunted by prurience, shame, and insecurity. As Hegel states in his *Lectures on Aesthetics*, "it is the feeling of modesty (*Schamhaftigkeit*) that drives man to cover himself with clothes." It is thus "the beginning of anger over something that ought not to be."[1] Since these can never be fully satisfied, fashion lives on endlessly in the chain of fetishes.

The relationship of fashion and ghosts can also be examined in a different way. The original piece in haute couture appears always already as a double or triple, modeled and represented before it is individually owned. This means that from the very outset the wearer is effectively a specter or revenant (from the French *revenir*, to come again or come back). In contemplating the contemporary polemic of the so-called End of Fashion, we might arrive at the conclusion that any suggestion of the end of fashion leads us not to an outermost abyss, but to an insight into fashion's very ontology. For as it is often said of fashion, it is over once it has arrived. But further still, the arrival is already marked by a pre-arrival (the inspiration, the model, the representation), which means that the presence of fashion in the form of this arrival is as a phantom, a phantom that is complicit in fashion as phantasy, an active and material constituent in the construction of the way the world is apprehended and understood. Perhaps fashion's "life," that is, the period before its supposed death, is the great phantasy of fashion before it came to grips with its inner nature and truth, a life that had to be undergone

to facilitate the more robust state of death. This "death" of fashion has aligned to the heroic afterlife in the wake of Nietzsche's "last man," or Dostoyevsky's gnomic statement that "God is dead, now everything is permitted."

The philosophical terminology of this chapter draws heavily from Jacques Derrida's later work, particularly his essays on Marx, under the title *Specters of Marx* ([1993] 1994). Here Derrida asks where the "true" Marx resides: there is the historic Marx, the Marx who lived, there are his interpreters and those who devised new ideas under his aegis, while there are also differentiated variety of "Marxisms" in both theory and practice. And, whether or not communism of one or another state can be called Marxism is all a matter of position and rhetoric. As such, Marx for Derrida lives on in a multiplicity of forms[2]; Marx is also a metonym—if not the name for a theoretical artifact—for humanist meliorism, economic fairness, and ultimately the messianic wish for a better future. But Marx's continued presence was also confirmed by the pervasive rhetoric at the end of the twentieth century of his death.

This paradox is explored in an important passage early in Derrida's book. Writing at a time when the eruptions of Perestroika were still fresh, Derrida discusses the perceived end of the revolutionary age and turning away from the "old Europe," which gives way to a kind of pen-cultural euphoria. "The dominant discourse," states Derrida, "often has the manic, jubilatory, and incantatory form that Freud assigned to the so-called triumphant phase of mourning work."[3] Following the "incantatory" proclamations of "Marxism is dead, communism is dead," and so on is the new refrain: "long live capitalism, long live the market, here's to the survival of economic and political liberalism."[4] Yet the transition, as Derrida argues, is far from simple and clouds a more preponderant state of affairs. For "never, never in history, has the horizon of the things whose survival is being celebrated (namely, all the old models of the capitalist and liberal world) been as dark, threatening and threatened. And never more 'historic', by which we mean inscribed in an absolutely novel moment of a process that is nonetheless subject to the laws of iterability."[5] The "old" laws and means that have been jettisoned thus re-arise (are the revenants) in different clothing, but requiring many of the old responses and diagnoses of the concepts that they jettisoned. For instance, the world of technology, language, and communication of the mass media was no better presaged by Marx himself. The "historicity" of contemporary society and its politics are precisely the way it seeks not only to mine history to prop up its legitimacy but also to find direction. (This need to draw from the past is also invoked by Derrida in the multiple uses of the term "debt.")[6] History has never been so present yet so structureless. And it is this very lack of structure that we fear, since "Marx" is the name for a structure. Hence, the more we seek to invoke alternatives to him while intoning his death, the more we reveal the extent to which he is mourned.[7] It is in repudiating him that he rises as a ghost to haunt the new world order, which is a mildly organized disorder.

Now to translate this to the present notion of the "hauntology" of fashion. Strictly speaking, contemporary fashion as a historical phenomenon can be traced back to the industrial revolution along with the democratization of luxury when the acceleration of time was triggered by industrialization and consumption. Fashion's birth as haute couture is, ironically, contemporaneous with Marxism, if only to begin crudely with a series of dates. Marx and Engels's *Communist Manifesto* was published in 1848, *A Contribution to the Critique of Political Economy* in 1859, and the first volume of *Capital* appeared in 1867. Meanwhile, in 1858 Charles Frederic Worth opened his fashion house on the rue de la Paix (not too far from another monument of Baroque revivalism, Charles Garnier's Opera House or "Palais Garnier," began in 1861 and completed in 1875). Two years later, Princess Pauline von Metternich appeared in court wearing a Worth dress, which drew the envious attention of the Empress Eugénie. Not long after Worth had close to exclusive say over all aspects of the Eugénie's wardrobe, and the bulk of her entourage; he also clothed numerous celebrities of the time, including the Australian operatic soprano Dame Nellie Melba. On one hand, Worth's clientele were a concentration of the highest elite, who, on the other hand, were dressed in a sumptuousness that was only matched by the courts of the seventeenth and eighteenth centuries. There were no greater heights to go and after Napoleon III's spectacular fall, the house of Worth itself lived on for a little while in its own particular shadow.

Worth's greatest debt—the term by now is now quite loaded—was to artists during the heyday of the European oil painting tradition, from the Renaissance through to the early decades of his own century. His "inspiration" was voracious and promiscuous, taking from Titian and Bassano to Fragonard, Gainsborough, and Thomas Lawrence. Perhaps his favorite influence was Rubens's greatest pupil van Dyck, whose paintings he plundered, while adding his own finishing touches and luxury finishes such as gold tuille or mother-of pearl. It was very much as a result of Worth that the hitherto specialist area of fine art became a talking point among the upper classes, such that wearers self-consciously wore not only a Worth "creation" but also the added value of the artists to which he was indebted. In short, the birth of haute couture is indissociable from the revenant of identifiable paintings and aesthetic forms, allowing these paintings to live on, more pervasively and with greater force, if only as facsimiles. By repeating the image of a dress in a painting, the dress is imbued with a new life, but a life that is as a shadow of the previous one. It is by repeating something that what is repeated is rendered original, but also therefore distant and dead. Moreover, the lived, performed presentness of the fashion is perpetually haunted by the past, engendering an imprecise past and future. As Derrida observes that with appearance of the specter "no one can be sure if by returning it testifies to a living past or a living future."[8] And although fashion is always past, its ghosts in terms of influences, inspirations, homages, and stylistic paradigms persist as ghosts

that as signs in fashion history have a robust life. In Derrida's words again, "a ghost never dies, it remains always to come back and to come-back."[9] To gloss the innumerable subsequent cases of inspiration in fashion history would be an exercise in alignment and comparison that would soon lose its interest. Instead we will turn to the notion of the ghost *within* the garment.

Fashion, depredation, and death

Fashion in modernity in the early twentieth century was very much steeped in life. While Poiret claimed credit for freeing women from the corset, Patou and Chanel laid enormous emphasis on activity, sportliness, and mobility. Fabrics were repurposed—most famously by Chanel, who made a practice of making once prosaic material chic, such as schmuck jewelry, and most famously her redeployment of jersey in the name of postwar frugality and affordability (although she herself noticed how easily it was to get her clients to pay high prices for garments made of cheap materials). This era of reinvigoration reached a slightly compromised juncture with Dior's "New Look," which despite the name in fact conjoined the clean lines of modernism with the constraints of an earlier era. In the first half of the twentieth century, clothing played a key role in shaping the utopian dreams of art and society. Bauhaus principles of functionality held for furniture and housing implements as it did for dress.

The early decades of the twentieth century, which was a fertile period for collaborations between artists and designers—Schiaparelli and Dalí, Chanel's work alongside artists like Picasso with the Ballets Russes, are oft-cited examples—also witnessed artists making forays into clothing design. Avant-garde artists such as Giacomo Balla and Alexander Rodchenko designed clothing that was unmistakably futuristic. These garments, real or unrealized, were utopian with little regard for the past. Under the aegis of Russian Constructivism, Rodchenko's designs were intended as a fusion of Constructivist formalism and everyday life, the higher ideals of art made available to the proletariat. Alas, their success was limited to say the least. While modern and modernist designs had little regard for the past, it was, however, precisely because of their unfulfilled (failed) ambitions that they ushered in some sense of an ending. After the Second World War, what was new would always be understood in terms of the inevitable, and interminable newness inscribed within the fashion industry, but the newness was not necessarily philosophical. Even Courrèges's sci-fi designs were not ordained for a utopian future rather they were very much "cold war," a celebratory sartorial aftereffect of the arms and space-race.

Ironically, the new age of newness returns with garments that look back again to the past. But such retrospection differed from Worth's appropriation from art in a number of ways. For designers in the 1970s, Vivienne Westwood

and Rei Kawakubo were the most influential in introducing history to the very fabric and material of clothing. Westwood would begin what would be her signature practice of alluding to an historic model or example, but her foundational work with Malcolm McLaren approached clothing in a very lateral way that no longer placed the newness of the fabric at a premium. By stressing, tearing, wearing, and tarnishing the fabric, these designers were instrumental in adding a new value to the perception of quality in clothing, giving a new kind of material and visual syntax. By reusing materials, or suggesting that a piece of clothing had had a previous life, Kawakubo and Westwood were effectively inserting a ghost into the clothing. As opposed to the ghost in the machine, which gives the machine a greater functionality, the ghost in the garment is the trace of unreachable and irretrievable events, where the garment is somehow a residual form of something past. The new garment is a definite term, an ideal or standard object ready to be inserted into the events of life. The recycled garment, or the new garment that replicates signs of wear, is from the start a provisional entity in which the present state of wear is haunted by implications of a better past, that of the time before wear and before the garment had to bear the burden of being unique. For to be unique is either to be an artifact or to have the signs of use. The latter form of uniqueness is not particularly auspicious, just bearing the irregularities wrought from the passage of everyday life, the way that teeth are unique, or the irregularities on the surface of the skin. It is this element of the quotidian and even the indifferent that lends itself to the refrain, "fashion is dead, long live fashion," since the language of repurposed clothing affords fashion with an afterlife.

Death and decay are familiar themes in contemporary fashion practice and are often found in the work of conceptual and experimental designers such as Martin Margiela and Hussien Chalayan. Margiela's reuse of old garments that he unpicks at the seams and reworks into new arrangements with cut out darts and dyes are a vestige of historical resonances containing the revenants of past memories and lives. As Caroline Evans observes,

> Margiela transformations of "abject" materials in the world of high fashion mark him outa s a kind of golden dustman or ragpicker, recalling Baudelaire's analogy between the Parisian ragpicker and the poet and his poem "Le Vin des chiffonniers" (The Ragpickers; Wine). Like Baudelaire's nineteenth-century poet-ragpicker who, although marginal to the industrial process … recovered cultural refuse for exchange value, Margiela scavenged and revitalized moribund material and turned rubbish back into the commodity form.[10]

Margiela was re-newing clothing and drawing attention to the contemporary concept of "disposable fashion." Equally these designs were a metaphor for modernisms throwaway culture and the transience of time.

Margiela's preoccupation with the past resurfaces in his 1997 exhibition, *9/4/1615* at the Museum Bojimans, Rotterdam, where garments treated with live bacteria and mould were then displayed on mannequins. Margiela's intention is to draw attention to the fashion cycle process and its preoccupation with the constant death and rebirth of new styles. The revenant appears, like Walter Benjamin's "Angel of History," to signal the destruction of the past and the passing of time in the storm of progress. And, yet for Hussien Chalayan's moulded dresses sculptured in resin (*Ventriloquy*, Spring/Summer 2000–2001), the ghost of time is arrested in the materiality of the resin. These are signal examples of the way in which designers have often turned to death and transgression to explore the limits and excesses of corporeality in their attempts to foreground the provocative power and role of clothing as a vehicle to understanding contemporary issues of cultural anxiety.

Modernist clothing denied the past by turning to the future, or assumed a neutral, default position whence the garment came, and understood clothing as smoothly integrated into the composite flow of life. By contrast, the past evoked in the clothing of designers like Kawakubo or Margiela is postmodern inasmuch as they consciously evoke the past and seek to reconsider and reconfigure it. Using terms borrowed from literary and cultural theory, their approach and philosophy of clothing is historicist, or rather "new historicist." As Brook Thomas contends, "One measure of a new historicism might be, then, the extent to which it risks experimenting with new forms of narrating the past."[11] Thomas is writing from a literary perspective, yet his conclusions prove to be enormously useful for understanding new historicism in clothing. As he continues: "To pose the question this way is to identify two strains of the new historicism. One tries to offer new narrative structures to present the past. The other retains traditional narrative structures but offers new voices from which to tell the past."[12] "New narrative structures" is analogous to repurposed clothing, including clothing made from previous clothing, while the retention of "traditional narrative" offering "new voices" is the garment modified by stress and wear which impose different meanings from the ones of the untouched original garment.

Even when the original garment is the stressed, marred garment, it resides within the garment's syntax, a putatively usullied and ideal origin, otherwise the aesthetic of stressing would cease to have much meaning or effect. This creation of a fiction around the garment, or within the garment, has telling consequences. For, bracingly and profoundly, the practice of designing clothing that had the semblance of wear in effect introduced a language of absent-presence into clothing: someone had been there before. But unlike secondhand clothing, that person was from the start a conjuration, a hypothetical and imaginary presence. This absent-presence begins its life as ghost; ghostliness is woven into the fabric itself. One is literally invited to wear wreckage, to clothe oneself in memories. These memories can be fluid and alterable, thereby revealing the inner nature of history

and memory. Or to put this differently, the end of fashion has been reached before the garment is even worn, and the wearer returns the clothing to the world. As a result, the wearer's subjectivity is displaced to become a revenant, one's identity redeployed within the spaces of memory that the garment aggressively exudes. Like Walter Benjamin's and Charles Baudelaire's "rag picker," the allegorical figure who finds value in the detritus and is the essence of consumerism, so too Margiela designs become a metaphor for modernism throwaway culture and the transience of time. The poet and philosopher Giacomo Leopardi explored the power of fashion and its relationship to death when he personified them as sisters in the *Dialogue Between Fashion and Death* (1824). "I'm saying that it is our nature and our custom to keep renovating the world" (Leopardi, 1982, 7–8), says Fashion to Death, to which Death replies, "then I believe that indeed you are my sister, and if you want me too, ill hold it more certain than death itself— without having to prove it with a parish birth certificate" (Leopardi, 1982, 7–8). "Does fashion die ... because it can no longer keep up with the tempo- at least in certain fields?" (Leopardi, 1982, 7–8). While Walter Benjamin believes "that fashion mocks death,"[13] fashion's erasure and abolition of the past, argues Jean Baudrillard, "comprises of [the] death and the ghostlike resurrection of forms."[14] For Baudrillard is convinced that every form of identity is impacted by fashion because of its very ability to revert all forms to non-origin and reoccurrence. In other words, the constant repetition and recycling of styles renders fashion as *rétro,* because of its abolition of the *passé* (the past); "the spectral death and resurrection of forms."[15] Its up-to-dateness and its relevance is not a reference to the present but to the past, to a *dead* fashion that presupposes a *dead* time of forms: "signs, that by a twist of time, will return [like revenants] to haunt the presentFashion draws from the death and modernity of the *déjà vu.*"[16]

An example in this vein that deserves detailed attention is the first collection that earned Kawakubo widespread critical attention (Spring/Summer 1983), which spawned the phrase *La Mode Destroy*, which can figuratively mean both "fashion of destruction" and "the means of destruction."[17] Called alternatively an "aesthetic of poverty" and "deconstructivist fashion," this was an approach to fashion that placed perturbations and imperfections at a premium: torn and stressed material, asymmetry, superfluity (an extra sleeve), haphazard make-up—in short anything that could register as incongruent to the body or to conventional beauty. This aesthetic was the equivalent of the "freak" aesthetic in the manner of the maligned and banned film *Freaks* by director Tod Browning (1932, a year after he directed *Dracula*). Kawakubo's aesthetic of deformity occupies a very particular place in fashion, and in late twentieth-century culture more generally, for like Browning's film—despite accusations of exploitation—it is neither a self-conscious ploy to "give voice to the Other" nor simply a masochistic game of ugliness. Rather, it operates more in the direction of Degas's images of washerwomen which in their time were considered ugly and reprobate images.

Yet Degas's actual intent was to find gestures and silhouettes that were outside of the conventional classical repertoire, the repertoire on which he had been slavishly schooled as an art student under the great academician Ingres. Similarly, Kawakubo's collection is the expression of impatience with conventional fashion silhouettes, deeming them exhausted believing what can be considered chic can be stretched and ultimately modified.

Another important component for evaluating Kawakubo's approach that also enriches the understanding of the end of fashion is that of status of art and culture after the Holocaust of the Second World War. Kawakubo is assertive to the point of aggressively reticent about connections between her work and the nuclear cataclysms and Horishima and Nagasaki, but her work nonetheless invites them. In his much-quoted essay, "Culture Criticism and Society," Theodor Adorno makes the provocative gnomic statement, "To write poetry after Auschwitz is barbaric." "Cultural criticism," Adorno explains, is faced with the "dialectic of culture and barbarism" such that "critical intelligence cannot be equal to this challenge as long as it confines itself to self-satisfied contemplation."[18] These are multivalent statements that have been lavished with a considerable amount of subsequent critical attention. One of the main meanings that can be distilled from it is that after an event such as Auschwitz—which stands for the name of a place but is also a metonym for systematic atrocity and mass killing, just as Hiroshima is the name of a city but is also the metonym for nuclear holocaust—earlier approaches and understandings of what can be considered beautiful can no longer apply. For beauty has lost its innocence and disinterested critical or aesthetic contemplation can no longer be taken for granted as such. Kawakubo's tendency to distort and subvert the shape of the body and the garment can be read against such a position, as her designs continually give life to a hidden, maybe monstrous element to contemporary life that is the residue of atrocity, affliction, and trauma. In the contemporary sense of the term, conventional beauty is to be distrusted if taken on its own and as a given, as it exists at the expense of what it dominates and represses. Kawakubo is not implying that "ugly is beautiful," far from it. Rather her aesthetic gives rise to an awareness that beauty sits among a broader reservoir of terms, just as the fabric of life is full of exceptions to habitual expectations.

Kawakubo's wariness to affix holocaust references to her work is understandable as such corollaries are apt to be expanded at the expense of what else she sets out to achieve. To be sure, as Yuniya Kawamura observes, Kawakubo's "controversial collections include an apparent anti-war statement, when army uniforms were deconstructed and remade; clothes misinterpreted as a reference to Auschwitz uniforms, and in the early 1980s, knitwear with deliberately gaping holes that were dubbed 'Swiss cheese' sweaters."[19] In many respects, Kawakubo plays significant role in fashion and memorialization, and the way in which past as series of traces and signifiers can be melded into the garment and worn on the body.

After the death/Post-death

Much has been written of how clothing acts as a vessel that contains memories embedded in its fabric. Stains, shapes, and sweat that belong to the wearers past but are contained in the present. Cloth preserves the past as evidence of human interaction and is a powerful trigger for social and cultural memories— the revenant of times past that returns to haunt the living. The power of clothing to invoke emotions and memories is captured in a scene from Ang Lee's film *Brokeback Mountain* (2005). Based on Annie Proulx's short story of the same name, the film narrates a tale of desire and forbidden love between two cowboys, Ennis Del Mar (played by Heath Ledger) and Jack Twist (played by Jake Gyllenhaal) during a summer spent on Brokeback Mountain in the Wyoming ranges. On hearing of Jack's untimely death (the result of a homophobic attack), Ennis visits Jack's parents with the offer to take Jake's ashes back to the mountain. Jacks parents refuse, preferring to have Jake interned in the family plot and instead they permit Ennis to see Jake's childhood bedroom, where he finds his bloodstained shirt hanging on a nail. Underneath his shirt was another shirt belonging to Jack, also stained from the fight they had on the mountain that summer. It was the shirt that he thought he had lost on Brokeback Mountain instead, Jack stole the shirt as a memento of the time that they spent together.

> [Ennis] pressed his face into the fabric and breathed in slowly through his mouth and nose hoping for the faintest smoke and mountain sage and salty sweet stink of Jack, but there was no real scent only the memory of it, the imagined power of Brokeback Mountain of which nothing was left but what he held in his hands.[20]

Ennis and Jack's shirts become mediators of memories that highlight the passing of time. Like an image or a text, the shirts are painfully isolated vestiges of that idyllic summer. Surviving in memory like revenants long after Jake and Ennis relationship has ended. In a different, but similar context, Susan Sontag observes with regard to photographs that continue to represent people and places long after they have changed or perished; "all photographs testify to time's relentless melt."[21] The same can be said for garments.

In her essay "Memory and Objects," Juliette Ash writes that clothes serve as memory objects that remind one of the people whose body once wore the garment and the associative memories belonging to that absent person. She writes that

> the associative memory of an absent person, stimulated through the viewing or sensing of an item of clothing requires us to be imaginative about the past, about the object or person when they did exist.[22]

Not only do garments function as signifiers of loss and absence, they also serve as a representation of death and as a reminder of the past that is lost. Garments in this sense become a substitute, a surrogate, or consolation for something that is missing. In death clothes are considered a memory material that function as a receptacle for the lived body by virtue of the garments close proximity to a breathing body. Now absent, they contain the revenant of the person that once resided in its folds. In *Adorned in Dreams*, Elizabeth Wilson begins her seminal study on contemporary fashion among the eerie and disembodied garments in a costume museum. Wilson writes that the "deserted gallery seems haunted [as the] living observer moves, with a sense of mounting panic, through a world of the dead."[23] In the beginning of his essay "Valéry Proust Museum," Theodor Adorno insists that the *"museal"* ["museumlike"] produces discomfort and contains overtones of unpleasantness. This is because it "describes objects to which the observer no longer has a relationship and which are in the process of dying."[24] For Adorno, the objects collected in a museum are preserved to mark a historical moment, rather than to serve the needs of the present. "Dead visions," he writes, "are entombed there."[25] Much like Walter Benjamin, who eloquently argues in his essay "The Work of Art in the Age of Mechanical Reproducibiliy" (1935), that works of art contain an *aura* of authenticity, that even the most perfect reproduction will lack the presence of a particular time and space that is unique to the artwork. Much like photography's ability to make a historical claim by preserving the past by means of the captured image, fashion preserves the past in its constant deferral. Like objects in a museum, artworks in a gallery are testaments to a historical moment that is no longer in the present. Making an analogy (not just phonetically) between museums and mausoleums, Adorno implies that museums, much like mausoleums, are places where objects are saved out of time. Borrowing Adorno's analogy, Elizabeth Wilson writes that garments of the past are like "congealed memories" suspended like specters in the "mausoleums of culture," vestiges of a life once lived but now long gone. "Once they inhabited the noisy streets the crowded theatres, the glittering soirées of the social scene. Now like ghosts in limbo they wait poignantly for the music to begin again."[26]

Similarly, Charles Dickens, who Wilson quotes at great length, wrote about the ghost-like qualities of embedded in discarded clothing. In "Meditations in Monmouth Street," Dickens recalls the secondhand clothing market that once existed on Monmouth Street in London with its "extensive groves of the illustrious dead."[27] For Wilson, the anxiety and uneasiness experienced by viewing clothes in a museum (or in a secondhand store) is largely because dress, as an embodied object, gives social meaning to a biological body. Dress marks the lived body into the social world, leaving its imprint via discourses of class, age, gender, sexuality, and so on. It speaks of the wearer's identity forging their existence, their place, and position in systems of communication and the order of things. As

Wilson eloquently puts it, "dress is the final frontier between the self and the not-self." Its removal from a "breathing" living body is akin to death, for the garment no longer fulfills its role in the present but is cast into the realm of the symbolic. When Marc Jacob's was interviewed by the *Los Angeles Time*s as to whether he would consider a retrospective exhibition of his work in a gallery or museum, he replied that

> fashion is only valid if it is lived in and worn. I make clothes and bags and shoes for people to use, not to put up on a wall and look at. I think clothes in a museum are complete death. I have seen exhibitions of the clothes of Jackie Kennedy and I am not interested in her wardrobe. I am interested in the life and the women who wore those clothes.[28]

Baudrillard argues that is by no coincidence that the development of contemporary fashion is aligned with that of the museum. Defined as a "single cultural super-institution," the museum (much like fashion) is the archive of signs gone askew, the "gold-standard of culture" where artifacts (and styles) are gathered and stockpiled in a temporal reserve. The temporality of works is gathered and displayed as signs of a "perfect" past that is never *actual* but announces fashions ephemerality.[29]

Let us return to Derrida, not to his writing on Marx, but to his concept of the archive, which he developed in *Archive Fever: A Freudian Impression* (1995). For Derrida, the concept of the archive is twofold; it marks the place of commencement (*arché*) as the place where "men and gods command," or as "the place in which order is given."[30] As the place of commencement "there where things commence—physical, historical, or ontological principle,"[31] the archive is ambivalent but its implication is closely tied to the production of knowledge. Derived from the Greek, *arkhein* means the house or address of senior magistrates, the *archons*, those who order over and interpreted the archive. The *archons*, Derrida writes,

> were considered to possess the right to make or represent the law. On account of their publically recognized authority, it is their home, in that place which is their home …. That official documents are filed. The *archons* are the first of all the documents guardians. … They have the power to interpret the archives. Entrusted to such *archons*, these documents in effect speak the law: they recall the law and call on or impose the law.

In other words, the archive houses traces of the past that are considered or deemed *of value* by those chosen as the "legitimate hermeneutic authority"[32] to preserve and interpret documents as historical evidence. These documents, "which are not always discursive writings,"[33] are subjective constructions with

their own histories of negotiations and contestations over knowledge and power. Derrida contends that this *archontic* power gathers the functions of compilation, identification, and classification and consigns (to deposit) into a place; a container or depository of *signs*. This gathering of signs is coordinated into a single corpus; a system in which all the elements create an ideal configuration that is worthy of preserving. No element can function as a sign without referring to another element. This interweaving of elements, what Derrida calls *textile*, produces a *text* only in the transformation of another text. Each new *text* contains traces of the past that is always present or absent; in other words, all new forms carry *traces* of the ghost of past time and memory. If read in terms of fashion, the archive's presence in a brand is twofold; as a corpus of garments selected for its representational qualities associated with a brands identity and as a system of representation that builds on historical narratives that efface (not erase) the *original* design by coalescing elements of the old garment with the new. Fashion exploits the past by creating new narratives that are attached to previous narratives and their representations. These narratives appear embedded in garments of past collections, technically or conceptually, creating new garments that are grafted on multiple designs and their representations. Fashion's capacity to inscribe the past in a season's collection and its ability to present the collection as innovative and original are the bedrock of fashion.

Conclusion

The "end of fashion" is a problem of filiation. Filiation finds itself in historicism, in the endless troping, quoting, alluding, and implication of the past. This is done by the designer, or it is done by the consumer—and it is now also done by algorithms that rhizomatically locate references and similarities to anything, and anywhere. The problem of filiation also arises in copies and imitations. Shazaming an item of haute couture can yield numerous results of how to procure items similar to it at cheaper prices, as well as items that may go well with what has been chosen. The "end of fashion" is the era of branding where Nike no longer makes sneakers but places its brand on sneakers produced by third world countries, or where a fashion brand stands for a company of nameless designers working under his labels. We are a long way from the unique "creation" as conceived by Worth. The unique creation in fashion, in light of all the ends we describe, stands like an uncanny waxwork, a revenant from a time when the demarcations of materiality and immateriality, of quality and identity were easier to discern. Fashion now exists in a nanosphere in a state of global flux of multiple representations.

3
FASHIONSCAPES

Patrizia Calefato

*Landscape—that, in fact, is what Paris becomes for the flâneur. Or,
more precisely, the city neatly splits for him into its dialectical poles:
it opens up to him as a landscape, even as it closes around him as a
room.*[1]

These words by Walter Benjamin symbolically describe the idea of "landscape"
in the city at the end of the eighteenth century, at the very beginning of mass
society, when the new urbanization process transformed European capitals—
especially Paris—into cities of communication, lifestyles, consumption, and
fashion. The landscape was then the space into which the social subject of
the modern city, the *flâneur*, lived and acted with ease, without any boundaries
between the inside and the outside of his social environment, as if he was in
an open space and in a closed room at the same time. Benjamin's model of
urban landscape worked until the most part of the twentieth century as the
pivotal place for fashion as social practice, body language, narration of time,
and a means of communication of style. It was in the city that, during the last
century, fashion transformed itself in response to historical processes such as
wars, women's emancipation, and youth rebellions. Street styles created by the
other prototypical image sketched by Benjamin, "the collective," were born in the
urban landscape. Benjamin describes the collective in this scenery:

> Streets are the dwelling place of the collective. The collective is an eternally
> unquiet, eternally agitated being that—in the space between the building
> fronts—experiences, learns, understands, and invents as much as individuals
> do within the privacy of their own four walls.[2]

The first usage of the term "fashionscapes" is by Vicki Karaminas in "Image: Fashionscapes—Towards
an understanding of new media technologies and their impact on contemporary fashion imagery," in
Fashion and Art, eds. Adam Geczy and Vicki Karaminas (Oxford and New York: Berg, 2012), 177–187.

Between the end of the twentieth and the beginning of the twenty-first century, this landscape model significantly mutated. Globalization has shattered the stable hierarchy of center and periphery, the neat distinction between the cities and non-urbanized areas has faded, the mobility of people has immensely increased, and the means of communication have become places for social life. Contemporary landscapes have taken the form of flows: of signs, images, bodies, as proposed by anthropologist and sociologist Arjun Appadurai's "global and cultural flows" model. Fashion is one of the most interesting forms of this global cultural fluidity. Its "landscapes" are marked by objects and signs, bodies and images, myths and narrations: these elements reproduce themselves and move as digital information impulses do, continuously traveling around the world.

In his book *Modernity at Large*, Appadurai describes his view of the contemporary world as "a congeries of large-scale interactions" that have proved to be "of a new order and intensity" in comparison to how they were in previous times.[3] He writes that "the world we live in today is characterized by a new role for the imagination in the social life."[4] In the definition of the idea of imagination, different meanings are at play, according to Appadurai: the "old idea of images, especially mechanical reproduced images (in the Frankfurt School sense)."[5] To this I would add Walter Benjamin's philosophical interpretation of the serial reproduction of the work of art and of signs. Then Benedict Anderson's "imagined community," according to which every idea of community postulates an imaginative act, that is, an ideological network which renders the conception of it as a bonded human group.[6] Finally, there is "the French idea of the imaginary (*imaginaire*) as a constructed landscape of collective aspirations, which is no more and no less real than the collective representations of Emile Durkheim, now mediated through the complex prism of modern media."[7]

Based on these theoretical references, Appadurai's concept of imagination is conceived as an active productive force and as a social fact, which can play a pivotal role in the global cultural interactions of our time. Within such interactions Appadurai identifies a constant tension between homogenization and heterogenization.[8] In other words, globalization as we know it comprehends many contrasting tendencies, as in the pair global/local. In the dynamics of this pair, some cultural practices, such as internet communication, *cuisine*, or fashion, show how the complexity of the present is determined.

In the field of internet communication, social networks unveil how Marshall McLuhan's global village focuses—at the same time and contradictorily—both on the "global" perspective of a network of unknown friends located on the entire planet and on the "village," a familiar, friendly, "neotribal" dimension of communication itself.[9] In the field of *cuisine*, adjectives such as "ethnic," "exotic," "national" coexist and feed off the homogenization and widespread knowledge of habits and cooking fashions; at the same time the latter praise more and more low food miles, DIY, urban agriculture, farmers' markets as cultural and

political practices for common wellness and sustainability. In the field of fashion, it is shown how, mostly in the last two decades, its economic and cultural dimension, represented by big commercial and luxury brands and by fast fashion multinationals, must relate to local, idiolectal, and personal characters of clothing, which are extensively expressed by day-to-day styles, domestic laboratories for clothes and accessories, and also unpredictable exchanges, fusions, and translations of fashion signs circulating in the social imagery through digital media.

Appadurai categorized the fundamental disjunctions of culture, economy, and politics of our world into five dimensions of the "global cultural flows": ethnoscapes, mediascapes, technoscapes, financescapes, ideoscapes.[10] Each of these dimensions, whose nature is explained by the root preceding the suffix "-scape," describes our world as a fluid landscape, constantly moving. Appadurai writes that it shows "the multiple worlds that are constituted by the historically situated imaginations of persons and groups spread on the globe."[11]

Resonating with Appadurai's landscapes, I am inserting the idea of fashionscapes—with which I refer to the stratified, hybrid, multiple, and fluid disposition of imageries of the clothed body of our time. Building on Vicki Karaminas's coinage, fashionscapes[12] set up fashion nowadays according to new processes that are different from Simmel's classical model—imitation and distinction, from upper to lower classes—and from the late twentieth-century models, based on the relationship between institutional fashion and subcultures, summarized by the phrase "from the streets to the runway." The idea of *mass moda*, which I introduced in 1996, and again in 2007 in *Fashion Theory*, describes how those models changed at the end of the twentieth century by confronting to "a variety of tensions, meanings and values—not only in relation to the clothing dimension" of fashion.[13] This complexity has its core in the body and its way of being into the world, of its representations, its masking, its disguises, its measures, and its conflicts with stereotypes and myths.

Even the *mass moda* model seems outdated by the opening of new scenarios that, rooted in fashion or their surroundings, translate fashion beyond itself. The metaphor of fashionscapes can easily describe this mutation, according to which fashion is firmly part of the contemporary global cultural flows. International fashion studies are perfectly aware of this transformation, as the December 2016 conference *The End of Fashion* demonstrates.[14] The validity of the claim of the "end of fashion" rests on four fundamental events. First, the modes of production, communication, and consumption of the fashion system and the resulting relationship of fashion and time in the wake of the diffusion of internet and digital media. Second, the already mentioned collapsing of boundaries between global and local. Third, the increasing permeability of the division between fashion and art. And fourth, the dissolution and growing fluidity of the idea of identity as related to clothing. This chapter looks at fashionscapes not only as spatial vistas but far

more as a temporal complex. It considers that the "ends" can be read in terms of the way that temporal the palimpsests of fashion—the way a style from the present bears the imprint of one(s) from the past—have become less discernible. "Fashionscapes" as I read it later is the refolding of time such that the layers and lineaments, as in a landscape seen from afar, have become scarcely visible.

The time and the seasons of fashion

The relationship of fashion and time has already been largely analyzed by the classic authors of fashion, from Simmel to Benjamin. In this paper I would like to treat the subject according to two fundamental and complementary branches: the time of production and the time of patina. I begin with the former. When Roland Barthes analyzes the title of a fashion magazine piece entitled Blue is in Fashion This Year, he highlights that fashion is mostly a system of signification.[15] The style of magazines is the model for the communication and reproduction of the "actual" fashion system of modernity, and the proof of this is represented by how the time of fashion, as social time, is built through that style. Barthes picks some titles and captions containing other phrases such as "the accessory makes springtime," or "for a tea-time dance at Juan-les-Pins a lavish, straight neckline."[16] That these are "true," that there actually is a relationship between the shape of a neckline and the occasion of a dance in that precise place, for example, cannot be certified by an alleged objective truth. Yet there is a semantic relationship represented by the magazine as a natural or utilitarian fact of fashion signs, along the line of the most clear tradition of semiotic construction of contemporary mythography. The relationship between these signs and time must seem natural, always given, and also functional, because the magazine says so, and more extensively, it is a construct of fashion discourse.

Fashion discourse's construct of time defines the time of its production both materially and symbolically. The so-called seasonal quality of fashion was in fact invented during the passage from the sumptuary law society to the society of fashion as Appadurai describes the transformation of societies dominated by a selection and a limitation of consumption into the actual society of mass consumption.[17] Production, exchange, and consumption of fashion have been dictated—exclusively until the end of the last century, less drastically nowadays—by "seasons," called "Autumn/Winter" and "Spring/Summer," to which still correspond events such as fashion shows and exhibitions, commercial practices such as orders, clearances, opening or closures of stores, social practices such as shopping, end of season sales, holiday gifts. There are many examples of occasions in which fashion literally creates time and space. From another point of view, it is created through imagined times and spaces: the evening or day dress, the cocktail dress, holiday fashion, walking shoes, or work bags.

These models of signification are now different indeed: on no account would any fashion report sound so old fashioned, giving a normative function of time to one more or one less ribbon on a hat, in our age of layered clothing. Wearing layered clothes, from the lightest to the thickest, is a way to be apt to confront any situation. It is a way of dealing with occasions such as travel to places with variable weather, such as hiking on mountains, where in the summer the weather can change from suffocating heat to very cold, from sun to rain, from low to high pressure. Ironically, this is a paradox in our age of real-time online weather reports, which being based on satellite data and refined algorithms are actually vulnerable.

Of course fashion nowadays is completely into the idea of layering: for many years everyday clothing brands sold matching items, from tank tops to windbreakers, vests, and lightweight sweaters, to be worn one on top of the other. Trousers that can become bermudas by unzipping the over-the-knee zip are not only items of outerwear anymore, but are part of urban street style, while keeping an eye on the occasion and the rules imposed by the environment. The urban landscape also becomes the scenery of a travel when being out of the house for an entire day faces the risks of any change of the weather.

This condition is not only an issue for meteorologists and fashion designers, but also for the artists whose work focuses on the relationship between the body, its clothing, and the setting it inhabits: from the dress to the house, from the city to the country. In the nineties, as an example, British artist-designer Lucy Orta designed a collection named *Refugee Wear*, inspired by the living conditions of the homeless and the outcasts living on the streets: her shelter–dresses become almost houses, a domestic and public space, a frontier object interfacing the skin and the street. The clothing item, with this particular concept behind it, shields the wearer from adverse climatic conditions and brings back clothing to one of its primary functions, protection, which has been obliterated by fashion and luxury in favor of the symbolic function of social distinction.

The 2010 Hamburg Museum für Kunst und Gewerbe exhibition named *Climate Capsules: Means of Surviving Disaster* was based on the subject of the relationship between human body and climate change. Artists and designers answered the question "How do we want to live in the future?" by creating protective objects—capsules, indeed—that could preserve human life despite the potential environmental and climatic disasters. These artistic metaphors combine design, architecture, geo-engineering, and fashion. The capsules incorporate the vital parts and wrap the bodies both as an armor and as a refuge: inside them it is possible fertilizing the soil with sea water and diffusing sulfides in the atmosphere, sheltering endangered plants, or distorting background noises.

The concept of capsules was developed in many projects of the twentieth century—such as the capsules of space missions—but nowadays it takes new meanings: the need for protection is not due to the unpredictability of space

travel, but to the earthly travel in our everyday locations, where serious and precise responsibilities decree climate change and its effects on human beings and life in general. Climate is not in fact a "neutral" variable, but it has a direct relationship with social inequality. These are augmented by disasters, or better, often disasters are related to social forms, to exploitation of the environment, on the ground and on the water, and to fundamental common goods.

Travel and weather therefore meet in reality and in metaphor, sealing their bond in the name of the uncertainty and signature of the present. Therefore, one must be prepared: clothing, in a very ample sense, is also a life-saving "capsule." So, the habit of layering clothes could be seen from a theoretical point of view. The actual and metaphorical uniforms we wear make us fixated and stereotypical. On the contrary, wearing many clothes that enable us to cover or uncover ourselves, depending on the weather changes, could represent the symbol of a condition of flexibility, of prudent adaptability, of willingness to accept any of the circumstances, while never becoming capricious.

If, on the one hand, the succession of "Spring/Summer" and "Autumn/Winter" still pace the production, the market, and the consumption of clothing; on the other hand, we can report a bizarre randomness in the relationship between weather and clothing. The practice of layering, or the rise of new synthetic materials, has nowadays created an ideal of "clothing for all seasons," not in the sense of clothing that can be equally worn in the summer heat and in the below zero cold, but as an abstraction, as a condition of possibility of breaking the traditional rules of meteorology. This abstraction is often possible in an imaginative act, as the one we accomplish when, under our own gaze or even on our own legs, a pair of trousers known by the *retro* name of "Capri pants," as in the sixties, stopped referring only to icy lemonades, bare feet, and sunny *piazzas,* and became recontextualized in a rainy autumnal urban environment. The textiles are warmer, and wool, fleece, pile protectively veil the legs down to the knees or just under them. Bright colors and chequered patterns are tight on the thighs or slide wide onto them. The "Capri" model explodes into the more traditional "knickerbockers," and, contrastively, the bell-shaped line models of the more classic jeans. Fashion immediately grasps the slang and re-elaborates it: knee-length trousers under imperial laden or flashy fur coats, the revival of the "skorts" from the seventies, "plus fours" variations. The military or mountain universes provide the models to copy, substituting the traditional summer icons whose prototypes can be traced in Brigitte Bardot and Jackie Kennedy on the paved streets of Cote D'Azur or the actual Capri. The clothing therefore dissolves the limits of the physical seasonality and becomes the symbol of a narration, and a virtualization of both weather and time.

Forms of time in fashion have noticeably changed since the first years of the twenty-first century. From the productive point of view, the rise of fast-fashion has dismantled, even if not completely, the old pace of seasonality because the

productive chain is based not on the long terms of prêt-à-porter anymore but on the fast needs of consumption. From the communicative point of view, traditional media is now accompanied by new ones, from blogs to TV series, which sometimes completely substitute them, other times they complement them. The narrative aspect, the first person, and the individualization of consumption act more strongly nowadays than in the past in the construction of fashion discourses. Blogs have partially taken the place of magazines, e-commerce is becoming more and more captivating and customer-friendly, the practice of storytelling is more and more common in marketing and commercials, and fashion is integrated in other cultural and communicative systems.

These transformations concern what I call the time of patina. Appadurai writes that the patina is "that property of goods by which their age becomes a key index of their high status."[18] It is a regular alteration of time on the surface of things, lasting and becoming the place where the true, worn out, endured identity of the objects covered by it is gradually inscribed. Fashion lives in and lives off of the time of the patina, drawing inspiration and nourishment from intrusions in the past which help it to revive more ages at the same time on bodies, through the dresses and the accessories that represent them. The patina is an element of symbolic enhancement of value: for example, it is said that one of the customs of some dandies was the habit of letting a servant wear a new suit for some time, before wearing it in public. This way the suit developed a patina on itself, both actual and metaphorical, both as a mark of time and as an alteration generating the uniqueness of the model.

Nowadays vintage is the most stable and complete expression of the time of the patina. Originally referring to a practice relating to clothing fashion, the revival of the past, and its subsequent decontextualization and recontextualization in the present of its signs, it has become mostly common sense in the many fields of living. The term "vintage" nowadays usually defines those items of clothing, of furnishing and generally the taste for things coming from a close past, dating in a span of half a century or little more. Extending the use of the word, we say "that person has a vintage vibe," "that place has a vintage environment," "that musician has a vintage style," in order to refer to situations in which the close antique is hinted at or actually revived. It can be a "space" mini-dress, as those designed by Courrèges and Paco Rabanne in the sixties, a seventies' punk-inspired leather jacket, a big hairstyle as Madonna in *Desperately Seeking Susan* (Susan Seidelman, dir. 1985), or a square-designed car from the eighties. Today we recognize these signs as "evergreens," but there was a time in their history when their popularity was in fast decline and they were forgotten, sometimes even with a hint of disgust. Decades later, those signs come back into fashion: newer generations discover them as if they were appearing for the first time in the world of images and communication; the older generation appreciates their revival with mild sentimentality.

The first field involved in vintage is clothing, because it is directly related to the body, skin, the sense of tact, and therefore it has a privileged relationship with all human senses. However memory and nostalgia are not a sufficient explanation of the contemporary fascination with the close past. Through the objects, the images, and the signs of vintage we can enter a historical perspective, we can relive the experience of time—although short, as in Eric Hobsbawm's famous definition of "short twentieth century"—which is seemingly impossible in the present. We are in fact forced to become accustomed to values such as speed, multitasking, immediacy, brevity, and sometimes also ubiquity: these values are not inherently negative, but sometimes they are so pressuring that we have to be superficial, ordinary, and we lose the sense of time and space. The time of the patina, otherwise, gives us back the best of the past; it retrieves the aura of things and invites us to pursue practices of reuse and recycling of objects and signs.

The museums of fashion

A logical step in the discussion of fashion and time is to turn to the artifact, the relic, and the archive, and where they all conjoin as spectacle, namely the museum. "Museumization" is a term which we often use with a derogatory connotation: past its literal meaning, which simply refers to "display or preservation in, or as if in, a museum; transformation into or confinement in a museum," as it is in the Oxford Dictionary, there is also a further meaning of this word implying the transformation of an object, an environment, and a social phenomenon into something lifeless. The underlying concept in this meaning is the antiquarian attitude toward history, to use Nietzsche's term, and toward the objects of the past. It is the concept behind common idioms such as "museum piece," meaning something old fashioned, stale, which has not any effect on the present and, therefore, it better be secluded into moldy rooms!

Despite this common meaning, new concepts of museum are getting more and more relevant all over the world nowadays, with new museums concerning not only the art of any time and place, but also the art of tourism, mountain culture, photography, toys, popular traditions, cinema and, last but not least, fashion. The museumization of fashion elicits all the ambiguity of the word, as we have already seen: on the one hand clothing and accessories are considered worthy of immortality; and this dignifies fashion, its creators, and its system, making it a proper branch of contemporary art. On the other hand, the clothing, being museum pieces, lose the vitality that only the contact with a body and with day-to-day life can give them, so that fashion becomes a universe for fetishists, more than it already is. To put this in yet another way, they exist essentially as

vintage items, but denuded of any dynamism. The museums confer a special status on these objects as being both of time and suspended from it.

In spite of all the debates surrounding the withdrawal of clothing from the body to the vitrine, fashion exhibitions remain popular and museums are founded in fashion's name. For example, the museum of fashion, MoMu, opened its doors in 2002 in Antwerp, and works as a beacon for the great artists/designers who studied in that school, based on Martin Margiela's legacy. And it quickly made the old diamond trade city a new world capital of clothing culture. Sometimes, fashion also transforms old museums into progressive and very contemporary locations, as in the London Victoria and Albert Museum, which has undergone something of a renaissance since the beginning of the twenty-first century, thanks to its new fashion and design branches. The fashion museum is, in fact, not only a place for preservation of objects, but also a place where a virtuous conjunction of art and the technology of displaying objects-goods inherent to the fashion system as the production system of the social imagery is put to test: dresses, bags, photographs, those signs that create the atmosphere of time. It may be a film, a song, or a literary excerpt ideally linked to an image of the clothed body; fashion in museums recalls the contemporary mythology, recreated by the space of the museum itself or else produced as originals. This is the reason why today it is most common for fashion museums, for example The Museum at the Fashion Institute of Technology based in New York, to host courses in new concepts of museology and museography, linking art and life in an essential, critical, and innovative way.

It often happens that great traditional museums open their gates to a wider audience through fashion, gaining new visitors or giving them the opportunity of learning aspects of lesser-known cultures. Such is the case of the 2011 exhibition of the Beijing National Museum, in Tiananmen Square, named *125 Years of Italian Magnificence*, on the history and display of Bulgari jewels, which was previously hosted at the Rome Palazzo delle Esposizioni in 2009 and at the Paris Grand Palais in 2010. The derogatory connotation of museums and culture in general, often considered "useless" expenses to be cut, seems to be a predominant attitude in the age of radical financial capitalism. Language and common sense must instead acknowledge the mechanisms of museums into cultural capital. They are an organic part of mass society, as shown by the long queues that tourists patiently form outside the most renowned ones throughout the world. They are affected by the society of the internet, as it is demonstrated by the smart and constant use of new technologies, from online museums to video-art apps. No less, they are part of the society of consumption, as it is proved by the sale of magnets, book, postcards, and gadgets in the museum-related bookshops. But, above all, museums are an active part of our historical, anthropological, aesthetic, and human awareness.

Between stories and history

Clothing tells stories, contains passions and memories, builds maps with textiles, colors, styles, sounds archived in it as a written memory, a mobile writing, which models the past and foretells and shapes the present and the future. Fashion is the system which organizes the sense and the social meaning of the dress in the modern age, and it does that in an intrinsically literary way. Not because it is a subject of literature, but because its reasons and the tensions which originate it are made of the same stuff as literature. To begin with, its "aesthetic function" was theorized in the thirties by anthropologist Pëtr Bogatyrëv (one of the members of the Prague Linguistic Circle) identifying a hierarchy of functions of the dress—practical, magical, ritual, and aesthetic—of which the latter is the least functional. Similarly, the phatic function of language, whose purpose is solely limited to maintaining the communication channel, was theorized by Roman Jakobson in Bogatyrëv's same years and same intellectual context. What is indeed the meaning of fashion, and moreover of the dress, of the decorations, of the clothing, of the body, if not only "being in fashion," stating a volatile pleasure, depending and at the same time creating the taste as common sense? This principle transforms cyclically the taste, sometimes even forcing it, but it always acts in the field of the same unfunctionality and phaticity of signs that is also the foundation of literature.

There are many ways in which dresses, accessories, the objects of fashion, and the fashion system itself are able to narrate. There are many stories of dresses, but fashion has a peculiar style of narrating them: it is the tangible manifestation of how history in itself is not a linear path on a horizontal timeline, but it proceeds forwards and backwards in leaps. As already mentioned, Walter Benjamin wrote, in his theses on the philosophy of history, of fashion as a leap of a tiger (*Tigersprung*) toward the past. Benjamin writes: "Fashion has a flair for the topical, no matter where it stirs in the thickets of long ago; it is a tiger's leap into the past."[19] While we all have to live in modernity, in a never-ending present in which fashion has a central role, the perspective of the "tiger's leap" is the one conceiving fashion as history, as the depth of past into the present. Clothing narrates by itself, but often it has to interact with other visual systems of signs, especially with cinema. In cinema the sign–clothing creates a fundamental narrative unity, acting often at the same level of dialogue or voiceovers. As an example, Antonella Giannone writes, in *Moda e Cinema*, about the black and white film *Schindler's List* (1993), where "the uniform clothing marked by the Star of David is an active part of creating the anonymous mass of Jews deported and killed by the Nazis, and where, in order to highlight a particular little girl, the director literally colours her red coat in postproduction."[20] The same coat, in a later sequence of the film, stands out dramatically in the carriage transporting the bodies of the prisoners after their passage in the gas chambers, offering us the implied narration of the horror of the death of the little girl.

Clothing therefore narrates a history, in the meaning of *Historia rerum gestarum*, but is able to do so only through the narration of stories, often involving individual affections, memories, blurred images, sensation that we carry on ourselves as a scent or a flavor.

Fashion as cultural translation

The final step in what is a much larger itinerary is that of fashion as cultural translation. The role of time is critical to any conception of culture, which is defined according to past events, examples, and images. Culture always exists as a configuration, a constellation, in which temporal residues are key. The "end point" with respect to fashion is the endless possibility of translation and re-adaptation, in which the past is reinvented with that of the present.

By way of example, the Indian film *The Lunchbox* (Ritesh Batra, dir. 2013) recounts an interesting perspective through which we could reconsider the time of communication. Actually, it is not a film about fashion, however fashion is involved in the "beyond fashion" sense of this chapter. For more than a century, it has been common for Mumbai workers to have their lunches delivered by *dabbawallas*, people who, late in the morning, collect lunchboxes (*dabba*) containing the meals cooked by housewives (or sometimes by some restaurants) and deliver them to their recipients, using trains or bicycles to reach their destinations. Each *dabba*, a pile of metallic cylindrical containers stacked one over the other, reaches its recipient using a code of signals, numbers and colors. The entire process of delivery was studied in 2010 by Harvard Business School as a case study.[21] A number between 4,500 and 5,000 *dabbawallas* accomplish every day in Mumbai between 175,000 and 200,000 deliveries; the margin of error was reported to be one on sixteen million deliveries.[22] The film narrated one of these very unlikely errors. The *dabba* prepared by Ila, the film's protagonist, instead of being delivered to her husband, reached Mr. Fernandes, a still attractive office worker on his way to retirement; a widower, a misanthrope who especially despises change. Fernandes immediately acknowledges the excellent quality of the meal, especially tasteful as opposed to the insipid meals which he receives from the restaurant. Realizing the mistake, Ila sends a note to her unknown recipient in one of the containers. This causes the beginning of a daily correspondence between the two characters, kept by the persistence of the mistake of the *dabbawallas*, during which both characters change, develop mutual feelings and the awareness that will determine some decisive choices in the lives of both.

Even if the film is set in our times and many of its scenes take place on Sajaan Fernandes's open space office, technological media such as computers and mobile phones are not the primary means of communication. It is central, on the

contrary, to the role of means bound to individual bodies and craftsmanship—the handwritten notes, Ila's tasty food, her dialogues with her aunt living upstairs, whose voice is the only thing we experience of her—or of vintage means of communication, such as Ila's radio and her aunt's audiotapes. Communication is performed through the smells of Ila's lunchboxes, almost perceptible in the scenes of their preparation, the spices and the many ingredients put together by her, until they arrive on Fernandes's desk, who, silently, enjoys them. The colors and the noises of the busy streets of Mumbai have a communicative role, the songs sung by the children in the streets played by the radio, the chants of *dabbawallas* in the evening after work and their pure white clothes. Or on Ila's husband's shirt, which she smells before washing it, realizing that he has been cheating on her. Communication in this cinematic narration therefore completely relies on the senses and the body, reclaiming the need for individuality, intimacy with things, sensoriality, which seems to be completely lost nowadays. Analyzing this film, Rey Chow highlights the role of the writing voice that, in Ila's case, has a peculiar connotation. Chow writes:

> What is vocalised on the screen is a message placed not just anywhere but in a lunchbox. If cooking, as a creative act, is de facto Ila's voice (albeit a silent one like many housewives' domestic labour), the message in the lunchbox is more precisely a supplement, a communication that is added as an extra or second voice to her daily culinary performance.[23]

The relationship between the two protagonists is established by chance, by the *dabba* going to someone who was not its presumed recipient. But it was actually meant for that one person, according to the serendipitous philosophy of life of Sheikh, the young employee destined to replace Fernandes after his retirement, with the sentence: "My mother always said that sometimes the wrong train brings you to the right station." The events happen, therefore, after an unwanted chance, according to which, while being headed toward something we err, but erring we find the right destination.

It is the same way in which the cultural flows influence the world, translating a way where, when we leave, we do not know where the translation will bring us, in the sense of bringing something through something else, as the lunchboxes of Mumbai are transported on bicycles by *dabbawallas*. And, as in the film, the translation of cultures interpreted by fashion transfers signs and senses into the space of imagination. It is not a case that the cinematic metaphor I chose comes from Indian cinema, belonging neither to Hollywood nor to Bollywood, as the *New York Times* critic Anthony O. Scott wrote (2014), it is influenced by themes of the old Hollywood such as Ernst Lubitsch's *The Shop around the Corner* (1940) and Nora Ephron's *You've Got Mail* (1998). Cinema and fashion reinstate themselves as forms of cultural translation, as I maintain in my book *La moda oltre la moda* [Fashion Beyond Fashion]:

Cultural translation is based on a sometimes almost automatic or complex mechanism, through which the signs of a culture migrate into another and are interpreted, reproduced, utilized, reinvented, cited, mixed, hybridised. Cultural translation can be the forced transposition of said signs into a stereotype, for example when a dominant culture absorbs and improperly re-elaborates the signs of a subordinate or "other" culture; but it can also be—and this is the meaning I intend to use—the construction of a space of interaction, a "third term," in Rey Chow's words, a third space between cultures.[24]

As an example, the self-production of clothing all over the world is nowadays often on mixing forms and inspirations from the past, classics of fashion, and innovative styles. Moreover, the attention to practices such as recycling and reusing, and generally the ethical attention toward the production and the times of fashion highlight issues in which cultural translation also means recognizing common opportunities in the global world. This disrupts the classic differentiation which, in the creation itself of fashion as a system of social cohesion, was established between fashion (Western) and tradition (non-Western), between the center and the peripheries, between empires and colonies. The clothed body is not a standardize body, always repeating itself in the name of alleged "traditions" or the "primordial" traits of cultures: even the clothes which we wrongly consider more traditional and always the same are regulated by the cycles of fashion and taste.

On this subject, it is very interesting to analyze the unconscious stereotypes of a piece in the Giorgio Armani collection of 2011, which was inspired by the Japanese tradition in the forms, the textiles, and the cut of the dresses: "Paris runways are strutted by a geisha who is not a geisha, a concept of Japan, a dream, images imprinted on memory and transferred to the catwalk by Italian style and the purely European art of couture."[25] The underlying concepts of this excerpt are: the European models are the expression of an identity opposed to the "geisha," while "Japan" represents at most memory or dreams, whose images inspire the Western designer. The art of *couture* is completely European— how could it be otherwise? The style undoubtedly "Italian." The postcolonial East is again colonized in the imagery and the language. But are those images "authentic?" Or are they an orientalist projection, in the double meaning of the word "projection," being an external transfer of feelings that the subject refuses or does not acknowledge as its own, and therefore are attributed to other people or objects, on the one hand; and the projection of images, as in projecting a film on the screen, on the other hand?

On the same occasion, Armani declared: "When we draw inspiration from Japan, the risk is creating clothes that resemble costumes, but I keep far from folklore, I am still faithful to the European forms."[26] The fixed idea underlying such sentence is the one counterposing Europe as the place of fashion (and of

modernity) and Japan (and the East) where the traditional clothing is prevalent, typical of a culture in the sense of "folklore," always the same from centuries and immune to modernity. These stereotypes elicit the same discomfort as Arjun Appadurai expresses toward the term "culture,"[27] which sometimes becomes a term linked to the preservation of what is presumed always the same ad is actually always changing, instead. This recalls the beautiful David Cronenberg film *M. Butterfly* (1993), in which a French diplomat in China is attracted by a local opera singer, and is so much fixated on his idea of how the "oriental woman" has to be according to the stereotype, which he has interiorized through Puccini's Butterfly, that he does not realize that the woman he loves is actually a man.[28]

Fashion theory is a complex, varied, and transdisciplinary field of knowledge that translates the great power of the human body as a creator of not only unpredictable signs and meanings, but also constraints and stereotypes, the objectification of the body through fashion and its imagery. The concept of translation is to be intended both metaphorically and literally, as an inter-cultural relationship, according to Benjamin's concept (2002) of translation as a practice in which language thinks the "unfamiliarity of languages" as its limit, but at the same time it is the only possibility to achieve its highest and purest form. In this sense, fashion theory today meets the universe of fashion studies which involves the material and professional processes of its production and reproduction: planning, design, communication, industry. Moreover, fashion theory includes issues such as sustainability, ethics, the relationship between East and West, between the South and the North of the world, the role of clothing in the creation of multiple identities, the relationship of the body with different technologies, of fashion and media, the new cultural and economic of luxury in our age, the crossing of languages and cultures.

A sort of conclusion: The hill of safety jackets of Lesbos

During 2015 and in the first months of 2016, the Greek island of Lesbos was a passage for around half a million migrants and refugees, fleeing by sea mostly from Syria to Europe. While disembarking, many of them threw away their used safety jackets, amassing them in a part of the island in a proper black and orange hill. For many of them the crossing of the Mediterranean was fatal, because many of those safety jackets were made in clandestine factories in Turkey, with unsafe and unfit materials. In January 2016 some international nongovernment organization volunteers created an artistic installation in that location, by arranging 2,500 safety jackets into a gigantic peace symbol. Nowadays on the hill of Lesbos thousands of safety jackets are piled, carrying their wearers' DNA

on themselves: they are not bomber jackets or parkas, nor trendy leather jackets, but clothes that recount a passage and the hope for freedom. Filmed by a drone in the occasion of Pope Francis's visit to the island, the life jacket hill of Lesbos is a symbol of the modern condition of the clothed body and of the cultural flows of which the body is the protagonist.

Translated from the Italian by Sveva Scaramuzzi

4

PHOTOGRAPHY AND THE BODY

Olga Vainshtein

Contemporary fashion has increasingly generated theoretical discussions on the end of fashion and the connection of fashion with postmodernism and post-postmodernism.[1] The mounting transformations inside the fashion system have led to destabilizing traditional understandings of style and beauty, the rejection of authorities, new appearance modes that transcend rigid gender categories, and blurring the distinctions between visibility and illusion. Present-day culture is particularly marked by what is often called a "postmodern sensibility": irony, play, pastiche, and the dominance of the visual over the verbal. This is a world of playful simulations, quotations, and hints creating a hovering sense of instability, fluctuation, and indeterminacy. "Let us be witnesses to the unpresentable, let us activate the differences,"[2] wrote Jean-François Lyotard, one of the leading theorists of postmodernism. In the realm of contemporary fashion, one can discern a number of "trouble sites" where "undecidability" is at work. This chapter will examine how Jacques Derrida's notion of undecidability operates in the world of fashion and fashion photography, revealing its self-transgression, and present a detailed analysis of several areas in which the discussions and conflicts are a significant sign of new stakes being introduced in culture.

Derrida introduced the idea of "undecidability" (*L'indécidabilité*) to describe the space of hesitation where opposites merge in a permanent exchange of attributes. The concept of "undecidability" proved to be one of the useful working tools for describing the postmodern culture. Using the method of deconstruction that he popularized, Derrida revealed the hidden contradictions in numerous philosophical concepts such as friendship, giving, writing, and speech.[3] Derrida read these ideas in such a way as to show how they reveal condition of undecidability and the need to alter established rules. And indeed, there are occasional "rips" in the fabric of culture that serve as evidence of a paradigm shift and the dramatic change in aesthetic and ideological structures. According to Jack Reynolds,

An undecidable is one of Derrida's most important attempts to trouble dualisms, or more accurately, to reveal how they are always already troubled. An undecidable, and there are many of them in deconstruction (e.g., ghost, Pharmakon, Hymen, etc.), is something that cannot conform to either polarity of a dichotomy (e.g., present/absent, cure/poison, and inside/outside in the above examples).[4] For instance, the term "Pharmakon" in Plato's "Phaedrus" means both "poison" and "cure" and contains an undecidable contradiction: "Pharmakon properly consists in a certain inconsistency, a certain impropriety, this non-identity with itself, always allowing it to be turned against itself."[5]

Derrida's theory has parallels with some directions in contemporary fashion design: the works of Ann Demeulemeester, Martin Margiela, Dries Van Noten, Hussein Chalayan, Rei Kawakubo of Commes des Garçons were consistently labeled "deconstructionist (or deconstructivist) fashion." "*La Mode Destroy*" was a term taken from Kawakubo's early 1983 Spring/Summer collection, and work in this mold has been analyzed as approaches to fashion in which the processes of fabrication and/or outcomes are analogous to the philosophical strategies of Derrida.[6] Destabilizing the fixed meanings in metaphysics was frequently compared to operations that make experimental garments look "unfinished," "asymmetrical," "worn inside out" or "decomposing." Caroline Evans has demonstrated, for instance, how the use of vintage and secondhand fabrics by Martin Margiela and Hussein Chalayan effectively erases the opposition of old and new in their designs, thus creating undecidable collisions.[7] Similarly, the work of designer Demna Gvasalia (Vêtements) presents an ironic play with symbols of pop-culture, mixing high fashion and reconfigured street style, such as oversized clothes.

New technologies quickly lead to the revealing of potential contradictions and development of conflicts. It is these trouble sites where a state of "undecidability" arises, as described by Derrida, the tension between old and new conceptual structures becomes more acute, and one can notice obvious ruptures caused by unsettling of long-standing institutes and social norms. The symptoms of this fertile tension include doubt, distrust, and suspicions concerning visual credibility, animated debates, and conflict. And this is generally when people begin to talk about "gaps," illusions, and doubts.

"How bad Tavi's bow really was": Fashion Bloggers vs. Editors

A powerful sign of the major shifts in the world of fashion is the tension between fashion bloggers and the editors of glossy magazines, a friction that has been

occurring in various forms now for several years. One of the first of such events involved the thirteen-year-old popular fashion blogger, Tavi Gevinson, whose enormous large pink Stephen Jones hair bow flustered the viewers of a Dior display in 2010 (Plate 2). "How bad Tavi's bow really was" was one of numerous comments from enraged spectators of the show. More recently, a shouting match erupted in the autumn of 2016, when a group of *Vogue* editors publicly accused well-known bloggers of engaging in continuous self-promotion, and wearing outfits provided by brands as a form of product placement. The insults that were hurled – "desperate," "pathetic," "heralding the death of style," – represented serious personal attacks on these bloggers.[8] In response to these critics, the popular bloggers Susie Bubble (Susanna Lau) and Bryanboy accused the "old guard" from *Vogue* of wanting only to protect their own "ivory tower," contending that the fashion blogosphere is where the principles of democratization and diversity actually take place (Plate 3). "The fashion establishment don't want their circles enlarged and for the ivory tower to remain forever that. Towering and impenetrable," tweeted Susie Bubble.[9] Also, she noted, "bloggers who wear paid-for outfits or borrowed clothes are merely doing the more overt equivalent of that editorial-credit system."[10] These examples make clear that there was an inherent contradiction between print magazines and new media. The two sides represented different generations in the fashion world and, more importantly, fundamentally differing systems of fashion. Whereas the traditional system was ruled by the glossy magazines and seasonal shows presented six months ahead, the new system is based on instant broadcasting of fashion shows through video reporting and live streaming on Instagram and other social networks.

The new system of fashion that has emerged from the digital revolution is largely centered, in marketing terms, on popular bloggers, who have unprecedented influence due to their massive numbers of subscribers. If an elite blogger (an "influencer")[11] has more than half a million subscribers, his or her influence can be worth a significant amount of money: the value of a single post mentioning a particular brand is in the range of five figures. Obviously, this approach leads to limited ability to make independent critical judgments. However, when choosing an outfit for a photoshoot, an influential blogger is guided not only by the profit motive but also, and primarily, by a sense of style. Otherwise, the trust of subscribers may be lost. For subscribers to an Instagram page, their idol is not merely a guide to the latest fashion, but is the key to an aspirational lifestyle. The direct personal contact between popular bloggers and their subscribers allows the former to be an intermediary between the brand and the consumer. This role is not available to models, whose position makes no allowance for expressions of personal taste.

The changes in the professional status of fashion bloggers are significant. Initially, enthusiasts would start a fashion blog to make a name for themselves, and later find work in the industry proper, but fashion blogging has now become a

profession in and of itself, conferring both prestige and significant money. These changes are starkly reflected in the new ways of determining who is placed in the front row at fashion shows. Tradition dictates that the seats of honor in the front row (the "frow," as it is known) are given to the editors of glossy magazines, but now these places are frequently given to the new elite—the celebrity bloggers. It would seem that the conflict around the "pink bow" problem remains critical as a sign of democratizing of fashion reporting, and is indicative of the major changes in the world of fashion.

Undecidability in Photography

Photographs have been retouched for about as long as photography has existed. The desire to perfect the photograph was surely there from the beginning, to make it conform to a particular stylistic standard and the taste of the client. The Countess Castiglione, a legendary beauty and the prototype for many contemporary models, colored and drew on her own photographs to maximize their effect. Indeed in the nineteenth century, doctoring of portraits was practically obligatory. Nadar's portrait studio in Paris had twenty-six employees, of whom six worked solely on retouching. As Franz Fiedler, the German portrait photographer and author, wrote of the end of the nineteenth century, within forty years of photography's existence, "Preference was given to the studios which made the most assiduous use of retouching. Wrinkles on the face were smeared away; spots on faces were 'cleansed' by retouching; grandmothers were transformed into young women; a person's distinguishing features were well and truly wiped away. An empty, flattened mask was cherished as a successful portrait. Tastelessness knew no bounds, and trade in it flourished."[12] One interesting detail in this passage is the suggestion that retouching as a cultural act was, from the very beginning, aimed at adapting photographs to the dictates of mass culture. As we will see, this has continued.

More recently, as the possibilities of computer processing have grown and developed, the number of "improved" pictures has increased immeasurably. As early as 1992, there was an article entitled "Photographs That Lie."[13] This piece recounted the most scandalous forgeries of the time: one of the pyramids at Giza was shifted to fit onto the cover of *National Geographic*; the color of the sky in photographs of the 1984 Summer Olympic Games in the *Orange County Register* was made flawlessly blue; Ron Olshwanger, a Pulitzer Prize winner, had a can of Diet Coke removed from his hand in the postproduction process. In the wake of these revelations, the credibility of photography was compromised. As J. D. Lasica puts it, "the 1980s may have been the last decade in which photos could be considered evidence of anything."[14] Lasica quotes Ken Kobre's summary of the situation: "Digital manipulation throws all pictures into a questionable light.

It's a gradual process of creating doubts in the viewer's mind."[15] Contemporary scholars use the term "soft image" to describe digital photographs to reflect the characteristically pliant, transient, and uncertain nature of digital images.[16]

This situation leads to a number of questions: is it admissible to use photographs as evidence in legal proceedings? Can news photographs be trusted (as long as journalists remain prepared to resort to photo montages in search of a sensational story)? And finally, the more fundamental problems: what are the ethical consequences of this loss of visual credibility? Where is the line between the documentary qualities of photography and the artifice of art?

The most common tools now used to process photographs are Adobe Photoshop, Adobe Illustrator, and other special software that can combine up to twenty images into one. But the problems with Photoshop have recently led to increasing criticism. Gone is the time when Photoshop was adopted enthusiastically, and consumers more and more often reject Photoshop as a lie, a trick intended to deceive them. This is particularly apparent in the case of photographs meant for advertising. The gravest doubts in this regard concern the documentary accuracy of photography in advertisements. And while there are various new programs that allow users to determine whether Photoshop has been applied, these are used primarily by specialists, and ordinary consumers raise the red flag only when a picture is egregiously altered.[17] Consumer actions in this vein sometimes have startling results. For example, L'Oréal Paris was forced to pull an ad starring Julia Roberts from the UK due to excessive Photoshopping. Consumers were also successful in a campaign against the use of computerized models on the website of the H&M Internet store.[18]

In the latter case, the heads from photographs of real models were pasted onto identical bodies, which some consumers noticed. Nevertheless, this practice is in fact quite widespread, and there are even advertising agencies that specialize in creating photo-montages from various body parts. Models are often chosen based on the supposed perfection of a specific body part. As Danielle Korwin, founder of Parts Models, Inc., puts it: "Yes, we do handle all body parts. Everything from finely manicured hands and feet to pouting lips, weathered hands, even models with two differently colored eyes"[19] As advertising photographer Michael Raab states, "it's difficult to get the foot, ankle and calf perfect on the same leg. Sometimes you have to strip images together to get all three perfect."[20] Such mechanical assembly leads to advertising images that are composed of disparate "ideal" parts and often appear standardized and lifeless. It should come as no surprise that such an aesthetic leads to an alienation that gives rise to doubts on the part of consumers, and even potential conflicts.

These confrontations, which have been repeated in various countries and with various causes, often include the same echoing arguments from the opposing sides. Those who alter photographs professionally defend their craft, sometimes in a rather cynical way:

I create the image that people want to see. It's up to me to fake people out
…. Basically you lie to people. You create … a picture and then they adapt to
that picture. You can bring people up in taste level, you can bring them down
in taste level, just by what you create.[21]

The actions of professional photoshoppers are guided by a particular
understanding of "style." They create the images that the market demands.
These frequently reproduce the Hollywood glamour standard of sensual beauty,
combining ideals developed in the mid-1920s and 1930s, when photography
and retouching began to follow set rules to achieve the effect of glamour. The
pioneers of this technique were the Hollywood photographer Edward Steichen
and, just after him, George Hurrell. They were the first to establish the canonical
features of glamour photography: an aura of sensuality, a particular lighting that
made the subject appear to shine, streaming illumination, a focus on the face,
and sharply contrasting tones. All of this contributed to the transformation of
the body into a commercial product, the "objectification of the body," and thus
making it possible to easily distribute images in postcard form.[22]

The work of the professional Photoshopper results in the ideal Barbie Doll
body, the projection of a glamour ideal onto real human bodies. The most
common alterations in magazine photography are to create an even hairline,
render the whites of the eyes pure white, and create a smooth philtrum, flawless
armpits, sharp elbows, round breasts, smooth knees, and symmetrical feet with
evenly sized toes.

To some extent, this process can be compared to the revision of an article
by the editor of a glamour magazine, forcing the author's living text into the
stereotypes of glamour writing: in both cases, it is referred to as "editing." In both
cases, everything "superfluous" is removed. The text editor cuts the author's
lexical repetitions and run-on sentences and revises awkward turns of phrase.
Typical tasks when retouching photos are to make someone thinner, take out a
wrinkle, remove extra hairs, even out the color, adjust the silhouette of the outfit,
and fill in the holes in the hairdo.

The end product is a perfectly smooth body in which all "superfluous"
corporeal aspects are removed: a complete package, an ideal background to
an ad for whatever fashion or cosmetics product you wish. We might compare
it with the role of a sauce added to a dish to give it a "glossy" look when being
photographed for a culinary magazine, as Roland Barthes once described: "The
'substantial' category which prevails in this type of cooking is that of the smooth
coating; there is an obvious endeavour to glaze surfaces, to round them off, to
bury the food under the even sediment of sauces, creams, icing and jellies."[23]
From this perspective, the body takes on a state of visual closure, a completeness
reminiscent of a sealed packaging. One can also analyze the phenomenon in
terms of the Nature/Culture dichotomy, in which repressed natural corporeality,

with its hair, fluids, and all manner of bumps and bulges, is dispensed with, and in its places triumphantly appears a perfectly rounded and smoothed product, a representation of the body shaped to conform to all rules and intended for consumption as part of glamour culture.

Any disruption of the smooth contours of the body is interpreted in this framework as indecent, a scandalous manifestation of repressed Nature. In such cases, feminist critics often use the term "leaky vessels."[24] "This discourse inscribes women as leaky vessels by isolating one element of the female body's material expressiveness—its production of fluids—as excessive, hence either disturbing or shameful," writes Paster about the images of women in Renaissance city comedies.[25] According to Gail K. Paster, this discourse connects liquid expressiveness with women's verbal fluency and asserts the need of patriarchal control.[26]

The word "leak" is often used in such contexts, and may be associated in contemporary culture with all sorts of discordant violations of the glamour canon. We see here a typical example of how the body involuntarily "leaks," and goes along with all the other manifestations of corporeality that have no place in the world of glamour: blood, saliva, sweat, phlegm, tears, fat, wrinkles, pimples, and so on.[27] Thus the female body becomes the locus for the battle between nature and culture, a constant source of contradictions and doubts.

"Photoshop of Horrors"

In 2011, the American Medical Association warned that altered advertising images pose a threat to the health of consumers by creating unrealistic ideals. By way of example, they pointed out that no natural human body has a waist circumference less than its head circumference. However, natural proportions are the least of the worries of advertising photography professionals, and in many cases they go a bit "over the top," resulting in absurd images. The feminist website Jezebel once had a regular column entitled Photoshop of Horrors, which presented stark examples of bodily distortions: impossibly twisted arm positions, unbelievably narrow knees, extra body parts, and missing body parts[28] (in June 2012 issue of the Chinese version of *Vogue*, the Dutch model Doutzen Kroes was deprived of her right leg).

A few years ago, a series of photographs circulated on the internet with the caption "What's the secret of my beauty? Adobe Photoshop day cream."[29] This series included images of Madonna, Angelina Jolie, Britney Spears, Gwyneth Paltrow, Beyoncé, and other stars. The finished product in each case was a mashup with two sides of a face, before and after processing with Photoshop. The difference was so striking that it rendered the unaltered faces almost unrecognizable. The people who alter the photographs often compare their work

with the everyday use of makeup. In this seemingly innocuous interpretation, women are said to be diligently "retouching" their own appearance, while these professionals are modestly taking these efforts to their logical conclusion (Plate 4). Certain ads are even explicitly based on the parallel between Photoshopping and cosmetics: Maybelline's anti-aging cream, The Eraser, is presented in an image as a graphic editor that removes wrinkles just like Photoshop.

Recent years have seen an increase in the number of scandals associated with the use of Photoshop: in 2014, the famous comedy actress Lena Dunham (Plate 5) was photographed for the cover of the American edition of *Vogue*, but her fans were disappointed when they hardly recognized her after the extensive alterations. The list of changes wrought by Photoshop in the actress's appearance is quite exhaustive:

- Shoulder/back of neck shaved down, lengthening the neck
- Line near mouth on face removed
- Jawline sharpened
- Neckline of dress pulled up—cleavage altered, armpit covered
- Waist/hip smoothed, made narrower
- Elbow shadow/dimple removed
- Hands smoothed[30]

To say the least, Lena Dunham's appearance underwent substantial changes. The feminist site Jezebel paid $10,000 for the original unretouched photos of the actress, and the difference was astonishing. The photographer was the famous Annie Leibowitz, who decided to shoot Dunham as her character Hannah from *Girls*. Along with Dunham, the shoot included her co-star Adam Driver. It is noteworthy that his fate was considerably different: his face and body remained largely untouched (as did the dog in the shot). This is indicative of how culture treats the female body specifically as the object of "editorial corrections," given that it is the traditional object of commodification. However, in the case of Lena Dunham, who is not a professional model but rather an actress known for her intelligence, this standard approach was unexpected to say the least.

Protesting Against Photoshop

Owing to the rise in public scandals over Photoshop horrors, the movement against Photoshop has mounted steadily. A new fashion for naturalness is developing: the original, unadorned appearance is proving to be more compelling. One of the first signs of this change[31] with regard to makeup in 2014 was the emphasis on natural eyebrows instead of plucked "threads." In addition

to ordinary women, models also started posting natural pictures of themselves, including ones with armpit hair and visible pimples on their skin.

The Australian website MamaMia recently launched a campaign called "Body Positive" in which women were asked to post photographs of themselves without makeup. In addition to just faces, the site's editors suggested taking photos of "a particular body part that bothers us [for which] we tend to buy clothes that hide or cover or draw attention away from it."[32] Readers were given challenges such as taking a picture after a workout, or a shot of their body after giving birth. The creators of the project wanted to emphasize the body in action rather than its static outward attributes. The hardest task was the final one: tell about shaming comments made about a particular part of your body and then post a photo of the same body part. The purpose of this challenge was to allow the participating women to be freed from the burden of negative impressions left by past insults and to "rehabilitate" their own bodies in their own eyes. The reaction to the Body Positive project, from both viewers and participants, was resoundingly affirmative. The concept behind the project was to create a new idea of what constitutes "normal": the "new normal" is "diverse and interesting and REAL. One that talks about the female body in terms of what it can DO and not what it looks like."[33] Another example in the same vein was the documentary film *Embrace*, released in 2016. The director, Taryn Brumfitt, interviewed women and analyzed their relationships to their bodies' image in connection with unrealistic advertising. The picture gained honors at the Sydney Film Festival and has enjoyed great success.

Reactions from Stars

Certain celebrities have also spoken out against alteration of their photographs and begun to post unaltered photos online. Some have requested that magazines remove their retouched photographs. Emma Thompson and Rachel Weisz have issued statements against unrealistic beauty retouching in ads. Kate Winslett even included a "no retouching" clause in her contract with L'Oréal.[34] Rumer Willis protested against photographs of her in *Vanity Fair* in which the size of her jaw had been substantially reduced. Willis referred to this as a form of "bullying" and insisted that she was happy with her appearance and had no need for such "editing." As evidence of this, she presented an ordinary selfie on her Instagram page.

A similar event involved the American actress Zendaya (Plate 6) She also posted selfies on her Instagram page after the magazine *Modeliste* published photos of her with significant alterations: her thighs and waist were narrowed, and her skin lightened. "[I] was shocked when I found my 19 year old hips and torso quite manipulated."[35] When comparing the two photos, Zendaya's Instagram

followers unanimously remarked that the selfie without Photoshopping looked far better.

Hence the protest against manipulation of photographs is gradually becoming an indicative trend, and in some cases even an advertising technique. Aerie, a lingerie brand, increased its sales substantially after it began refusing to use Photoshop in advertisements. After publishing photographs of real bodies, with moles, tattoos, and the various individual peculiarities, the brand increased it's commercial success with consumers responding to the more honest approach to advertising.

Legislative Initiatives

History provides us no shortage of examples of laws regulating fashion. Sumptuary laws date back to Middle Ages as a means of regulating trade or status. Our era requires different sorts of laws. On March 27, 2014, the US House of Representatives considered the Truth in Advertising Act, which contained a "strategy to reduce the use, in advertising and other media for the promotion of commercial products, of images that have been altered to materially change the physical characteristics of the faces and bodies of the individuals depicted."[36] The text of the bill points out that the truth in advertising criteria set by law had not changed since 1983, and that the time had come to update the law based on the requirements of the new digital era. The bill proposed implementing recommendations from experts for high-risk categories: children and adolescents, and so on. In 2014, the bill did not pass. In 2016, another attempt was made and this time more progress was made. The bill has not yet been passed and at this writing is in committee, which is just the first stage of passage. In the 2016 version of the "Truth in Advertising" bill, the Federal Trade Commission (FTC) was required to submit a report to Congress on the current status of visual images that deceive consumers and threaten their health by creating unrealistic conceptions of the body through digital processing. The final aim of the bill on truth in advertising is to create a legal mechanism to track post-processing changes made to bodily proportions, alterations to skin tone, and reducing signs of age.

A similar law was passed in France in December of 2015.[37] This law states that, first of all, photographs must indicate that they have been retouched or processed in Photoshop. The fine for failure to comply with this law is 37,500 euros. A second innovation of this law is that models working in France must submit a medical certificate which, among other things, indicates their body mass index and states that they are permitted to work professionally in the modelling industry. The fine for failing to have such a certificate is 75,000 euros. This law is meant to fight anorexia and eating disorders among young people. Despite the

fact that 30,000 to 40,000 people in France suffer from anorexia, representatives of the modelling industry commenting on the law have attempted to defend their corporate interests by disputing the connection between anorexia and images of emaciated models.[38]

There have also been attempts to change the status quo through mass petitions. This issue has been raised regularly on Change.org, a website for creating petitions and gathering signatures. A petition under the title "Help Us Create Positive Change for Young Women by Reducing Photoshop in Magazines" attracted a great deal of attention when it was initiated. The petition was created by photo editors from well-known glamour magazines. As the petition text stated: "We want to see cover girls and editorial in your magazines that don't alter the already perfect bodies of the women you feature and don't erase their fine lines or the unique attributes that make them truly beautiful. Remove a pimple or that crazy stray hair if you must, but other than that let their natural beauty shine!"[39] The petition garnered 4,927 signatures before closing, but this was well short of the goal of 10,000.

A petition initiated by the fourteen-year-old Julia Bluhm for submission to the editors of *Seventeen* magazine met with more success. In April 2012, this petition, entitled "Seventeen Magazine: Give Girls Images of Real Girls," asked the magazine to print at least one photo spread per month without the use of Photoshop.[40] The magazine's chief editor, Anna Shokets, invited Julia and her mother to meet with her and the request was granted. The petition received more than 86,000 signatures. As of this writing, *Seventeen* continues to publish one photo spread per month without the use of Photoshop.

One of the most interesting cases is that of the Dove Company, which was among the first to take a stand on body image issues with its "For Real Beauty" campaign in 2004. Since its inception, these photos of ordinary women, far from the expected appearance of models – plump, aged, freckled, and so on – have been enshrined in the history of advertising. And yet, as was later revealed, even these photographs were retouched with Photoshop. The post-processing of these pictures was performed by the renowned photo editor Pascal Dangin, who confessed to the *New Yorker*: "Do you know how much retouching was on that? But it was great to do, a challenge, to keep everyone's skin and faces showing the mileage but not looking unattractive."[41] This publication was followed by several contradictory and vague statements from Dove, which hardly served to dispel the doubts of their audience. In 2014, again on Change.org, a petition was circulated to "Ask Dove to Help Protect Our Children from Photoshopped Ads and Beauty."[42] This petition earned 9,867 signatures, just short of 10,000. The petition's creator, Seth Matlins, a father of two from Los Angeles, called on Dove to refrain from publishing Photoshopped advertisements in places where children might see them. Matlins also called for the use of a special "Truth in Advertising" label if an ad had been produced with Photoshop. In response, however, Dove

gave no more than a statement claiming that they always try to preserve all features of the shape of the face, the skin color, age-related changes, and so on. Concerning the suggestion that they specially label ads made with Photoshop, Dove chose to remain silent. These are but a few examples that reflect a crisis of representation in fashion photography and in advertising in general.

The French philosopher Jean Baudrillard developed the now famous idea of the simulacra, an imperfect copy, a sign that does not reflect reality. Baudrillard identified four forms of relationship between sign and reality:

1. It is the reflection of a basic reality;
2. It masks and perverts a profound reality;
3. It masks the *absence* of a basic reality;
4. It bears no relation to any reality whatever: it is its own pure simulacrum.[43]

With regard to the fourth form, pure simulacra, Baudrillard notes: "Simulation is infinitely more dangerous, since it always suggests, over and above its object, that *law and order themselves might really be nothing more than a simulation*."[44] And this is the reason why attempts to regulate the use of Photoshop by law meet resistance. It is also why perpetrators easily avoid responsibility, remain silent, or mince words indefinitely. Pascal Dangin, having initially admitted openly how he convincingly showed the "mileage" of Dove models, retracted his claims after the interview. In a society where forgery and distortion are the norm, even such "rigid" criteria as bodily integrity and financial losses are blurred.

As such, it is a major challenge to preserve these criteria. Yet they are inevitably eroded by constant distrust in authenticity, in a situation of undecidability. Digitally altered images straddle the border of simulacrum. This boundary is transparent: the viewer initially presumes that the image "reflects a profound reality," but then it becomes clear that masking and distortion have taken place, and that there is clearly an "absence of profound reality." An important attribute of simulacra is the unnoticed substitution, which shifts the criteria, erasing the boundaries between reality and the constructed image. Photoshop artists, if they engage in pure creative art, are making the fourth type of simulacrum according to Baudrillard's classification.

But what should one do as a consumer if one needs, for example, to make an informed decision about an internet purchase based on a virtual image? Undecidability complicates the decision-making process. What should one do if one is a parent of a young girl whose weight is dropping to an unhealthy level based on the example of advertising simulacra? And what should people do whom society suspects of falsifying or altering their appearances by plastic surgery?

Cosmetic Surgery: Mind the Credibility Gap

Plastic surgery is yet another area that raises crucial doubts, where a "visual credibility gap" continually surfaces. This is a space of secrets, silence, guesswork, dispute, and denial. With regard to such operations performed on celebrities, the veil of secrecy is often particularly opaque, and journalists are left to guess or consult with specialists to determine whether plastic surgery has been performed. Cases where the opposite happens are quite rare. Kim Yu-Mi, who held the title of Miss Korea 2012, was accused of being helped to win the competition by her previous plastic surgery (Plate 7). Yet she managed to defend herself and retain her title after calmly acknowledging the fact, which protected her from further reproaches. More frequently, however, celebrities continually deny such operations, and it is almost impossible to determine what is true and what is not. According to Luciana Ugrina, "online cosmetic surgeries databases often identify evidence of surgical procedures in celebrities photos when, arguably, cosmetic surgery may not have been performed."[45]

One typical case is that of the actress Renée Zellweger (Plate 8). In October 2014, she first appeared in public with her face unrecognizable. Commentators immediately remarked that her new appearance was the result of several rounds of plastic surgery, most significantly blepharoplasty (eyelid surgery). After presumably changing her appearance, Zellweger joined the ranks of Hollywood Barbie dolls, despite the fact that she was best remembered for her role as Bridget Jones, not least because her appearance stood out from that of other actresses. It should come as no surprise that the overwhelming majority of viewers reacted in a highly negative way to these changes in her appearance. Many called on her "to own the work." Her fate was to lose a number of future roles. However, the actress herself wrote an essay in *the Huffington Post* in which she refuted her critics and called the judgments about her appearance "humiliating." As she emphasized:

> Not that it's anyone's business, but I did not make a decision to alter my face and have surgery on my eyes. This fact is of no true importance to anyone at all, but that the possibility alone was discussed among respected journalists and became a public conversation is a disconcerting illustration of news/ entertainment confusion and society's fixation on physicality.[46]

Even after Renée Zellweger's article, many people from the viewing public are still doubtful. As Ugrina notes:

> The preponderance of images of surgically enhanced bodies in celebrity media, along with increasing unreadability of these images, demonstrates that

celebrity cosmetic surgery images produce a proliferation of meanings that do not always correspond with stable and predictable patterns of "before" and "after."[47]

Most members of the audience react negatively when stars have plastic surgery, for two main reasons. The first is that they are used to the accustomed appearance of famous actresses. When stars change their image, they are contravening established expectations and disrupting predictability. Many viewers very likely grew to love them precisely because of their particular appearance, and so any attempt to change is taken as a violation of the established relationship between the celebrity and the public, a breach of an unspoken social contract. Cosmetic surgery is thus taken as a lie, a replacement of the old "authentic" image with a new, false one: a persona instead of a person. It becomes another cause for doubt, by analogy with the artificial beauty created by makeup and other "tricks." The second reason is more complicated. Among the religious conservative segment of the viewing public and in their traditionalist world view, plastic surgery violates the integrity of the body and distorts the person's original image. For Christians, as the Bible says, man is made in the image and likeness of God, and thus a change in one's appearance can be thought of as a loss of spiritual integrity that might even prevent the resurrection of the soul after death. Based on this same line of thinking, conservative critics and religious fundamentalists remain unsympathetic to avant-garde art.

It is worth noting that plastic surgery itself is subject to the vicissitudes of fashion. As Bor Stenvik remarks,

"Diamond noses," once popular, were replaced by "Rosenberg noses" (so named for the plastic surgeons who developed these particular shapes). The human face has become a fashion object. The thin, elongated faces that were once in style have been replaced by the latest innovation, the so-called "new new face," which has more child-like features and requires a greater effort from the plastic surgeon. Now they are not limited to the usual facelift, but the facial muscles themselves must be slightly raised to create a new shape so that the face becomes more like that of a child.[48]

The rise of different fashions even within plastic surgery adds yet another aspect of undecidability, indicating the instability of beauty standards even here. Thus plastic surgery, just like retouching of photographs, multiplies doubts, creating an erosion of identity (particularly when the subject denies that any plastic surgery has been performed). The difference with plastic surgery, however, is that we are speaking not about a representation, but rather about the human body[49] itself or, more precisely, about "corporeality," which has traditionally been considered a bulwark of authenticity, original-ness, and truth.

A useful analogy is the fate of the work of art in the era of mechanical reproduction. As Walter Benjamin states, reproduction removes a unique work of art from the realm of tradition, causing it to lose its authenticity and its aura, resulting in a change in the emotional interpretation.[50] In this new structure of interpretation, standard faces, as objects of mass reproduction, also lose their individual "aura," becoming part of the usual postmodern visual landscape.[51] Broadly speaking, plastic surgery is causing faces to become more uniform, to lose their individuality, as it reproduces whatever canonical standards of beauty are fashionable at the time.

Deconstructing Gender

Another area that frequently involves doubts about bodily authenticity is the attitude toward transgender models. Contemporary transgender people must often prove that they are "the real thing." Gender-bending has regularly found its way into fashion in the past. Suffice it to recall the "la garçonne" style of the 1920s or Marlene Dietrich and her love of trouser suits. In recent decades, famous androgynous stars have included David Bowie, Tilda Swinton, and Annie Lennox.[52] But if before these were merely marginal trends, now, with the new ideology of diversity, the popularity of transgender models is growing steadily, and they are more and more often stepping confidently to the podium. These include Saskia de Brauw, Carmen Carrera, Hari Nef, and others (Plate 9). In 2014, the runway model Geena Rocero was invited to speak at the White House on the problems faced by transgender models in modern society (Plate 10). Not long before this, her TED talk, in which she spoke about her decision to change her sex, garnered 2.6 million views.

The best-known transgender model is Andreja Pejić, a former man born in Bosnia (originally known as Andrej), who in 2014 completed a sex change operation (Plate 11). Prior to this, Pejić had appeared in showings of both men's and women's collections by Jean-Paul Gaultier, who in 2011 entrusted him with the final role of "the bride." Pejić was also seen on the cover of the French *Vogue*, and in ads for push-up bras. Many assumed that Andrej(a)'s career would end after the surgery because now, as a woman, (s)he had lost the uniqueness of being a transgender model and become just one of the crowd (and thus subjected herself to much greater competition). However, the flamboyant green-eyed blonde Andreja recently took a bold step: in an interview with *Vogue* in 2015, she openly informed the world about her operation: "It is about showing that this is not just a gimmick" she declared.[53] Soon after this, Andreja collected $63,325 on Kickstarter to make a film about her transformation.

Andreja's transgender colleagues have assumed a wide range of roles. Erika Linder, who bears a striking resemblance to Leonardo DiCaprio, has appeared in

both male and female fashion shows and has launched her own brand of unisex clothing. There are also women who cross over to the male side: Elliott Sailors was a women's clothing model for a long time, but then cut off her long blonde curls, wrapped her breasts, and became a male model.[54] Elliott claims that she made this decision in order to extend her career.

The fluidity of gender standards is also reflected in clothing design. Many collections by both established designers (Marc Jacobs) and younger ones (the Vaquera, Vejas, and Gypsy Sport brands) are showing a marked tendency toward unisex styles. In 2016, even the mass market giant Zara released its "Ungendered" line of gender-neutral clothing. Men's collections are including increasing numbers of pieces with feminine leanings, and women are boldly usurping male clothing by cross-dressing. This is hardly a new trend, however: as early as 1985, Jean-Paul Gaultier developed a collection with skirts for men under the title, "Une garde-robe pour deux" ("Wardrobe for Two"). And in 2003–2004, the Metropolitan Museum of Art staged a popular exhibition entitled *Bravehearts: Men in Skirts*. In the last two years, the number of men's collections that borrow articles of clothing from women has grown and, more importantly, this fashion is spilling over into everyday decisions about clothing. All of these changes are of course taking place more broadly than just in the world of fashion. The transgender trend is partly supported by Japanese popular culture, and it is no accident that many Manga and Anime characters have androgynous appearances. The Japanese rock star Gackt became famous for his theatrical experiments with feminine images in the "Visual Kei" style.[55]

Similar processes are underway in the cinema: in 2014, Amazon.com released a series entitled *Transparent*, telling the story of a man who acknowledged his true nature as a woman. At the age of 70, he revealed the secret of his transformation to his former family, including his three adult children. The series was phenomenally successful: the lead actor Jeffrey Tambor and the director Jill Solloway were both awarded Golden Globes, and in 2016, Solloway also won an Emmy. The film *The Danish Girl* (2015) is in the same vein, telling the story of a transsexual in the 1920s, played by Eddie Redmayne.

Fashion and Optical Illusion

The topic of optical illusions in fashion has recently been surfacing with increasing frequency.[56] This is becoming a new trend in the world of fashion and the internet. It all started in February 2015, when a Tumblr user aired his confusion: what color was the tight-fitting dress in the picture: white and gold, or blue and black? The question was instantly seized upon, dividing the internet community.[57] However, no one could reliably determine the true color of the dress, and passions flared. The number of posts on social networks grew exponentially, and hashtags

began to appear: #whiteandgold, #blueandblack, #thedress, and #dressgate, with the latter enjoying particular popularity. News soon spread of arguments about the dress among families and friends. Celebrities stepped in with their views: Kim Kardashian and her husband Kanye West joined the argument (and with differing opinions), as well as Justin Bieber, Taylor Swift, and Lady Gaga. Within 24 hours, the dress had been the subject of 4.4 million tweets. Analysts compared the speed and scale of the discussion with the spread of a new meme or a viral media campaign.

Neurophysiologists then joined the discussion, cooling the heat of passion somewhat by explaining the different interpretations through the structure of the eye and the process of chromatic adaptation. The difference in perception is associated with individual features and habituation to artificial or natural lighting, which causes our brains to process visual information differently.[58] It was thus determined that the dress was in fact blue and black, and the illusion occurred due to the type of lighting used in the photograph and to the way the image was digitally processed.

Naturally, after this eruption of animated interest, sales of the dress skyrocketed, and the manufacturer, the British company Roman Originals, soon issued a limited-edition run of another version of the famous dress, this one white and gold, so as to please everyone. One of the white and gold dresses was put up for a charity auction on e-bay and fetched a significant amount of money. The picture of a heavily beaten woman with bruises wearing the white-and-gold dress was used in the innovative campaign by South African Salvation Army. The slogan "Why is it so hard to see black and blue" was aimed at raising awareness of violence and abuse against women.

And yet the story still did not end there. In October 2016, another "dressgate" (the term had become widely circulated by now) began to spread, this one regarding the color of a bag. To some, a Kate Spade handbag appeared white, and to others it looked blue. In reality, the bag was light blue, or at any rate the manufacturer itself referred to the color as "Mystic Blue." After the bag, everyone started talking about a plaid shirt that magically changed colors. One of the most recent optical viral illusions circulating on the internet asks whether a pair of legs is oily or smeared with paint.[59] At first glance, the legs appear to glisten with oil, but after a few seconds the viewer begins to see that this is not glistening oil, but rather streaks of white paint. The originator of the photograph, Instagram user @ leonardhospams, revealed that the effect is indeed caused by streaks of white paint.[60]

As these stories show us, fashion has unwittingly become a touchstone for questions about the reliability of visual images. But as long as the game of illusions is to some extent inherent in the structure of our perception, it is added motivation to remain attentive, to document, and to analyze the areas of doubt and undecidability that emerge in contemporary culture.

Conclusion

In reading the texts of Stéphane Mallarmé, Derrida astutely discusses how appearances often contain an element of illusion that erases the distinction between truth and falsehood. Speaking of the idea of "false appearance," he defined this as "mimicry without imitation, without verisimilitude, without truth or falsity, a miming of appearance without concealed reality, without any world behind it, and hence without appearance: false appearance."[61] This is a classic example of "undecidability." "Undecidability" in visual images is the equivalent of the state of doubt caused by the multitude of information sources on the internet. The uncritical assimilation of information from the internet (including such sites as Wikipedia) often leads to false "knowledge" and further dissemination of errors. As Brenda DeMartini-Squires remarks, "Internet or virtual browsing, although seemingly lightening quick and convenient, can involve hour after hour of false starts, interruptions, and quite frequently, questionable 'information.'"[62]

It is clear that technological progress and the equally feverish search for novelty have now crossed over into the realm of new technologies. If fashion was once a testing ground, a priority area for innovation, then now the users of new technologies are the victims of anxiety and a need for constant change. This involves intense competition among brands and an endless anticipation of new models and new versions. Consumers are prepared to go to great sacrifice and suffer significant inconvenience for the sake of prestige, even if the latest version is perceived as inferior to the previous one. Clothing fashions are primarily left with fusion styles and self-irony, while the most interesting processes take place at the intersection of fashion and new technology, in body modifications, in the blogosphere and on social networks. At the cutting edge of these dynamic processes are teenagers and youth who have had a symbiotic relationship with gadgets since their birth. This is a generation that cannot imagine itself without the internet. It is a generation that lives in a double world reminiscent of what the early nineteenth century European Romantics – Novalis, Friedrich Schlegel, and E. T. A. Hoffmann – postulated as dualism of day dreams, a permanent strain between the world of dreams and reality. Today's "techno-dreamers" exist halfway in virtual reality and are programmed from childhood to see themselves in representation: through selfies and endless Instagram posts. They deftly calculate the effects of various perspectives, instinctively adopt fashionable poses and trendy facial expressions, and expertly Photoshop their own pictures.[63] Due to this array of visual skills, they are often more successful in things related to public self-expression and image management skills. The conflict between fashion bloggers and editors discussed in the beginning of this article signals precisely this tension. Thus a new model of corporeality is gradually emerging, developed in no small part through the activity of young users of new media.

Doubts almost always apply to the accuracy of photographs and advertisements, as the use of Photoshop is assumed by default.[64] The use of such software is only an indicator, a litmus test, of all the new areas of doubt and undecidability in contemporary culture. These are found, as we have seen, in various areas: not only in Photoshopped pictures but in debates around plastic surgery, the popularity of transgender models, and the unprecedented interest in optical illusions. In all likelihood, there is no reason in our current era to expect truthful communication and "pure" facts in the world of fashion. It seems we must get used to the new rules of the game: a permanent condition of underlying doubt.[65]

The tendency toward critical doubt in the world of fashion is more relevant now than ever before. But with regard to making responsible decisions concerning the health of children, for example, or the identification of individuals, or the possibility to make informed consumer choices, we are facing the other side of the undecidability coin: a demand for truth and authenticity. This is what we see in the consumer protests, the movement against Photoshop, the fashion for a new naturalness, the legislative initiatives for truth in advertising, and the petitions on Change.org. These are attempts to confront the world of "hyperreality," and they are also a signal: this is a time when games with visual signs require constant analytical awareness.

Translated by Keith Blasing

The author would like to thank Rebecca Arnold for her friendly advice and feedback.

5
CELEBRITY

Pamela Church Gibson

The new cultural landscape

Although it is a truism, if not a complete cliché, that the Internet and the immense, extraordinary power of social media have, between them, altered the world almost beyond recognition, there is nevertheless no consensus that these radical changes have in any way altered things for the better. For among other things, they have in fact facilitated and now shore up the new, all-pervasive power of contemporary celebrity culture, of which Chris Rojek has written: "Latching onto a star in celebrity culture is to voluntarily submit to a kind of modern serfdom …. the serfdom in question is the bondage to celebrity culture."[1]

Certainly celebrity culture has radically changed "fashion" and has arguably divided its history in two.[2] At the same time, it has reconfigured traditional patterns of stardom in the film industry[3] and altered many aspects of the "art world."[4] Of course, "celebrities" themselves are a centuries-old phenomenon, as Leo Brandy has convincingly argued.[5] However, in the past, public interest was invariably related either to the political power or to the social status the celebrities possessed, or to their demonstrable and recognized talent. Until recently, a focus on their physical attributes and their private lives was secondary to what Rojek has called their "ascription" or their "achievement." He identifies three types of celebrity; the first category is that "ascribed" or created by birth and his second is that "achieved" through unusual talent. But today there is a predominance of celebrities in Rojek's third and final category, that of "attributed" celebrity, which describes those who become famous by attracting media attention in some way, and indeed are colloquially described as "famous for being famous."[6] The work of other media theorists and cultural historians, of course, provides a backdrop to this same phenomenon.[7]

The new mediascape has also created our so-called post-truth era, in which "alternative facts" can now be publicly cited and a reality television star, on becoming the most powerful politician in the Western world, can choose

not to communicate through conventional means but through Twitter "feeds" and widely advertised public appearances. Ironically, in the past some cultural theorists firmly believed not only that drastic changes to the traditional media were necessary, but that these would, when implemented, radically improve our quality of life. The most notable example is, perhaps, Hans Magnus Enzensberger's essay "Constituents of a Theory of the Media." This often-quoted and highly optimistic text, published at the close of the 1960s,[8] was a conscious updating of Walter Benjamin's famous essay "The Work of Art in the Age of Mechanical Reproducibility."[9] Half a century ago, in that period of great political and cultural upheaval when there was still a sense that scientific, political and cultural progress were inevitable and interlinked, Enzensberger carefully set out his egalitarian ideals. He was firmly convinced that, very soon, we would be able to create and to use our own media, so replacing our dependence on a mediascape rigidly controlled by those with political and social power. The participatory model that he proposed was part of an overall socialist strategy to develop the potentialities of communication media. He advocated collective production and general participation, and interestingly in a pre-digital era effectively predicted what Henry Jenkins would later christen "convergence culture."[10]

Arguing that contemporary capitalism depends completely on the exploitation of unreal and "false" needs, he suggested that a truly socialist movement ought not simply to denounce these needs but rather to take them seriously, investigate them carefully, and then make them politically productive.[11] Using Lefebvre's concept of mass consumption as "spectacle, exhibition and show,"[12] he developed this further into his own notion of "a totality, a permanent theatre" in which "the fetishistic nature of the commodities triumphs completely over their use value."[13] This, he argued, was actually based on a real and undeniable "mass need," a need with "physiological roots," which could "no longer be suppressed." It was not necessarily one restricted by the "internalised rules of the game as played by the capitalist system."[14] He concluded with his belief that "consumption as spectacle is—in parody form—the anticipation of a Utopian situation."[15]

Sadly, the new media landscape of the second millennium is simply a nightmarish parody, even an inversion, of his Utopian dream. We are still enslaved by "false needs," albeit now presented to us in a profoundly different way; global capitalism is more entrenched and all-powerful than ever. And while Enzensberger lamented the fact that fashion design was a "largely unexplored" sector of industry,[16] it is now of course part of a massive world-wide phenomenon employing millions; however, they work within fashion production rather than fashion design, and very often do so under appalling conditions for derisory wages.[17] Interestingly, with a very few exceptions, the academic discipline of fashion theory has not given its attention nor analyses over to the exploration of

fashion production, with a minute number of exceptions.[18] How many on the left — liberals and *bien-pensants*, so many feminists—are now deeply compromised in this respect? We should be talking and writing here from a point of complicity.

The new media have assisted in, if not created, the proliferation of a celebrity culture based in the main on physical attributes, at a time when there is an ever-growing, seemingly insatiable interest in fashion. This has led, inevitably, to the careful, highly profitable mining of the new "celebrification" by the fashion industry in general and by the luxury brands in particular. It is this particular combination of factors that is conceivably responsible for any announcements of the "end of fashion." For although "fashion" itself is undeniably flourishing under these new conditions, it is the *fashion system* as we understood it which has, if not ended, then undergone radical reconfigurations in order to survive, to function, and arguably to triumph under these changed conditions. It is not that the traditional system with its patterns of creating, communicating, and disseminating changes has broken down; it continues to operate. The combination of "high-fashion" trickle-down[19] and street-style "bubble-up"[20] is working as before; however, as this article will show, it now has a rival "celebrity"-based system working busily alongside it. And possibly this rival system is now as powerful as its predecessor—perhaps more so.

For the new competing system combines the endless possibilities of the digital era with the extraordinary commercial potency of our celebrity-dominated culture. Agins[21] and Edelkoort,[22] who both announced "the end of fashion," were writing from a marketing perspective and so did not seek to locate their insights within a wider social and cultural context. The rival system now spans the entire spectrum of industry activities, from the marketing of luxury brands to the creation of cheap clothes mimicking celebrity choices.

The divided system

Thirty-three years ago, Elizabeth Wilson famously defined fashion as "dress, in which the key feature is rapid and continual changing of styles"[23]; today, that "change" is more "rapid" than ever. In 2014, I described the way in which the system of fashion seemed to have split in two, creating separate systems with very different ideals and images.[24] However, the intervening years have brought further changes; not only is there now significant overlap between these divergent and competing forms of "fashion," but the traditional system has seemingly capitulated in certain important ways to its rival. However, in an attempt to defend itself, it is simultaneously encouraging forms of resistance and rear-guard action.

As I have previously argued,[25] developments within and around celebrity culture have offered women an apparently new image, a highly sexualized,

curvaceous body template which, combined with a very different way of making-up and dressing, challenges the traditional silhouette of high fashion. This style of self-presentation I called "pornostyle"[26] since it deploys the longstanding and recognizable tropes of "glamour modeling" and soft-core pornography, bringing them firmly into the mainstream. Significantly, both the magazines and the newspapers of traditional print culture and the new forms of social media much prefer this "glamorous" ideal to the slender body and restrained makeup associated with catwalk shows and ultra-fashionable magazines. The makeup and clothes of the "celebrity look" are no doubt familiar to those reading this: fake fingernails, nude "wet look" lips, liberal use of facial "contouring" techniques, eyelash "extensions," plunging necklines, skirts slit to mid-thigh, high heels, and tight boots. But this style does not mean a lack of "labels" or designer clothes, now perhaps more desirable than ever; in this mode, they are worn and accessorized in a different way. There is currently a penchant for "nude" and "sheer" fabrics, deployed rather differently from their use within "high fashion," here used to reveal whatever parts of the body might have to be covered outside a domestic setting. The "celebrity" body should possess pronounced breasts, which can be the result of artifice or intervention, a tiny waist and lightly tanned limbs—here "fake tan" seems *de rigueur*.

The epitome of this look, at the time of writing, is, of course, the ubiquitous Kim Kardashian, who has added very prominent, deliberately accentuated, occasionally bared, and frequently photographed buttocks to what is already a hard-to-achieve "celebrity" ideal (Plate 12). These buttocks of course are presented, it seems, as a deliberate provocation, flouting the fashionable ideal and even triumphing over it. Her body, its constant display, and indeed some of her behavior are all, quite deliberately, "transgressive" in a perhaps unprecedented way and she appears to be happily complicit in the public construction of her physique as that of a new-millennial "Hottentot Venus," as has been suggested elsewhere.[27] In the nineteenth century, the original of the title, Sarah Baartman, whose body was exhibited in "freak shows" across Europe, was in fact a prisoner whose captors reaped the profits. But in a new millennium, it is of course Kardashian herself who both parades and profits from her own unusual physique. It is she and her family who will be the epicenter of this essay, forming both reference point and case study.

They are of course perfect examples of Rojek's "attributed celebrity."[28] In 2007, Kardashian achieved her first moment of fame through a leaked "sex tape," her partner in crime being rap star Derek J. Throughout the film, she constantly pouts at, and poses for, the camera. There were suggestions that the "leak" was deliberate in some way, but it seemed that she had no part in it so, after much legal wrangling, she accepted a payment and then conceded ownership of the footage to a company, Vivid, which made it widely available. In the same year, her entire family—Kim herself, her mother and stepfather, her sisters, stepsisters,

brother, and assorted partners—became the stars of their own reality television show, screened on cable network E!. Despite consistently adverse criticism, the show became extremely popular; a thirteenth season began in March 2017. The family's tendency to be "transgressive," to flout whatever convention might still be at stake, together with their pride in their perceived "otherness," has been on display throughout their rise to worldwide fame. Her stepfather, a former Olympic athlete, underwent highly publicized gender reassignment in 2015, appearing in her changed identity as Caitlyn Jenner on the cover of *Vanity Fair*.[29] Since then, Kardashian and her various siblings have exploited the full potential of every form of social media, gaining in the process extraordinary popularity, immense wealth, a global reach—and making "celebrity style" something desired by millions. She has also, as this essay will show, managed—after frequent attempts—to make successful inroads into the diametrically opposed world of high fashion. Her stepsister Kendall Jenner, whose body is the antithesis of hers, conforming perfectly to catwalk standards, has become a leading fashion model. But Kim's own relationship with the historic fashion system, to which her constantly proffered, pneumatic body constitutes a permanent challenge, is rather complex. She was originally regarded with some hauteur by many in the industry; things changed considerably when she became first the girlfriend and later the wife of rapper Kanye West, himself already embedded within this system in a number of ways.

Social media: The dissemination and consumption of "celebrity fashion"

If what many want or need from cyberspace is simply some form of reassurance through virtual contact with perceived "friends," significantly for "celebrity fashion," a vast number seek further instruction in the art of self-presentation. So for this—and other complex reasons—they assiduously "follow" the posts and the videos of established celebrities, together with lesser known fashion and beauty "bloggers." Those, like the Kardashian sisters, who are already public personalities, have the chance massively to increase their incomes through various forms of product placement; others who were previously anonymous figures have used these new digital platforms to create careers and achieve "celebrity" online, if not elsewhere. Of course, many of the most successful "fashion bloggers" are involved in the traditional world of "high fashion." The most popular online posts, however, display the rival "celebrity look."

Endless instruction in how to create this very different ideal of "beauty" can be found in cyberspace. While there are indeed "beauty tutorials" created, as well as consumed, by young women in modest suburban bedrooms, some reach a far wider audience. Interestingly, the "teen Instagram star"[30] Essena O'Neill left

the platform and deleted her posts; she announced that "I just want young girls to know this isn't candid life; it's contrived perfection made to get attention."[31] But it doesn't seem as if many young women paid attention to her example; a recent estimate put the number of Kardashian "followers" across the entire digital spectrum at "half a billion between them—twice the size of the US population."[32] Among these online exemplars of style, the various Kardashian sisters, Kim is well to the fore—it is she who today would be recognized anywhere in the world. Of her sisters and stepsisters, it is Kylie, small in height and generous in curves, who comes second in popularity. The tall, slim Kendall, with her highly visible modeling career at the heart of high fashion, comes third.[33]

The three sisters I have just mentioned are among the "top ten" most-followed figures on social media, and in fact they are the only "celebrities by attribution" on these lists across the various manifestations of social media. For the other young women followed are successful young singers. Significantly, corroborating the growing concerns about young girls enslaved to their smartphones, there are only three men currently in the running and, while one is singer Justin Bieber and another the well-dressed footballer Christiano Ronaldo, the third is the uncompromisingly unstylish wrestler-turned-film star Dwayne "The Rock" Johnson, star of the critically ignored and massively successful franchise, *The Fast and the Furious*.[34] Kim Kardashian's overwhelming online presence means that she is currently offered up to half a million dollars each time she promotes a product on social media[35]: her sisters and half-sisters are offered slightly less. The actual nature of the products they promote are rather worrying; while new Apple phones are expensive but harmless, "weight loss teas," meal substitutes created to facilitate weight loss, and "waist whittlers" are more disturbing. A "waist whittler" looks like a brightly dyed piece of period underwear and constricts the waist as fiercely as its name implies; however, unlike its historical predecessors, it is designed to be worn during vigorous exercise, supposedly in order to enhance its effects. Kim directs her followers not only toward innocuous products such as nail polish and makeup, but also, perhaps more questionably, toward home laser treatments for the total eradication of every trace of body hair demanded by 'pornostyle', and to 'morning sickness' pills. Of course, these women have a vast variety of their own branded products. These include Kylie's "lip kits" for those anxious to emulate her trademark pout, and the "Kardashian Kollection" of clothes at Sears. There was even, albeit briefly, a "Kardashian Mastercard."

However, Kendall may have diminished her earning potential, after a massive controversy, across print media and online, around her commercial for Pepsi-Cola in April 2017, which had to be "pulled" after twenty-four hours. She was paid 40 million dollars for this advertisement, in which she is seen posing for a fashion shoot just as an unspecified "protest march" comes past, made up entirely of good-looking young people from a variety of ethnic backgrounds. She removes her fashionable accessories and joins the protesters. The march is

swiftly halted, and she walks alone to the waiting policemen, offering one a can of Pepsi-Cola and so resolving any possible tension.[36]

Shifts, changes and academic responses

Riccardo Tisci, head designer at Givenchy from 2009 to March 2017, proclaimed in an interview given just after he left this post: "Four or five years ago, no fashion house would touch her. But Kim represents the woman of today—she defines society today."[37] Kardashian and her sisters used to shop on the American high streets; now their stratospheric incomes mean that they can patronize Parisian couture houses. This is not done so that they may conform to the rules of traditional "high fashion," however, but rather as a demonstration of their extraordinary power. Significantly, there are new young designers in some old, established houses who like Tisci are aware of changes in supply and demand; consequently, they now produce the kind of clothes that embody the "celebrity look." Olivier Rousteing, for example, who took over at Balmain in 2009, is a friend of Kanye West and creates glitzy clothes for celebrities; the ethos of the design house has changed drastically. Journalist Jess Cartner-Morley called his clothes "colourful, tight, and bright."[38] Tisci, the former designer at Givenchy, is also a friend of West. He invited Kardashian to her first "Met Ball" in 2013 when he was helping to host this annual event, usually referred to as the Oscars of fashion, and designed her dress for the occasion. He also created the clothes for her spectacular two-day wedding to West, making both her dress and his tuxedo; the ceremonies involved a formal dinner hosted at Versailles, to which the couple were driven in a coach formerly used by royalty or state visitors. He was also responsible for Madonna's bondage bustier and her bared, black-lace-covered buttocks at another Met Ball in 2016. She herself defended the outfit as a "feminist statement" made to combat ageism.

If the clothes created by other designers are not sufficiently form-fitting or revealing, they can always be adapted to fit the rules of "celebrity style." A judicious rearrangement of couture garments can ensure the maximum exposure of flesh, while there is always scope for celebrity "accessorizing" of a kind that could be anathema to devotees of the designers. Kardashian was photographed at the Balenciaga shows in October 2016 wearing a trench coat pulled so far off her shoulders as to constitute a parody of the Vogue-endorsed trend for "shoulder-robing." Hardly a figure associated with the more minimal aesthetic of Céline, she was nonetheless photographed in March 2017 wearing one of the house's long knitted dresses, but pulled so far down that it hovered just above and sharply defined her breasts. On her feet—in sharp contrast to the sneakers favored by the Céline designer Phoebe Philo—she wore very high-heeled snakeskin boots. It is worth noting that, by contrast, those in charge of Céline had in fact already

carried out a certain form of resistance to contemporary celebrity; in 2016 they employed the venerated writer Joan Didion, then in her eighties, to model in the advertising campaign for their sunglasses, thus declaring a preference for cultural over "erotic" capital.

At first the two co-existing systems were locked in a kind of "Mexican standoff" whereby the traditional fashion world saw itself as working to protect the notion of "good taste." Although celebrity covers were already widely used in order to sell fashion magazines, only those celebrities who sought to follow the "fashion look" rather than the "pornostyle" template were featured, invited to high-fashion events, and given front-row seats at shows. "Glamour girls" were not offered these privileges, nor were they asked to be "brand ambassadors" for fashion houses, or to feature in exclusive "fragrance" campaigns. Certain couture houses declined offers to design for them, and refused to lend them clothes for publicity shoots. But in 2017, much of this had changed: the industry increasingly obeys purely economic imperatives and "celebrity fashion" is in the ascendant. Alas, these changes within fashion, which surely constitute a paradigm shift, do not seem thus far to have been fully acknowledged within fashion *theory*, just as fashion-related issues have not been properly addressed within the new and expanding area of "celebrity studies." This latter discipline, newly created and with a variety of different aspects, is curiously averse to exploring its extraordinarily strong links not only with the "fashion system" but also with the field of "fashion studies," itself of course another late and sometimes unwelcome arrival in the groves of academe.[39]

Although Rojek argued that "we will not understand the peculiar hold that celebrities exert over us today unless we recognise that celebrity culture is irrevocably bound up with commodity culture,"[40] he did not specify precise, susceptible *forms* of commodity culture. David Marshall, one of the earliest writers on the phenomenon of modern celebrity culture, has consistently suggested that it is a means within consumer capitalism whereby the dominant classes can ensure social control.[41] This could suggest, perhaps, a "bread-and-circuses" model worryingly appropriate for the contemporary cultural and political landscape.

Fashion, art and celebrity culture

Whatever lines of demarcation still remain between "high art," popular culture, fashion, celebrity, and commerce, these by now are increasingly blurred, given the modus operandi of the fashion industry and the "celebrification" of the art world.[42] Today, not only does Kim Kardashian have a marked presence right across the current landscape of popular culture and increasingly within both "fashion systems," she has also crossed other significant boundaries. Over the last few years, she has acquired a presence within the "art world," if only as "subject" rather than producer of art. Her image has moved from magazine covers to gallery walls, and she herself is seen at private views and art fairs.

Her marriage to musician Kanye West—who is himself adept at self-promotion, has collaborated with designers in different ways for several years, and is now finally enjoying a coveted success as a fashion designer—has increased her visibility and her access to "high end" fashion. Significantly, for a tour in 2013, West was dressed by Maison Margiela, hardly a publicity-seeking fashion house. The year before, in a 2012 episode of her reality show, he had publicly cleared out Kim's wardrobe and restocked it with "high fashion" garments and accessories. Acting together, they have managed successfully to infiltrate the inner citadel of "high fashion," which had until recently worked hard to keep Kim and her family at bay. West's move from rap artist to fashion designer has helped them here.

Their wedding showcased not merely Tisci's Givenchy outfits, but matching leather jackets for the couple especially decorated with slogans and images by the Los Angeles artist Wes Lang; he has also designed tour merchandise for West in the past. West's design career started with footwear; his collaborations— with Nike and later Adidas—have been enormously successful. The 2016 music video for his song "Wolves" also turned out to be a promotional fashion film for Balmain, which West directed. It starred his wife and her fashion-model sister Kendall alongside assorted supermodels and some Victoria's Secret underwear models. Still images released to accompany the film were the work of leading "high fashion" photographer Steven Klein. Throughout, West and his wife both wore the futuristic Balmain outfits made for the Met Ball in May of that year.

West's own Yeezy fashion range, featuring both menswear and womenswear, gradually began to win approval, with the acknowledged arbiter of American fashion taste, *Vogue* editor Anna Wintour, attending his shows and happily publicizing them. West has employed artist Vanessa Beecroft to choreograph these shows; she did the same for the various events that took place as part of his wedding. Beecroft is herself a part of the new art-fashion-celebrification process, while transgression—seemingly integral to Kardashian success—is central to her work, and indeed led to her self–imposed exile from the art world. She became especially famous through the installations that she created for Louis Vuitton. For the opening of the large shop on the Champs-Élysées, she created an installation made up of semi-naked models, all women of color, displayed fetishistically and provocatively on the shelves of the store, adorned with carefully arranged Vuitton belts and bags. As the belts were entwined around their legs and arms in a way suggestive both of Bondage and sado-masochism (BDSM) and of prison shackles, the work received an enormous amount of publicity, a good deal of it negative. Beecroft claimed that the installation was a reflection on gender and ethnicity; her critics saw it as a disturbing reminder of slavery.[43]

When she became the subject of a documentary film screened at the Sundance Festival in 2008, about her attempted adoption, two years earlier, of two orphaned Sudanese babies, she was deemed to have gone too far, and there were calls to ban her work.[44] This film included footage of the distressed nuns who ran the Darfur orphanage trying to stop her stripping the babies naked

in a chapel, before having herself photographed attempting to "breastfeed" them in a white Prada dress with specially cut out nipple zones. Copies of this image, entitled "White Madonna," were sold for fifty thousand dollars apiece. This unsurprisingly caused outrage in the black community, despite Beecroft's insistence that she self-identifies as black. Beecroft removed herself precipitately from the art world and later resurfaced working for West.

It seems as if West and Kardashian now have a public presence and economic power reminiscent of that wielded by the powerful dynasties of Renaissance Italy (without the taste many of these family members possessed). West in fact likened his wife's semi-naked "selfies" to Renaissance paintings when they were collected together for her book, *Selfish*, published by the respected art publisher Rizzoli.[45] Her very first foray into the art world in November 2010 had seen her naked, but for Barbara Kruger's blocks of text, on the cover of *W* magazine's *The Art Issue*.[46] But she has since moved on and up. Jeff Koons became her friend, featuring in one of her Instagram photos in 2013. In the following year, it was the art-fashion-magazine *Paper*[47] that published a very revealing photograph on its cover, advertised as her attempt to "Break the Internet." The picture was taken by the respected photographer Jean-Paul Goude, and Kardashian was invited to the promotional dinner held at "Art Basel Miami," a very important annual event that has, of course, become thoroughly "celebrified."[48] In April 2016, she and Kourtney Kardashian were photographed for the "Yeezy 3" campaign by Juergen Teller; in one of these deliberately controversial images, the pair seem to be wrestling in mud and Kourtney is clawing at her sister's naked buttocks. Another photograph, showing Kardashian crawling up a stony slope wearing only a fur jacket and knee-high boots, was blown up and exhibited at another significant annual event, Art Cologne. In August of the same year, she helped to sculpt her own naked body for the life-size sculptures of sleeping celebrities created for West's music video, *Famous*. Here she and Kanye are depicted in bed with a group that includes Donald Trump and Anna Wintour. The sculptures were exhibited soon afterwards at the Blum and Poe art gallery in Los Angeles. It may well be that Kardashian now sees herself as an "artist" and not simply as an "attributed celebrity"; for International Women's Day in 2017, she posted a selfie of herself made up and accessorized to look like Frieda Kahlo.

Fashion's factions: Infiltration and resistance

If the walls of high fashion were first breached by the use of "celebrities" on magazine covers, the "celebrities" chosen always fitted the "fashion-model" template. Actress Kiera Knightley, an early favorite for fashion titles and later for prestigious advertising campaigns, became and remains a "brand ambassador"

for Chanel. In fact, she played the designer herself in one of Karl Lagerfeld's digital productions.[49] The actress Kristen Stewart has moved away from Hollywood and found success in European art-house cinema, so that she brings cultural capital to her own role as a current Chanel ambassador.

However, US *Vogue* capitulated some time ago; in March 2014 it featured Kardashian and West on the cover.[50] The result produced horrified readers, a "Twitter storm," and canceled subscriptions. But in December 2016, UK *Vogue* seemed to be claiming back lost ground, asking hopefully in its pages, "Whatever Happened to the Cleavage?"[51] It featured and championed demure red-carpet appearances by Alicia Vikander and other successful, slender actresses.

Another form of fightback against what might otherwise seem to be the unstoppable force of "celebrity style" has garnered a good deal of publicity—and generated enormous sales. Some designers in "high fashion" are producing designs that are radically different from the form-fitting, curve enhancing designs, which appeal to celebrities; they are often semi-androgynous and deliberately not glamorized. The most notable and commercially successful designer of clothes that is the complete antithesis of the tight, glitzy garments that characterize, say, Rousteing's designs for Balmain is Demna Gvasalia, whose work for the newly established Vêtements made that label inordinately successful (Figure 5.1). The catwalk models in his womenswear shows were devoid of makeup and sometimes crop-headed; the first dresses he showed were very loose and overlong, and he created outsize "hoodies" for both sexes. The well-known and very influential blogger Leandra Medine, whose professional soubriquet is "Man Repeller" champions a "fashion aesthetic" that resists overt sexuality in dress. Her strapline is "Seeking Love, Finding Overalls," so it would seem that she might respond positively from the first to Gvasalia's work.

But initially this was not the case. "Confession—I Don't Get Vêtements," she wrote, in 2016. She went on to explain: "You want to lose your shirt over clothes that make you feel like 18th century royalty while you're washing the dishes—I totally get that. But to wear clothes that make you *feel* like you're about to wash dishes? Where's the grand illusion there?"[52] Four months later, however, she was converted, writing that the brand was "becoming an ongoing art installation, which is what I really like about it."[53] She has continued to support Gvasalia's aesthetic, praising his use of older, unconventional models in his catwalk shows. She has also noted with pleasure across the past few months such features of his work as "secretary suits" (Plate 13), police mackintoshes, "punk" bath towels covered with emojis, plastic macs, camouflage battle dress, and a parody of the classic Chanel suit.

However, a certain kind of celebrity—young musicians in particular—liked and wore some of the clothes, particularly the hooded sweatshirts and slouchy track suit trousers: Rihanna, Justin Bieber and, inevitably, the label-aware West. Inevitably, Kardashian herself was finally seen in a Vêtements hoodie, although

it was worn with thigh-high fetish boots designed by West for Yeezy and little else (Figure 5.1). Eventually, Gvasalia succumbed, as a favor, it seemed, to Kardashian, and temporarily abandoned his anti-bling aesthetic. Kim and her daughter, North, were then photographed in October 2016 in matc aesthetic hing tight, sequined dresses he created especially for them.

Gvasalia has also had an extraordinary effect on "high street" fashion. While his original "reconstructed" Levi's cost over a thousand British pounds, copies of these jeans, with their distinctive stepped hems, swiftly appeared on the high street—at every "price point." Gvasalia went on to be creative director of Balenciaga, one of the most revered ateliers, previously known for its elegance. Other young designers have also produced desirable clothes that do not emphasize or display the body. Simon Porte Jacquemus's designs for his eponymous company garnered much "high fashion" enthusiasm, and were displayed in glossy magazines across the globe. In a different kind of "anti-celebrity" style and statement, Louis Vuitton, the creator of the instantly recognizable luggage carried by so many celebrities, made a deal in March 2017 with *Supreme*, designers of skateboarding and streetwear coveted by young people across the world.

Figure 5.1 Celebrity proof? Fashion at Vêtements. Fall/Winter 2017. Public domain

The resistance, however, may seem to have only a rather tenuous purchase. Indeed, for one English fashion journalist Kardashian seems to be an arbiter of fashion change on a grand scale. Writing about "fashion's return to technicolour" after "decades when it was essentially a bit naff to wear anything that wasn't black," Cartner-Morley outlined the gradual shift:

> The erosion of the status of black began when it started to be outranked by navy, and went mass when Kim Kardashian underwent a style make-under which involved wearing grey or beige head to toe.[54]

So it seems that, whereas in the past leading designers—first Poiret, then Chanel, later Yohji Yamamoto and Rei Kawakubo—dictated radical changes in the color palette, today that task is carried out by whoever is the current leading arbiter of celebrity style.

Seeking explanations

This new-millennial, all-conquering media spectacle is largely constructed around photogenic young women with spectacular bodies. Some journalists—able to publish far more speedily than academics in this rapidly changing landscape—and celebrities themselves have claimed that the current display of the female body is in fact a form of "female empowerment" and should be championed as "postfeminist." Yet, rightly, Susan Bordo argued back in the 1990s that the female body is increasingly over-disciplined[55] in the Foucauldian sense, over-determined by the "commodified body"[56] and the entrepreneurship of the self prevailing within the contemporary scene. Her ideas have found wide acceptance among scholars. The new, opulent bodies, insistently presented as a mode of self-advertisement, are likewise "disciplined"[57] and surely feed on the more and more obsessive self-scrutiny of young women and their increased fear of imperfection, of gaining weight, of ageing.

In a recent feature in *Harpers Bazaar* online, quoted earlier in this essay,[58] it was mooted that "the Kardashians are to blame for the rise of millennial women getting cosmetic procedures." Ironically, the Kardashian-Wests always feature heavily in both the print and the online versions of this magazine. Here, cosmetic surgeon Dr Simon Ourien, whose patients are getting ever-younger—some are in their teens—has claimed that "the reason for this shift is because of social media, selfies and the Kardashians."[59] Another well-known cosmetic surgeon also interviewed for this *Harpers* feature, one Dr. Sebagh, called the phenomenon "damaging" and "absolutely mad." He argued that these new young patients "have such insecurity and such image perfection issues" because they are "constantly on their smartphones."[60] "High fashion" has of course traditionally

been blamed for the obsession with slenderness, for causing young women to starve themselves in order to achieve fashion-model slimness, so risking anorexia. Now these surgeons are suggesting that the ubiquitous images of "celebrity style" are equally damaging, in a different way. Although displayed online as selfies, many of these pictures involve and even acknowledge the work of makeup artists in their achievement of glossy perfection. There seems, here, to be a covert insinuation that celebrity style could cause emotional distress and even mental health problems[61] rather than the debilitating physical conditions and even illnesses that can be the result of a preoccupation with high fashion. In this respect, both forms of fashion seem equally open to being problematized or interrogated.

In defence of "celebrity style," it has been claimed that the semi-naked celebrity selfies are an instance of women taking total control of their "own sexuality." Feminist writer Naomi Wolf seemed convinced by this particular argument when she interviewed celebrity Emily Ratajowski, herself possessed of a spectacular body, for, once again, *Harpers Bazaar.*[62] Ratajkowski herself is another example of "attributed celebrity." She is regularly photographed at premières and award ceremonies, her designer dresses the subject of fascinated fashion copy. She was in fact an "erotic model," until she appeared in a music video for *Blurred Lines* in 2013, described by one journalist as "the most controversial song of the decade" for its seeming defence of non-consensual sex.[63] The video created a "separate but overlapping controversy"[64] since it featured Ratajowski and two other models dancing topless with, and around, three fully dressed male musicians. This brought Ratajowski to public attention and to a small part in the equally successful film *Gone Girl*.[65] The highly photogenic Ratajowski—slender-bodied but full-breasted, so combining both "celebrity" and "high fashion" attributes—has worked as a fashion model for Miu Miu and Marc Jacobs, together with her "glamour" covers for *Sports Illustrated*.

The Naomi Wolf interview was illustrated by a full-page image of Ratajowski rather than of Wolf and she together, and showed her sitting naked astride a white horse without bridle or saddle. When she explained to Wolf her claims to be a "new kind of feminist," the writer of *The Beauty Myth*[66] surprisingly seemed to accept them. The naked selfie that Ratajowski had shot together with Kardashian—which attracted optimum publicity—was, she explained, a gesture of sisterly solidarity after the latter had been vilified for posting a previous "selfie" in which she herself was for the first time completely naked. She managed to persuade Wolf that this was indeed empowering, at a time when government reports in the UK have shown that young women have lower self-esteem than ever before.[67]

How can we begin to think about, let alone theorize, this bizarre narrative? Those of us who have worked—however briefly—within the new field of celebrity studies, coming from whatever academic discipline or practitioner perspective,

have surely all wanted to find the Holy Grail of a single ur-methodology—which while providing us with a truly political perspective, will finally allow us to bring together what seems at times to be a very disparate and diffuse subject area. What we need, in fact, is a near-magical way of making proper sense of the endless diverse and constantly developing activities around celebrities, which we could bring together and fully understand. It is difficult to know which previous scholarship might be best employed in our efforts to understand the continual changes around us and the new, frenetic consumption of both goods and images. Fifty years after *The Society of the Spectacle*, Guy Debord might find it difficult to comprehend the way in which "spectacle functions and dominates society now," so far does it exceed everything he described.[68] Before this age of consumption that is not only "conspicuous" but continuous, and which in its insidious way crosses every social strata and income level, Thorstein Veblen might retreat, baffled.[69] The melancholy if not bewilderment of the various different members of the Frankfurt School would be understandable enough.[70]

It is tempting to read off one specific site of study, the Kardashian celebrity narrative depicted here, against the model of the "historical stages" in the relationships between symbols and reality as outlined by Baudrillard in *Simulacra and Simulation*.[71] He was of course linking these "stages" to different historical moments in the development of capitalism across two centuries, rather than as stages in a personal saga across a single decade. But just as there are four stages in Baudrillard's historical model, spanning the period from before the Industrial Revolution to the advanced stages of late capitalism, so the Kardashian career, central within the narrative unfolded above, has gone through four perceived stages of development. The "faithful image" of stage one would be the "sex tape" that began this story. The years during which the "reality show" became so extraordinarily popular might constitute Baudrillard's "breakdown of reality," the "second stage." The "signs and images" of the stage that he calls "the order of sorcery" would involve the stepfather's change of gender, the lavish wedding to West, motherhood, art gallery openings, and the bare-buttocked shoot for Teller. The fourth and final stage is characterized by a complete *lack* of reality. And there is no sense of reality in this family saga any more, only insatiable public interest in bizarre dramatic stories: robbery at gunpoint, breakdown and madness, incarceration.

But, neat and ingenious as this correspondence of four-phase narratives might be, it does not take us quite far enough. Enzensberger's "theatre" has become a dizzying circus.[72] So profound a shift in the culture is perhaps best accounted by means of the new and varied forms of radical political critique—Naomi Klein, Wolfgang Streeck, Franco "Bifo" Berardi, David Graeber, Nick Srnicek, and many others[73]— that has been notably emerging or consolidating itself since the crisis of 2008, and its understanding of what has been happening to us since (approximately) the early 1990s. One might fasten in particular on

Berardi,[74] not least for his resituation of Baudrillard in this context. For Berardi, Baudrillard was a prophet of what is by now a catastrophic age (catastrophe, here, should not be read as betokening more or less imminent apocalypse; the catastrophe is, perhaps, more than anything else, ethical, or incipiently ethical). For understandable reasons, the modern promise to which the twentieth century so ardently subscribed, if with often disastrous results, has broken down. In effect, says Berardi, the future is over. In our "postfuturist" culture, the new is no longer just the eternal return of the same which Benjamin thought constituted modernity in its satanic aspect. By now, the new is as likely to spell regress as it is progress, to the point where the terms themselves seem nugatory. So, too, we are witnessing a wholesale shift from what Berardi calls the "conjunctive" to the "connective," from community and solidarity, for example, to aleatory and disparate relations between "infospheric individuals"[75] as monadic entities, above all, as a result of the growth of the digital web, the development being so pronounced as to breed and proliferate new psychopathologies. Postfuturism is eradicating the cultural, juridical, and psychic conventions of modernity. The ironical manner in which I have used the word "transgression" throughout this essay underlines the point. For Berardi, these days, "transgression" is embodied by the likes of Berlusconi and smoothly reconcilable with media-populism. It was Baudrillard who heralded this psychic mutation and the implosion of thought and value implicit in what he took to be the "logic of simulation," and foresaw the contemporary reversal of the "energetic subjectivation" characteristic of modernity.[76] We might think that, with what is represented in the Kardashians and their remarkable and increasing influence, fashion culture has reached its "postfuturist" phase, revealing itself as both "stimulated hyperexpression" and, at the same time, a form of "exhaustion."[77]

6
CINEMA

Hilary Radner

Cinema, fashion, and femininity

In the 1958 Hitchcock classic *Vertigo*, the protagonist "Scottie" (played by James Stewart) takes his girlfriend, soon to become his lover, to a department store. He wishes to buy her a gray suit, a specific gray suit that a woman wore the year previously, a woman whom he believes to be dead. The viewer, along with "Judy" (Kim Novak), a counter girl at another store and the recipient of "Scottie's" attentions, watch as a house model displays a nearly identical suit, which "Scottie" dismisses as not being what he wants (the room is littered with further rejected garments). While some women spectators may have scoffed at the idea that a man might readily distinguish between a self-belted subtle peplum and a straight seam, they might equally fantasize about a partner able to appreciate the finer details of their clothing choices. Finally, the head saleswoman, seized by inspiration, instructs her assistant to find last season's suit, which not coincidentally was precisely the item that "Scottie" had in mind.[1]

Classical cinema and *Haute Couture*

I begin with a description of this scene because it invokes the world of fashion[2] as it was conceived at the time, in which shop girls like "Judy" sought to emulate the look of a married woman whose dress served to communicate the status and affluence of her husband. Fashion was imported from France with *haute couture* designs adapted to the American body and sold in department stores on a piece by piece basis, sometimes made-to-order, but, more often, with in-house dressmakers tailoring the garment to suit the taste and dimensions of the consumer; less affluent shoppers grabbed similar, more cheaply made items off the rack, perhaps adjusting these themselves, or taking them to a local dressmaker.[3] The fashionable woman kept track of the dictates generated by Parisian *couturiers* from season to season and year to year, dutifully updating a

set of prescribed garments for every occasion, with eveningwear, for example, clearly demarcated as such. Stars such as Grace Kelly continued the traditions of the pre–Second World War years, functioning as fashion templates on the big screen, reflecting American iterations of Parisian glamour for women viewers, who constituted Classical Hollywood's most important audience.[4]

Yet, with the rise of television and youth culture, beginning in the early 1950s, both cinema and fashion were already in decline, or at least their dominance had been challenged. Significantly, what is colloquially called *beatnik style* had already made it to Hollywood, perhaps the first example of what would later be routinely called "bubble up" style, in which fashion was determined anonymously on the street rather than by a designer and his wealthy clients.[5] Audrey Hepburn in the 1957 *Funny Face* (Stanley Donen) is best known for the black Capri pants and black turtleneck, an outfit put together by Edith Head, the film's costume designer, inspired by contemporary street style, which she wears before her conversion to high fashion. Viewers are less familiar with the opulent gowns designed by Hubert de Givenchy that she dons at the film's conclusion, having converted to high fashion.[6] Kim Novak would herself wear stovepipe trousers and a black turtleneck in the role that follows that of "Judy," in *Bell, Book and Candle* (Richard Quine, 1958), in which she plays a beatnik/witch.

The black stovepipe trousers and turtleneck combination was also widely imitated by young fans whose budget did not include the upscale garments found at the local department stores that served wealthy women in the days before the advent of catalogues that catered to credit card orders phoned in by customers, not to mention the internet shopping that would follow. The black pullover/narrow trouser outfit, especially the turtleneck, in the 1950s and the decades that ensued, was a wardrobe staple for males and females under twenty-five, presaging the androgyny that would become increasingly prevalent as the century progressed, and undermining fashion's function as marking the gender of the wearer.

New paradigms: Disintegration or rejuvenation?

By the 1980s, both cinema and fashion had changed irrevocably. Theatrical release and *haute couture* had both become loss leaders, a means of advertising a vast array of products to a wide spectrum of consumers. Yet, in many ways, both style and screen narratives continue to occupy, if anything, a growing importance in consumers' lives, with their choices, arguably, multiplying. While a notable army of scholars have commented on the passing of cinema,[7] only a few journalists and scholars have noted the demise of fashion.[8] What precisely has changed? Is there a connection between the much-lamented death of cinema and the quieter end of fashion as the dominant force determining

modes of dress? Both cinema and fashion have been dismissed as unimportant dimensions of human activity, mere entertainment in the first case, and "the very exemplum of superficiality, frivolity and vanity" in the second.[9] And yet the first is often categorized as the art form that captures the essence of twentieth-century culture, or modernity itself,[10] and the other as one of the primary mechanisms whereby the subject's relations to itself (its body) and to others are regulated, "one of the means by which bodies are made social and given meaning and identity."[11] Or, in the words of Giuliana Bruno, "Skin is our first coating, our first dress, and then fashion becomes our second skin. Fashion is the way we decorate our epidermic selves. … By way of dress we actually 'fashion' our own selves, which also means our identities."[12]

With the advent of television, exacerbated by VHS, DVD, and other forms of delivery, cinema no longer offered a unique experience over which the viewer exercises little or no control. Rather, the second half of the twentieth century witnessed a radical decentralization of viewing and production in comparison with the structures generated by the classical studio system. Currently, popular advertisements for home delivery services promise that each individual viewer may revel in the opportunity to watch what he or she wants, when he or she wishes, as many times as he or she desires. A sense of community and cohesion that marked earlier viewing situations makes way for relationships founded on aggregations and networks of overlapping experiences that are grounded in choice and are essentially individualistic.[13] The formation of communities that may be geographically dispersed, but united in terms of aesthetics, politics, and ethics, offsets this initial risk of solipsism, while viewers' choices remain constrained and directed by what the larger institutions governing distribution, from the Hollywood conglomerates to national internet providers, deem financially advantageous. The majority of viewers are loyal to the blockbusters pushed by the conglomerates. In contrast, groups of cinephiles (literally, "film lovers") obsessed with cinema and certain esoteric films communicate and exchange movies over the internet. Initially, cinephila was associated with large urban centers, in particular Paris, beginning with the French New Wave. It is now a global phenomenon. Digital media have made available rare films by directors such as Jacques Rivette and Jean Eustache, some of which have not been screened theatrically for decades. Cinephiles distribute these directors' works on a global, if modest, scale, in terms of numbers, manipulating networks perhaps initially generated for monetary gain, but here serving a different purpose.[14]

Decentralization and atomization

Arguably, the circulation of fashion and style operates similarly, with the result that today fashion scholars often talk about style tribes rather than seasons,

pointing to, for example, the longevity of the Perfecto leather jacket in certain contexts.[15] Designers such as Tatsuro Horikawa for the line Julius, or Julius 7, develop international reputations without recourse to the red carpet,[16] while remaining relatively unknown even to the readers of magazines such as *Vogue*, which circulate news and advice about fashion in print and digital form (Condé Nast, the magazine's publisher, distributes over 20 editions). Developments in the garment industry have contributed to these changes: perhaps most notably the entry of China into the clothing market, with its ability to produce attractive garments quickly and cheaply, accompanied by new distribution networks delivering goods to retailers with increasing rapidity, in spite of the distances involved.[17] New media contributed: the rise of the global fashion blogger who promulgates the principles of eternal style across national borders, with no regard for time zone, served to intensify the shift away from Paris as the epicenter of fashion.[18] On the one hand, scholars argue that consumers are caught up in a frenzy of continued, planned obsolescence in which poorly made garments are endlessly replaced.[19] In reaction, consumers have turned to secondhand clothing, optimistically referred to as "vintage," and to home sewing, which is enjoying a renaissance. On the other hand, a chorus of voices argue that we have witnessed the democratization of fashion, with a consequent undermining of the categories of class and gender.[20]

The nature of the audience and its relations to a mode of distributions did not produce the only notable transformations. Technology had a fundamental role in other ways as well. More people making more movies than ever before, as manifest in phenomena such as cell-phone film festivals, and the development of national cinemas such as that of Nigeria (otherwise known as "Nollywood"), which are founded on digital technology and straight-to-video production. Scholars such as Roger Odin, taking a more optimistic view, consider that the twenty-first century witnessed the rise of new cinematic cultures, distinctive yet still properly cinema, which itself always encompassed a degree of diversity, using the history of home movies and amateur film to exemplify his argument.[21] Others, such as Raymond Bellour, take a more pessimistic view, pointing to the loss of cinema as a specific kind of collective experience grounded in a unique shared memory of a particular event.[22] Yet scholars, whether in one camp or the other, or, more typically, located in between, agree that cinema as an economic and social institution has undergone crucial changes.

The first set of changes were generated by the 1948 Paramount decree, which required that the Hollywood studios set up safeguards that would prevent them from exercising a monopoly over the three arms of the cinematic institution (production, distribution, and exhibition) exacerbated by a significant population shift from urban centers to more fragmented suburban townships, accompanied by the rise of television. By the end of the 1960s, and certainly by the 1970s, the package unit system of production had been put in place, creating what

Tom Schatz has described as "New Hollywood," which replaced the old studio structures.[23]

Consequently, the star and his or her agent, rather than the studios, became the most influential forces in Hollywood. By the 1990s, stars and agents were quick to take advantage of digital technology as offering new forms of communication in order to further promote themselves beyond their performances, recognizing that, in the words of Pamela Church Gibson, "images now 'bleed' right across the whole spectrum of the media through its formerly discrete strands."[24] Stars became franchises rather than actresses or actors. They consciously developed themselves as "brands" that endorsed everything from jewelry to home appliances. This movement intensified in the 1990s as new media became more pervasive, underlining the continued cultural and social shift toward "rhizomorphic" structures, to use the metaphor proposed by philosophers Gilles Deleuze and Félix Guattari.[25] In other words, the new structure whereby images circulated was metaphorically closer to a geometrical decentralized figure called the rhizome than the hierarchies identified with the vertical integration of the studio system, in which the roles of producer and consumer had been clearly defined. For example, in the studio era, a spectator bought a movie ticket in order to see the movie; the film was a product that the studios delivered to the viewer. Today, theatrical release is less about selling tickets (though selling tickets is critical to a film's success) than it is about selling an array of ancillary products. Similarly, when a viewer watches a film on television, the network is not selling the movies, but rather using the movie to attract numbers of viewers for prospective advertisers.

Fashion followed a similar path, insofar as its breaks with the past are generated around two important moments: the 1960s "youthquake," in which style became the purview of the ready-to-wear market geared toward a more youthful, androgynous, and less well-moneyed set of consumers. Yves Saint Laurent's embrace of the counterculture in his ready-to-wear lines in the late 1960s and 1970s emblemized this movement. Concurrently, there was also an attendant de-emphasis on *haute couture* and made-to-measure dress in general, accompanied by the gradual falling away of categories such as daywear and eveningwear. Cristóbal Balenciaga closed his house in 1968, proclaiming that *haute couture* was no more.[26] Balenciaga's statement carried weight, given his position in the world for fashion. Susan Irvine, writing for the *Telegraph,* explained, at the time that he died in 1972, "There was only one king of couture, the one whom Christian Dior called 'the master of us all,' while Coco Chanel said he alone was 'a couturier in the truest sense of the word. ... The others are simply fashion designers.'"[27]

Arguably, the second such transformation in the fashion system occurs in the 1990s, marked by the rise of high street fashion and the flooding of affluent countries with inexpensive, poorly made, but trendy, clothing. The clothing

industry responded by focusing increasingly on style as part of an entertainment system in which fashion as spectacle, in the form of television programming, from news reporting to reality shows, became a topic of wide interest to broadly based audiences, who had no intention of actually wearing what they saw.

The reign of celebrity culture

Cinema and fashion have continued to come together through the cult of celebrity, which has grown unabated throughout the twenty-first century, surviving, and even profiting from, the demise of Hollywood, which set the stars free from their studio contracts.[28] Stars are now cross-media phenomena who maintain their presence in the public eye across a wide variety of media from print to Twitter, in which performance in a particular medium may be relatively unimportant to their credibility. Brigitte Bardot in the mid-twentieth century, because of her bikini, was an exception. She was a media celebrity before she became a film star. The obsessive attention of the paparazzi ensured that her image was disseminated to audiences who had never seen her in films.[29] Today, many fans follow celebrities whose films or concerts they may have never attended—and without any intention of doing so. Fashion has followed suit: if, in the past, film stars may have been one of the privileged vehicles whereby the designer presented his creations to the world, today, celebrities may take over the role of the designer, sometimes in name, but often in fact. Style and celebrity are becoming synonymous, with the celebrity figure thus dictating future trends.[30]

In the 1990s, the fact that a particular actress such as Sarah Jessica Parker sported a specific handbag in her role as Carrie on the television program *Sex and the City* (HBO, 1998–2004) was enough to ensure that consumers would rush to buy the item, recalling Hollywood studio days when Joan Crawford inspired thousands of young girls to copy the party dress she wore in *Letty Lynton* (Clarence Brown, 1932).[31] Crawford, however, earned nothing from this transaction. Thirty years later, in the 1960s, stars such as Audrey Hepburn began to seek some form of financial reward for their participation in the fashion system. Today, in the twenty-first century, while the specifics of these arrangements are confidential, stars earn thousands, and even millions, of dollars through various forms of endorsement, including personal appearances.[32] Scent, long a mainstay of the fashion industry, has now become a routine extension of the celebrity franchise, with celebrities endorsing traditional brands, or often creating their own fragrances. Products themselves are available for immediate purchase through phenomena such as "e-tailing," whereby component parts of a celebrity outfit are quickly identified and located for interested consumers online.[33]

In response, international brands have arisen that refuse to enter the celebrity circuit, preferring to be identified with less mainstream publications such as *i-D*.

One of the most prominent is Rick Owens, a California designer who has lived in Paris since 2003.[34] He describes his clothes as "anti-status" … "my clothes are supposed to be not about status, not about novelty" [*sic*]. He explains: "I may not do any of that red-carpet stuff … but I know that people buy my stuff by the armful to wear in their real lives, and there's something really nice in that."[35] In 2009, the *New York Times* considered that he "may be fashion's most imitated designer." Owens, however, avoids designing for red carpet events, and neither advertises nor seeks endorsements.[36] The *New York Times magazine* describes his operation in 2017 as "relatively small. His turnover is approximately $140 million, paltry when compared to luxury behemoths. But it's perfectly formed." Notwithstanding, in the same article he is described as "the Cristóbel Balenciaga of our time," with Balenciaga, in the view of Alexander Fury, the author of the article, having "influenced an entire generation of designers." Fury opines, "Owens' technique has stealthily proved just as influential."[37]

Owens's New York store is a cavernous, monochromatic structure, where shop attendants (young men with vaguely British accents) wear black beanies, low slung trousers with dropped crotches, white singlets, and black trainers. They lounge on the street corner smoking cigarettes during their breaks, and could be mistaken for young urban lads of indeterminate income almost anywhere in the world. Pleasant and chatty, they are a far cry from the snotty saleswomen of the past, notoriously satirized in *Pretty Woman* (Gary Marshall, 1990).

Modernity and its vexations

Both the rise of fashion as the primary means of regulating dress and the development of cinema as a socioeconomic institution have been associated with modernity and a break from the past—from cultures associated with tradition and hierarchy—thus heralding a new mode of being in which social and geographic mobility have increasingly become the norm. Not unsurprisingly, modernity was not monolithic, but often paradoxical and contradictory, being associated with diverse social trends from the rise of nationalism to the secularization of public culture. The twentieth-century fashion system itself, from the perspective of scholars such as Bonnie English, sowed the seeds of its own disintegration from its inception, as illustrated by designers such as Charles Worth, who "attempted to establish himself as a creative artist" while exploiting his position to ensure "international commercial fame (which led to greater financial returns)."[38] Thus, even in the nineteenth century, designers such as Charles Worth sought to market (and protect) their designs, while in the early twentieth century, others, like Coco Chanel, were eager to sell their wares to the largest number of consumers. English argues that "while haute couture reigned supreme at the turn of the century, ironically it predicated its own demise."[39]

In contrast, for scholars such as Barbara Vinken, fashion is crucially linked to modernity as a largely twentieth-century phenomenon.[40] Looking back on the 1970s, she proclaimed, "The century of fashion is over. ... On the one hand, the fashion-buying public has increased; on the other hand, this public no longer determines trends, but reacts to trends that emerge from subcultures."[41] Other scholars see the break with traditional fashion coming later in the century. Teri Agins argues, "By the early 1990s, a confluence of phenomena arising from retailing, marketing, and feminism began transforming the ways of fashion forever."[42] For Adam Geczy and Vicki Karaminas, the development of the Internet, and of inter-media forms in the twenty-first century, such as the fashion film, constitutes the significant break. This new fashion system, "increasingly blurring the line between fashion and industry, creativity and control,"[43] has resulted in what Karaminas describes as the emergence of "fashionscapes" as a "transformative moment."[44]

As in the case of cinema, to argue that fashion has disappeared seems counterfactual. Both, however, have undergone significant transformations, or, perhaps more accurately, a series of transformations in the past century. The important question, then, is how the evolution of these institutions offers insight into the nature of the larger changes of which they are, perhaps, the consequence. Are these transformations the harbingers of even more radical transformations to come? Do they have a role in influencing the further inevitable developments that will follow? Church Gibson avers that while "film had a greater influence on fashion than any other form of visual culture, ... the very shaping of consumer culture ... depends upon the cinema and its unique power to generate both demand and supply."[45] Peter Wollen, commenting on Walter Benjamin's influential writing, claims that for this philosopher: "Fashion displays both an object lesson in commodity culture and a possibility of messianic redemption."[46] Film scholars, beginning with Vachel Linsay, the American poet,[47] have underlined film's utopian possibilities, with others reposting with more negative predictions that extend to mass culture in all its manifestations.[48]

Gender issues

A significant facet of cinema and fashion is that both have been inextricably implicated in the ways in which gender has been constructed and reproduced as governing social categories within modernity. In the same period during which scholars have been heralding the ends of cinema and fashion, feminists such as Sneja Gunew have proclaimed. "We are post-woman. Get over it,"[49] suggesting that we may, perhaps, at least in the view of feminist scholars such as Gunew, be experiencing the end of gender, or, at least, of the concept of "woman."

A crucial dimension of contemporary identity is "gender," tied to a fashion system that emerges in the nineteenth century in which, as students have dutifully repeated over the last three decades, "men act and women appear,"[50] and which is marked by what is known as, in the words of John Flügel, "man's 'great renunciation' in matters of dress," often referred to as "the great male renunciation."[51] When feminists such as Gunew proclaim (as they have been for a few decades), "we are post-woman," they are alluding to an array of changes with regard to gender in which both cinema and fashion inevitably participate.

Fashion has long been a topic of debate and concern among feminists.[52] Scholars who study the history of feminist criticism know the name Carolyn Heilbrun as a groundbreaking literary scholar in this area during the 1960s. She is described by *New York Magazine* as "one of the mothers—perhaps the mother—of academic feminism laying the groundwork for women's struggle over the past decades with what they called the 'patriarchy.'" *New York Magazine* also noted that "she had stopped wearing nylons and heels at 62, as always, as a matter of principle," a fact that no article commemorating her life and death has failed to mention.[53] Born in 1926, Heilbrun would have been 62 in 1988, a period that witnessed a number of dramatic changes in women's wear. Indeed, wearing "nylons and heels" might have seemed anachronistic in the late 1980s, with pantyhose and lycra the norm in Manhattan, which Heilbrun called home at the time, and where she filled a named chair in English literature at Columbia University.

The 1980s, arguably the height of a philosophy known as "dress for success," or "power dressing" for both men and women,[54] also saw the working woman (as opposed to the wealthy socialite) firmly ensconced as the icon of style, a trend that had begun earlier in the century, in spite of remonstrations by the like of Heilbrun. By the late 1980s, women such as Donna Karan, launching the Donna Karan New York collection in 1985,[55] built a career on catering to women who wished to look successful and attractive while having minimal amounts of time to invest in fashion. Karan, herself, is "widely credited with changing the way working women dress."[56] The tailored primness popular earlier in the decade gave way to an ideal that emphasized a woman's body while forgiving her what was termed her curves, through the use of elasticized fabrics that molded to her form while shaping it subtly. Known for her "seven easy pieces"[57] that could take a woman from her desk to an evening affair, Karan embodied this woman in her own life. She developed a "wardrobe" that combined ease with glamour and eschewed an aesthetic that required a "new" look with each season and which was, as a consequence, largely impervious to trends. For Heilbrun, and her kind, however, to be a feminist was to discard the trappings of a fashion system in which feminism was equated with to-be-looked-at-ness, and femininity *tout court*.

Popular feminism, exemplified by designers such as Donna Karan, advocated a form of feminism referred to as "neo-feminism," "post-feminism," "market place feminism," "consumer feminism," and so on[58]—a feminism that embraced "to-be-looked-at-ness," with an emphasis on dimorphism (breasts, derrières, and shapely fuzz-free legs), as a source of feminine empowerment and identity. In advocating a season-less look that did not change from year to year, designers such as Karan challenged aspects of the fashion system. They also preserved, however, a strong division between femininity and masculinity. With the demise of Karan's designer line in 2015 (and Karan's retirement) described by the *New York Times* as a "major shift for fashion,"[59] fashion seems to be increasingly challenging the masculine/feminine and even the male/female divide, at least in certain sectors, as suggested by the continued vigor of designers such as Rei Kawakubo who emphasize androgyny as a fashion choice.

Androgyny and fashion

Indeed, the 1980s highlighted not only the sexy "neo-feminist" incarnated by Karan but also what is known as the "Japanese invasion," including Rei Kawakubo whose fashion line is called Comme des Garçons, or "like the boys." While Donna Karan retired in 2015, her licensing businesses and diffusion lines continued to be economically viable. Her designer line, however, which bore her own name and design imprimatur, did not correspond to contemporary sensibilities. Kawakubo continues to dress the generations, with new converts in each successive decade, promoting a design philosophy that supported a vision of the subject as essentially androgynous. In 2017, Rei Kewakubo became the second living designer to be honored by an exhibition at New York Metropolitan Museum of Art (May 4–September 4, 2017). *Rei Kawakubo: The Art of the In-Between* as the exhibition is called, represents a tribute to the prestige that she and her designs enjoy in the twenty-first century.[60]

Should heilbron choose to visit Comme des Garçons in Paris, or in any of the other major fashion capitols graced with dedicated retail outlets affiliated with Kawakubo's lines today, she would have no trouble finding stylish attire that met her requirements, established in "her sixties" when "she had the courage to throw out her high heels and skirts and dress entirely in flat shoes and trousers." *Washington Post*'s Selwa Roosevelt (clearly no fan of Comme des Garçons) opined in 1997, with respect to Heilbrun's sartorial choices, "There I doubt if she will find many takers, and she is aware of that"[61] The continued success of Rei Kawakubo's design philosophy suggests otherwise, proving that two decades later, in Heilbrun's words, "at least some women will wish to be judged by qualities other than their dress, their ability to appear thin and helpless, their success in inspiring male lust."[62]

For Heilbrun, the move away from a femininity defined in terms of "dress," and as "thin," "helpless," and sexy to men was not a move toward masculinity. Drawing on Virgina Woolf, Heilbrun advocated an ideal grounded in androgyny. She introduced her benchmark volume *Towards a Recognition of Androgyny*, first published in 1964, with the following words: "I believe that our future salvation lies in a movement away from sexual polarization and the prison of gender toward a world in which individual roles and the modes of personal behavior can be freely chosen." The term "androgyny" for Heilbrun "defines a condition under which the characteristics of the sexes, and the human impulses expressed by men and women, are not rigidly assigned."[63] Vanessa Grigoriadis explained in an article in *New York*, written shortly after Heilbrun's death in 2003, that "the object was not for women to become men per se but rather (as Woolf similarly argued) for a 'reunification of the sexes in the self.' To recommend that women become identical to men, Heilbrun writes, 'would be simple reversal, and would defeat the whole point of androgyny, and for that matter feminism: in both, the whole point is choice.'"[64] Heibrun's clothing choices were a figuring forth of her convictions, however unconventional they may have appeared at the time.

Not unimportantly, Rei Kawakubo's designs are noted for their "radical abandonment of the conventional notions of attractiveness."[65] In the rare photographs available of Kawakubo, she routinely wears a version of the biker jacket, a long skirt, and a pair of trainers. Her fashion shows and the exhibition at the Met offer what might characterized as experimental designs that challenge notions of clothing, "wearable abstractions," in the words of *New Yorker* fashion writer Judith Thurman.[66] Her "'easier-to-wear' subsidiary line," "Comme des Garçons, Comme des Garçons," formerly known as "Robe de Chambre," with a more practical thrust and described as "a microcosm of her own wardrobe,"[67] has many items that would meet with Heidbrun's approval, including flat and very comfortable shoes designed in collaboration with Doc Martens, the producer of the standard subcultural footwear initially associated with skinheads in 1960s Britain—as well as generously tailored trousers, forgiving of both male and female forms.

The persistent androgyny advocated by Rei Kawakubo, and others such as Rick Owens, Gareth Pugh, and Ann Demeuelemeester (whose line's designer is now a man, Sebastien Meunier),[68] suggests a shift in the ways that appearance and gender are articulated within a particular, if perhaps limited, arena, but one that has strong ties to youth and street culture as evidenced in such publications as *i-D*. Indeed, in 2015, fashion writer Ruth La Perla announced "fashion's gender blur," and a concomitant "narrowing of the sexual divide," in the *New York Times*.[69]

The consequences of the much-heralded end of cinema, the less loudly proclaimed end of fashion, and the, perhaps uneven, fading of "woman" are reflected in the topics pursued by contemporary cinema, especially, but

not exclusively, independent cinema, which seeks to offer an alternative to Conglomerate Hollywood fare.[70] Jim Jarmusch's *Only Lovers Left Alive* (2013) constitutes a significant meditation on the confluence of the cultural trends that have inspired scholars to talk about, variously, but rarely together, the end of cinema, the end of fashion, and the end of gender.

Only Lovers Left Alive

Jim Jarmusch is described by the *Guardian* as a "hipster" and "without a doubt the most rock'n'roll of filmmakers."[71] Like many films that he directed, all of which challenge the norms of contemporary Conglomerate Hollywood, *Only Lovers Left Alive* had a fraught production history. Jarmusch shot the film digitally because he was "hemmed in by financing"; however, Sony Pictures Classic[72] (an arm of one of the conglomerates) ultimately distributed the title, though original funding was from Cyprus, France, Germany, and the UK. The production might be described as an independent American film (shot in Michigan, Germany and Morocco) with a Euro-pudding funding profile, neither national cinema nor international fare, and certainly not independent of the conglomerate system.[73]

Investors' reticence was not ill founded; the film was well received critically, but its box office failed to recover its initial budget.[74] Thus, like many independent film projects, its purpose was artistic and personal, rather than being financially motivated—with Sony most likely encouraged by the prestige afforded by the status of director and cast. This project, like many others in its category, in terms of medium and distribution, suggests the fragmentation of cinema, which is, arguably, no longer a mass medium, but one that is divided between "event films" targeting ever younger viewers, and the so-called niche films that may enjoy cult status, while never achieving box office success.

Only Lovers Left Alive revolves around the centuries-old relationship between two globe-trotting vampires, "Adam," played by Tom Hiddleston, and "Eve," played by Tilda Swinton. Atmospheric rather than plot-drive, the film recounts the couple's attempts to survive the contemporary world. The film concludes in Tangiers as the two vampires prepare to murder a couple of young lovers as their only means of survival. The vampire as a narrative conceit afforded Jarmusch the opportunity to "sneak in an overview of cultural history,"[75] in which, among other things, he revisits a cinematic past that includes an old movie palace, now a car park, which, metaphorically, marks the death of cinema (Figure 6.1).

The obsession with the past in the present was literally embodied in the costumes worn by the vampires, all of which were made for the film, which highlights that these garments had no direct connections to the world of fashion. Jarmusch, in particular, avoids any involvement with the luxury industry, or mainstream culture more generally, which has contributed to his status as an

Figure 6.1 From movie palace to parking garage in *Only Lovers Left Alive* (2013), directed by Jim Jarmusch

authentic "indie" director.[76] Tilda Swinton was intimately involved in the creation of her look, claiming that she and the costume designer always work together very closely:

> As far as I'm concerned it's the lion's share of my work, putting together the disguise. ... We had such fun putting all the looks together, ... we had to keep alive that they were living in all centuries at once. So every element, the height of the heel, the substance of the pants, the cut of the jacket had to, or rather needed to not indicate one period. So, the jacket might be a bit fifties, a little bit 1530's, a little bit last season. That feeling of fluidity and lastability was essential and fun to do.[77]

Only Lovers Left Alive was, however, promoted by fashion publications, particularly with a view to its sartorial choices. For example, *Vogue*'s Patricia Garcia extolled the film's look: "There's a special kind of nonchalant cool found in every Jim Jarmusch film." She continued invoking Swinton and Hiddleston as fashion models: "Inspired by their bedhead and their grungy rock-'n'-roll style— there's a white leather jacket we need in our closets right now—we picked six looks you can make your own" (Figure 6.2). *Vogue* then goes on to detail how the consumer can recreate various outfits worn by the characters by purchasing contemporary garments.[78]

Through her "look" in this film and her status as a fashion icon, Swinton challenges the division between the fashionable and the unfashionable, while at the same time supporting, and being supported by, an economic system that is grounded in something like "a timeless style," ironically predicated on clothing as increasingly disposable. Through her appearance, she suggests a physical ideal that is neither feminine nor masculine, but, rather, androgynous, and famously so, a cult figure among feminists, the offspring of Heilbrun's generation.[79] Swinton nonetheless maintains a degree of "to be looked-at-ness" as a desirable quality, with her penchant for disguise putting into question the very notion of a stable identity, while at the same time enhancing her iconicity as the emblem of perpetual transformation, the ideal spokesperson for various brands.

Her character in the film enjoys a doubly privileged position, as a wealthy immortal, that is neither a function of gender nor of class as typically conceived. The film, however, does not so much advocate a classless system as describe a new class system in which the autonomous individual (rather than groups) is singled out as the site for identity. Vampires metaphorically occupy a place of extreme privilege that depends upon their exploitation of others as a result of their nature, as the film's conclusion makes abundantly clear. Temporarily without money or connections, the two vampires attack two young lovers in order to survive, their ethical reservations notwithstanding.

The messianic dimension of the film and of fashion, highlighted by Lindsay and Benjamin, respectively, is apparent in the way that neither vampire is content with how things are and must always strive for something new, something better. In this vein, the vampires are consistent critics of contemporary culture, which

Figure 6.2 Tilda Swinton wearing her must-have leather jacket with Tom Hiddleston in *Only Lovers Left Alive* (2013), directed by Jim Jarmusch

is never sufficient to fulfill the dreams of the past, and which are kept alive in the present, paradoxically, by the vampires' privileged status as immortals (they are great collectors of books and art, for example). Vampires also typically represent a being that may be notionally gendered, but for whom gender is not the defining moment of identity. In the words of Geczy and Karaminas, "The vampire exists outside of time and subsequently history and language, collapsing the binaries between man and woman, human and animal, heterosexual and homosexual, lodging themselves outside the slippages and folds of language."[80] In the hands of Jarmusch and Swinton, the figure of the vampire is used to question the very notion of identity, including gender. While the vampire is technically immortal, he or she changes over time, becoming something that is no longer human, no longer himself or herself—a condition of being that is often a source of anxiety for the vampire in question. For example, in the case of *Only Lovers Left Alive*, Tom Hiddleson's character "Adam" routinely suffers from depression and a pervasive anomie. Swinton's "Eva" is post-woman because she is first and foremost a vampire and notably more rational than "Adam." Nonetheless, her position as gendered is effectively conveyed in the film as part of her star persona. Her fashion choices are equally ambiguous, suggesting how boundaries between binary systems (including that of gender) have become increasingly blurred without disappearing as such.

Conclusion

At the end of cinema, films, or more properly screen narratives, are not simply messianic in terms of their themes; as a medium film is, increasingly, everywhere and nowhere, as film theorists such as Raymond Bellour have repeatedly noted.[81] Film has become a democratic art form not simply in the viewing (though this is the case more intensely than ever), but in the making, with more movies being made than ever before, owing to the facilitation made possible by digital technology and the internet. Similarly, as noted by Karaminas, "fashion imagery, as a mode of representation, is in constant flux with the social forces that shape culture and political change."[82] The new "fashionscapes" described by Karaminas have authorized an ever-widening range of cultural intermediaries, with style icons developing a global reach that is ever more fragmented in the discourse and standards that these last disseminate.[83] Fashion, like cinema, is everywhere and nowhere.

Tilda Swinton as a star emblemizes this paradox. She is a fashion icon who is indifferent to fashion; a mother who is celebrated for her androgyny; a film star noted for her ability to disguise herself and her accent; an aristocrat known for her lack of pretension. If she has one single defining characteristic, it is perhaps her capacity to endlessly transform herself, a practice that incarnates and reflects

the shifting terrain of contemporary culture in the twenty-first century. This trope of transformation applies perhaps equally to fashion and film, neither of which has disappeared. Rather, both have continued to mutate into multiple versions, fragments of what they once were, now taking on new forms, that nonetheless recall the old.

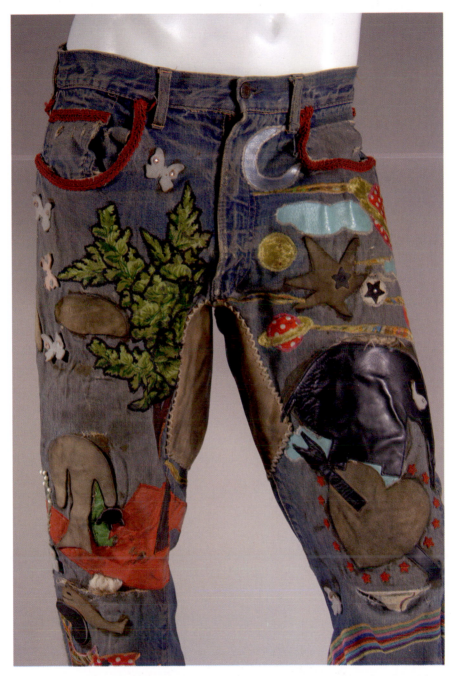

PLATE 1 Levi Strauss & Co., jeans hand-embroidered denim, *c.* 1969, USA. Gift of Jay Good. Photograph © The Museum at FIT

PLATE 2 Tavi Gevinson. Drawing by Erica Parrott. Wikimedia Commons

PLATE 3 Susanna Lau (Susie Bubble) in 2007. Wikimedia Commons

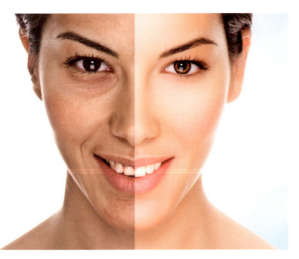

PLATE 4 The power of retouch. A model's face is divided into two parts – good retouch and bad retouch. Getty UK 154949082

PLATE 5 Lena Dunham at Maryland Film Festival 2010. Photo by Alison Harbaugh for the Maryland Film Festival. Wikimedia Commons

PLATE 6 Zendaya. Wikimedia Commons

PLATE 7 Kim Yu-Mi, Miss Korea 2012. Wikimedia Commons

PLATE 8 Renée Zellweger at Berlin Film Festival 2009. Wikimedia Commons

PLATE 9 Hari Nef on the red carpet of the Berlinale 2017 opening film. This image was published by Martin Kraft under the free licence CC BY-SA 3.0, Wikimedia Commons

PLATE 10 Geena Rocero. Photo by Steve Jurvetson. Wikimedia Commons

PLATE 11 Andreja Pejić at Galore Pop-up party, New York City, February 6, 2013.
Wikimedia Commons

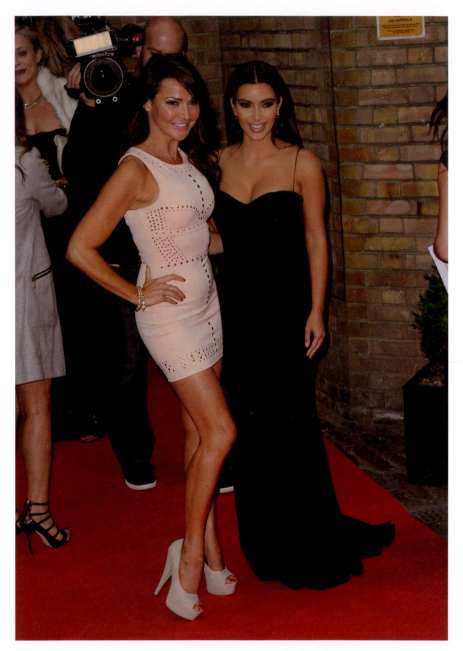

PLATE 12 Kim Kardashian in an earlier incarnation and a transitional phase: her companion is television presenter and former footballer's wife, Lizzie Cundy. Photographer, Anne-Marie Michel

PLATE 13 Gvasalia's secretary suits on the runway at Balenciaga. Vêtements. Public Domain

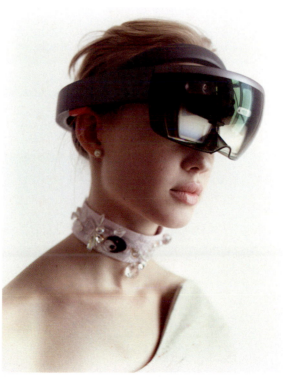

PLATE 14 Martine Jarlgaard Spring/Summer 2017 collection could be viewed using Hololens headset and holographic technology for a mixed reality experience. Photo Brendan Freeman, courtesy Martine Jarlgaard

PLATE 15 CuteCircuit New York Fashion Week Autumn/Winter 2014 Finale with smartphone operated LED-illuminated clothes. Photo Theodoros Chliapas, courtesy of Cute Circuit

PLATE 16 Fyodor Golan "digital skirt" for Nokia at London Fashion Week Autumn/ Winter 2014, featuring a connected array of smartphones. Photo courtesy Fashion Innovation Agency, London College of Fashion

PLATE 17 Richard Nicoll fibre optic light emitting Tinkerbell dress for Disney with Studio XO. London Fashion Week Spring/Summer 2015. Photo courtesy Fashion Innovation Agency, London College of Fashion

PLATE 18 Zero prototype simulation of design by Teatum Jones for made-to-order portal MIXIMALISTE.COM 2017. Image courtesy MIXIMALISTE.COM

PLATE 19 Suits by Cristobal Balenciaga, 1951 and Demna Gvasalia, 2016, shown at *Balenciaga: Shaping Fashion,* The Victoria and Albert Museum, London, May 24, 2017 – February 18, 2018. Photo by Nicky J. Sims/Getty Images

PLATE 20 "Harmonic Mouth," by Henrik Vibskov. Installation view from *fashion after Fashion,* 2017, The Museum of Arts and Design, New York. Photo by Jenna Bascom. Courtesy of the Museum of Arts and Design

7
MEDIATIZATION AND DIGITAL RETAIL

Agnès Rocamora

Introduction

The word "mediatization," although not a new one,[1] was refashioned—
"awakened" as Gianpetro Mazzoleni puts it[2]—in the late twentieth century, but
especially in the early 2000s by social sciences and humanities scholars to
reconceptualize the relation between media and society. Whereas media had
often been studied as conveyors of meaning, they started being conceived as
agents active in the making and transformation of social and cultural practices.
In the growing literature on mediatization,[3] the contrast between the two
approaches is sometimes signaled by the use of the term "mediation" to refer
to the representational role of the media and "mediatization" to refer to their
agentive power.[4] Studying mediatization does not mean studying the media per
se, but rather studying the sites and practices they saturate and shape, and
the forms this shaping takes. As Eric Rothenbuhler puts it, mediatization is "the
process by which activities of various social spheres come to be conducted
under the influence of the media, with the media, through the media, or by the
logic of the media."[5] Mediatization interrogates the transformative power of the
media, and their role in the "moulding" of society is the focus of theoretical and
empirical discussions, and a guiding research agenda.[6]

The bulk of mediatization studies has concentrated on politics. However, the
concept is useful for investigating a broad range of practices and fields, including
fashion, as I have argued in an article in the journal *Fashion* Theory.[7] In that article,
I discussed examples of fashion shows, bricks and mortar retail, and makeup,
in the light of digital culture and argued for the importance of mediatization as
articulated in digital media, as opposed to traditional, mass media. Indeed, much
of the literature on mediatization has attended to this process as taking place
through the latter, but more attention needs to be paid to the specificity of digital

mediatization.[8] As Kunilius *et al.* observe, "the dominant mediatization narrative still extrapolates from the epoch and conditions of mass mediatization. This begs the question, how is this theorizing valid in the current, networked media environment and infrastructure."[9]

In this chapter, I pursue my engagement with the idea of digital mediatization, and in particular as taking place in the field of fashion, by focusing on e-commerce. It is also an opportunity for me to return to a concept that is useful for making sense of digital fashion media: remediation.[10] In bringing mediatization and remediation together in an analysis of fashion e-commerce, the chapter also turns to the notion of commercialization to account for the ways it intersects with both remediation and mediatization. It shows that current online fashion retail practices allow us to explore the congruence of processes of mediatization, remediation, and commercialization. This chapter first looks at the rise of e-commerce, and more specifically at the concept of shoppable magazines, to comment on the idea of the history of the mediatization of fashion commerce, and on the logic of entertainment that underpins retail and the media. It then turns to the notion of remediation as a way of conceptualizing shoppable magazines, and to examine mediatization in relation to digital culture. Finally, it addresses the theme of commercialization, discussing the idea of brands as publishers—and the related notions of branded content, content marketing, and native journalism—in the light of the idea of the commodification of everyday life through online fashion.

In exploring the nexus mediatization/remediation/commercialization in the field of fashion, this chapter aims to contribute not only to current debates on mediatization but also to understandings of recent developments in the field of fashion. What is discussed is not the end of fashion, contra many pessimistic views of the current state of both fashion and the media, but fashion's reconfiguration. This chapter thus shows the relevance of all three concepts for grasping this reconfiguration.

e-commerce and shoppable magazines: Context

While the nineteenth century was the century of the department store, the twentieth century that of the shopping mall, the twenty-first century could be seen as that of online commerce. Facilitated by the use of credit cards, non-store retailing grew in the 1990s,[11] and, today, online commerce is "the fastest growing retail channel."[12] Also known as e-commerce, online retail began in 1995. At first relatively shy—in March 1996, for instance, nine months after it had gone online, Argos had sold only twenty-two items[13]—it quickly accelerated. In 2015, in Great Britain alone, business-to-consumer e-commerce reached 157 billion

Euros,[14] with 77 percent of UK internet users having purchased something online.[15] And in the UK, as in many countries, the most popular type of online purchase is clothing (Ecommerce news 2017), which, together with textile and footwear, accounted for 14.1 percent of all online retailing in April 2017.[16] The emergence of e-commerce followed an older tradition of home shopping by phone and mail through print catalogs and television. However, with the rise of mobile technologies such as smartphones and tablets, non-store shopping soon detached itself from the fixity of place to become mobile, in the form currently know as m-commerce. Thus, in the words of Kenneth Laudon and Carol Traver, "in 2015, 2.25 billion people worldwide use a mobile device to access the Internet, and over 45% of total Internet traffic comes from mobile devices."[17] E-commerce is also s-commerce, which stands for "social commerce," a form of commerce social networks and online sociability enables.[18] This includes platforms such as Facebook, Twitter, YouTube, Instagram, and Snapchat. Social e-commerce is still in its early days. However, as Laudon and Traver observe, "in 2014, the top 500 retailers in Internet Retailer's Social Media 500 earned about $3.3 billion from social commerce, a 25% increase over 2013."[19]

Where window-shopping once referred to looking through the panes of glass of shop frontages, it now also involves engaging with a digital screen.[20] Where it once involved an urban *flânerie* only, it now involves digital *flânerie* as well.[21] As Anne Friedberg puts it, "to glide electronically through shops" has become "the digital equivalent of an escalator ride."[22] The words of New York's Saks Fifth Avenue fashion director Roopal Patel somewhat capture the importance that digital window shopping has taken up in consumers' lives. In discussing the store's recent see-now-buy-now operation during the New York and Paris collections, Patel states: "The Fifth Avenue windows were set to go live at 9 p.m. after the [Ralph Lauren] show and a digital e-mail was sent to customers immediately after the show went live."[23] Here, an expression, "go live," normally used in reference to the launch of online events and websites, is applied to a bricks and mortar space. This semantic transfer is also indicative of the merging of off- and online retail practices: omni-channel retailing—the selling of products through various channels and the integration of bricks and mortar stores with websites and mobile platforms[24]—is currently on the agenda of many retailers and brands.

The history of e-commerce is also the history of the development of ever-new and enticing ways of capturing the attention of online users. The year 2000 saw the creation of *Net-a-Porter.com*, the first luxury fashion e-commerce site, and in October 2016, it was said to have 5.2 millions visits per month.[25] In 2013, *Net-a-Porter* launched the weekly *The Edit*. With an editor's letter, a contents list, fashion features, and fashion spreads, this online magazine/e-commerce space looks, on the screen, like a traditional print glossy, only, it is immediately shoppable— hence the name "shoppable magazine"—for by clicking on a link the user can

head toward check out. There, goods are worn by models and laid out as on the pages of a glossy, captioned by attention-grabbing headlines. By clicking on the arrows on the left or right outer margins of the digital magazine layout, the user can browse through the issue, turning the pages of *The Edit* as if those of a print magazine. Advertisements are included, once again, as in "glossies." The front pages are reminiscent of the covers of *Vogue*, *Harper's Bazaar*, and other high fashion magazine titles. The May 10, 2017 issue, for instance, features social media fashion celebrity Olivia Palermo sitting on the stairs of a grand mansion, while the cover lines read "Secrets of Chic," "Wave Hello," and "Need Right Now," the latter indeed capturing the immediacy shoppable magazines afford, with expressions such as "right now," "the latest," or "just in" having become common tropes of online fashion.[26]

In *Window Shopping: Cinema and the Postmodern*, Anne Friedberg refers to the "mobilized gaze" for the way of looking at goods that emerged with their *mise–en–scène* in the nineteenth century.[27] An elaborate staging of commodities started serving as a facilitator for the gaze of the passersby, encouraging consumption. The gaze became transformed into a commodity and "sold to a consumer-spectator."[28] In the late twentieth century and early 2000s, and in the context of what some have described as a "poverty of attention,"[29] enticing shoppers to click through to check out means finding new ways of mobilizing and catching the contemporary mobilized gaze; the fickle gaze of the digital *flâneur*.[30] A lavish layout such as that of shoppable magazines is instrumental in this mobilization.

The Edit is not the only shoppable magazine, and *Net-a-Porter* not the only e-commerce platform that is also a purveyor of editorial content. A newcomer, for instance, is *Semaine.com*, launched in 2015. *Vogue* describes it as an "online magazine–meets–concept store."[31] Each week is devoted to a new personality, interviewed about their life, their work, their taste, their favorite outfits, all instantly shoppable in a "shop profile" section. Capturing the ideal of time-space compression that underpins many online platforms, Georgina Harding, the creator of the site, states that "everything is within reach."[32] On accessing the home page, the user can head straight to the "shop" section, or she or he can choose to access past profiles in a "stories" section that features, among others, Leaf Greener, Caroline de Maigret, Pixie Geldof, Nick Jones, Jean-Charles de Castelbajac. From there the user will always be able to browse and purchase goods.

A shoppable magazine is an online platform but it can also be a print one. Where *The Edit* is a shoppable e-magazine, *Net-a-Porter* is also behind the shoppable print magazine, *Porter*. Launched in 2014, and with six issues a year, *Porter* resembles the likes of *Vogue*, *Harper's Bazaar*, *Elle*, and other traditional fashion magazines. An app enables the reader to scan the goods featured on its pages to then acquire them online. As with *The Edit* the commercial and the editorial blend with each other. Such blending also informed publishing group *Condé Nast*'s decision to make *Vogue* and *GQ* shoppable via *Style.com/Vogue* and *Style.com/*

GQ. Formerly reserved for editorial content, *Style.com* was revamped in 2015 to become a commercial platform. In April 2017, it started featuring lavish shoppable "The Vogue edit" and "The GQ edit" fashion spreads. Online viewers were invited to "shop the shoot." They could buy "As seen in" *Vogue/GQ* items by clicking through related hyperlinks. In June 2017, Style.com was discontinued and, following a partnership between Vogue.com and e-commerce website Farfetch.com, users started being redirected to Farfetch. An official statement reads: "The partnership will offer readers the unique ability to browse and shop Condé Nast's inspirational editorial content on a global scale, further commercialising the editorial platform."[33] Similarly the digital platforms of magazines such as *Harper's* or *Grazia* allow readers to instantly buy some of the products featured by clicking on a hyperlink that takes them to an e-commerce site selling the linked product. In the field of fashion, the distinction between commercial and editorial content is becoming increasingly tenuous, an idea I will return to later.

Shaped by the format of fashion magazines, and sometimes indistinguishable from them, e-commerce platforms instantiate the process of mediatization that is informing online fashion retail. It is characterized here by the transformation of online retailers into media content providers akin to traditional fashion media. The notion of "media logic" is useful for understanding this idea. Developed by David Altheide and Robert Snow, "media logic" has underpinned much discussion of mediatization, where the latter is defined, then, as referring to the process whereby, in their ways of doing, institutions conform to media logic.[34] It functions, Altheide and Snow argue, "as a form through which events and ideas are interpreted and acted upon."[35] It is a "way of 'seeing'" and "consists of form of communication; the process through which media present and transmit information."[36] By adopting the format of glossies—including a glamorous cover image with cover lines, a content list, an editorial, features, fashion stories, beauty and travel sections—the way sites such as *Net-a-Porter* commercialize their goods is an instance of mediatization. No longer are they simply commercial platforms, they are editorial ones too, a transformation indicative of the mediatization of e-commerce.

Furthermore, Altheide and Snow identify entertainment as a key dimension of media logic.[37] The logic of entertainment, they write, has become "a 'normal form' of communication."[38] Similarly, entertainment has long been a key component of shopping.[39] Indeed, with the advent of department stores, the nineteenth century sealed the relation between consumption and spectacle, also making shopping "an acceptable leisure activity."[40] Thus, "the history of modern consumer culture," Christoph Grunenberg writes, is "in essence also a history of the continuous evolution and ever increasing sophistication of commercial display and presentation methods."[41] Grunenberg does not discuss e-commerce, but the novel use of content-rich formats such as shoppable magazines is another step toward the increasing sophistication that he writes about. Thus the use

of the print media format in e-commerce can be seen in the light of a logic of entertainment that is at the heart of both the media and retail. Mediatization allows for the consolidation of e-shopping as a source of entertainment, much like browsing through a fashion magazine and its fashion stories. It is a logic that serves the interest of capitalism and brands' aim to increase their profit by selling ever more commodities, an issue dealt with in the final section of this chapter.

Mediatization is frequently defined as a recent phenomenon and a feature of late modernity.[42] However, some scholars have insisted on the importance of historicizing mediatization, contending that as a process it has a long past,[43] and can even serve as a concept for historical research.[44] Thus a comprehensive investigation of the mediatization of fashion would have to trace and analyze this process as occurring since the birth of the first fashion media—print titles such as *Le Mercure Galant*, or even the use of fashion dolls before the circulation of print media.[45] A historical analysis of the mediatization of fashion could also take into account the particularity of the media genre discussed in order to consider the heterogeneous nature of mediatization.[46] This would attend to what Ekstrom *et al.* argue is missing in existing approaches to mediatization: the comparison of media forms and communicative contexts.[47] One could, for instance, look at the rise of color photography and its role in the mediatization of fashion, or that of the moving image and television. A historical analysis would allow one to revisit the interplay between fashion and the media. This would highlight the role of media texts as not only representational (as in much work in fashion studies) but also as transformative of practices (of production, distribution, consumption, and representation).

This kind of historical analysis is outside the scope of this chapter. However, in the instance of the relation between fashion commerce and print magazines, we can turn to the past for examples of the mediatization of fashion retail that predate shoppable magazines. For instance, department stores, in order to promote and sell their wares, have long used catalogs with a layout often reminiscent of fashion magazines. In the United States, one of the precursors was Sears Roebuck (1886). Pages from the 1920s issues, for example, are reminiscent of fashion plates.[48] *Bloomingdale's Illustrated 1886 Catalog* (1988) also features fashion illustrations evocative of fashion plates and magazine illustrations. In 1976, the American department store commissioned fashion photographer Guy Bourdin to illustrate its lingerie catalog *Sighs and Whispers*.[49] Now a collectors' item, its pages are more akin to those of a glossy fashion magazine than a commercial catalogue. Similarly in 1978, the founders of Banana Republic, the Zieglers, created a catalog full of what Robin Cherry calls "wit and whimsy, with Mel, a former journalist, writing quirky copy and Patricia, an artist, drawing the sketches".[50] This blurred the distinction between the editorial and the commercial, pointing to the mediatization of retail.

By adapting the conventions of fashion media to e-commerce and through the transformation of their e-commerce platform into an editorial space akin

to fashion, magazines sites such as *Net-a-Porter.com* illustrate the process of mediatization of online retail, a mediatization characterized by the union of newer (websites) and older (glossies) forms of media, and by the transformation of e-commerce brands into purveyors of editorial content. The notion of remediation is helpful for making sense of this coming together and of the type of mediatization that is articulated on sites such as *Net-a-Porter*.

Remediation

Ulrike Klinger and Kurt Svenson argue that mass media logic and digital media logic can inform each other and overlap.[51] Similarly, Morton Michelson and Mads Krog ask, "what happens when an 'old' medium like radio is influenced by Internet-based media and must adapt its practices to web 2.0 and individualized listening? Are radio and the Internet two distinct processes or just the media?"[52] They wonder if one can talk about "double mediatization," enquiring "if cultures had been through one mediatizing process related to a specific medium, how did this culture function in relation to later processes (from printed to recorded music, mass-circulated print media in relation to electronic media)?"[53] Indeed, websites are media, and so by virtue of appearing as websites, e-tailers are forms of fashion media. This online presence can be seen as an instance of the mediatization of retail, that is, of the transformation of retail from an activity located in three-dimensional spaces— physical shops—to one tailored to, enacted through, and indeed turned into, a media interface. E-tail is therefore mediatized retail. However, when e-commerce sites adopt the conventions of older media, such as glossies, a second process of mediatization takes place whereby an e-tailer turns into a provider of editorial content and becomes akin to more traditional fashion media. It is on this second process of mediatization that this chapter has focused in discussion of sites such as *Net-a-Porter*. Both this second process, and the intertwining Ultike Klinger and Jakob Svvenson identify, can be addressed through the notion of remediation.

Theorized by David Bolter and Richard Grusin in 1999, the term "remediation" points to the importance of attending to the ways digital media refashion other, including older, media.[54] It is "the representation of one medium in another" and "a defining characteristic of the new digital media."[55] The newness of digital media "lies in their particular strategies for remediating television, film, photography, and painting" but also the book, radio, the magazine or DVD Multimedia.[56] The Web repurposes and recontextualizes traditional media.[57] *Net-a-Porter*'s *The Edit* is an instance of such a process. Other examples of remediation include the ways fashion blogs remediate some of the conventions of print magazine, in the bloggers' poses, for instance, which are reminiscent of those of models in glossies, as I have argued elsewhere.[58] But one could also look at the use of fashion illustration in blogs, such as Garance Doré's (now Atelier Doré), or the

remediation of fashion photography by fashion films, or indeed that of fashion plates by fashion photography.

In terms of e-commerce, fashion e-tailers do not just remediate print, they also remediate moving images. When browsing through the March 16, 2017 issue of *The Edit*, for instance, the flow of still images is interrupted by a short video-ad for luxury watchmakers Audemars Piguet. E-tailers also remediate blogs. Asos's "Fashion and Beauty Feed," for instance, opens onto a range of sections the user can access, such as, on April 12, 2017, "Brand Buzz: Meet cult beauty brand the Ordinary." By clicking through the post, the site displays images and written texts formatted like a beauty blog. *Asos.com* also have their own blog, updated on a regular basis in an a-chronological temporal order characteristic of a blogging format. Thus, as Knut Lundby also observes, mediatization "may incorporate the concept and processes of remediation" because the media are constantly in dialogue with, and influenced by, other media.[59] Remediation is the process by which new media refashion other media, but it is also the process by which older media transform themselves in response to the challenges set out by newer media. This argument can be considered in the light of print media, such as *Vogue* and *Grazia*, which have responded to the challenges of e-commerce by developing online shoppable platforms.

Although they do not use the expression, Altheide and Snow also point at the process of remediation that underpins the development of much media: "As legitimizing agents," they write, "the dominant media in a society also serve as agents of legitimation on other media." Further, "This occurs in several ways: one medium may adopt the format of another medium; the format of one medium also may affect the content of another; and, overall, a standardization of media formats may occur."[60] In this respect, remediation may be seen as another dimension of media logic, while also being a process that allows e-commerce to respond to the logic of entertainment that underpins both commerce and the media, and is formative of today's "experience economy."[61]

The notion of remediation suggests that new media are never completely new. Yet some features are particular to digital media technology and the binary makeup of its data.[62] In the case of e-commerce remediating print magazines, one of those features is the possibility of immediate purchase. Where with print the act of browsing through a magazine and the act of purchasing a commodity are temporally and spatially divided, with shoppable magazines these acts are collapsed into a single operation. Hence when studying mediatization as articulated in digital media, one should bear in mind their specific media logic. Scholars should move away from the idea of media logic in the singular to that of media logics, in the plural,[63] which entails attending to the specific logic of digital media.[64] Mass and digital media may share certain logics, such as entertainment, but others are tightly linked to digital media affordances such as connectivity and immediacy. José Van Dijk and Thomas Poell, for instance, discuss "social media

logic,"[65] while Klinger and Svenson refer to the idea of "network media logic," a logic characterized by personalization, reflexivity, connectivity, and virality.[66] Mazzoleni also identifies abundance, interactivity, mobility, dis-intermediation, speed, and immediacy as central to "network media logic."[67] The collapsing, in e-commerce, of browsing and purchasing into a single immediate act captures the logic of immediacy that underpins digital media, and digital fashion media in particular: a logic of speed, "real time," "the instant" being at their heart.[68] One could even go further by talking about digital fashion media logic. Indeed, accounting for media logic as a heterogeneous process also means attending for the specificity of the field within which it is enacted. In that respect, Pierre Bourdieu's notion of the field can prove useful.[69] For in the same way that one could tease out the logic of digital media, one could tease out the logic of digital fashion media. Further research, beyond the scope of this chapter, could explore this logic and the relevance of Bourdieu's field theory for understanding processes of mediatization.

In this context of the mediatization of e-tail, a mediatization also characterized by remediation, it is no wonder then that former fashion journalists have taken up editorial positions in e-commerce.

Lucy Yeomans, for instance, left the editorship of *Harper's Bazaar* to become *Net-a-Porter*'s "Editor-in-Chief," the merging between the commercial and the editorial being captured by the use, within a retail context, of a title— "Editor-in-Chief" —normally reserved for magazines. Similarly, in 2014, Marks and Spencer hired fashion writer Nicola Copping, formerly of the *Financial Times* and *Times* to create "magazine-style content" for their website.[70]

In reference to mediatization, Jesper Strömbäck and Frank Esser note: "As most media are run as commercial businesses, media logic both follows from, and is adapted to, commercial logic."[71] However, one could also add that, as most commercial businesses are run as media too, commercial logic both follows from and is adapted to media logic, a process characteristic of mediatization. Various mediatization scholars have drawn attention to the intersection of mediatization and commercialization, a process articulated in the mediatization of consumption, as exemplified by shoppable magazines and the wider phenomenon of branded content.[72]

Mediatization and commercialization: The blurring of the editorial and the commercial

Mediatization, it has been argued, is not an isolated meta-process and must be studied in relation to other meta-processes such as globalization, individualization, and commercialization.[73] Some authors have drawn attention to the importance

of accounting for the capitalist framework within which mediatization is inscribed, and for the ways it interacts with commercialization.[74] This is an approach, Graham Murdock notes, that has too often been neglected and, given the rise of the marketization model characteristic of neoliberalism, is "like a ghost haunting recent commentaries by leading writers on mediatisation."[75] Private corporations have developed a strong hold over communication networks and the production and circulation of information, taking over systems that used to be regulated by public institutions and formerly not subject to commercial logic.[76]

Such marketization is blatant when considered in the context of digital culture. Indeed, various scholars have documented the commodification of digital and social media spaces once outside of the forces of commerce.[77] With the rise and proliferation of social media and the concurrent appropriation of such spaces by fashion brands and retailers, the link between mediatization and commercialization is consolidated. The intertwining of marketization with mediatization which shoppable magazines instantiate must be looked at in the light of brands' involvement in the creation and distribution of editorial content, a practice known as content marketing.

As with mediatization, "content" is not a new term, but like mediatization, it was redefined in the early 2000s to refer to the reconfiguration of marketing and promotional practices in the context of digital culture. Content marketing became a key business strategy. Also known as branded content and native advertising, it refers to the production of texts which, although promotional, do not appear as such and are often destined for circulation over the Internet.[78] As Patrick De Pensenmacker puts it:

> The assumption behind content marketing is that advertising is most effective when the consumer does not recognize it is advertising. Moreover, the commercial message itself cannot be skipped by the viewer, the reader, or the surfer on the Internet without losing program content, and native advertising cannot be effectively recognized by ad-blocking software. As a result, the lines between advertising and entertainment and content have become increasingly blurred.[79]

Although the hybrid editorial/commercial is not new to digital culture—in print culture it can be found in advertorials, for instance[80]—with the advent of the web and social media, it has extended to cover a broad range of platforms and texts.

"Content" encompasses a variety of (often digital and social) media products, such as, in the field of fashion, fashion films, blog posts, YouTube videos, or Instagram images. With branded content, as Daniel Bô and Matthieu Guével note, brands turn into media, making the distinction between the editorial and the commercial murky.[81] As Teresa Craner puts it in her business book *Inside Content Marketing*:

You may not know content marketing when you see it. In fact, if the content creators are doing their jobs right, you often won't notice you're being marketed to until it's too late, and you're already poking around the brand's site—or are even in a store—to purchase the product the marketers were hoping you would buy all along. To complicate matters further, content marketing often doesn't even reveal what it's selling.[82]

In turning brands and retailers into purveyors of media content seemingly distinct from commercial content, and even publishers in their own right through channels and platforms such as YouTube and blogs, branded content can be conceived as a mode of mediatization of fashion.

Content marketing aims at increasing a brand's symbolic capital, which, as Bourdieu shows, can be turned into further economic capital.[83] It is an aesthetic project that serves the interest of commerce and is part and parcel of the logic of aestheticization that informs contemporary capitalism and "the stylization of consumption."[84] This logic is tightly linked to mediatization, for, as André Jansson observes, "most kinds of consumer goods have become increasingly image-loaded, taking on meanings in relation to media texts, other commodity-signs, entire lifestyles, and so on."[85] This is why, he suggests, it is no longer possible to make a distinction between consumer culture and media culture: "they collapsed into one another."[86] In that respect, following Jansson, mediatization also entails a process of commercialization, and vice versa. Branded content is an example of the blending of mediatization and commercialization into one another.

For example, in 2017, Chanel launched, in partnership with Caroline de Maigret, the blog-like site CdMdiary.com. A print and catwalk model in the 1990s, after having somewhat disappeared from the traditional fashion media, Maigret in recent years rose again to visibility through her Tumblrs and Instagram accounts. Chanel capitalized on the model's online fame (which soon translated into print visibility too) to make her an ambassador of the brand and to promote Chanel on a site reminiscent of personal fashion blogs. Short films feature as if shot from a smartphone. They are interspersed with images of Maigret dressed in Chanel, with posts on her favorite music tracks, her dining and going out places and other snippets of information on her likes and dislikes. Although not directly shoppable, the site is branded throughout; a space made by and for Chanel. The "about" section describes it in the following terms: "CdMdiary by Caroline de Maigret was created for the purpose of sharing a lifestyle that incorporates various facets of our times narrated by Caroline de Maigret, spokesperson and ambassadress for the House."[87] Indeed narration, or storytelling as it is known in the business literature, is key to branded content and is a technique many fashion brands use. Their websites become the repository of visual and written stories that further consolidate the aura of the brand and transubstantiate it,[88] a process also supported by convergent media platforms[89]

and their hyperlinked network of Twitter, Facebook, and Snapchat channels, as well as Instagram and its visually enticing images. In this respect, one can also see the logic of entertainment which informs both the media and retail as key to commercialization in that entertainment is enacted as a way of selling more, an idea the marketing notion "retailtainment" captures. One must provide spectacle and entertainment to sell, a strategy the marketing literature on branded content also makes clear.[90]

The overlap between commercial and editorial practices branded content promotes is also articulated in the concurrent practice known in the business literature as "native journalism." Journalists are hired by companies to produce the content that will promote their services and commodities. Their role is to tell the stories—the practice known as storytelling—that will infuse brands with ever more symbolic capital accumulated through the viral sharing and liking logic of digital networks. Commenting on Marks and Spencer's hiring of fashion writer Nicola Copping to produce content for their website, the retailer's e-commerce director Laura Wade-Gery observes that editorial content can boost the site's sales by 24 percent.[91] She observes: "That's why we have put publishing and browsing at the heart of the site."[92] In this context of the mediatization of brands and retailers by way of content marketing, the roles and responsibilities of journalists changes, a change in turn indicative of the mediatization of fashion journalism and the transformation to which it is currently subject.[93]

Branded content and native journalism raise the issue of the integrity of brand and media practices,[94] and hence of the "moral and ethical consequences of mediatisation."[95] Indeed as Lundby notes: "While 'mediatization' is a non-normative concept there may be a range of normative issues involved with mediatization processes."[96] As Jonathan Hardy puts it: "It used to be that advertising and editorial were kept separate. Today, brands are burrowing into media content, eroding their own credibility and readers' trust."[97] A deception of consumers might take place compounded in the UK and the United States by a current lack of regulation of the demarcation between editorial and commercial content.[98] This is an issue fashion blogs are facing, as I discuss elsewhere.[99] Many fashion blogs and their hyperlinked Instagram accounts have become monetized platforms, with some of the most financially successful bloggers professionals who generate a large income. Brands have capitalized on bloggers' popularity to use their platforms for operations of branded content. The commercial links are not often made clear and transparency has become an object of debate.[100]

Personal fashion blogs and fashion and beauty Instagram posts can also be seen as instances of mediatization in that the media technologies bloggers and Instagramers use inform practices of the self, a mediatized self.[101] Makeup, dress, and digital technologies are appropriated to fashion and define oneself for a connected other.[102] Brands have even responded to this trend by

developing digital screen—friendly makeup products, yet another instance of the mediatization of the field of fashion.[103]

On an Instagram feed, pro-bloggers' shots may be interspersed with images from, and of, friends, who may sometimes, like a blogger, post a picture of their outfit of the day, sharing the same visual conventions while also using the popular instagram tag #ootd (for "outfit of the day"). Not only are the images not necessarily clearly presented as commercialized, but in being mixed with non-commercial posts in a wider hypertextual flow of private and public postings, the distinction between the commercial and the non-commercial becomes ever more difficult to ascertain. Hypertextuality may well erase hierarchies between online spaces, but in doing so, it also melds the commercial and the non-commercial into one another.[104] One's everyday visual landscape becomes a de-differentiated space of commodified and non-commodified images.

The blurring of the editorial and the commercial that branded content nurtures, the monetization of seemingly non-commercial spaces, and the spread of such practices across a broad range of texts and platforms that individuals engage with—all draw attention to the idea of the commodification of everyday life. This commodification is intensified by the spread of online fashion platforms and texts and the concomitant convergence of mediatization and commercialization. Commercialization weaves itself through everyday life through ordinary practices of mediatization of the self which, together with the digital mediatization of commercial practices, collapse into a de-differentiated plane of the commercial and the seemingly non-commercial.

Conclusion

This chapter has argued for the usefulness of "mediatization" to understand online fashion commerce and the digital culture it is part of. Central to mediatization theory is an analysis of the ways the media, including digital media, have transformed ways of doing and ways of seeing. In the context of fashion's rapid appropriation of digital media and related digital interfaces, it is important to unpack the changes of practices with which they are associated. This has implications for the skills needed to establish oneself as a fashion journalist, as the practice of native journalism suggests. It also has moral and ethical implications such as the rampant monetization of everyday life, to which current digital media practices in the field of fashion point. Contrary to arguments of technological determinism, new technologies are not outside of the social; they are made by and for social beings and must be subject to the same critical and analytical unpacking that informs many social sciences studies of society and culture, including fashion.

8
SUSTAINABILITY AND DIGITALIZATION

Sandy Black

"Fashion is often very old-fashioned," said Ines Haag of avant-garde design duo Bless when I interviewed her and partner Desiree Heiss in 2011 for *The Sustainable Fashion Handbook*.[1] She was particularly referring to how conventional the teaching of fashion was in colleges, where innovation should be paramount. The sentiment that fashion is old-fashioned has been repeated more often recently by influential people in fashion, including designer Stella McCartney, speaking on issues of sustainability at London College of Fashion (LCF)[2]; trend forecasting guru Lidewij Edelkoort reaffirming her 2015 *Anti-Fashion Manifesto* in London[3]; and by designer Prabal Gurung at the 2017 Copenhagen Fashion Summit of industry leaders.[4] While clearly making good journalistic copy, this sentiment also highlights the paradoxical nature of fashion—its ethos is predicated on speed and novelty, yet the industry itself has been slow to change and develop from the practices and schedules established in the mid-twentieth century, especially in relation to both sustainability and digital technologies.

Contradictions abound, particularly when the complexity of contemporary globalized fashion supply chains and issues of sustainability are factored in.[5] Fashion is the craftsmanship of couture and bespoke set against high volume cheap ("disposable") fashion; the luxury of New York's Fifth Avenue or London's Bond Street contrasted with the poverty of many producer communities; and the inherently wasteful cycles of seasonal change, that also sustain livelihoods and generate crucial income; an obsession with the new coexisting with the valorization of vintage. The rise of ubiquitous mobile phone technology has stimulated e-commerce in the fashion space.[6] The desire for faster access to fashions has fuelled recent disruptive initiatives such as the "See now, buy now" trend to monetize the catwalk by selling direct to the public, pioneered by brands such as Burberry and Tommy Hilfiger. The realization has grown within the industry that the established fashion system—based on bi-annual seasonal

designer presentations to wholesale buyers traveling the globe between the key fashion capitals—seems increasingly inappropriate in the twenty-first-century digital economy. External pressures such as natural resource depletion, escalating consumption and waste, globalized, conglomerate-led markets and financial fluctuations driven by the accelerating pace of fashion cycles, coupled with high-profile designer tragedies, resignations and turnover at luxury fashion brands, all strongly evidence that the current fashion system is unsustainable from the perspectives of environment, economy, and now, its creative leadership.

Nevertheless, the fashion industry plays a significant role in many economies around the world, including the UK. According to a 2017 fashion industry report, global apparel and footwear consumption is projected to rise by 63 percent, to 102 million tons in 2030,[7] increasing the imperative for the industry to address its vast environmental and social footprint. There is a critical need for fashion research—both academic and industrial—to take a radical lead in shaping a more economically, socially, and environmentally sustainable fashion industry based on alternative paradigms and business models that harness new ways of creating and producing fashion, and engaging with consumers through co-creation and novel experiences.

Research commissioned by the British Fashion Council (BFC) in 2009 (updated in 2016) shows the continuing economic significance of the fashion industry to the UK—valued at £28 billion to GDP, an increase from the 2009 figure of £21 billion and more than double the value of the automotive industry.[8] According to business research organization Mintel, £27 billion worth of womenswear ready-to-wear was sold in the UK in 2015, predicted to grow 23 percent by 2020 to £32 billion.[9] The UK designer fashion sector (excluding retail), which is recognized as a creative engine of inspiration and innovation for the wider UK and global industry, is comprised of a high proportion of innovative micro and small businesses.[10] These design-led businesses are capable of being highly agile, using local and novel smaller-scale production methods and practices to meet changing demand efficiently, and respond to consumer needs, but often struggle to survive.[11] With their ability to maintain control of their entire supply chain, these micro and small businesses are often pioneers, testing novel business models and design practices that also work toward full transparency in environmental and ethical practices.

Since the turn of the millennium, a dramatic shift has taken place toward a digital economy, resulting in significant disruption in many sectors of commerce including the music industry and publishing, together with the rapid development of digital visualization stimulated by the film industry and the fast-growing gaming sector. However, the fashion industry at its core deals in physical products, and excepting marketing and retail, it has been slower to take up the opportunities that the digital opens for design and manufacturing.

As Normann predicted in 2001, the digital economy has liberated us from the constraints of:

- Time: when things can be done,
- Place: where things can be done,
- Actor: who can do what (human and non-human)
- Constellation: with whom it can be done.

This new paradigm of time-place-actor-constellation has particularly affected the dissemination of fashion through imagery—now instantly available globally from live streamed catwalk presentations, and arguably more significant than the products themselves. Even before the current digital revolution, Angela McRobbie's 1998 sociological study of British fashion designers highlighted the power and significance of fashion imagery disseminated through media channels—at that time predominantly printed fashion magazines. She asks: "Is designer fashion, as the respondent suggests, really about spectacle and the production of images, a kind of service sector to the high street fashion retailers and to the wider mass media?"[12]

After a slow start, digital marketing and e-commerce have now gained significant traction in the fashion industry, overcoming the initial skepticism that consumers would not buy clothing or accessories that they could not touch, feel, and try on. Recent statistics show 68 percent of UK internet users buy clothing and footwear online, and 29 percent of total spending online is on clothing and footwear, up from 13 percent in 2011[13] and global e-commerce luxury fashion sales are predicted to increase fourfold from 3 percent in 2010 to 12 percent by 2020.[14] Many consumers now shop using multiple channels and combine physical browsing with online purchasing or vice versa. The growing acceptance of online sales platforms has led to an increasing number of initiatives to create virtual try-on systems online and in retail stores,[15] such as Fits Me.[16] Experiments with virtual reality (VR) and augmented reality (AR) consumer visualization systems are prevalent, with predictions of an important future for them as new marketing channels that can bridge the physical and digital. For example, Top Shop in London and Tommy Hilfiger in the United States staged simultaneous in-store VR presentations of their 2015 catwalk shows using immersive headsets. In 2016, London designer Martine Jarlgaard invited buyers to a virtual showroom to experience a novel mixed reality fashion presentation using holograms superimposed into the space that could be experienced in the round by wearing a headset[17] (Plate 14).

However, despite advances in presentation and marketing, many design and production aspects of the fashion industry are still comprised of fundamentally craft-based practices: designers creating garments by draping cloth on a dress stand, cutting patterns, using tailoring techniques and couture-level sewing or

embellishment. Most importantly, garments are still produced by skillful individuals using manually operated sewing machines, a practice found in factories around the globe at every market level of manufacturing, including the high volume markets. Although aspects of the design and mass production of clothing such as bulk fabric cutting and industrial knitting have been largely automated and computerized in developed countries, this is not the case in many emerging producer nations such as Vietnam or Bangladesh.

It is also not the case within the small creative enterprises comprising the majority of the UK designer fashion sector—often micro-businesses set up by designer-entrepreneurs shortly after graduating from one of the UK's many higher education fashion courses, especially those in London. In common with current UK trends, where 95 percent of all businesses are classed as micro-enterprises, the designer fashion sector consists largely of businesses with under 10 employees, many being start-ups in their first few years of trading.[18] Around 80 percent of the designer fashion businesses in Britain (estimated at 400 by Centre for Fashion Enterprise) are located in the London area because of its status as a global fashion and media city.[19] Because of the fast cycle of seasonal fashion, designers operate in an extremely time-sensitive and high-intensity system leaving little time and resources for strategic development. However, a number of innovators are developing alternative business models that harness digital technology for creative purposes in addition to marketing and e-commerce, demonstrating the potential for such businesses to be both more environmentally and economically sustainable. This chapter discusses findings from research with micro and small designer fashion enterprises, investigating their knowledge of digital technology and process innovation in the context of sustainability. It presents case studies of businesses that challenge the current paradigms, suggesting new models for future fashion.

Digital fashion and the fashion designer in the UK

The UK is renowned for its creative industries, first defined in a 1998 government report from the Department of Culture Media and Sport (DCMS), and including designer fashion as an identified sector alongside product design, graphic design, and architecture. Based on categories used by Mintel, a later updated report in 2001 identified designer fashion as including four areas: (a) couture; (b) international brand designated by a single name; (c) diffusion–collaboration with high street retailers; and (d) high fashion—up and coming, usually endorsed by celebrities.[20] The report also identified the UK fashion sector as highly populated by small businesses, in contrast to the United States, France, and Italy. In a

2003 report to the UK Department of Trade and Industry, Malcolm Newbury defined the designer fashion sector as comprising "individuals or teams that combine creativity and originality to create collections that have a specific or 'signature' identity and are exemplified by businesses that participate in international trade shows such as London Fashion Week."[21]

This is still the dominant model of wholesale trading that many designer fashion enterprises operate today, but which is beginning to see serious disruption. A 2008 report by the Centre for Fashion Enterprise (CFE) *The UK Designer Fashion Economy* identified a typology of business operations in the designer fashion sector from micro to SMEs, and mapped a range of business relationships, from the individual artisan or creative partnership to designers with licensing, manufacturing, or investor partnerships. I offer here an alternative definition of designer fashion enterprises as foregrounding innovation, creating impact through innovative forms, fabrication techniques or methods of engagement with users, and sometimes creating radical conceptual fashion that disrupts the established codes and norms.

Much of the attention to digital economy developments in the fashion industry has focused on emerging paradigm-shifting advances in marketing and retail, including virtual and augmented reality presentations, mentioned above.[22] At the same time, awareness and acceptance of 3D printing technology has grown exponentially as it transferred from the engineering and product design sectors to mainstream consumer markets via strong media promotion. In tandem, the FabLabs (fabrication laboratories) and maker spaces movement originating at Massachusetts Institute of Technology (MIT) in the United States in 2001 have developed to support communities and small-scale designers to gain access to a range of digital processes for product design. These include 3D printing, laser cutting, and CNC milling, enabling product prototyping and small batch production. In contrast, resources available for fashion designers largely consist of sewing machines and tailor's body forms, with some access to programmable industrial textile facilities (weaving, printing, knitting, and embroidery) within arts universities and large companies, where proprietary computer-aided design (CAD) software and systems for design visualization, pattern preparation, or lay planning require significant budgets to install.

In order to improve knowledge of the needs of small-scale entrepreneurial fashion design businesses, we developed research at the London College of Fashion (LCF), University of the Arts London, focusing on increasing understanding of the perceptions and practices of fashion designers and their innovation processes. This was done by working directly with designer businesses to catalyze knowledge exchange. Before entering education, I was designer and director of my own namesake knitwear brand, a small business selling internationally via the fashion circuit of wholesale trade shows in London, Milan, New York, and Tokyo. It is pertinent to note that although technology

and communications have changed dramatically in the intervening decades, the issues of survival facing a small fashion business have not. These include financing the production of experimental prototypes, sample collections, trade fairs, marketing, and bulk production—all months in advance of any income being received. Moreover, gaining access to key technical resources could be difficult as a very small player competing for the same manufacturing resources as larger fashion and retail businesses.

Experimenting with applications of technology developments in the context of sustainable production and consumption, our project Considerate Design for Personalized Fashion examined the use of body scanning technology and 3D printing for personalized product development processes, including seamless industrial knitwear, a 3D printed flexible glove form and bespoke ergonomically shaped handcrafted bags.[23] The aim was to create products that engage and delight the consumer for longer through personalization utilizing novel processes.

In the knowledge exchange project FIREup (Fashion, Innovation, Research, and Enterprise), we took an action research approach to support innovation in product development and communication, by pairing fashion academics and researchers with London-based designer fashion businesses over a six-month period.[24] FIREup funded four small catalyst projects, two of which involved the use of digital technologies for product development and potential production, discussed here. The first project worked with accessories designer and maker Michelle Lowe-Holder, a micro-business operating since 2010, to introduce her to 3D printing technology and computer-based digital design, in contrast to her usual craft- and materials-based approach. Working in collaboration with 3D virtual fashion researcher Thomas Makryniotis, she was able to develop prototypes for a clutch bag design, and went on to develop further prototypes independently with a London 3D printing bureau. Lowe-Holder's aim was to use 3D printing to create structures that could not easily be realized in small numbers by traditional methods of metal forming, then work with these as a modular base for a range of designs. Lowe-Holder's perception of this computer-based design and production process was that "3D print has to be looked at as a modern process to help bring about small scale design possibilities creating samples previously not possible economically for a small designer like myself."[25] The second catalyst project involved upcycling pioneers Worn Again and academic researcher Kate Goldsworthy. It developed new prototypes for Goldsworthy's ongoing Laserline project, working with polyester textiles and zero-waste garment design, combining laser welding of seams and laser surface decoration techniques. This one-step garment creation process has potential for reduction of resources and waste, by using a polyester fiber that can play a key role in circular systems of material use within the appropriate system infrastructure.[26] A collaborative research process of experimental testing of new concepts had

significant benefits to all involved. For example, Worn Again commented, "there is now a proof of concept with tangible samples to take the conversation with industry to the next level."[27] These two catalyst projects, although small in scale, demonstrated the potential of digital processes within a fashion design and production context to create a new workflow and innovative product development with sustainability gains.

What's digital about fashion design? Mapping the landscape

Results from the FIREup project, including a survey of 56 fashion enterprises, found that there was little understanding of university-level research, or the potential benefits of collaboration. There was also little sense of moving research beyond the inspiration and sourcing of ideas for the next collection. These findings stimulated a further project specifically focused on the affect and integration of digital technology into designers' creative and studio processes, as opposed to retail and consumer facing applications. In collaboration with research consultancy AAM Associates, the FIRE team at London College of Fashion devised a project aiming to explore how technology was (or was not) being used within the designer fashion community.[28] Although, as discussed earlier, new sales channels have disrupted and changed other sectors, and despite more clothing being sold online, designer fashion businesses are still working mainly to a wholesale model of sales and production. We wanted to identify if and how traditional fashion design is being transformed by digital technology, and to see how willing designers are to adopt new digital methods and models. The first task was desk research to map current and emerging digital technologies onto the fashion design and production cycle. Key stages of the fashion cycle were identified as:

- Design inspiration and concept development
- Prototyping and sample product development
- Sales (wholesale and business to business)
- Bulk production and delivery to retailers
- Retail sales and promotion through stores and/or online
- Bespoke and customized sales direct to consumer.

These stages are not discrete, as design for the next collection will overlap with production and delivery of the previous one, creating pressures on resources—both financial and human (Figure 8.1).

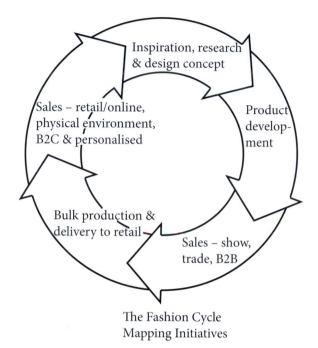

Inspiration, research
& design concept

Sales – retail/online,
physical environment,
B2C & personalised

Product
develop-
ment

Bulk production &
delivery to retail

Sales – show,
trade, B2B

The Fashion Cycle
Mapping Initiatives

Figure 8.1 Diagram showing stages of the fashion cycle. Source: FIRE project team

As expected, although few independent designer fashion businesses had set up transactional websites for direct to consumer sales, research showed a far greater number of digital technologies and systems on offer at the consumer-facing marketing and retail stages than others, working across both physical and online retail contexts.[29] These include combinations such as the so-called magic mirror visualization systems of augmented reality in stores where clothes and cosmetics can be tried on virtually. Since the concept of mass customization was first posited in the 1990s,[30] "aiming to produce goods and services catering to individual customers' needs with near mass production efficiency,"[31] personalization and customization of goods have been something of a holy grail in retail sales.[32] Accurate garment fit and sizing is another major retail issue, and technologies such as body scanning and foot scanning systems that produce accurate 3D body images have the potential to enable individually sized garments to be created in a personalized service. However, despite early retail efforts by the company Bodymetrics (a spin-out from the 2004 UK Sizing Survey[33]), to provide bespoke designer jeans with Selfridges and Harrods stores in London and later Bloomingdales in the United States, body scanning technologies have yet to be

seamlessly integrated into the retail shopping experience. This is in part due to sensitivity to the accurate results of bodyscanning technology.[34] Alternatively, virtual try-on systems comprising interactive mirrors that capture and reflect a customer's image and overlay it with specific garments the customer browses can express rewarding body images, and link to social networks for fun shopping experiences.

In contrast to these consumer-facing marketing and social shopping approaches, the technologies most relevant to the fashion design and product development process include: digital printing and embroidery onto 2D surfaces, laser cutting and welding, 3D printing, and 2D and 3D simulation and visualization of clothing designs (with some systems such as Marvelous Designer and Optitex using virtual stitching techniques, see Makryniotis [2015] for detailed explanations). Digital printing of imagery onto fabric has already enabled a new paradigm in printed fabrics freeing up the scope for complexity of colors and imagery, scale and non-repeating placement of pattern and design. Fashion designers whose work is highly distinctive in their use of digitally printed textiles include Mary Kantranzou, Alexander McQueen, and Dries Van Noten. However, 3D printing has received the widest media coverage, as desktop 3D printers (e.g., Makerbot) have become available and online bureaux such as Shapeways offer 3D printing services to anyone. In fashion terms, key designers, such as Iris Van Herpen, Francis Bitonti, and, more recently, Noa Raviv, have taken a creative lead in the conceptual development of wearable 3D printed showpiece garments, working with architects and 3D computer design experts, inspiring many others. Much of the output of 3D printing uses rigid nylon materials. The challenge taken up by pioneers Freedom of Creation and university research groups has been to create a flexible textile-like surface from modular interlocking elements. Recently, the Modeclix project has prototyped 3D printed dresses from similar structures, moving research a step closer to the goal of comfortable and wearable 3D printed clothing.[35]

Scanning the horizon for digital systems that will affect fashion, much research is ongoing into wearable technology including electronic textiles or e-textiles. Since the beginnings of wearable computing in the 1980s when Steve Mann and others at MIT first experimented with distributed computing functions around the body, there has been an exponential rise in new developments in what is now termed fashion technology or "fashtech."[36] The prospects for this field, in which clothing becomes smarter and responsive to external stimuli, capable of monitoring vital signs, emotions, location, well-being, and keeping us entertained—perhaps also changing color and form at will—is widely regarded as the biggest opportunity for clothing. That is, once all the component elements have become truly compatible. Much has still to be developed but research has moved forward strongly in the last fifteen years.[37]

Electronic textiles that can respond to pressure, or conduct heat, have been developed and mass produced by pioneers such as Asha Peta Thomson (a weaver) and Stan Swallow (an engineer) of Intelligent Textiles. Founded in 2002, they now work exclusively for military research. Since 2015, Google has invested to scale-up research into electronic functional textiles with their Jacquard project, which at the time of writing this chapter awaits the release of its first commercial product—a Levi's denim jacket that can help take calls and messages on the move. A novel approach to e-textiles is taken by research in the Functional Electronic Textile Technology project at Nottingham Trent and Southampton Universities that embeds miniaturized semiconductors and LEDs directly into the structure of yarns for weaving and knitting.[38] These initiatives will undoubtedly lead to novel garment applications for both therapeutic and general fashion use.

On the fashion and entertainment side of the industry, Cute Circuit (fashion designer Francesca Rosella and interaction designer Ryan Genz) developed their own fabric technology and hardware components to create large LED arrays displaying color imagery across clothing. This pioneering company created its novel Hug Shirt concept in 2005, a shirt that could transmit the electrical sensation of a hug to a loved one from afar. They later developed the first interactive dress that could display live messages via Twitter. In 2014, Cute Circuit repositioned their offer to launch a couture line of stylish garments with LED panels displaying moving imagery controllable by the wearer (Plate 15), and have recently released a dress incorporating a graphene-enhanced stretch sensor that captures the wearer's breathing pattern.

Further promotional projects for the catwalk, brokered by the Fashion Innovation Agency at LCF, are milestones in communication of fashion technology. These include a "digital skirt" commissioned for London Fashion Week February 2014 by Nokia, in collaboration with fashion designer Fyodor Golan and interaction designers Kin Studio. This used Nokia mobile phone technology in a literal but eye-catching way for the catwalk—ironically the very opposite of a truly wearable fashion technology garment (Plate 16). At the other end of the spectrum, a dress project shown in London the following season—a collaboration between Disney and late designer Richard Nicoll—created a magical fashion experience using light optic fibers, realized in collaboration with another early pioneer of wearable technology Studio XO, founded by Nancy Tilbury and Ben Males (Plate 17). Their knowledge base also combines fashion, textiles, and computing skills. Studio XO have created showpieces for entertainers including Lady Gaga. Tilbury and her team are now setting up a platform for connected devices that will emotionally engage entire music audiences in a digitally enabled experience. With the emerging Internet of Things, where devices in the environment and the home are wired, connected, and accessible to our smartphones, Mark Weiser's prophetic vision of ubiquitous computing seems about to come true: "The most

profound technologies are those that disappear. They weave themselves into the fabric of everyday life until they are indistinguishable from it."[39]

It is clear from the above examples that the integration of digital technologies in diverse ways is profoundly changing the fashion industry. However, a key issue to be resolved in the development of all new categories of wearable technology and functionalized electronic clothing is the simultaneous and seemingly unwitting creation of a new waste stream of inseparable electronic and textile components. These new products of the future must be designed for disassembly from the outset to address the considerable issues of sustainability in both the electronics and fashion industry. Cute Circuit, for example, have designed their LED display panels and controllers as modules for disassembly, but these are issues which need to be widely addressed in this burgeoning industry, alongside user need, privacy from potential surveillance and monitoring and user's control of personal data. To this end, a collaborative EU-funded project WEAR Sustain has recently been set up to encourage sustainable innovation in wearable technology through experimental prototyping.[40]

What's digital about fashion design? Insights from an industry/academic workshop

To interrogate the question "What's Digital about Fashion Design?" we convened a workshop with twenty-two established fashion designers, industry representatives, and academics to discuss how the fashion industry currently operates within the digital economy.[41] The purpose was to identify where opportunities for innovation in both product and business development lay, and three themes were established. A comment from one participant reinforced the slow changing ethos of the fashion industry: "The fashion industry likes how it works, it has an entrenched way of operating—the seasonality is very difficult to change."[42]

The first theme to emerge was the *Challenge to Tradition*. In scrutinizing the traditional fashion design cycle, we questioned how the transition from wholesale to direct to consumer retail is impacting fashion design. It was agreed that while digital activity is mainly focused on sales, there is an unexplored opportunity to introduce digital technologies in the earlier stages of the design process, which could have the potential to transform both a designer's practice and business. The group acknowledged that while it was important to challenge fashion traditions, nobody wanted to see digital entirely replacing craft methodologies, rather it could be integrated in a way that would enhance a designer's practice and raison d'être: "Digital technology obviously isn't going to be a replacement

for craft-based design practices, it should be more about how it can enhance what I want to achieve."[43]

The second theme, *Digital and the Design Process*, challenged the potential of digital interventions to help save time and costs in day-to-day processes. It is a given that fashion designers are time-poor, working at a fast pace, and on a tight budget—concerns strongly shared by workshop participants. Conversations explored how designers could potentially invest more time and money into creative research and development processes if physical overhead costs were cut and replaced with digital services. The idea of removing the physical store was just one proposed solution, and by all means not for everyone. However, by removing the high cost of company stores, designers would be able to embark on new journeys and perhaps bring in new team members such as consultants and software developers. Replacing the physical with digital would have an effect on budgets and free up spending for embedding digital into day-to-day operations. The thought of this seemed plausible and exciting to several participants: "We need to collaborate and open research—that is the only way things will change and [fashion] designers will start to define their place in the digital economy."[44]

The group discussed how more collaborations between fashion, technology, and manufacturing are needed to integrate technology successfully into both design and production processes. Participants speculated about more of a start-up culture in fashion, borrowing working practices from the entrepreneurial technology industry who, unlike fashion designers, are not wedded to the traditional fashion design cycle, and who are seen to be driving the development of new revenue models. Fashion designers often think of themselves as a one-man band, whereas tech startups form functional cross-disciplinary teams, and are more entrepreneurial in seeking funding—a major cultural difference. The potential to house designers and technology start-ups in the same building, in incubator spaces such as Makerversity in London, might organically spark these types of collaborations and knowledge sharing.

Developing New Models was the third theme. By the end of the workshop, participants considered that fashion designers were critically well-placed, with their specialist knowledge and understanding of design, to help shape developments in digital technology. There was a shared cautiousness about adopting digital business operations as there is a lack of available technology in fashion environments to support the transformation. Skepticism remained as to what extent digital engagement could be integrated into the entire product development lifecycle within the present fast-paced business and protracted cash flow models. Although digital was felt to be important, "Not many designers are able to invest time, energy and money in understanding what digital services would work for them. They're too busy getting ready for the next season!"[45]

This workshop made a contribution to understanding the potential for digital technologies in fashion design, breaking down the barriers and exploring

opportunities for new models of practice in this period of significant growth in the digital economy. With the rapid growth of business-to-business trade fairs such as Decoded Fashion taking place in international fashion capitals, and many other meet-ups and events focused on wearable and digital technology, the fashion industry is now moving quickly into the digital space.[46] Indeed, in 2016, the Centre for Fashion Enterprise started a three-year EU-funded initiative, to help establish fashion and technology start-up businesses. Digitization will continue to play an increasingly important part of daily life, and the workshop showed that the SME designer community is open to using technology to serve both the design process and the product and business model development. But it is in need of collaborative support to achieve this change.

Case studies of new business models

As the workshop illustrated, practices with small design-led fashion companies come from a conservative place, possibly based on previous education, which has been slow to evolve, both in terms of digital technology and in terms of sustainability. Perhaps fashion and design businesses can learn from the start-up culture of technology businesses. Two London-based start-ups are discussed below to exemplify new types of business models with digital processes at the heart of their development that potentially disrupt existing business paradigms. Both have clear sustainability benefits compared to existing business models.

UNMADE: customized knitwear

Unmade is an award-winning start-up design company, founded in 2013, that in their own words set out to "revolutionize the fashion industry."[47] Working with the concept of fashion on demand, the company has harnessed the fundamental digital programmable capacity of industrial knitting machines to enable the creation of exclusive one-off knitwear pieces, at a unit cost similar to mass manufactured premium quality knitwear. Unmade have created an impressive interactive touch screen interface allowing anyone to customize a sweater design and then have it knitted as a unique piece. The customer manipulates a realistic visualization of the garment's patterns and color palette to create variations of placement, colors, and scale, of any available pattern design. Having effectively "hacked" the proprietary programming system and written their own software to directly command Stoll industrial knitting machines, Unmade has bypassed the expert programmer role to effortlessly enable designs to be created online by anyone and sent direct to the machine. The sweaters are knitted in the standard industrial manner using jacquard structures in fully fashioned (shaped) pieces,

but one-off knitted garments can be made for the same cost and speed as mass production, which is in effect mass customization for graphic patterned sweaters.[48]

Unmade was founded by three partners, interaction designer Ben Alun-Jones, fashion knitwear designer Kirsty Emery, and former mechanical engineer Hal Watts, who all met at London's Royal College of Art. Their complementary expertise and new business model, focused on customer experience and digital technology, soon attracted venture capital. The company quickly grew to include software designers and developers working in the same space as people who made up the sweaters. Unmade is so called because each piece is unmade until the customer is involved. No stock is held. Their system—and the revolution they refer to—is that only goods that have been pre-ordered are produced, so overproduction is avoided together with the consequent wasted stock, an endemic issue in the fashion industry.

An Unmade pop-up store, complete with knitting machine, featured in the Selfridges London *Bright Young Things* installation in spring 2016, showing emerging businesses with a sustainability ethos. The speed of knitting technology—about 90 minutes to knit a sweater—meant that customers could see their piece being made, creating a direct link to the process of manufacturing their personalized design. While researchers and industry players, for example Larsson and colleagues in Sweden[49] and Shima Seiki industrial knitting machine builders in Japan, have previously investigated knit-on-demand services, Unmade have achieved this long-term aim of moving from mass production to mass customization. Initially, Unmade produced the knitwear themselves in their own London studio in collaboration with fashion designers such as Christopher Raeburn, each of whom created distinctive graphic patterns. Unmade now classify themselves as a software design company, shifting their goals from customer service as a brand to providing their technology platform for much larger collaborative projects with industrial manufacturers.

In the first realization of this goal, a three-way collaboration launched in November 2016 with cult brand Opening Ceremony, major e-commerce platform Farfetch, and traditional knitwear manufacturers Johnston of Elgin, created a limited edition collection of knitwear pieces available to a much wider audience. By integrating the Unmade technology platform with a scaled-up production process and embedding its online retail interface in an existing portal, anyone can order their customized sweater online and receive it within three weeks (Figure 8.2). By aligning their service with the digital disruption of 3D printing, Unmade have caught the imagination of the industry and the public—despite industrial knitting having been digital and fully programmable for decades. This has led to some confusion with journalists referring to 3D printing or print-knitting a sweater—Unmade's knitwear is neither 3D printed nor 3D knitted.[50] There are currently some limitations such as limited sizing and styles available, and the focus

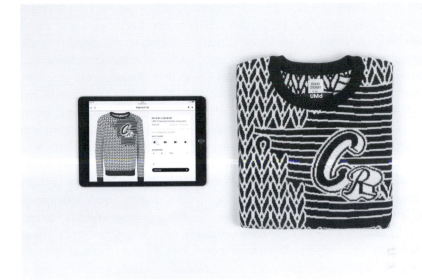

Figure 8.2 Unmade online interactive e-commerce site in collaboration with Farfetch and customizable knitwear designs by Opening Ceremony

on graphic jacquard patterns only—although an interesting elliptical sweater has been devised—however Unmade have their sights on other techniques for customizations including stitch structures which is far more challenging. They also have ambitious plans to revolutionize other digital production areas including customizing digital print and embroidery processes—a revolution indeed.

MIXIMALISTE.COM – 3D fashion visualization and zero prototyping

A perhaps even more experimental start-up company is Change of Paradigm—an ambitious name for an ambitious project. This is a business start-up that designs, develops, manufactures, and distributes luxury fashion capsule collections through its own online e-commerce platform with an entirely new business model for the creation and selling of fashion virtually. This is based on zero prototyping—that is, no actual sample garments are made but virtual patterns and photo-realistic simulations are created as 3D models using a suite of 3D CAD software packages to develop highly sophisticated renderings of designer fashion styles.

After three years of development and successfully seeking investment, the platform was launched in October 2016 under the new brand name MIXIMALISTE. A series of exclusive capsule collections are designed and developed in collaboration with well-recognized London-based independent fashion designers such as Boudicca, Fyodor Golan, and Teatum Jones, which are made available on their e-commerce platform MIXIMALISTE.COM for a limited period of three weeks.[51] All the fashion outfits are displayed as 3D simulations on 3D mannequins using sophisticated software (Plate 18). By collaborating with recognized independent fashion designers, collections with identifiable signature style are created using the designers' own fabrics, which physically exist and are realistically rendered. From a hand-drawn sketch, the fashion designer and the company's 3D specialist, together with the creative director, work together to develop the virtual patterns from the designs—using CAD programmes including Marvelous Designer and/or Clo3D (for more detail, see Makryniotis 2015). These pattern pieces are then virtually stitched together in 3D and rendered onto 3D mannequins. Significantly, the outfits are shown highly realistically not only in static form (back, front and side views) but also as moving garments in a video sequence changing in 3D display between front and side views, illustrating how a customer might actually wear the piece and how the fabric looks, moves, and drapes around the body.

It is worth reiterating that there is no physical garment, pattern, model, or even photograph in this system: all is virtual computer-generated imagery and data, only the fabrics are real, based on scanned information. The innovative online visualizations are super-realistic with much attention clearly having been paid to creating lifelike fabric and body movements working together. Like Unmade, the designs are available for pre-order—nothing is made until ordered and a 50 percent deposit paid. Unusually, only one designer is featured at a time, within a visual setting developed as part of the creative collaboration between the designer and MIXIMALISTE's 3D virtual design team.

CEO Henri Mura says, "MIXIMALISTE goals are to enhance the entertainment value of online shopping for fashion and to promote a sustainable pre-order business model where cost savings are passed on to customers."[52] Pricing operates on a direct to consumer basis, passing reductions in overhead and prototyping costs onto the customer, based on an even split between the parties: MIXIMALISTE, the designer, and the manufacturing costs. This they claim offers a competitive half-price premium compared with a normal retail price markup structure of at least 300 percent. Mura elaborates: "The idea is to offer women an alternative to both fast fashion, which is often made with low quality materials, and can be unethically sourced, and luxury fashion with its premium price. We enable a fashion connoisseur a new entry level to designers they love."[53]

Although, at the time of writing, only a small number of outfits have been sold, MIXIMALISTE.COM is open for business—albeit in its beta-testing phase. The brand's journey is only part way through toward developing a fully commercial business offer and the company has plans, currently in development, to make the experience truly interactive in 3D. Soon to be launched are three different technological systems. In the first, customers can visit a virtual showroom space, using VR headsets to visualize the pieces and walk around (virtual) mannequins in full 360 degrees. The second uses augmented reality applications on mobile devices to interact in the real world with the virtual collections, including customers' own living rooms. The third application will use holographic technology in which a 3D representation of the modeled outfit will literally "come out of the screen." This level of 3D sophistication has already required several technology challenges to be solved including complex cloth physics (with multiple layers of cloth/body interactions), and integration with games engines to allow real-time interaction, rendering of high quality textures, and delivery of video streams in real-time (or quasi real-time) to multiple users.

MIXIMALISTE are clearly pioneers in a field which anticipates the time when the paradigm really does shift from 2D experiences of shopping online to a stage when 3D digital experiences become an everyday matter, including having 3D cameras on mobile phones as standard. As Mura says, "combining online fashion shopping with a new user experience" creates interactivity by merging digital simulation with our real world experience for a mixed reality.[54] He envisages a mixed business model where brands might offer a 3D online experience with their standard collections, together with the new preorder model for exclusive ranges.[55] Of course, the crucial commercial aim is to convert this experience to purchases, which still remains to be tested.

Conclusions

Both case studies discussed here work with a new paradigm—changing the fashion business model from Design/Make/Sell to Design/Sell/Make. This is more radical than it may seem, requiring a flexible infrastructure to be able to work with fulfilling individual orders efficiently on a modular basis, but at similar cost to traditional bulk production methods. Both Unmade and MIXIMALISTE.COM businesses have harnessed the digital systems available and developed new digital processes to connect with the customer from an initial online engagement and experience through to communication of production information (knitting sequence and machine instructions for Unmade and garment pattern and sizing information for MIXIMALISTE.COM).

There is widespread recognition that fashion, as we currently know it, is in a state of flux, undergoing a process of fundamental change—the "end of fashion" referred to in the title of this volume. The question remains, how can fashion businesses thrive while aiming to reconcile the complexity of commercial, creative, environmental, and social issues in our global connected and increasingly digital economy? There is greater acceptance of and expectations for digital technology to pervade all aspects of everyday life beyond communications into services and experiences but urgent consideration must be given to the overuse and depletion of natural resources including water and the rare earth metals essential to the manufacturing and operation of electronic devices. It is imperative to align these technological advances with design for sustainability thinking, requiring whole life cycle design and circular material flows for both biological and technical systems.[56]

Developing new business models for fashion to reduce consumption but increase delight by harnessing the benefits of digital technologies could be a significant contributor to a sustainable future, including for developing countries that have deftly bypassed the need for fixed based technologies, going straight to mobile platforms, an infrastructure enabling full access to globalized online systems.

Mass customization has long been a goal of large-scale businesses, and apart from the bespoke tailoring and dressmaking services still widespread in several countries, especially in Asia, digital technologies, interfaces, and capabilities appear to be finally synchronizing to realize this personalization ambition for a wide community, now fuelled by small, agile, and innovative businesses. Sportswear brands such as Nike have been at the forefront of development of mass customization with their NikeID platform for personalizing trainers, launched in 2006. More initiatives are taking place: early in 2017, Adidas opened a pop-up shop Knit for You in Berlin testing a customization platform with a small range of 3D (seamless) knitted sweaters. Similarly in Boston, Ministry of Supply launched a knit on demand store with a single seamless 3D knitted jacket. With the arrival of Amazon selling strongly in the fashion space, no doubt there will be acceleration of innovation and competition to create and maintain customers.

The workshop discussed above focused specifically on fashion designers' attitudes and requirements, and questioned to what extent digital engagement could be integrated into the entire fashion product development cycle, highlighting issues within the present business and cash flow models. Fashion designers could be in a position, with their specialist knowledge and understanding of design and its cultural as well as economic significance, to help shape developments in digital technology, especially the burgeoning wearable technology market and its relationship to the Internet of Things and to the human experience. There remain further research opportunities to interrogate how the traditional model of

fashion design is and can be transformed by digital technology, and to support the SME designer fashion community to adopt new models of engagement with manufacturers, wholesalers, retailers, and consumers that can underscore the crucial sustainability agenda. Revisiting the observations of Sarah Scatturo from 2008, the following still resonates: "If selectively and rationally embraced, technology can continue to serve the sustainable and ethical requirements of modern society, enabling ever sophisticated methods of clothing creation, consumption, and disposal."[57]

Acknowledgments

The FIRE team, led by Sandy Black with partner AAM Associates, were funded for the project What's Digital about Fashion Design? by Research Councils UK, under the scheme NEMODE Network+ (New Economic Models for the Digital Economy) in 2015. Thanks are due to Mary Jane Edwards and Andy Hamflett of AAM and Gabrielle Miller at London College of Fashion for their valued collaboration and contributions.

9
GLOBALIZATION

Jennifer Craik

Introduction

It might seem paradoxical to argue that national fashion cultures have benefited from global fashion given the major disruptions to traditional business models within the fashion industry. Significant changes include the decline of manufacturing in many fashion cities, nations, and areas; the disappearance of many established national/local designers, brands, and retailers nationally and globally; a massive increase in the number of fashion design, fashion communication, and fashion merchandising tertiary programs and graduates; an increasing rate of turnover of new, emerging fashion designers, labels, and brands; and steadily growing links with other creative industries, cultural clusters, and design-related enterprises. With such major changes, how is this affecting national and local fashion industries? Central to understanding and responding to this new environment is the need to re-vision fashion as a cultural and symbolic value-adding component integral to post-industrial restructuring, and re-positioning it as a much broader and more significant role than as an industry that makes and sells apparel.

While national fashion may often not be a profitable or viable industry, de-centered and not-so-global fashion cultures "have had a marked influence on national images and place-branding strategies" as a symbolic industry.[1] Rather than focusing on the classic fashion capitals of Paris, London, New York, and Milan, fashion commentators need to shift their focus to second tier—or what have been called "not-so-global" and "polycentric" cities, nations and places—and conceptualize them as dispersed nodes with new and distinctive potential as fashion cultures and alternative fashion industries.

Part I. The wicked problem V lived experience of fashion

The fashion industry has attracted the epithet of constituting a wicked problem due to the contradictory and multiple forces that shape its complex and diverse characteristics. The rise of fast fashion has added another level of complexity as global fashion brands have come to dominate the fashion industry and offer universal availability that has radically shifted and shaped consumption habits. But as the fast fashion industry reached maturation, what are the implications for fashion in the future? Do the negative aspects and effects of global fashion outweigh the positives? Is the advent of digital marketing, consumption, and taste formation increasing or decreasing individual consumer choice and reinforcing fashion trends or creating alternative fashion systems?

A particular feature of the contemporary fashion system is the multiplication of cities and places that market themselves as fashion capitals and are increasingly challenging the status of first-tier fashion capitals as second-, third-, and even fourth-tier entrants crowd the field of fashion capitals.[2] Contenders include Tokyo, Berlin, Madrid, Dubai, and Shanghai although many other cities compete for the fashion city tag as the center of fashion shifts away from Western Europe and North America to Asia, Eastern Europe, South America, and Middle East/Africa. New and emerging fashion capitals include Beijing, Mumbai, Singapore, Moscow, Stockholm, Reykjavik, São Paulo, Buenos Aires, Rio de Janeiro, Abu Dhabi, Dakar, and Beirut. These and many other cities are staging fashion weeks which are attracting attention away from the iconic fashion capitals in a bid to establish their reputation as fashion forward, ultra modern and as offering enviable cosmopolitan lifestyles. These "peripheral" fashion cities are increasingly seen as developing alternative and edgy fashion sensibilities.[3]

At the same time, there are a growing number of commentaries lamenting "the end of fashion" and the scourge of fast fashion.[4] Amid the gloom, the number of careers in fashion-related communications, styling, commentary, retailing, and so on is expanding as expenditure on apparel continues to grow, fashion outlets migrate to new sites and cultural precincts, e-tailing and omni-tailing continue to transform marketing and selling, and the number of new entrants to the industry continues to grow. Supporters of the fashion industry argue that these trends show that fashion is alive and well as the most significant of cultural industries and visible symbol of the vitality of place. In this scenario, there is enormous potential for fashion to stand for and transform city life globally. To this end, fashion cities and fashion weeks have been described as a "travelling discourse that mobilises people and organizations in different countries."[5] However, there is a tension between the fragility of local fashion industries and the vibrancy of fashion and allied creative and design cultures.[6]

Part II. How do we position "national" and "local" fashion identity in discourses of fashion inspiration?

Paradoxically, despite the domination of global fashion trends and undermining of local holistic (that is, from design to manufacturing) fashion industries, increasing numbers of cities and regions are defining themselves through their fashion cultures. "Not-so-global" fashion cities[7] have been called "islands of identity,"[8] reflecting their peripheral status that has enabled cities like Cork in Ireland to project an identity of difference through fashion distinctiveness. Here the driver is the adaptation and appropriation of international styles which are "interpreted and re-interpreted in a local context" rather than merely copying with minor modifications called "knock-offs."[9] As a result, there has been the growth of selling identity through fashion, as, for example, has happened in the case of Italian-designed, made and marketed fashion that is branded as embodying the spirit of Italy or what Alice Dallabona calls "Italianicity."[10] Italian fashion shares a tradition for both couture, as well as more accessible and cheaper lines, and popular brands that are fused in the label of Italianicity.[11] The positive resonances of the "made in Italy" label includes the success of the town of Prato which is synonymous with manufacturing fast fashion that is made in Italy by Chinese migrant workers.[12]

By contrast, Scandinavian fashion (primarily represented by the fashion cultures of Denmark, Norway and Sweden) has experienced a shift from design nations (hooked on modernist aesthetics and social progress) to fashion nations (projecting dynamic and shifting national identities to an international audience).[13] Yet, a deeper examination of Swedish fashion indicates that the idea of place-making a brand as Swedish depends on mythologies of Swedishness that can be leveraged in different ways that appeal to different markets, namely, provincial (Resteröds Trikä, Sandqvist), pseudo international (Lexington, Hampton Republic), national (Eton, Tiger of Sweden, Hasbeens) or cosmopolitan (H&M, Acne, Nudie Jeans).[14] While Swedishness might seem cool to international markets, Swedes seek coolness elsewhere, for example, the brand Lexington Clothing Co. promotes an American New England profile.[15] National identity in fashion brands is, then, based on circulating mythologies about place, heritage, tradition, and nationalist stereotypes. Even the largest Norwegian brand on the international market, Moods of Norway, is another example of a marketing paradox. Promoting itself as a naïve label based on iconic and humorous images of Norwegian-ness, it is aimed at an international market that is undifferentiated beyond constituting "happy clothes for happy people." Its signature is a bright pink tractor that symbolizes the rural traditions of Norway and is a simple yet unmistakable logo on its smart casual diverse range of clothes. After a decade of success and growth, the company got into trouble by too fast global expansion and exposés of lack of supply chain transparency.[16] These examples show that

branding national identity is a diverse and contradictory project especially amid international awareness of issues of corporate social responsibility.[17]

Whereas "Scandi" fashion is often seen internationally as a unified and coherent fashion embodiment of regional characteristics, the fashion cultures of Belgium and Holland are regarded as different.[18] Belgian fashion, typified by the "Antwerp 6" who trained at the Royal Academy in Antwerp, is touted as developing fashion as part of its re-invention as a culture city with cultural industries along with regional (Flemish) promotional identity compared with Dutch inspiration, as Lise Skov (2011) observed. Across the board, fashion designers draw on a wide range of visual and tactile sources of inspiration as well as references to the local characteristics and symbolism.[19] Local inspirations include popular cultural motifs (such as folk culture or national culture), cultural heritage and crafts, local places and landmarks, and key events in history. However, they are keen to avoid "cultural stereotypes by making sure their version of the local [is] not obvious" but rather "an eclectic mix 'n' match" that implies cosmopolitan cultural sophistication.[20] Exploring sources of fashion inspiration, Alice Payne (2016) found that Australian fast fashion designers are primarily influenced by international trends with 75 percent citing the following sources: online sources (trend sites, blogs, key designers, etc.); travel experiences especially overseas and to exotic places; and the trends and fads of well-known celebrities. Local cultural inspirations such as their target consumers, magazines, and new products found at markets, popular music, art and aesthetic trends, vintage fashion, and successful designs of previous collections accounted for a minority of inspirations. This suggests that, even when local brands are competing with fast fashion incursions into their market share, they are following global trends (found on sites like WGSN, Instagram, and influencer posts), rather than maximizing "local" inspirations and distinctiveness.[21]

Part 3. Strategies for local and national fashion

The challenge facing local and national designers, labels, and industries is how best to maximize their distinctiveness in the increasingly global marketplace. In this section, five strategies are proposed.

Selling takes time: As important as design and manufacturing is attention to, and tweaking of, techniques of selling

One of the identified failures of local fashion is the assumption that once product is made, buyers will come, yet the crucial challenge for local fashion retail models

is creating and nurturing a client base that knows a brand, is attracted to it and its values, and identifies with the brand as fitting with a consumer's image and lifestyle. This is often referred to as the designer's muse, target consumer, ideal customer, or "our girl,"[22] and detailed profiles of this consumer can be developed. However, it is still necessary to engage and persuade the target consumer to buy products and hopefully become a regular fan and consumer that becomes part of the brand "family."[23] Louise Crewe, Nicky Gregson, and Kate Brooks discuss the importance of creating a group of "like-minded" followers who share an aesthetic and a knowledge and language of fashion that appreciate the look and are regular shoppers.[24] Equally, such retailers "position themselves and talk about themselves as part of a creative scene-setting milieu, which is understood to constitute the alternative-as-imagined." These fashion retailers interact with other retailers, designers, creatives, and club regulars engaging regularly in cultural and collaborative activities. This "knowing, elite, distinctive cognoscenti" also requires setting themselves against or outside the mainstream of "unknowing and undifferentiated" consumers who are regarded as "inappropriate" even when they buy product.[25] Equally important is retail location as shopping malls, high streets, and outlet centers are dominated by major players, forcing independent, niche, and small retailers to seek out alternative locations and markets that are "more discerning, style-conscious and image-centred" thus boosting the impression of an alternative creative community.[26] Many niche fashion labels prioritize stocking by independent retailers and focusing on the specificities and differences of local markets by offering a clearly identified point of difference and matching it to target consumer groups. Above all, it is important not to copy fast fashion trends but find a counterpoint to mainstream fashion.

Refining omni-tailing and mix-and-match retail strategies

Bricks and mortar remain important for local and national fashion retailers despite inroads by e-tailing especially by younger consumers; however, retailers are increasingly looking at multiple channels or omni-tailing to reach different sub-groups of consumers. As well as providing multiple channels of access and contact including websites, email, pop-up stores, apps, mobile and tablet connectivity, fashion retailers need to make use of Instagram, Facebook, Twitter, Pinterest, and Siri. This requires considerable investment in deciding which techniques best suit the label and consumer as well as maintaining and upgrading systems and promotional strategies. The interaction between physical, direct, digital, and experiential ways of connecting with consumers is essential for today's fashion retailer.

Embrace and engage with the competition internally and externally

As well as social and cultural connections between others in the fashion/culture space, fashion retailers typically pay considerable attention to what competitors are up to in order to meet them head-on and second-guess their next moves. This industry intelligence is crucial to keeping abreast of trends and adjusting to shifts in the marketplace internally. At the local level, this means monitoring the activities of other fashion retailers within a locality, as well as trends across the nation or region (such as Los Angeles versus Miami; Sydney versus Melbourne; Milan versus Florence; Shanghai versus Beijing; or Mumbai versus Delhi).

Along with internal competition, fashion retailers need to monitor external competitors and trends between jurisdictions, such as Amsterdam versus Antwerp; Stockholm versus Copenhagen; Berlin versus Vienna; and Kuala Lumpur versus Singapore. Interestingly, in the case of Scandinavia, the fashion cultures of Norway, Sweden, Denmark, and Finland both compete and cooperate, balancing fierce national pride in, and ownership of, their designers and labels while, at the same time, promoting "Scandi" or "Nordic" fashion as a tangible and attractive fashion genre for global consumers and fashionistas.[27]

Creative collaborations between fashion and other design fields

In recent years, there has been major growth in collaborations between creatives in adjunct fields in terms of both individual designers and practitioners, as well as other cultural sectors, agencies, organizations, and spatial locations.[28] To this end, fashion retailers have invested in developing design communities of interest, up-skilling in business and strategic planning and management; and fostering and nurturing a customer base through real-time links and interactions.[29] These strategies may seem a long way from designing innovative apparel and product development but in many ways are more important for survival and success.

Recognizing different types of local and national fashion cultures

There are three main forms of distinctive local fashions: the reinvention of tradition (e.g., England, Italy, and Paris); disrupters to traditional fashion systems (e.g., Japan and Belgium); and cultural re-invention of "non" places through fashion (e.g., Ireland, Portugal, New Zealand, Australia, and Reykjavik). Additionally, fashion is also being employed to re-brand regions as cultures such as the invention of "Asian" fashion as an imaginary entity[30] or Hong Kong

fashion as a distinctive genre.[31] A related strategy has been the use of fashion as part of the promotion of the new cultural economy as a replacement for other industries, for example, New Zealand.[32] In other places, fashion is a visible symbol of local conditions such as lifestyle, subculture, and climate where a tag like "subtropical" can come to identify the fashion of a place, such as Australia[33] or Brazil.[34]

Fashion is also entering the world of power and economic strength as a strategy to compete with and challenge the dominance of first-tier fashion centers reflecting the global shift of economic dominance from Europe and North America to Asia, South America, Africa, and the Pacific. This has been called the construction of "dressed power" in which "fashion is an attribute that nations no longer seem to be able to do without."[35]

Conclusion

In sum, there is an imperative to appreciate the important role of local fashion in the national and global context as micro-fashion cultures that underpin cultural identity and differentiation. This requires challenging the hierarchy of fashion city tiers by constructing a typology of not-so-global fashion tiers as parallel fashion segments with niche dynamics and strategies depending on macro-factors such as geographic location, industry capacity, and economic strength, as well as micro-factors such as characteristics of the consumer base, honing of appropriate retailing models, and understanding the "style DNA" of local fashion cultures. In so doing, fashion reflects and promotes diversity and difference through visible and tangible dress codes. In short, rather than global fashion obliterating local and national fashion, arguably it has created opportunities for cultural uniqueness. As quoted in relation to the emergence of distinctive regional fashions throughout Ireland:

> You can't give away black in Cork. It is a really different look there—everybody loves colour and black is for funerals. In Galway, they love dressing up and you really see it at the taxi ranks at the Galway races. There's a great sense of style in Limerick and some great boutiques outside the city. That's why the UK multiples get it wrong. Each of our regions has to be treated differently and that's what gives us the edge.[36]

Only when fashion engages with its backyard, be that local or regional, as well as seeking global exposure and export markets, will "polycentric" fashion really thrive. Fashion will never end but it will have other and diverse futures across cultures and places.

10

PRODUCTION AND MANUFACTURE

Véronique Pouillard

Introduction

The crisis of the fast-fashion model has received important media attention in recent years. Labor rights and ecological effects represent major challenges for the fashion industry. Forecasts indicate that the British population will have discarded 680 million garments during the spring 2017 season alone—one-third of which (235 million garments) will go to landfill, representing an average of nineteen pieces of clothing per person in Britain. Many ecological problems result from discarding garments: one difficulty is finding a use for the items that will be consigned, another is the environmental cost of sending a portion of the donated garments to overseas markets, and yet another is the environmental impact of the various clothing materials sent to landfill. Over the last decades, recycling programs have been launched by many fashion producers and retailers, from the veteran H&M Hennes and Mauritz AB Group to recent and more niche enterprises like the US firm Reformation.[1] Ecologically minded fashion entrepreneurs face a daunting set of entangled challenges. Up the chain of production, water consumption, damage due to pollution, and degraded crop production result from insufficiently regulated textile and garment industries.[2] Down the chain, marked effects of fashion overconsumption include pollution created from washing and landfill comprising throwaway fashions. The majority of today's fashion firms produce nondurable garments, which are worn only a few times and then discarded.[3] Furthermore, the environmental problems faced by the textile and garment industries are interconnected with problems of labor conditions.

Despite considerable technological advances, the sewing machine is still at the core of fashion production. While there have been important changes—such as the invention of the zipper, as well as developments in the chemical dying industry and in knitting machines—these innovations have hardly changed the

way the fashion industry works.[4] Since the invention of the sewing machine in the mid-nineteenth century, technology has been remarkably stable[5] and innovation has resided less in the technological realm than in design. In other words, it is first and foremost seasonal novelty that drives change in the industry. The acceleration of fashion cycles is also a fundamental factor in its prosperity, even if, as explored in this chapter, it comes with consequences for production.[6]

Fabrics need to be guided through the machine by human hands, and machines today are operated by men and women who often work far away from the headquarters of retailing firms. Fashion is an important source of employment worldwide. Competition between contractors at the local level keeps labor prices down, but sourcing from distant locations is a challenge for firms. At the beginning of the twentieth century, fashion was manufactured largely in urban centers, close to the firms that worked on image, media, and value creation. Paris was the center of design and of bespoke women's fashions, and London was the center of tailoring and of woolen clothing, while New York emerged as the world's most dynamic manufacturing center.[7] In these major cities, unions and activist groups including consumers' leagues worked hard to gain more control over the conditions of production.[8] They denounced the use of *sweated labor*: the exploitation of low-paid, often immigrant, women and children working in tenements and insalubrious buildings. To encourage reasonable consumption, the consumers' leagues perpetuated the common belief that clothes produced in bad conditions could carry diseases from the workers, for instance, tuberculosis. Scientific developments eventually made such beliefs distant memories, and thanks to the actions of reformist groups, the labor conditions of garment workers improved to some extent in the West. But, as observed by labor historians, sweatshops remained endemic. Historian Nancy Green has shown that the Jewish workers of Gilded Age New York were replaced by new waves of immigrants, including Italians, Chinese, and Puerto Ricans. Sweatshops that employed illegal immigrants in precarious conditions never completely disappeared.[9] Another phenomenon that took place in the garment industries of the West is the offshoring of garment production. It began in the 1950s when American manufacturing plants relocated to less-unionized areas within the United States, mainly in the South. New, more competitive places of production also emerged in southern and eastern Europe. From the 1960s onward, garment production was relocated again, from Western countries to Asia, the Caribbean basin, and North Africa. The offshoring of garment production accelerated in the last decades of the twentieth century with the lifting of quotas and trade barriers.

Many studies have been written on the history of the garment industry. This chapter aims to give a concise overview of the debates on fashion production and to place them in the context of the longer-term history of labor and consumption. This research is based on a wide array of press sources, secondary literature on labor and consumption history, and reports on garment work by NGOs and governments.

The human hand

Until the 1950s, New York City's garment district was the largest purveyor of ready-to-wear clothing in the United States. American retailers bought finished garments from manufacturers specializing in different price levels and distinct stages in the manufacturing process. Fabric was prepared and cut by the cutters. Specialized workers then made bundles, or loads of cut fabric ready to be sewn. The bundles were generally sent to another workshop in the city. Today, it is not uncommon that bundles of cut fabric are sent to another country to be assembled; then, the garments may be sent to yet another part of the city, or to another country, to be finished there.

Then and now, an important part of the manufacturing work could be subcontracted. In the first half of the twentieth century, the work was very specialized and the manufacturer, who in New York's garment district was called the "jobber," sent work to a contractor, who often delegated a part of the assembling to subcontractors. To cut down the prices, jobbers relied on competition among contractors, who were eager to receive orders.[10] In recent decades, the places of production have changed, but the competitive principles have remained the same. One effect of the subcontracting system is that, in a process in which orders are distributed to subcontractors, retailers may lose track of who their suppliers are.

The postwar period was characterized by the advent of fashions for all, although this phrase needs to be considered carefully. Historians of vintage fashion have adequately shown that even in the affluent West, there have always been significant numbers of consumers who could not afford to buy new, even at the lowest price point, and had to rely on charity programs and secondhand garments to make ends meet.[11] The idea of mass fashions, even nuanced by the persistence of secondhand markets, was nonetheless rooted in the ideal of a democracy of styles. Fresh designs were no longer reserved for the elite who were able to pay for haute couture originals. The democratization of fashion was a long-term process that developed alongside the rise of the ready-to-wear industry. A few fashion centers set the tone for style. While the New York garment district was the world's largest center of fashion manufacturing during the first half of the twentieth century, most manufacturers there were not ready to gamble on styles. These manufacturers, who often worked with tight margins, wanted to avoid being left with stock of unsuccessful designs. Middlemen such as Tobe Coller Davis and Amos Parrish were in charge of scouting Paris trends and, for a subscription fee, selecting and reporting them to American manufacturers.[12] Copyists and counterfeiters also contributed to making the most desirable styles available at a variety of price points and participated in the democratization of fashion by providing substitute goods.[13] Fashion stopped being purely a luxury and became a commodity.[14]

In the last half of the twentieth century, the rhythm of fashion accelerated like never before. The 1960s featured faster cycles and the first micro collections.[15] This change was possible thanks to small units of design and production, often homegrown. Entrepreneurs in the British "swinging sixties" fashion business—like Barbara Hulanicki (through her store, Biba) and Mary Quant—favored batch production for their clothing, but the problem of restocking on time remained an issue.[16] Clothing items were often discontinued, while brand identity was ensured by advertising and by the licensing of lifestyle and beauty lines.[17]

Offshoring fashion manufacturing

Issuing desirable styles for the masses in the right numbers, and on time, was a challenge. Concomitant with this challenge was the offshoring of large parts of fashion production. In some sectors of the textile and garment industries, a fear of distant overseas competition emerged during the interwar period. In Europe, for instance, Flemish lace makers started in the 1920s to denounce the competition from Chinese and Japanese lace makers. Lace making was labor-intensive, precise work that was deeply anchored in the history of several European regions. Textile experts observed at the time that while the differences between Flemish and Asian lace production were still important, for many buyers it was only the price that mattered. Belgian producers feared that Asian workers, having learned the technical skills, would end up competing with the Flemish production.[18]

The conditions of manufacturing in the textile and garment industries were also subject to discussion in the United States. The measures taken during the mandates of United States President Franklin D. Roosevelt to alleviate the effects of the Great Depression, and especially those that improved traceability of production within the framework of the National Recovery Administration during the first and the second New Deals, played an important role in the international mobilization of experts on the textile and garment industries. Roosevelt convened the first international conference on the textile industry in Washington, DC, in 1937. The conference brought together experts—representing governments, workers, and firms—to discuss a report prepared by the Bureau International du Travail (International Labor Office), in order to evaluate technical, economic, and social changes in the textile and garment industries at the international level.[19]

During the postwar period, such efforts to develop a dialogue on the global future of textile and garment manufacturing could not keep up with the pace of relocations to less unionized centers in the United States, to southern and eastern Europe, and to Southeast Asia. During the 1970s, the consequences of the offshoring of production became visible in the old manufacturing centers. In Europe, regions such as Lodzkie (around the city of Lodz in Poland), northern

England, and Flanders (in Belgium) were hit hard by the loss of large numbers of manufacturing jobs.[20] Countries that had developed a comprehensive welfare state were unfairly penalized in comparison to those that had not done so and could for this reason produce at a lower cost. To this day, this remains the core problem in the industry.

In Belgium, for instance, textile production was hit hard by the economic crisis that resulted from the 1973 oil shock. Then, in the second half of the 1970s, the country's textile production rose again, but not its garment production—the balance of trade was negative from 1976 onwards.[21] Economist Thierry Charlier, who wrote an extensive study on this question, notes that the reason for this was the import of garments produced in low-cost countries, especially in Southeast Asia, eastern Europe, and the Mediterranean basin. The differences in industrial and retail structures between Belgium and the Netherlands also played a role in the Belgian garment industry's decline. The Netherlands, observes Charlier, "had purposefully let their domestic garment manufacturing industry die in order to become the first transit hub of the trade of low cost clothing."[22] Indeed, retail chains like C&A flourished in the Netherlands.[23]

From the 1970s to 1980s, new trade agreements allowed manufacturing-intensive countries to use low wages as a competitive advantage in garment exports. Northern European countries, the United States, Canada, Australia, and New Zealand were now outpaced by other countries in the flow of cheaper merchandise, notably Hong Kong, Taiwan, and South Korea. Lower wages, longer hours, and local production of textiles allowed the new places of production to offer fashionable goods for retail sale in the West.

In an attempt to limit competition, trade agreements were negotiated between the low-cost manufacturing countries and the Western importers within the framework of the General Agreement on Tariffs and Trade (GATT). The Multi-Fiber Arrangement, for instance, had a limiting effect on exports by some of the countries producing low-cost fashions. Experts have observed, however, that frauds related to import quotas of garments and the country of origin were common.[24] Agreements also ended up favoring some countries while penalizing others, for example, in southern Europe. Since the end of the Multi-Fiber Arrangement, on January 1, 2005, the low-cost garment industry has undergone a new boom. Despite the negotiation of new bilateral agreements, unbridled liberalism dominates in the global garment and textile trade.[25] For the consumer, the result is increased availability of cheaper, inferior-quality garments, and for the producer, decreased costs of labor.

The offshoring of fashion production to distant places raises the question of what happened to the manufacturing sites that were deserted because of the relocation overseas of garment and textile production. Movements for rehabilitating local production have a long history and can take different forms. They can be associated with forms of nationalism; an example is the Swadeshi

movement in India, which aimed to promote locally made goods, and especially textiles, as a token of political independence and which was influenced by Mahatma Gandhi.[26]

In the West, many of the original production centers and their abandoned sites, or neighboring cities, became postindustrial creative centers. A multiplicity of actors contributed to make such reconversions possible: city and state officials who were eager to reignite activity in dormant regions, designers attracted by cheaper rents, the last firms left behind, and new entrepreneurs. Returning to the case of the Belgian region of Flanders, a former center of industrial production, we see that the project of its rehabilitation was fostered by creative entrepreneurs, the presence of local firms and know-how, and the federal government of Belgium, led by Prime Minister Wilfried Martens. For a period of ten years starting in 1983, the Belgian government financed the Textile Plan, which offered funding to entrepreneurs, and awarded cash prizes to support creativity.[27] The city of Antwerp, which had a tradition of supporting the arts and was a bustling port city, became a stage for the transformation of a dormant textile region into a new hub for value creation through creativity and retail. The reconversion of former production sites into creative centers depends on many factors and does not entirely make up for the loss of production activity. The true economic impact of recovery programs like the Belgian Textile Plan of the 1980s is difficult to quantify, notably in terms of unemployment that can persist in the rejuvenated centers. Yet, through this process, Antwerp has earned a place as one of the new, dynamic, and exciting fashion centers of the postindustrial age.

From the 1990s onwards, flexible specialization firms began to adopt systems of quick response that were made possible through the development of specific IT programs.[28] In the case of fashion retailer Zara, the company makes decisions about batch production based on data gathered from consumers' purchases.[29] Today, the fast-fashion groups that developed these IT systems in the first place—like Inditex, owner of Zara, and Fast Retailing, owner of Uniqlo—can turn out a fashionable new garment in thirteen days from the drawing board to the shop floor.[30] Many of these designs are inspired by the innovative and creative fashions presented on the runways by high-end firms. A new fashion system has emerged from these conditions of production—one that combines the nearly instantaneous availability of fashionable designs with access to immediate image diffusion via social media platforms.

The race to the bottom

The idea that fashion is a sociological phenomenon that has a beginning and an end was developed by sociologists such as Gilles Lipovetsky, who wrote that the fashion system had a life span of a hundred years, from the mid-nineteenth

century to the mid-twentieth century. This chronology coincides with what is known as the golden century of Paris haute couture.[31] The acceleration of the fashion cycles had been analyzed before, for example, by Roland Barthes, who identified a series of factors that drove the phenomenon.[32] But since Barthes, the fashion system has become even faster, with its cycles only a few weeks long, instead of the traditional two six-month seasons a year. In the West, a consequence was that sewing became devalued and considered a chosen hobby instead of an economically sound activity.[33] The term "disposable fashion" has since been coined to describe products sold at the lowest prices by retail chains like Primark. Indeed, garments are considerably cheaper at Primark than at most other affordable fashion chains: on average, items are sold for £3.87 at Primark and for £10.69 at H&M.[34] There is no denying the attraction to the consumer of a wide array of up-to-date styles at very low prices. But what is the true cost of cheap clothing for the people who are at the starting point of the chain of production? This question has gained prominence in the mass media landscape, prompting the title of Andrew Morgan's 2015 documentary film, *The True Cost*.[35]

Fashion production provides many people with entry-level jobs but, Morgan's film suggests, it has gone too far. In recent years, dozens of fast-fashion retailers have had their brand names associated with grave labor accidents. On April 24, 2013, 1,135 people were killed as a result of the collapse of the Rana Plaza building in Savar, an industrial suburb of Dhaka, Bangladesh. At the time, more than 3,000 people were working in the building, producing apparel for various subcontractors. Among the survivors of the collapse, many were gravely injured. Several other accidents in apparel factories had occurred in the preceding months, and others since then have taken hundreds of victims.[36]

In the days preceding the Rana Plaza collapse, workers employed in the building had noticed cracks in its construction, but they were pressured to go to work. The Rana Plaza had initially been built to be a shopping mall, not to host factories with their heavy machinery and vibration-inducing generators. The contractors who worked on the building had used inferior-quality concrete and worked faster than was recommended for materials to dry, in violation of construction safety codes. Despite the compromised security, three floors were later added above the ones in the original design plans. This was endemic of local corruption leading to unmonitored building development.[37]

The Rana Plaza building housed at least five factories owned by subcontractors who filled orders for clothing and accessories from mass retailing groups such as Benetton, H&M, Inditex, Loblaw, Primark, and Walmart. Finding the firms that outsourced work to the Rana Plaza factories proved difficult. Brand labels were collected in the rubble of the Savar building, revealing the large number of popular brands that were made there. Since firms cut expenses first on fabric and design, what is left for mass fashion brands is to push down the price of the workforce.[38] This phenomenon of a "race to the bottom" is at the core of

the tensions in fashion production.[39] The retailers that found their brand image tarnished by the Rana Plaza disaster stated publicly that they had not been fully informed of the conditions of production. They subsequently engaged in reparation and developed corporate social responsibility (CSR) programs.[40]

Consumers' guilt

The news of the Rana Plaza collapse, and of other, similar disasters, caused public outcry worldwide. Guilt and soul-searching were voiced in the West. The Rana Plaza tragedy took on symbolic proportions because of both the magnitude of its death toll and the global popularity of the brand-name tags found in the rubble after the collapse. The image of the Western consumer was also damaged considerably at this time—at best complacent, at worst responsible for unethical purchases. Consumer culpability emerged from the association made between the deaths of the workers and the frivolous pleasure associated with fashion. In numerous media discourses, mass fashion became synonymous with guilt. In some of the most affluent countries in the word, new discourses encouraging more restrained, responsible consumption have risen to prominence in the media and on consumer forums, including social media. The genres of prescriptive literature, consumers' guides, and self-help books have seen an increase in discourses promoting restrained consumption, which often translates into minimalist styles. But these discourses are ambivalent. Encouraging consumers to cull their belongings has the effect of creating more landfill—and making space for buying new objects again.[41] More importantly, despite ever-present media coverage of the difficult labor conditions and safety hazards in garment factories, the market share of rock-bottom-price new fashions shows no signs of abating.[42]

In the media, discussions of consumer ethics occupy an increasing amount of space, but the offer of and demand for fully traceable fashion-branded goods is not only marginal, but reserved for consumers who belong to a cultural elite. In Norway, a TV series that first aired in 2014, called *Sweatshop Deadly Fashion*, sent a small group of young fashion bloggers to experience the working conditions of garment factory workers in Cambodia. The series shed light on the divergence between the fast-fashion consumer lifestyle and the conditions of workers who stand behind the product.[43] The documentary *The True Cost* had a similar effect.

The Rana Plaza disaster was one of exceptional magnitude, but more than twenty years before, the Sacara factory fire in the suburbs of Dhaka had killed twenty-five women and children trapped in a locked garment workshop. Labor unrest and union creation followed in Bangladesh, but with little effect on the industry. After that accident, Clean Clothes Campaign—the Dutch-

founded alliance of NGOs and labor unions—carried out in-depth research that unequivocally showed dangerous labor conditions in Bangladesh.[44] Despite the efforts of NGOs and unions on the ground, the last two decades in the country have been marked by repeated accidents in factories, regularly killing dozens of workers.[45]

Going back further in time reveals periodic occurrences of such accidents, and not only in developing parts of the world. The problem of safety in the workplace has become more acute since the advent of the modern factory. In New York, the Triangle Shirtwaist Factory fire on March 25, 1911, was the most significant labor accident in the US garment industry, resulting in the death of 146 workers, most of them young women. The subsequent inquiry showed that the fire had probably been caused by a lit cigarette that had fallen in a basket of fabric scraps. The fire spread to the ninth and tenth floors of the building where the Triangle Shirtwaist Factory had its workshops, on the corner of Greene Street and Washington Place. To prevent workers from taking unauthorized breaks, the doors of the factory had been locked—a practice that is still frequent today in low-cost garment workshops, despite not being permitted by safety codes. The workers who were not able to exit the building by its elevators before they stopped operating were trapped in the flames, and some of them jumped to their death.[46]

After the Triangle Shirtwaist Factory fire, workers gathered in the street to mourn their relatives, friends, and colleagues and to protest against hazardous labor conditions. The State of New York then passed new legislation to protect factory workers from similar accidents. Audits were organized to check safety and labor conditions, and controllers were sent to work sites in person. Historically, a recurring problem has been finding enough police and auditors to check that laws and labor codes are respected in the long term. During the interwar period, the garment workers of New York were the best paid and worked shorter hours than in any other fashion production center, including Paris. New York's garment district workers also became the most unionized in the industry.[47]

Before the First World War, a double movement had begun to develop in the West: workers unionized, and consumers started to express solidarity with the people in distant locations who sewed their clothes. Consumers' leagues in Western countries had helped awaken consumers to the danger of acquiring goods without tracing their production.[48] Such activists were concerned by industry workers' ages, wages, and health. They visited the tenements in order to alert public authorities of the dangers of precarious labor conditions, and they lobbied authorities for regulation of the minimum age of labor.

Following the economist Albert O. Hirschmann, the behavior of Western consumers can be analyzed using three *repertoires*, or types of actions: exit (e.g., boycott practices, blacklisting), voice (e.g., communication campaigns, consumer lobbying), and loyalty (e.g., "buycotts," white lists of ethical companies). As

consumption historians have shown through many examples, neither the boycotting nor the *buycotting* of fashion products carries a single political viewpoint.[49] Hence, *loyalty* can also refer to the loyalty of consumers who keep buying from companies that participate in the "race to the bottom."[50] Still, boycott and *buycott* practices have contributed to the coming of age of grassroots politics, especially for groups deprived of full citizenship rights.[51] In recent decades, associations like the Clean Clothes Campaign work with NGOs, the International Labor Organization, local unions, firms, and governments to establish better labor conditions.

Made in the West?

Debates on the conditions of production in the fashion industry have shed light on the precarious conditions in which many men and women, some of whom are underage, work in the manufacturing industries. In 1999, the publication of Naomi Klein's book *No Logo: Taking Aim at Brand Bullies* was the focal point of an important new wave of consumers' discontent with the aggressive branding of large multinational conglomerates that produced cheap goods at the expense of workers' well-being. Klein explored what she presented as two faces of a single problem: the value of Western brands had skyrocketed, while less and less effort and money were being spent on the well-being of workers. Such brands, argued Klein, had engaged in a *race to weightlessness*. They had invested in the immaterial aspects of the brand, which was often headquartered in a Western country, and had left uncontrolled the manufactured production, most of which took place overseas. The victims were the workers, especially in developing countries and tax-free hubs, where most of the production was relocated. Klein identifies herself as a repentant brand addict. Most importantly, her book turned the spotlight on associations that work to enforce basic safety codes and to implement a living wage—which has proven to be difficult, and sometimes dangerous, work.[52] The promotion of Klein's book turned into a campaign of activism. Historians acknowledged that *No Logo* had an effect on their research agenda, prompting them to investigate, for example, the history of the early consumer activists who were the ancestors of today's Clean Clothes Campaign and other associations.[53]

Klein's work contributed to the public discourse around the tensions between material and immaterial determinants in the fashion industry. The demand for endless new fashions, met by the fast response of large groups, has brought fast fashions to the masses. Contemporary fashion industries, characterized by flexible specialization and rapid response, are characteristic of post-Fordist economies.[54]

Buying Western or national is a strategy that consumers may deploy in order to soothe their own conscience when shopping. Historians have shown

that economies supposed to be liberal use various barriers to protect certain sectors, or, put differently, that there is no such thing as a free market.[55] The term "re-shoring" is currently used to describe new projects that aim to bring back components of garment manufacturing to the old Western centers of production.[56] One challenge facing re-shoring initiatives, as important as they are, is to ensure that buying garments labeled as made in the West will in fact contribute directly to the greater good of the workers behind those garments. As noted earlier in this chapter, the fiber harvesting, fabric weaving, cutting, sewing, and finishing of a garment may all, or in part, be carried out in different countries. Only one or two of these steps will appear on the label that is sown onto the garment for retail. It is also possible that even a garment made in a Western country is made in a workshop employing people in illegal conditions.[57]

The question of re-shoring applies to the Western retail firms whose accountability is at stake here. Should global retail chains divest from economies like Bangladesh? Or are they already so involved in these economies that they have to face their responsibilities on the ground? In the case of low-wage garment production industries, many actors tend to agree that it is better for multinationals to avoid doing a "cut and run" on their orders when they face subcontractors who do not respect labor codes. Liesbeth Sluiter of the Clean Clothes Campaign writes that NGOs generally encourage multinationals to stay and to make sure they work together with local contractors, unions, and government, as well as the International Labor Organization and NGOs, in order to solve problems locally and to improve labor conditions.[58]

The Rana Plaza disaster and several other labor accidents have become symbols of the urgent need for greater control of labor conditions in manufacturing industries. The structure of the fashion industry entails the delegation of manufacturing to subcontractors, and sometimes many subcontractors, who can themselves subcontract parts of the job like cutting or finishing garments. Contractors who cannot fill an order will offer the work to a subcontractor, and along this chain of production, responsibility becomes harder and harder to trace.[59]

New York Times journalist Adam Davidson has described low-wage garment factories as a part of the "T-shirt phase" of developing economies: a phase that developing economies have to go through in order to provide low-cost jobs to the masses, before in theory reaching a more advanced stage of economic development.[60] Fashion companies tend to cut costs wherever possible, by using cheaper textiles and by relocating to low-salary economies and tax-free hubs. Consumers and some of their defense organizations have frequently proposed boycotting goods made in such places. Yet in the so-called "T-shirt" economic phase, it is also often pointed out that bad jobs are better than no jobs at all. Davidson and other observers underline that the T-shirt phase is a limited one and should be followed by an influx of jobs for more qualified workers

and better labor conditions. But the research of labor historians tends to show that sweated labor comes back in waves, including in Western fashion hubs.[61] The recent history of low-cost-production countries—notably Bangladesh, Cambodia, China, and Pakistan—does not tend to support Davidson's thesis: deadly accidents have continued to occur in the industry over the last twenty years. Furthermore, attempts by workers to unionize and protests demanding better working conditions are often met with repression.[62]

New ways of production

Marketing researchers Sankar Sen and C. B. Battacharya show that companies benefit greatly from offering better conditions to their employees rather than simply complying with the minimum legal standards of the country where their workshops are located.[63] Compliance issues, however, remain numerous. A 2013 McKinsey report pointed out that less than 2 percent of textile and garment factories in Bangladesh had a high degree of compliance with safety and hygiene codes.[64] A disconnect between CSR programs and purchasing practices, lack of resources for carrying out social auditing, and auditing frauds observed at the local level are all major obstacles to the enforcement of labor codes.[65] In order to move beyond the problems of implementing a compliance-based paradigm, researchers and organizations propose replacing it with a cooperation paradigm involving continuous dialogue among retailing multinationals, private and public local actors, workers, and NGOs.[66]

Western firms whose brands were involved in recent labor accidents had to reestablish their reputation, and they tried to do this in several ways. Partly it was done through their engagement in CSR, which included signing long-term agreements regarding labor conditions. Another way they restored brand image was to develop sustainability programs. Production practices are evolving as well. One point that needs nuanced treatment, and further examination, is the tendency to associate fast fashion with geographically distant production. In the 1990s, Inditex Group—home to Zara and based in Galicia, a region of Spain— was already having the most fashionable items in its catalog produced closer to its headquarters, either in Spain, Portugal, Morocco, or Turkey. A shorter distance cuts time and thus serves the fast-response model that has been at the core of the firms's strategy.[67] The basic garments for these firms are made in more distant locations, for example, in Asia, but this is far from the case for the entire collections of the brand. Success resides in this diversification, allowing retailers to sell attractive, fashionable items made closer to home for sensibly higher prices, while continuing to have the cheap basics made overseas. The question is whether the fast-response model will survive a closer examination of the conditions of production. Recent studies show that if workers in low-

cost-production countries were paid a minimum wage, the effect on retail prices would be barely visible. This improvement in labor conditions may cost less than an extra dollar per item at retail.[68]

The sewing machine has remained at the core of fashion production and the development of more sophisticated equipment has not always translated directly into changes on the workshop floor. Innovative machines can be too expensive if their potential acquisition is correlated with the price of the workforce, thereby creating a disincentive for entrepreneurs to pursue technical innovation. Factory owners can also be reluctant to invest in machines created to perform technical operations that may become useless when new fashions appear in production. For example, industrialists may not want to invest in machines for embroidery if the fashion for embroidered garments is unstable, or if fashion cycles alternate between ornate garments and plain, unadorned garments.

As far as sewing is concerned, the industry still requires human mediation, because fabric is a soft material and therefore very difficult for a robot to manipulate. Recent innovators have tried to bypass this difficulty by creating a method for stiffening the fabric: specifically, the fabric is plunged into a bath of polymers, chemicals that stiffen when dried. The stiff fabric can be handled by a robot-operated sewing machine, and the finished garment is then plunged into a new bath to rinse out the stiffening product, before being dried and ironed.[69] The challenge at this stage is that the cost of the robots—and of 3-D textile or knit printing machines, another possibility for robotized garment making—is still not competitive in comparison to that of the workforce. Robotizing a part of fashion production could be the industry's most innovative breakthrough since the invention and commercialization of the sewing machine in the nineteenth century.[70] It could also relieve some of the physical strain on garment workers, but it may well result in large job losses.[71] So far, the cost of such machines has prevented change. Should it happen on a large scale in the future, though, the question of a living wage for manufacturers, and of the responsibility of firms toward their workers, will without doubt create new tensions of a different kind in the fashion industry.

Conclusion

The fashion industry is currently experiencing considerable attention from activist movements and NGOs, mainly centered on questions of production. The media features an overwhelming number of voices. The prevalence of such voices, albeit critical, may have prevented consumers from purely and simply boycotting fast fashions—or from *exiting*, to use Hirschmann's term. It is possible that a significant number majority of consumers will voluntarily adopt restraint, choosing to refrain from buying the cheapest fashions and thereby sacrificing the appearance of

affluence. Despite an increase in discourses that condemn mass consumption, many observers within and outside the industry still invoke arguments of freedom of choice.[72] In the past, consumer movements have been efficient laboratories for the exercise of political rights, yet change often did not just originate from the consumer; rather, it had to come from political decisions. It is likely that the range of action of consumers will once again remain limited and that the notion of consumer freedom may turn against them, as an argument for deregulation.

If altruistic arguments about the well-being of garment workers have little effect on the consumer, it is reasonable to expect that the issue of ecological sustainability will garner more attention. Consuming goods produced in better conditions will affect not only the lives of workers, but also the quality of the goods themselves, and thus help to diminish the levels of landfill and pollution.[73] In recent decades, NGOs and labor unions have accomplished daunting tasks at home and abroad. They have campaigned for consuming differently, and they have also observed, reported, and negotiated labor conditions in the field. Entangled social, economic, and ethical issues characterize manufacturing production. As such, fashion production is likely to remain a burning question, whether or not the industry takes a leap into new technologies.

11

CURATION AND EXHIBITION

Hazel Clark

Since the new millennium, an increasing number of informed fashion voices, including journalists, academics and other pundits, at various times, have alluded to the "end of fashion." The beginning of the end, so to speak, might be charted back to *Wall Street Journal* reporter Teri Agins's book *The End of Fashion* (2000). To be fair, the millennium was a somewhat inevitable historical watermark that infiltrated public consciousness around the globe due to the greater presence of the digital in everyday lives. Yet virtual communication also came into question— we can recall "Y2K" or the "Millennium Bug"[1] and the abounding anxieties that computers would cease to function effectively at the stroke of midnight. As we know, computers did not all shut down or scramble, but the example can serve as a reminder of the psychological significance that was attached to the year 2000. Then, all too soon and too tragically, came September 11, 2001 and the bombing of the World Trade Center in New York. The collapse of the twin towers felt like a metaphorical crumbling of the twentieth century, the modern world, and its institutions. The coincidence of the timing with New York Fashion Week S/S 2002 served also to highlight fashion's own sense of instability.

For Agins, the "end" came with the increasing market dominance by fashion brands. In the 1990s, the logo signified not just distinction, but also increasing competition between labels. It was no longer just a marker of the creative differences between styles. Agins notes how the branding of fashion "has taken on a critical role in an era when … just about every store in the mall is peddling the same style of clothes."[2] The consumer no longer went shopping for a particular style of garment, but rather for a "Calvin" or a "Ralph." Choices reflected a desire to project the brand image, be it "severe urban minimalism" (Calvin Klein) or "athletic, American conservatism (Ralph Lauren)."[3] The consumer, or more accurately speaking mass-marketing to the consumer, rather than the design of clothing, had become the seat of innovation as more and more brands competed for a

share in the business of fashion. According to Agins, "that's why we've come to the end of fashion. Today, a designer's creativity expresses itself more than ever in the marketing rather than in the actual clothes."[4] A sense of the designer being disempowered was reiterated by fashion theorist Barbara Vinken, who uses the term "postfashion" to describe the contemporary *Fashion Zeitgeist* where the designer loses absolute power.[5] She attributes the origins of postfashion to the 1970s, and the completion of a hundred years of Western fashion, stretching from Worth to Saint Laurent, with its high point in the modern designs of Chanel and Schiaparelli. After that period, fashion praxis "deconstructs modernity and, in the end, leaves it behind."[6] In the process fashion design engaged with the old, ugliness, sentimentality, kitsch, bad taste, and traces of the past through endless historical citation and cultural plundering.

So while fashion did not actually end, many changes took place in the final years of the twentieth century that reflected fashion's greater heterogeneity and ubiquity in commerce and culture, while exposing a dark side of the fashion system. Yet as fashion scholar Christopher Breward notes, taken from an historical perspective, "anxieties around the moral worth of fashion culture, or the ethical implications of sweated labor and global trade are as old as the first presentation of clothes designed for form as much as for function, for extrinsic as much as for intrinsic value."[7] Breward stresses how "an informed and critical apparatus for the study of historical and contemporary fashion is more important now than ever."[8] He would no doubt have included some fashion journalists and critics among those who were able to comment authoritatively and critically on the times. In their number we can count Vanessa Friedman, fashion director and chief fashion critic of *the New York Times*, whose neologism "fashionization" captured the growing presence of fashion in everyday life, not just as clothes, but also through a diverse range of methods of communication, including the internet, television, film, social media, and exhibitions.[9] Breward was also reacting to a manifesto that had just been issued by fashion forecaster Lidewij Edelkoort. In it, as he notes, Edelkoort critiques the prevailing model of fashion education as perpetuating the myth of star designers, runway shows, and luxury brands.[10] Declaring "the end of Fashion as we know it," she hurls brickbats also at marketing, retailing, the press, and consumers, foreseeing an "exodus of fashion" in favor of a "culture" and "celebration" of clothes. Edelkoort's manifesto ends with an "Afterthought" on the recent popularity of fashion exhibitions. She cites the hugely popular Alexander McQueen exhibition, *Savage Beauty*, originating at the Costume Institute of The Metropolitan Museum of Art in New York (May 4–August 11, 2011) as evidence of nostalgia "for the heydays of creation and couture." She observes, however, that brands increasingly host their own shows to control their brand identity and product placement, with the artworld a willing accomplice in the process. The outcome, Edelkoort concludes, is an iron grip by brands, which means that museums are less able to show fashion, and must

turn more to displaying clothes. Her corollary is that "the end of fashion curating is near."[11] While there is strong evidence to demonstrate that the currency and future of the fashion exhibition are much less bleak than Edelkoort states, her words nevertheless indicate how, as a form, the exhibition has come to reflect the complex state and nature of fashion and thus demands scrutiny. It is the task of this chapter to consider fashion curation and the fashion exhibition, in particular since 2000, and to question its position and role at "the end of fashion."

Expanding the field

To provide context we should begin with the late 1970s. It was then that art theorist and critic Rosalind Krauss published her seminal essay "Sculpture in the Expanded Field," to locate and investigate new sculptural practices that began in the late 1960s. Krauss cited work by artists such as Donald Judd, Mary Miss, and Robert Smithson, as having contributed to extending the conventional limits of the discipline into landscape and the jurisdiction of architecture, and to expanding the cultural field of modernism to postmodernism. In the process the very nature of what *was* sculpture became somewhat obscured:

> We had thought to use a universal category to authenticate a group of particulars, but the category has now been forced to cover such a heterogeneity that it is, itself, in danger of collapsing. And so we stare at the pit in the earth and think we both do and don't know what sculpture is.[12]

Now, exactly forty years later, we might say likewise of "fashion" that "we both do and don't know what [it] is." A hiatus appears to have been reached, an "end" of sorts, when the term "fashion" no longer defines clearly, but needs definition due to its expansion as praxis.[13] The fashion exhibition has developed the potential both to recognize fashion in an expanded field, as a cultural practice as well as an industry, and to contribute to establishing a critical discourse around and belonging to fashion. While this discourse is overdue, overdue, it is now drawing the attention of fashion scholars, thinkers, and practitioners.

While working on her doctorate at the London College of Fashion, Jessica Bugg developed the hypothesis "that there can be clearly articulated alternative strategies for fashion design and communication that are concept and context based, rather than being driven by commerce, market and trends."[14] Advocating an interdisciplinary approach, she called into question the preeminence of industry-driven definitions of fashion, in order to encompass "beyond the confines of the catwalk, the traditional store space, and the printed page [into]fashion film, animation, the music industry, art photography, fashion illustration and fashion graphics, virtual space, performance, curated space, and the art gallery."[15] In

tandem, Bugg noted how fashion curation emerged as a named discipline,[16] which could "be seen to reflect the shift towards contemporary fashion exhibition as a distinctive form, as opposed to the established practices of historical costume and fashion displays in museums."[17] This fashion "curatorial turn" was evident by the millennium, and, in common with developments in the fine arts, it had its origins in the latter decades of the twentieth century. Postmodern discourse, with its privileging of a plurality of voices over the grand narrative, was reflected in how and where fashion came to be exhibited.

The development of textile and clothing collections and their exhibition by museums since the nineteenth century have been well-documented, and do not need reiterating here.[18] Scholars agree that it was not until the 1990s that exhibitions of fashion, and in particular contemporary fashion, became accepted and popular in museums and galleries internationally. Such exhibitions coincided with and reflected new approaches to fashion history and the establishment of fashion studies as an academic field that encompassed history, theory, and criticism. In the early twenty-first century, the intellectual and cultural context which succeeded postmodernism and is one premise for this book is philosopher Slavoj Žižek's, *Living in End Times*.[19] Fashion, serving as a reflection of its own (modern) times, is inevitably implicated. As I have written elsewhere, from the 1990s it was acknowledged that fashion, as a contemporary cultural phenomenon, had "infiltrated everyday lives in an ongoing, sustained way over time and across class, gender, ethnicity, and generation."[20] At the same time fashion was "infiltrating" the museum to gain a status that was equivalent to that of the fine arts. A pivotal exhibition, well-documented in other accounts, was *Fashion: An Anthology by Cecil Beaton,* held in 1971 at the Victoria and Albert Museum (V&A).[21] By affording garments that had been worn by contemporary celebrities the status typically given to art objects, this exhibition marked a shift in the museum toward the display of *fashion* (rather than dress) that was also prescient, gaining the accolade of being previewed in British *Vogue.*[22] The *fashion* exhibition had begun to emerge and would continue to develop apace.

Exhibition making

Christopher Breward has drawn attention to the central role played by academic research in shaping curatorial approaches to fashion—and vice versa, and its impact on the fashion exhibition.[23] Breward identifies three specific research constituencies. The first, and most familiar, were specialist dress scholars (academics and curators). While this group would continue to use archival sources, Breward highlights recent exhibitions that had used historical archives to provide a more in-depth case study approach. He cites, for example, *Fashion and Fancy Dress—The Messel Family Dress Collection: 1865–2005,*

curated by Eleanor Thompson, Amy de la Haye, and Lou Taylor at Brighton Museum and Art Gallery in the UK (October 2005–June 2006), where family archives facilitated deep empirical research. Breward's second constituency was contemporary fashion practice, which he credits with having "inspired the most innovative and controversial shows of the past few years."[24] By mentioning Claire Wilcox's *Radical Fashion* at the V&A, London in 2003, and *Fashion* at Belsay Hall in the northeast of England a year later, Breward also draws attention to collaborative endeavors, specifically where curators worked actively with fashion designers to create new installations, rather than simply displaying existing work. A seminal example was *Malign Muses,* staged originally at the ModeMuseum Antwerp (2004) and then as *Spectres: When Fashion Turns Back* at the V&A (2005), by exhibition maker and curator Judith Clark, based on the writings of fashion scholar Caroline Evans. It was a collaboration that resulted in work being subjected to "an unprecedented layer of subjective interpretation and editing."[25] Elsewhere, Judith Clark notes the importance of the *installation* for a fashion exhibition as well as the exhibition content.[26] Collaboration is a strategy that has also been reinforced by Breward's third constituency—mainstream fashion brands, which began to influence the content and delivery of fashion exhibitions, rather than merely acting as sponsors. Resulting exhibitions make the case. Breward mentions in particular *Giorgio Armani* held initially at the Guggenheim, New York (October 20, 2000–January 17, 2001), and subsequently at the Royal Academy, London and at the Guggenheim, Bilbao. Controversial for many due to the confusion over fashion being exhibited simultaneously as art and commerce, the venue and the installation by the avant-garde American theater designer Robert Wilson made for a visually arresting show. This exhibition also demonstrated Breward's perspective that the fashion exhibition was occupying more complex cultural terrain.

The three constituencies articulated by Breward provide a valuable framework for considering fashion research and ideas made explicit in exhibition practices, acknowledging that evidence from actual exhibitions indicate how these categories were not discreet. Together they underpin the more recent fashion exhibitions discussed in this chapter, which were held in different international venues close to the time of writing—in 2017. Staged, broadly speaking, "within a framework that encompasses performativity, temporality, spatiality, and materiality,"[27] they address and contribute to fashion as an expanded field of practice and as a mode of inquiry.[28] Acknowledging that the (fashion) exhibition is a public forum that needs to be experienced to be appreciated fully,[29] I will now focus mainly on exhibitions which I visited, and with a final example that I co-curated.

The first fashion exhibition I visited in 2017 was *The Vulgar: Fashion Redefined* curated by Judith Clark in collaboration with psychoanalyst Adam Phillips at The Barbican Centre, London (October 13, 2016–February 5, 2017). As in her earlier

work (including with Phillips), Clark raised complex issues, this time with an exhibition whose use of familiar museum vitrines and plinths at first belied the complexity of its thesis. Selecting garments from the last 500 years, the exhibition addressed matters of taste in fashion—bad as well as good, and what determines which is which. Some of the pieces shown could have been anticipated interpretations of the theme—an eighteenth-century mantua dress with a skirt extending 2.5 meters, or Walter Van Beirendonck's Spring/Summer 2014 "Elephant Dress" with a dangling phallic trunk at the front (Plate 19) Others proved a surprise— seventeenth-century white, lace collars presented in a stark black setting to indicate the vulgarity of such purity. The exhibition set up challenges about the vulgar, enhanced by the detailed museum texts that accompanied the pieces. Text featured prominently in the installation, and paralleled Clark and Phillips's previous collaboration, *The Concise Dictionary of Dress,* held at Blythe House, the V&A's collection store in West London in 2010. A review of the latter also demonstrates some of the distinctions and comparisons between the two exhibitions and their venues.[30] Each was "archival" in its sources, focusing attention on contemporary fashion's relationship to its own past, while posing questions, rather than providing answers about fashion. As Marco Pecorari observes, the fashion archive is "indeed a place where it is possible to rebuild the activity of objects and reactivate and retrace the networks in which they participate."[31] Such reinterpretation in the guise of the fashion exhibition has been evident in different approaches to the display of garments from archives of major fashion designers, which not only bring together historic items, contemporary fashion practices and the brand, but also demonstrate how the exhibition can serve in an important reflexive role for fashion. To explain this further, there follows discussion of two exhibitions held in 2017, in different venues and cities, both devoted to the same subject—Balenciaga.

Balenciaga: A case in point

Admired as a master craftsman, the couturier Cristóbal Balenciaga could be described as a designers' designer, highly respected by his peers and his successors. The esteem in which he is held has resulted in substantial scholarly research[32] and many exhibitions. The Museo Balenciaga, which opened in the designer's hometown of Getaria, Spain in 2012, is also devoted to his work. One of the earliest major Balenciaga exhibitions was *The World of Balenciaga,* curated by Diana Vreeland at the Costume Institute, The Metropolitan Museum of Art in 1973 (March 23–June 30). Opening a year to the day after the designer's death, the exhibition is also considered a landmark as having introduced "a brand new approach to costume exhibitions. In a spectacular setting a fashion designer for the first time was given the focus reserved in museums for great artists."[33] More recently, *Balenciaga Paris,* held at the Musée des Art Décoratifs in Paris (July 6,

2006–January 28, 2007), was a collaboration between the museum's chief curator of fashion and textiles Pamela Golbin and Nicolas Ghesquière, then the creative director of the fashion house (1997–2012). This exhibition featured archival pieces, film footage illustrating Cristóbal Balenciaga at work, and garments designed for the house by Ghesquière. N. J. Stevenson notes how the strong presence of the work of the latter in the exhibition served to demonstrate a design continuity in the house, while also highlighting "a current phenomenon" where some of the Paris *grand maisons* had been relaunched under the leadership of younger designers.[34]

Balenciaga's fashion legacy was celebrated again with two major exhibitions, *Balenciaga: Working in Black*, at the Musée Bourdelle, Paris (March 8–July 16, 2017), and *Balenciaga: Shaping Fashion*, at the V&A, in London (May 26, 2017–February 18, 2018). The timing of these two shows, ten years after the Arts Décoratifs exhibition was not coincidental, but rather marked the centenary of the opening of Balenciaga's first fashion house in San Sebastian, Spain, and the eightieth anniversary of his house in Paris. The exhibitions each used archival material, but had different strategies toward presenting the designer's work as the "juxtaposition of the old and the new." This strategy has become more commonplace than the chronological and retrospective fashion exhibitions, but as Stevenson cautions, it is also potentially difficult, not least because a fashion exhibition can be subject to a plethora of different constraints and expectations, including from its audiences, donors, sponsors, and contributors.[35]

The V&A described its venture as, "the first UK exhibition to explore the work and legacy of the Spanish couturier … his protégés and contemporary designers working in the same innovative way today."[36] It featured over 100 garments and hats, largely from the 1950s and 1960s, which is considered the creative highpoint of the couturier's career. Supported by archival material, sketches, photographs, video, and fabric samples, the show also included "forensic" examination of some garments. A collaboration between X-ray artist Nick Veasey and pattern-cutting students at the London College of Fashion resulted in digital representations that revealed the detailed process and innovative structure characteristic of Balenciaga's designs. For the show, the V&A used its own collection of Balenciaga pieces, the largest in the UK. These were originally acquired by Cecil Beaton, a longstanding friend of Balenciaga, for *Fashion: An Anthology* (1971). Its 2017 successor was staged on two levels, the ground floor featuring the work of the couturier, and the upper floor designs and video interviews from a diverse range of designers who had been influenced by Balenciaga, including Azzedine Alaïa, Oscar de la Renta, Comme des Garçons, Simone Rocha, JW Anderson, Céline, Iris Van Herpen, Erdem, Molly Goddard, and Rick Owens. Their inclusion brought currency to the heritage of the couturier, while potentially extending the audience of the exhibition to aficionados of contemporary fashion. Also included was the work of two of the house's recent creative directors, Nicolas Ghesquière and Demna Gvasalia (2017–). A suit designed by Gvasalia was placed next

to a Balenciaga to construct a narrative of continuity, legacy, and relevance of the fashion house (Figure 11.1). Yet the increasingly rapid pace of change encountered by fashion brands and their employees can prove a challenge for exhibition making. This was highlighted by Cassie Davies-Strodder, curator of the V&A exhibition,

> "When we started 18 months ago we didn't know that the brand was going to be more prevalent than ever, so it's really fortuitous," said Davies-Strodder, referring to Gvasalia's appointment and recent acclaimed collections adding, "We kick ourselves that Gvasalia's latest collection which is so literal is just too late for us to include."[37]

For the collection in question, the Fall-Winter 2017 women's wear show launched in Paris in early March 2016, Gvasalia plumbed the house archives and produced "nine modern takes on iconic Balenciaga looks, including two in black: a voluminous tulle gown pulled in as poufs at bust, waist, hip, and knee by black ribbon, and a black velvet column tied off at the waist with an enormous taffeta bow." The homage was described as "a smart and timely business move," but one intended also to respect the legacy of his predecessor Cristóbal Balenciaga.[38]

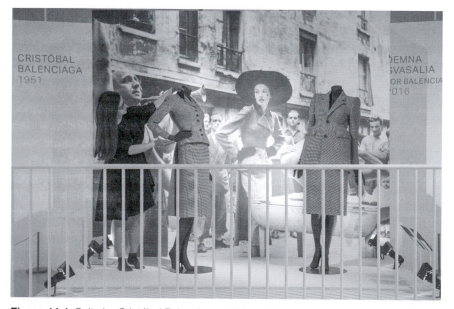

Figure 11.1 Suits by Cristóbal Balenciaga, 1951 and Demna Gvasalia, 2016, shown at *Balenciaga: Shaping Fashion,* The Victoria and Albert Museum, London, May 24, 2017–February 18, 2018. Photo by Nicky J. Sims/Getty Images

The "juxtaposition of the old and the new" referred to earlier also characterizes a tendency in contemporary fashion, which is being overtly promoted by luxury brands in particular. In a highly competitive market, where some houses have been acquired by large luxury conglomerates, notably and most significantly in terms of scale and impact, LVMH and the Kering group (which owns Balenciaga), "heritage" has become a commercial strategy. As a result, contemporary designers are charged with representing continuity and change, referencing the archives of a house, when they exist, in order to do so. This tendency to look back and forward is also reflected in fashion exhibitions, particularly where they are funded by a brand or fashion group, but they can confuse the visitor, especially those anticipating a historical show or a designer retrospective. Stevenson notes how *Chanel* at the Costume Institute (April 5– August 13, 2005) was criticized for appearing "heavy on branding," and for the amount of contemporary designs by the house's premier, Karl Lagerfeld.[39] While Lagerfeld has become renowned in the fashion system for "updating" the house by not only paying homage to but also parodying some of Chanel's classics, such juxtaposition does not necessarily sit comfortably in the museum exhibition, where certain expectations still prevail.

By comparison, *Balenciaga: Working in Black*, Musée Bourdelle, Paris was entirely historical in its content, and juxtaposed "old and new" somewhat differently, as a dialogue with its venue. The exhibition comprised seventy of Balenciaga's designs, all in black, sourced from the archives of the Palais Galliera fashion museum. Among them were a famed cowl-back silk crepe cocktail dress, from 1958, and the also renowned origami dress from 1967. Added to the monotone garment selection, the staging of the exhibition was also striking. Garments and (black) toiles were displayed amid the bronzes and marbles of this museum devoted to the work of the early twentieth-century French sculptor Antoine Bourdelle. Some pieces were positioned theatrically high, causing the visitor to look up at them, as if on a stage. Others were shrouded in black full-length cloth structures and could only be seen with the theatrical drawing back of a (black) curtain to peer at the dresses inside. Bourdelle's studio, which remains in tact, included Balenciaga hats in glass cases, which were hidden in plain sight among the artist's sculptures and his working environment. As a result, the design of the exhibition proved frustrating to some, as it took some intention to *look*, as well as to *see*, on behalf of the viewer. Organized by the innovative curator Olivier Saillard, it followed his previous exhibition at the same venue in 2011, devoted to the work of Mme Grès, where dresses were similarly displayed among the sculpture. This strategy encouraged direct comparisons between the garments and the art works, and thus between haute couture and fine art, while also enhancing the visitors' experience of the materiality of the fashion object.

Object lessons

As director of the Palais Galliera, Paris, Olivier Saillard was credited with having put that collection "back on the map in 2010," the year of his appointment.[40] The Galliera was closed for renovation until 2013, when Saillard staged his first exhibition, a retrospective of the work of fashion designer Azzedine Alaïa. Subsequently he has reinvigorated the presentation of fashion history in the spirit of the contemporary. His curatorial contributions have reinforced the status of the object, as well as bringing attention to the performative and cooperative nature of fashion. Most notable were his two collaborations with the actress Tilda Swinton. The first *The Impossible Wardrobe* was staged at the Palais de Tokyo in September 2012, as part of the Spring/Summer 2013 fashion presentations. During three 40-minute performances, Swinton, wearing gloves and a white muslin coat, the typical attire of models in couture salons, and latterly by the staff of Martin Margiela, walked 57 different items along a short runway (Figure 11.2). Included were pieces from the museum archive, dating from the late nineteenth to the mid-twentieth century, designed by fashion luminaries including Christian Dior, Coco Chanel, Elsa Schiaparelli, Mariano Fortuny, and Yves Saint Laurent, among many others. Even though she was not wearing the garments, Swinton was performing the pieces enhanced by her gestures and facial expressions, reinforcing fashion's corporeal interdependency. Other presentations by the curator and the actress did likewise. For *Eternity Dress* (2013), a garment was tailor-made on the body of the actress before a live audience. The following year *Cloakroom Vestiaire Obligatoire* had Swinton interacting with pieces of outerwear borrowed from members of the audience, whose personae she referenced by way of their garments.[41]

Through his curatorial projects Saillard has drawn upon historical archives to reinforce the relationship of contemporary fashion to its past. In June 2017, when it was announced that Saillard would be leaving his museum post in the following January to take up a position in the fashion industry, perhaps it was not surprising that he was joining a company with a long history. As the future "artistic, image, and culture director" of the French luxury men's shoe and leather goods brand J.M. Weston, Saillard described himself as moving from "studying the past to creating for the present."[42] The choice of company is revealing— established in 1891, it still produces shoes by hand, giving the products a lineage in common with the pieces in the Galliera collection. The move of a museum curator, and one with a particularly high profile, into the business of fashion draws attention to the closer correspondence between the professional fashion worlds of the exhibition and the trade. Luxury fashion brands have created exhibitions to promote their products, either in their stores[43] or more ambitiously in art museums, often in collaboration with artists. Louis Vuitton has collaborated with Japanese artists Takashi Murakami and Yayoi Kusama. Hermès, Chanel,

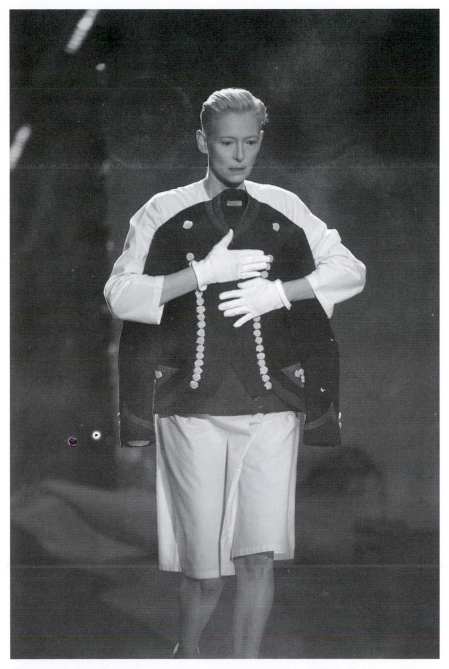

Figure 11.2 Tilda Swinton presenting a postilion jacket from 1860 in *The Impossible Wardrobe*, Palais de Tokyo, Paris, September 29, 2012. Photo: PIERO BIASION/AFP/ Getty Images

and Dior have similarly included contemporary artists in exhibitions which have been staged internationally in major art museums. Such "artification"[44] has been employed to reinforce the exclusivity and authenticity of luxury brands. In parallel in the academy, conservator Sarah Scaturro points out how the "material turn" enabled fashion curators to reaffirm their object-based scholarship, in symbiosis with "disparate cultural approaches."[45] Furthermore, the ubiquity of the virtual in everyday existence has arguably served to fetishize the expensive and exclusive fashion object, as commodity and as cultural artifact. As luxury fashion brands sponsor exhibitions to demonstrate their longevity and "authenticity," their heritage, associations with art, and their contemporary relevance, more (non-fashion specific) museums have begun to embrace fashion and its objects.

At the time of writing, the Museum of Modern Art, New York (MoMA) was about to open the exhibition *Items: Is Fashion Modern?* (October 1, 2017–January 28, 2018). This will be only the second fashion exhibition to be staged in the museum's almost ninety-year history at its midtown Manhattan location (excluding its PS1 venue in Queens). Fashion is also absent from the museum's permanent collection. The exhibition concept is based on its predecessor; held at the MoMA, be *Are Clothes Modern?* (November 28, 1944–March 4, 1945) was curated by architect and designer Bernard Rudofsky. While the rationale for that show is not clear, it was very unusual for the times; it has been credited as being "probably one of the earliest and most perceptive exhibitions on fashion."[46] Rudofsky's focus was on the relationship between fashion design, clothing and the body, and the way that bodies had been modified by garments, sometimes in what appeared an arbitrary and irrational way. While not a fashion scholar, Rudofsky's objective, to reflect on fashion and its nature rather than just to show clothes, was ground breaking for its time. As a result the exhibition has been highlighted "as a paradigmatically relevant precursor for that typology of exhibitions that aim to question and re-define the very notion of fashion," and compared to Judith Clark's *Malign Muses/Spectres* exhibition, referred to earlier.[47] The 2017 MoMA exhibition will follow the museum's object-focused trajectory in featuring "items" as a way of "exploring the present, past—and sometimes the future"[48] by means of 111 clothing typologies that emerged over the last hundred years. The MoMA co-curators Paola Antonelli and Michelle Millar Fisher have organized the exhibition into themes, including: mutating ideas of body and silhouette; the relationship between emancipation, modesty, introversion and rebellion; fashion and athleticism; everyday uniforms; and fashion and power. Existing and historical pieces will be enhanced by special commissions from designers, engineers, and manufacturers, who were charged by the curators with responding to "indispensable items with pioneering materials, approaches, and techniques."[49] In answer to the questions why now?, why MoMA? a Press Release from the museum describes fashion as "a crucial field of design—[that] touches everyone, everywhere."[50] According to Antonelli, the exhibition aims to present fashion as

A powerful form of creative and personal expression that can be approached from multiple angles of study, fashion is unquestionably also a form of design, with its pitch struck in negotiations between form and function, means and goals, automated technologies and craftsmanship, standardization and customization, universality and self-expression.[51]

In expressing fashion's relationship to creativity, personal identity and above all to design, Antonelli highlights aspects of fashion which often become lost in its more ubiquitous commercial arena, as well as in museum exhibitions. Recognition of fashion as a creative and *personal* expression also references fashion's everydayness, which is its extent beyond the realm of the art object. So while the MoMA is working within its established professional parameters of the curation of art and design objects, it is also contributing to expanding fashion's field. The status and popularity of the MoMA helps to reinforce fashion's social, cultural, and creative roles, and, moreover, its potential for critical self-reflection in the twenty-first century. The MoMA exhibition also follows after an increasing number of recent exhibitions that have taken a more critical position on fashion and highlight some of the issues associated with the "end of fashion." In the latter category are exhibitions that, in common with some of the MoMA items, are collaborations with designers and artists that have resulted in the production of new work, including site-specific installations. Two of these exhibitions are the subject of the next and final section of this chapter.

After Fashion

Dysfashional, curated by Luca Marchetti and Emanuele Quinz, in Luxembourg, Lausanne, Paris, Berlin, and Moscow (2007–2010), has been described as having less to do with clothing than with the sensibilities associated with what we wear, "gestures, noises, odors and self-image."[52] Featuring the work of high-profile designers such as Raf Simons, Hussein Chalayan, and Maison Martin Margiela, the show took the form of installations that focused on fashion as a means of creative exploration. Its curators described *Dysfashional* as, "a site where the exhibition space becomes an experimental space, an exploration ground for both the artists and visitors." They did not exhibit clothes. The installation by Maison Martin Margiela for example, comprised tapestry, photographs, and trompe-l'oeil (Figure 11.3). The exhibition also included a "para-site" that is a temporary "guerilla store" where paintings, drawings, jewelry, and 3-D models inspired by fashion and produced by fifteen young creators were available for sale on-site and online during the show. The nature of the activities in the exhibition, rather than the actual physical space/s in which it was held, led to it being described as "a hybrid space, halfway between a boutique and an art gallery."[53] Its form and content reflected the curators' concept

Figure 11.3 *Dysfashional*, cur. Luca Marchetti and Emanuele Quinz (edition 2007, La Rotonde 1, Luxembourg and Great Region—European Capital of Culture, April 21– May 27, 2007); *Untitled,* installation by Maison Martin Margiela, mixed media, original commission and production. Photo: André Morin.

"that fashion is, beyond the objects that materialize it, an unstable state of sensibility."[54] That sense of instability reiterates how fashion in the end times is an expanded field of practices that, through exhibitions, are becoming more self-reflexive.

It was the recognition of fashion's capacity to reflect critically that preempted the exhibition that I co-curated, with Ilari Laamanen at the Museum of Arts and Design, New York (April 26–August 6, 2017).[55] Titled *fashion after Fashion,* the exhibition responded to critical authorities, including those cited at the beginning of this chapter, and the work of many fashion designers, suggesting that fashion had entered a new phase. *fashion after Fashion* took up this call, offering a contemporary understanding of fashion that drew upon a range of design and artistic practices and ideologies. The exhibition included new site-sensitive installations by six designer teams who were thinking about fashion, as well as working in different aspects of the fashion industry, producing garments and images. We used fashion (in the lowercase) to signal a more reflective, concerned, attentive, and creative process that is not determined solely by commerce, the market, and passing trends, in comparison to Fashion (in the uppercase). By calling into question the state and nature of Fashion, the exhibition sought to challenge some of its main constructs, including the myth of the individual designer as author, short-lived and commodity-driven products, gendered dressing, ideal bodies, and waste. The work demonstrated the need to redefine the term fashion to signal the way in which its practices have become more complex, diverse, critically informed, and socially relevant. Perhaps contrary to expectations for a fashion exhibition, *fashion after Fashion* did not feature well-known designer brands and names, or display garments on mannequins (an approach it shared with *Dysfashional*). Rather, it addressed fashion within the expanded field of practice that is determined by concept and context, and whose practitioners work collaboratively across areas of design and art, incorporating performances, photographs, video, and sculpture.

For *fashion after Fashion*, we chose to include the Danish artist and designer Henrik Vibskov, because of the breadth of his experience working as a fashion designer and also in producing performances and installations internationally in a variety of venues, including public spaces. His original gallery installation *Harmonic Mouth* had been staged as a performance piece, in a forest outside of Copenhagen, which was shown as a video in the exhibition. It combined many references, to the small and intimate spaces of fashion rather than to its public places, to the visceral qualities of bodies and their relationship to clothes, as well as to fashion's relationship to the passage of time (Plate 20). The piece spoke to and about fashion, and like fashion it both confused and delighted, depending on the perspective and experience of the viewer. Next to it was an installation and video by Lucy Jones, a young, New York-based designer whose work aims to be inclusive of physical difference and disabilities. Her installation, comprising twenty-two fabric "elbows," was a visually poetic response to the complexity of the relationship between bodies and garments, enhanced by her process-based

video (Figure 11.4). The Finnish artist duo ensaemble also addressed relationships between body and clothes by referencing the inside of garments. New York fashion designers Eckhaus Latta worked with video artist Alexa Karolinski to produce a video that emphasized how the intimacies of our human identities and emotions are related to how we look and what we wear. Toumas Laitinen and Chris Vidal Tenomaa based a piece on their magazine *SSAW*, which highlighted Fashion's obsession with images. Japanese designer Ryohei Kawanishi challenged the way that Fashion's value system can be so dependent on brands and designer labels. This piece also brings us back to where this chapter began, and the dominance of the brand—one of the trigger points of Terri Agins's end of fashion, and one of Christopher Breward's three fashion research constituencies.

Breward's references to the fashion exhibition's relationship to archival sources, contemporary fashion practice and business, and their cumulative intertwining remain a fitting overview of recent exhibition practices, and also of fashion itself. As the examples given earlier demonstrate, the fashion exhibition is now more varied in both its concept and its practice than ever before. It can and should be acknowledged as an expanded field of practice that contributes to the establishment of critical discourse for fashion. Timing is important. This discourse is not only much needed, but long overdue. While the "end times" are not to be taken literally, for fashion they can be seen as signaling a period of hiatus, of taking stock, when complexities need to be addressed. Now, the fashion exhibition is an essential praxis for these times.

Figure 11.4 "Inclusive fashion," by Lucy Jones. Installation view from *fashion after Fashion,* 2017, The Museum of Arts and Design, New York. Photo by Jenna Bascom. Courtesy of the Museum of Arts and Design

NOTES

Introduction

1 Slavoj Žižek, *Living in the End Times* (London and New York: Verso, 2011), 480.

2 Arthur Danto, *After the End of Art: Contemporary Art and the Pale of History* (New Jersey: Princeton University Press, 1997), 15.

Chapter 1

1 Oscar Wilde, quoted in Radu Stern, *Against Fashion: Clothing as Art, 1850–1930* (Cambridge, MA: The MIT Press, 2004), 9.

2 Tansy E. Hoskins, *Stitched Up: The Anti-Capitalist Book of Fashion* (London: Pluto Press, 2014), 160, 185–202.

3 Barbara Vinken, *Fashion Zeitgeist: Trends and Cycles in the Fashion System*, trans. Mark Hewson (Oxford and New York: Berg, 2005), 63.

4 Teri Agins, *The End of Fashion: The Mass Marketing of the Clothing Business* (New York: William and Morrow, 1999), 280, 11.

5 Interview with Teri Agins, March 8, 2017.

6 Marcus Fairs, Interview with Li Edelkoort. *Dezeen*, March 1, 2015, last accessed January 30, 2017, https://www.dezeen.com/2015/03/01/li-edelkoort-end-of-fashion-as-we-know-it-design-indaba-2015/.

Marcus Fairs, "Li Edelkoort Publishes Manifesto Explaining Why Fashion Is Obsolete," *Dezeen*, March 2, 2015, last accessed January 30, 2017, https://www.dezeen.com/2015/03/02/li-edelkoort-manifesto-anti-fashion-obsolete/.

7 George Melly, *Revolt into Style: The Pop Arts in Britain* (London: Allen Lane The Penguin Press, 1970), 150.

8 Quant, quoted in Valerie Steele, *Women of Fashion* (New York: Rizzoli, 1991), 134.

9 See Christine Jacqueline Feldman, *We Are the Mods: A Transnational History of a Youth Subculture* (New York: Peter Lang, 2009).

10 Ibid., 209–210.

11 Ibid., 212.

12 Suzy Menkes, "The New Speed of Fashion," *T Magazine,* August 23, 2013, last accessed January 30, 2017, http://www.nytimes.com/2013/08/23/t-magazine/the-new-speed-of-fashion.html.

13 Cathy Horyn, "Why Raf Simons Is Leaving Christian Dior," *The Cut*, October 22, 2015, last accessed January 30, 2017, http://nymag.com/thecut/2015/10/raf-simons-leaving-christian-dior.html.

14 Karl Lagerfeld quoted in "WWD Overheated!" *WWD*, October 28, 2015, 50–59.

15 Ibid.

16 Mihaly Csikszentmihalyi, *Creativity: Flow and the Psychology of Discovery and Invention* (New York: Harper Perennial, 1996), 1, 31, 28.

17 Ibid., 8–9.

18 Iris Van Herpen quoted in Bradley Quinn, *Fashion Futures* (London: Merrell, 2012), 50.

19 Iris Van Herpen quoted in *Iris Van Herpen: Transforming Fashion* (Groninger Museum and High Museum of Art, 2015), n.p.

20 Elizabeth Wilson, *Adorned in Dreams: Fashion and Modernity* (London: I.B. Tauris, 1985), 244.

21 Ibid., 232.

22 "fashion after Fashion," Mad Museum, April 27, 2017, accessed June 1, 2017, http://madmuseum.org/exhibition/fashion-after-fashion.

23 Johan Deurell and Hanne Eide, eds., *Utopian Bodies—Fashion Looks Forward* (Stockholm: Liljevalchs, 2015), 11.

Chapter 2

1 G. W. F. Hegel, *Vorlesungen über die Ästhetik, Werke* 14 (Frankfurt am Main: Suhrkamp 1986), 402.

2 In a later essay, "Marx and Sons" based on a series of responses to *Specters of Marx*, Derrida states: "A shift from Marx to Marxism, then: why? *Who* is Marxism? Ahmad? All those he comes forward to represent? But already in *this* book alone, there is no possibility of agreement or homogeneity among all the 'Marxists,' all those who call themselves or are called 'Marxists.' Even if it were possible to identify all of them as 'Marxists,' it would still be impossible to identify them all with one another. There is nothing wrong with this, in my view, but it should make the identifying label 'Marxist' more uncertain than ever (I discuss this more than once in *Specters of Marx*)." "Marx and Sons," in *Ghostly Demarcations: A Symposium on Jacques Derrida's* Specters of Marx, ed. Michael Sprinker (London and New York: Verso, 1999 [2008]), 225.

3 Jacques Derrida, *Specters of Marx: The State of the Debt, The Work of Mourning and the New International*, trans. Peggy Kamuf (London and New York: Routledge, 1994), 51–52.

4 Ibid., 52.

5 Ibid.

6 Ibid., 93–94.

7 Ibid., 54.

8 Ibid., 99.

9 Ibid.

10 Caroline Evans, *Fashion at the Edge* (New Haven, CT and London: Yale University Press, 2009), 249–250.

11 Brook Thomas, *The New Historicism and Other Old-Fashioned Topics* (New Jersey: Princeton University Press, 1991), 24.

12 Ibid., 24–25.

13 Walter Benjamin, Convolute B. 2,4. in The Arcades Project, third edition, trans. Howard Eiland and Kevin McLaughlin, Boston: Harvard University Press, 2000., B, 2,4.

14 Jean Baudrillard, *Seduction*, trans. Brian Singer (Montreal: New World Perspectives, Culturo Toxt Sorioo, 1001), 131.

15 Jean Baudrillard, "Fashion or the Enchanting Spectacle of the Code," in *Fashion Theory. A Reader*, ed. Malcolm Barnard (London and New York: Routledge, 2014), 463.

16 Ibid.

17 See also Geczy and Karaminas, "Rei Kawakubo's Deconstructivist Silhouette," in *Critical Fashion Practice* (London and New York: Bloomsbury, 2017), 29–43.

18 Theodor W. Adorno, "Cultural Criticism and Society," in *Prisms*, trans. Samuel and Shierry Weber (Cambridge, MA: MIT Press, 1981 [1990]), 34.

19 Yuniya Kawamura, *The Revolution in Paris Fashion* (Oxford and New York: Berg, 2004), 138.

20 Annie Proulx, "Brokeback Mountain. Cowboys and Horses and Long, Lonely Nights in the Wilderness," *The New Yorker*, October 13, 1997, accessed September 2, 2017, www.newyorker.com/magazine/1997/10/13/brokeback-mountain.

21 Susan Sontag, *On Photography* (Harmondsworth: Penguin, 1979), 15.

22 Juliette Ash, "Memory and Objects," in *The Gendered Object*, ed. P. Kirkham (Manchester: Manchester University Press, 1996), 20–21.

23 Elizabeth Wilson, *Adorned in Dreams. Fashion and Modernity* (London: I.B. Tauris, 2007), 1.

24 Theodore W. Adorno, "Valéry Proust Museum," in *Prisms*, trans. Samuel and Shiery Weber (London: Neville Spearman, 1967), 175.

25 Ibid., 177.

26 Ibid.

27 Ibid, 2.

28 "Marc Jacobs says Fashion is not Art," *Los Angeles Times*, November 12, 2007, accessed September 23, 2012, http://latimesblogs.latimes.com/alltherage/2007/11/marc-jacobs-say.html.

29 Baudrillard, "Fashion or the Enchanting Spectacle of the Code," 466.

30 Jacques Derrida, "Archive Fever: A Freudian Impression," *Diacritis* 25, no. 2 (Summer 1995): 9.

31 Ibid.

32 Ibid.

33 Ibid.

Chapter 3

1 Walter Benjamin, *The Arcades Project* (Cambridge, MA: Harvard University Press, 1999), 880.

2 Ibid., 423.

3 Arjun Appadurai, *Modernity at Large: Cultural Dimensions of Globalization* (Minneapolis: University of Minnesota Press, 1996), 27.

4 Ibid., 31.

5 Walter Benjamin, *The Work of Art in the Age of Its Technological Reproducibility (1936) and Other Writings on Media* (Cambridge, MA: Harvard University Press, 2008).

6 Benedict Anderson, *Imagined Communities. Reflections on the Origin and Spread of Nationalism (1983)* (London and New York: Verso, 1991).

7 Appadurai, *Modernity at Large*, 31.

8 Ibid., 32.

9 See Michel Maffesoli, *The Time of the Tribes. The Decline of Individualism in Mass Society* (London-Thousand Oaks-Delhi: Sage, 1996), and Marcel Danesi, *La comunicazione al tempo di Internet* (Bari: Progedit, 2013).

10 Appadurai, *Modernity at Large*, 33.

11 Ibid.

12 See Karaminas, "Image: Fashionscapes," 177–187.

13 Patrizia Calefato, *Mass moda. Linguaggio e immaginario del corpo rivestito* (Genova: Costa & Nolan, 1996) (2nd edition, Roma: Meltemi, 2007)

14 Organized and convened by Vicki Karaminas and Hilary Radner, at the College of Creative Arts, Massey University, New Zealand, December 8–9, 2016.

15 Roland Barthes, *The Language of Fashion* (Oxford: Berg Publishers, 2006), 41.

16 Ibid.

17 Appadurai, *Modernity at Large*, 71.

18 Ibid., 75.

19 Walter Benjamin, *Illuminations*, ed. Hannah Arendt (New York: Schocken Books, 1968), 261.

20 Antonella Giannone, "La costruzione del senso filmico nell'abbigliamento e nel costume," in *Moda e cinema*, ed. Patrizia Calefato (Genova: Costa & Nolan, 1999), 32.

21 "Dabbawala," Wikipedia, the free encyclopedia, last modified May 29, 2017, https://en.wikipedia.org/wiki/Dabbawala#Origins.

22 Daniel Klein and Mirra Fine, "Dabbawalla" Vimeo video, 3:51, posted by "The Perinnial Plate," February 28, 2013, https://vimeo.com/60748502.

23 Rey Chow, "The Writing Voice in Cinema: A Preliminary Discussion," in *Locating the Voice in Film: Critical Approaches and Global Perspectives*, eds. Tom Whittaker and Sarah Wright (Oxford: Oxford UP, 2017)

24 Patrizia Calefato, *La moda oltre la moda* (Milano: Lupetti, 2011), 138.

25 Roberta Filipinni, "Armani privé riscrive eleganza della geisha," *ANSA*, July 6, 2011, www.ansa.it/web/notizie/photostory/spettacolo/2011/07/06/visualizza_new.html_789622551.html

26 "Geisha o Dea," La Repubblica, last modified July 6, 2011, http://ricerca.repubblica.it/repubblica/archivio/repubblica/2011/07/06/geisha-dea.html.

27 Appadurai, *Modernity at Large*, 12–13.

28 Rey Chow, *Ethics after Idealism. Theory, Culture, Ethnicity, Reading* (Bloomington-Indianapolis: Indiana University Press, 1998), 74–97.

Chapter 4

1 Marcia A. Morgado, "Fashion Phenomena and the Post-postmodern Condition: Enquiry and Speculation," *Fashion, Style, & Popular Culture* 1, no. 3 (2014): 313–339; Mike Featherstone, *Consumer Culture and Postmodernism* (London: Sage Publications, 2007).

2 Jean-François Lyotard, *The Postmodern Condition: A Report on Knowledge*, trans. Geoff Bennington and Bryan Massumi (Manchester: Manchester UP, 1991), 81.

3 Jacques Derrida, *A Derrida Reader: Between the Blinds*, ed. Peggy Kamuf (New York: Columbia UP, 1991).

4 Jack Reynolds and Jonathan Roffe, *Understanding Derrida* (New York: Continuum, 2004), 46.

5 Jacques Derrida, *Dissemination*, trans. Barbara Johnson (Chicago: The University of Chicago Press, 1981), 121.

6 Alison Gill, "Deconstruction Fashion: The Making of Unfinished, Decomposing and Re-assembled Clothes," *Fashion Theory: The Journal of Dress Body & Culture* 2, no. 1 (1998): 25–49; Francesca Granata, "Deconstruction Fashion: Carnival and the grotesque," *Journal of Design History* 26, no. 2 (2012): 182–198; Agata Zborowska, "Deconstruction in Contemporary Fashion Design: Analysis and critique," *International Journal of Fashion Studies* 2, no. 2 (2015): 185–201. Geczy and Karaminas, *Critical Fashion Practice: From Westwood to van Beirendonck* (New York and London: Bloomsbury, 2017).

7 Caroline Evans, *Fashion at the Edge* (New Haven, CT and London: Yale University Press, 2003), 249–253.

8 Sally Singer et al., "Ciao, Milano! Vogue.com's Editors Discuss the Week That Was," *Vogue.com*, September 25, 2016, accessed June 7, 2017, http://www.vogue.com/article/milan-fashion-week-spring-2017-vogue-editors-chat.

9 Carly Stern, "A VERY stylish showdown!" *The Daily Mail* UK, September 27, 2016, accessed June 7, 2017, http://www.dailymail.co.uk/femail/article-3809981/A-stylish-showdown-Vogue-editors-aim-pathetic-bloggers-sit-row-Fashion-Week-scathing-article-branding-online-stars-desperate-embarrassing.html.

10 Susie Bubble, September 26, 2016 (12:59 a.m.), Twitter post by @susiebubble, accessed June 7, 2017, https://twitter.com/susiebubble/status/780315796107034624.

11 As defined in the field of marketing, the influencer is the individual whose effect on the purchase decision is in some way significant or authoritative.

12 Franz Fidler, *Portretnaia fotografiia* (Moscow: Vsesoiuznoe kooperativnoe izdatel'stvo, 1960), 13.

13 Joseph Daniel Lasica, "Photographs That Lie: The Ethical Dilemma of Digital Retouching," in *State of the Ar: Issues in Contemporary Mass Communication*, eds. David Shimkin, Harold Stolerman, and Helene O'Connor (New York: St. Martin's Press, 1992), 189–194.

14 Ibid., 190.

15 Ibid., 193.

16 Ingrid Hoelzl and Marie Remi, *Soft Image: Towards a New Theory of Digital Image* (Chicago: Intellect, 2015).

17 See, for instance, last accessed June 7, 2017, http://fotoforensics.com.

18 Olga Vainshtein, "Digital Beauties: Strategies of Self-Presentation and Resistance," in *Beauty: Exploring Critical Perspectives*, eds. Pierre Wilhelm and Rebecca Nash (Oxford: Inter-Disciplinary Press, 2016), 81–93, Electronic book.

19 Stuart Ewen, "All-Consuming Images: Style in the New 'Information Age'," in *State of the Art: Issues in Contemporary Mass Communication*, eds. David Shimkin, Harold Stolerman, and Helene O'Connor (New York: St. Martin's Press, 1992), 196.

20 Ibid., 196.

21 Ibid., 197.

22 Liz Willis-Tropea, "Glamour Photography and the Institutionalization of Celebrity," *Photography & Culture* 4, no. 3 (2011): 261–276.

23 Roland Barthes, *Mythologies*, trans. Annette Lavers (New York: The Noonday Press. Farrar, Straus & Giroux, 1991), 78.

24 Gail K. Paster, *The Body Embarrassed: Drama and the Disciplines of Shame in Early Modern England* (Ithaca, NY: Cornell University Press, 1993), 25.

25 Ibid., 25.

26 Ibid., 23–64.

27 Vainshtein, "Digital Beauties," 81–93.

28 "Photoshop of Horrors," *Jezebel*, powered by Gizmodo Media Group, 2017, accessed June 7, 2017, http://jezebel.com/tag/photoshop-of-horrors.

29 "What's the Secret of My Beauty? Adobe Photoshop Day Cream – 25 after before Photos," *Webneel*, accessed June 7, 2017, http://webneel.com/webneel/blog/whats-secret-my-beauty-photoshop-after.

30 Jessica Coen, "Here Are the Unretouched Images from Lena Dunham's Vogue Shoot," *Jezebel*, January 17, 2014, accessed June 7, 2017, http://jezebel.com/here-are-the-unretouched-images-from-lena-dunhams-vogu-1503336657.

31 Maryann McCabe, Timothy De Waal Malefyt, and Antonella Fabri, "Women, Makeup, and Authenticity: Negotiating Embodiment and Discourses of Beauty," *Journal of Consumer Culture*, article first published online: October 16, 2017, accessed December 9, 2017, https://doi.org/10.1177/1469540517736558.

32 Jamila Rizvi, "Will You Help Turn These Numbers Around?" *Mamamia*, August 18, 2013, accessed June 7, 2017, http://www.mamamia.com.au/fernwood-body-image-survey/.

33 Ibid.

34 Michael Zhang, "Kate Winslet's Modeling Contract with L'Oréal Has a 'No Photoshop' Clause," *PetaPixel*, October 24, 2016, accessed June 7, 2017, https://petapixel.com/2015/10/24/kate-winslets-modeling-contract-with-loreal-has-a-no-photoshop-clause/.

35 Stassa Edwards, "New Photographs Show That Zendaya Was Heavily Photoshopped for Magazine Shoot," *Jezebel*, March 11, 2015, accessed June 7, 2017, http://jezebel.com/new-photographs-show-that-zendaya-was-heavily-photoshop-1740424576.

36 Truth in Advertising Act of 192014–H.R.4341, 113th Congress (2013–2014), *Library of Congress*, accessed June 7, 2017, https://www.congress.gov/bill/113th-congress/house-bill/4341.

37 Rachel Lubitz, "France passes law requiring companies to admit when models have been photoshopped," *Mic Network Inc.*, 2017, accessed June 7, 2017, https://mic.com/articles/130789/france-passes-law-requiring-companies-to-admit-when-models-have-been-photoshopped#.llGs9KeX3.

38 Kim Willsher and agencies, "Models in France must provide doctor's note to Work," *The Guardian* AUS, December 18, 2015, accessed June 7, 2017. https://www.theguardian.com/world/2015/dec/18/models-doctors-note-prove-not-too-thin-france.

39 "Raw Beauty Talks: Help Us Create Positive Change for Young Women by Reducing Photoshop in Magazines," *Change.org Inc.*, last modified 2017, accessed June 7, 2017, https://www.change.org/p/reduce-photoshop-in-magazines-to-create-a-better-world-for-girls.

40 Julia Blum, "Seventeen Magazine: Give Girls Images of Real Girls!" *Change.org Inc.*, last modified 2017, accessed June 7, 2017, https://www.change.org/p/seventeen-magazine-give-girls-images-of-real-girls

41 Lauren Collins, "Pixel Perfect. Pascal Dangin's Virtual Reality," *The New Yorker*, May 5, 2008, accessed June 7, 2017, http://www.newyorker.com/magazine/2008/05/12/pixel-perfect.

42 Seth Matlins, "Ask Dove to Help Protect Our Children from Photoshopped Ads and Beauty," *Change.org Inc*, last modified 2017, accessed June 8, 2017, https://www.change.org/p/dove-make-real-beauty-more-real-and-sign-the-truth-in-advertising-heroes-pledge.

43 Jean Baudrillard, "Simulacra and Simulations," in *Modernism/Postmodernism*, ed. Peter Brooker (London: Longman, 1992), 152–153.

44 Ibid., 156, my emphasis.

45 Luciana Ugrina, "Celebrity Biometrics: Norms, New Materialism, and the Agentic Body in Cosmetic Surgery Photography," *Fashion Theory* 18, no. 1 (2014): 35.

46 Renee Zellweger, "We Can Do Better," *Huffington Post, The blog*, August 8, 2016, last June 8, 2017, http://www.huffingtonpost.com/renee-zellweger/we-can-do-better_b_11355000.html.

47 Ugrina, "Celebrity Biometrics," 36.

48 Bor Stenvik, *Vse my vrem. Kak lozh', zhul'nichestvo i samoobman delaiut nas liud'mi* (Moscow: Alpina Publisher, 2016), 370.

49 Kathryn Yusoff and Claire Waterton, "Indeterminate Bodies," *Body and Society* 3, no. 23 (2017): 3–22.

50 Walter Benjamin, *Illuminations* (London: Fontana,1968), 214–218.

51 Elizabeth Wilson, "Fashion and Postmodern Body," in *Chic Thrills: A Fashion Reader*, eds. Juliet Ash and Elizabeth Wilson (Berkeley and Los Angeles: University of California Press, 1992), 3–17.

52 In 2013, David Bowie released his song "*The Stars Are Out Tonight*," which plays on the theme of androgyny. In the video Bowie appeared with Tilda Swinton, Andreja Pejić and Saskia de Brauw. See "David Bowie: The Stars (Are Out Tonight)," YouTube Video, posted by DavidBowieVEVO, February 25, 2013, https://www. youtube.com/watch?v=gH7dMBcg-gE.

53 Alice Gregory, "Has the Fashion Industry Reached a Transgender Turning Point?" *Vogue*, April 21, 2015, accessed June 8, 2017, http://www.vogue.com/article/ andreja-pejic-transgender-model.

54 Sadie Whitelocks, "Blonde bombshell who cut off hair to work as male model reveals how she and her husband now get mistaken for a 'gay couple,'" *The Daily Mail*, October 30, 2013, accessed June 8, 2017, http://www.dailymail.co.uk/femail/ article-2480168/Elliott-Sailors-female-works-male-model-gets-mistaken-husband- gay-couple.html.

55 Visual Kei is a movement in Japanese rock music. These musicians often aim at over-the-top theatricality and an androgynous appearance, with a preference for flamboyant outfits, exuberant hairstyles, and bold makeup.

56 The word "illusion" is etymologically derived from the Latin *illusio*, meaning deception or delusion, but the root ultimately relates to the verb *ludere*, to play. Many great minds have engaged in this play of illusions. For example, the "rabbit or duck" optical illusion was analyzed in detail by Ludwig Wittgenstein in his *Philosophical Investigations*.

57 Myles Udland, "The internet is losing its composure over this dress that might be white and gold or black and blue," *Business Insider*, February 26, 2015, accessed June 8, 2017, http://www.businessinsider.com/white-and-gold-black-and-blue- dress-2015-2.

58 Ian Sample, "#TheDress: Have researchers solved the mystery of its colour?" *The Guardian*, May 14, 2015, last modified February 22, 2017, accessed June 8, 2017, https://www.theguardian.com/science/2015/may/14/thedress-have-researchers- solved-the-mystery-of-its-colour.

59 Amanda Kooser, "Viral optical illusion asks if these legs are oiled or painted," *CNET Magazine*, October 26, 2016, accessed June 8, 2017, https://www.cnet.com/news/ viral-optical-illusion-legs-oily-paint-the-dress/.

60 Hunter, September 15, 2016, Instagram, posted by @Leonardhoespams, accessed June 8, 2017, https://www.instagram.com/p/BKZAe_zgQYl/.

61 Jacques Derrida, *A Derrida Reader,* 184.

62 Brenda DeMartini-Squires, "Now You See It: Disinformation and Disorientation on the Internet," in *A History of Visual Culture: Western Civilization from the 18th to the*

21st Century, eds. Jane Kromm and Susan Benforado Bakewell (Oxford and New York: Berg, 2010), 341.

63 For example, in the world of selfies in 2015, the previously fashionable "duck face," with the lips sucked in to resemble a duckbill, was replaced by the "fish gape" (a half-smile with the teeth slightly exposed).

64 Olga Vainshtein, "Everybody Lies: Fotoshop, moda i telo," *Teoria Modi* 43 (2017): 201–235.

65 Josh Toth, *The Passing of Postmodernism: A Spectroanalysis of the Contemporary* (Albany, NY: SUNY Press, 2010).

Chapter 5

1 Chis Rojek, *Fame Attack: The Inflation of Celebrity and Its Consequences* (London: Bloomsbury, 2013), 185.

2 See Pamela Church Gibson, *Fashion and Celebrity Culture* (London: Berg, 2012) and Pamela Church Gibson, "Pornostyle: Sexualised Dress and the Fracturing of Feminism," *Fashion Theory: The Journal of Dress, Body, and Culture* 18, no. 2 (2014): 186–206.

3 See, for example, Christine Gledhill, ed., *Stardom: Industry of Desire* (London: Psychology Press, 1991).

4 See Nicky Ryan, "Patronage," in *Fashion and Art*, eds. Adam Geczy and Vicki Karaminas (London and New York: Berg, 2012), 155–169, and Mona Schieren and Andrea Sich eds., *Look at Me: Celebrity Culture at the Venice Art Biennale* (Nuremberg: Verlag fűr Moderne Kűnst, 2011).

5 See Leo Braudy, *The Frenzy of Renown: Fame and Its History* (Oxford: Oxford University Press, 1986).

6 See Chris Rojek, *Celebrity* (London: Reaktion, 2011). The entire first section of this book is essential for a full understanding of his categorization of celebrities.

7 See, for example, Graeme Turner, *Understanding Celebrity* (London: Sage, 2004); David Marshall, *Celebrity and Power: Fame in Contemporary Culture* (Minneapolis: University of Minnesota Press, 1997) and Ellis Cashmore, *Celebrity Culture* (London: Routledge, 2006).

8 Hans Magnus Enzensberger, "Constituents of a Theory of the Media," *New Left Review* 1, no. 64 (November–December 1970): 13–36.

9 Walter Benjamin, *The Work of Art in the Age of Mechanical Reproduction*, eds. Michael Jennings et al. (Cambridge, MA: Harvard University Press, 1935/2008).

10 Henry Jenkins, *Convergence Culture: Where Old and New Media Collide* (New York: NYU Press, 2006).

11 Enzensberger, "Theory of the Media," 25.

12 Lefebvre quoted in ibid.

13 Ibid.

14 Ibid., 14.

15 Ibid.

16 Ibid., 16.

17 Louise Crewe, *The Geographies of Fashion* (London: Bloomsbury, 2017), 37–65, see also Hoskins, *Stitched Up*.

18 Among the few fashion theorists who have discussed production are Joanne Entwistle, *The Aesthetic Economy of Fashion: Markets and Value in Clothing and Modelling* (Oxford: Berg, 2009) and Tim Edwards, *Fashion in Focus: Concepts and Practices* (London: Routledge, 2011). For a clear account of the relevant issue, see the essay by Adam Briggs, "Capitalism's Favourite Child," in *Fashion Cultures Revisited: Theories, Explorations and Analysis*, eds. Stella Bruzzi and Pamela Church Gibson (London: Routledge, 2013).

19 The "trickle-down" theory of fashion was originally proposed by Thorstein Veblen, whose influential work *The Theory of the Leisure Class* was first published in 1899 and which has been reprinted constantly. It is also linked to an influential essay "Fashion" by Georg Simmel, republished long after Simmel's death, in *The American Journal of Sociology* 62, no. 6 (May 1957): 541–558. In fact, Simmel himself was drawing heavily on earlier work by continental theorists working in other disciplines, including the sociologist Emil Durkheim.

20 The term "bubble-up" was arguably first used by anthropologist Ted Polhemus, whose book was first published by Thames and Hudson to coincide with the 1994 exhibition, *Streetstyle: From Sidewalk to Catwalk* at the V & A Museum in London.

21 See, for what seems to be the first published use of the term, Terry Agins, *The End of Fashion* (London: HarperCollins, 1999).

22 Lidewij Edelkoort, an influential fashion forecaster, released her tract *Anti-Fashion: A Manifesto for the Next Decade* in July 2015; it was published by her Paris-based forecasting agency, Trend Union.

23 Elizabeth Wilson, *Adorned in Dreams* (London: Virago, 1984), 3.

24 See Church Gibson, "Pornostyle."

25 Ibid.

26 Ibid.

27 Alexandra Sastre, "Hottentot in the Age of Reality TV: Sexuality, Race and Kim Kardashian's Visible Body," *Celebrity Studies* 5, no. 1–2 (August 2013): 123–137.

28 See Rojek, *Celebrity*.

29 *Vanity Fair* (US) for July 2015 featured Jenner's "reveal" as Caitlyn, both on the cover and in an extended feature written by Buzz Bissinger.

30 See article by Elle Hunt, "Essena O'Neill Quits Instagram," *The Guardian*, November 3, 2015.

31 Ibid.

32 See article by Amy De Klerk, "Kardashians to Blame," *Harpers' Bazaar* (UK), March 31, 2017, May 26, 2017, http://www.harpersbazaar.co.uk/beauty/news/a40729/kardashians-to-blame-for-the-number-of-millennial-women-getting-cosmetic-procedures/

33 See article by *Harpers' Bazaar* online, item by Sarah Kamali, March 17, 2017.

34 *The Fast and the Furious* is an action film franchise, one of the most successful ever to be created for the cinema. Dwayne Johnson has been part of the cast since 2011.

35 Kamali, *Harpers' Bazaar*, 2017.

36 The Pepsi-Cola advertisement, withdrawn after twenty-four hours, was quite rightly criticized for trivializing protest movements such as Black Lives Matter and the Women's Marches against Trump through its use of particular images. The furore only increased when Pepsi-Cola apologized to Kendall Jenner for having "involved her."

37 See interview with Riccardo Tisci by Merle Ginsberg for *Prêt–a–Reporter*, The Hollywood Reporter, March 18, 2015, June 26, 2017, http://www.hollywoodreporter. com/news/givenchys-riccardo-tisci-why-he-782524.

38 Jess Cartner-Morley, "Oliver Rousteing on Rihanna, Kim Kardashian and the Balmain Army," *The Guardian*, September 15, 2016.

39 The best account of the relationship between fashion theory and more traditional academic disciplines is that provided by Valerie Steele in "The F Word," an essay in *Lingua Franca*, April, 1991, 17–20.

40 Rojek, *Fame Attack*, 185.

41 Marshall, *Celebrity and Power*.

42 Schieren and Sich, *Look at Me*.

43 See, among others, Nick Johnstone, "Dare to Bare," a profile on Beecroft in *The Observer*, March 13, 2005.

44 The documentary film, *The Art Star and the Sudanese Twins*, was directed by Pietra Bretkelly and received its first screening at the Sundance Film Festival in 2008.

45 The book of photographs, *Selfish*, is written by Kim Kardashian West, and published by Rizzoli (New York) in May, 2015.

46 W Magazine, *The Art Issue*, November, 2010.

47 *Paper* magazine, Winter 2014: Cover and Feature, "Break the Internet."

48 See, for example, Sarah Thornton, *Seven Days in the Art World* (London: Granta, 2008).

49 The film is *Once Upon a Time*, directed for Chanel by Karl Lagerfeld in 2013.

50 US *Vogue*, April 2014, cover photograph by Annie Liebowitz of West and Kardashian.

51 Kathleen Baird-Murray, "Whatever Happened to the Cleavage?" *Vogue*, UK, December, 2016.

52 Leandra Medine, "Confession: I Don't Get Vêtements," writing for her blog *Man Repeller*, March 30, 2016, http://www.manrepeller.com/2016/03/confession-i-dont-get-vêtements.html.

53 Ibid., January 27, 2017.

54 Jess Cartner-Morley, "What I Wore This Week," *The Guardian*, March 24, 2017.

55 Susan Bordo, *Unbearable Weight: Feminism, Western Culture and the Body* (Oakland: University of California Press, 1993).

56 Michael Foucault, *Discipline and Punish: The Birth of the Prison System* (London: Penguin Books, 1977/1991).

57 Ibid.

58 De Klerk, "Kardashians to Blame."

59 Ibid.

60 Ibid.

61 Ibid.

62 Naomi Wolf, "Emily Ratajowski's Naked Ambition," *Harper's Bazaar*, July 7, 2016.

63 Dorian Lynskey, "Blurred Lines: The Most Controversial Song of the Decade," *The Guardian*, November 14, 2013.

64 Ibid.

65 Aaron Milchan et al., *Gone Girl*. Film. Directed by David Fincher (US: 20th Century Fox, 2014).

66 Naomi Wolf, *The Beauty Myth: How Images of Beauty Are Used against Women* (New York: HarperCollins, 1991).

67 See, for example, "Growing Number of Girls Suffer Low Self-esteem, Says Report" by James Meikle, *The Guardian*, November 29, 2013 and also, *NYC Girls Project*, online 2017.

68 Guy Debord, *The Society of the Spectacle*, trans. Ken Knabb (London: Rebel Press, 2004).

69 See Veblen, *The Theory of the Leisure Class*.

70 The work of the Frankfurt School has been extraordinarily influential within the contemporary discipline of Cultural Studies. Originally dating back to Germany in the 1930s, the best-known members are arguably Theodor Adorno, Max Horkheimer, and Herbert Marcuse.

71 Jean Baudrillard, *Simulacra and Simulation* (Ann Arbor: University of Michigan Press, 1981/1994).

72 Enzensberger, "Theory of the Media."

73 See, for example, Naomi Klein, *This Changes Everything: Capitalism vs. the Climate* (London: Penguin, 2015): Wolfgang Stree, *How Will Capitalism End?: Essay on a Failing System* (London: Verso, 2016) and Franco "Bifo" Berardi, *After the Future* (Oakland and Baltimore: AK Press, 2011).

74 Berardi, *After the Future*.

75 Ibid., 137.

76 Ibid., 136.

77 Ibid.

Chapter 6

1 Some of the material included in the chapter appeared in a different form in the following publications: Hilary Radner, "An Elegy for Cinema," in *Raymond Bellour:*

Cinema and the Moving Image, eds. Hilary Radner and Alistair Fox (Edinburgh: Edinburgh University Press, 2018), 70–87; Hilary Radner, "Transnational Celebrity and the Fashion Icon: The Case of Tilda Swinton, 'Visual Performance Artist at Large'," *European Journal of Women's Studies* 23, no. 4 (2016): 401–414; Hilary Radner, "The Ghost of Cultures Past: Fashion, Hollywood and the End of Everything," *Film, Fashion and Consumption* 3, no. 2 (2014): 83–91.

2 Unless otherwise specified, the term "fashion" refers specifically to dress, including shoes, hats, jewelry, and other forms of personal adornment, rather than to the general phenomenon whereby contemporary life is understood as governed by various practices that change with varying degrees of rapidity over time in response to social and economic pressures.

3 Wendy Gamber, *The Female Economy: The Millinery and Dressmaking Trades, 1860–1930* (Urbana: University of Illinois Press, 1997).

4 Pamela Church Gibson, *Fashion and Celebrity Culture* (London: Berg, 2012), 53–66; Melvin Stokes, "Female Audiences of the 1920s and Early 1930s," in *Identifying Hollywood's Audiences: Cultural Identity and Movies*, eds. Melvin Stokes and Richard Maltby (London: BFI, 1999), 42–60.

5 Ted Polhemus, *Street Style: From Sidewalk to Catwalk* (New York: Thames and Hudson, 1994).

6 Hilary Radner, "Migration and Immigration: French Fashion and American Film," in *France/Hollywood: Échanges cinématographiques et identités nationales*, eds. Martin Barnier and Raphaëlle Moine (Paris: L'Harmattan, 2002), 210–211.

7 Raymond Bellour, "Le spectateur du cinéma," *Trafic* 79 (2011): 32–44; Giuliana Bruno, "Cultural Cartography, Materiality and the Fashioning of Emotion," in *Visual Cultural Studies*, ed. Marquard Smith (Los Angeles and London: Sage, 2008), 144–166; Francesco Casetti, "Sutured Reality: Film, from Photographic to Digital," *October* 138 (2011): 95–106; Jon Lewis, ed., *The End of Cinema as We Know It* (New York: New York University Press, 2001); Tom O'Regan, "The End of Cinema? The Return of Cinema?" *Metro Magazine: Media and Education Magazine* 124, no. 125 (2001): 64–72, 74–76.

8 Teri Agins, The End of Fashion: How Marketing Changed the Clothing Business Forever (New York: HarperCollins, 2000), Kindle Edition; Barbara Vinken, Fashion Zeitgeist: Trends and Cycles in the Fashion System (Oxford: Berg, 2005).

9 Vinken, *Fashion Zeitgeist*, 3.

10 Miriam Hansen, *Cinema and Experience: Siegfried Kracauer, Walter Benjamin, and Theodor W. Adorno* (Berkeley: University of California Press, 2011).

11 Joanne Entwistle, *The Fashioned Body: Fashion, Dress and Modern Social Theory* (Cambridge: Polity Press, 2000), 7.

12 Bruno, "Cultural Cartography," 147.

13 See Raymond Bellour, "Querelle," in *La querelle des dispositifs*, ed. Raymond Bellour (Paris: P.O.L, 2011), 13–47; see also Francesco Casetti, *The Lumière Galaxy: Seven Key Words for the Cinema to Come* (New York: Columbia University Press, 2015).

14 Campbell Walker, personal communication, November 7, 2014. See also James Quandt, "Everyone I Know Is Staying Home: The New Cinephilia," *Framework:*

The Journal of Cinema and Media 50 (2009): 206–209; Girish Shambu, *The New Cinephilia* (Montreal: Caboose, 2014).

15 Polhemus, *Street Style*, 12.

16 Judith Yeh, personal communication, October 29, 2014. In the last few years, this line has arguably gained much higher visibility through media forms such as Instagram and Pinterest.

17 Elizabeth Cline, *The Shockingly High Cost of Cheap Fashion* (New York and London: Penguin, 2013), Kindle Edition.

18 Agnès Rocamora, "New Fashion Times: Fashion and Digital Media," in *The Handbook of Fashion Studies*, eds. Sandy Black, Amy De La Haye, Joanne Entwistle, Agnès Rocamora, Regina Root, and Helen Thomas (London: Bloomsbury Press, 2013), 61–76.

19 Cline, *The Shockingly High Cost of Cheap Fashion*.

20 See, for example, Agins, *The End of Fashion*, location 188 of 6227.

21 Roger Odin, "The Amateur in Cinema, in France, since 1990: Definitions, Issues and Trends," in *A Companion to Contemporary French Cinema*, eds. Alistair Fox, Michel Marie, Raphaëlle Moine, and Hilary Radner (Malden, MA: John Wiley and Sons, 2015), 590–611.

22 Bellour, "Le spectateur de cinéma."

23 Tom Schatz, "The New Hollywood," in *Film Theory Goes to the Movies*, eds. Jim Collins, Hilary Radner, and Ava Preacher Collins (New York: Routledge, 1993), 8–36.

24 Church Gibson, *Fashion and Celebrity Culture*, 11.

25 Agnès Rocamora, "How New Are the New Media? The Case of Fashion Blogs," in *Fashion Media: Past and Present*, eds. Djurdja Bartlett, Shaun Cole, and Agnès Rocamora (London and New York: Bloomsbury, 2013), 155–164; Felicity Colman, "Rhizome," in *The Deleuze Dictionary,* Revised Edition, ed. Adrian Parr (Edinburgh: Edinburgh University Press, 2010), 232–235; Giles Deleuze and Félix Guattari, *Mille plateaux* (Paris: Minuit, 1980); Hilary Radner, "'This Time's for Me': Making Up and Feminine Practice," *Cultural Studies* 3, no. 3: 301–322. doi:10.1080/09502388900490211.

26 Valerie Mendes, and Amy De La Haye, *20th Century Fashion* (London and New York: Thames and Hudson, 1999), 194.

27 Susan Irvine, "The Mysterious Cristóbal Balenciaga," fashion.telegraph.co.uk, September 3, 2013, accessed May 10, 2017, http://fashion.telegraph.co.uk/news-features/TMG10275681/The-mysterious-Cristobal-Balenciaga.html.

28 Church Gibson, *Fashion and Celebrity Culture*; Teri Agins, *Hijacking the Runway: How Celebrities Are Stealing the Spotlight from Fashion Designers* (New York: Gotham Books, 2014), Kindle Edition.

29 Ginette Vincendeau, "Hot Couture: Brigitte Bardot's Fashion Revolution," in *Fashioning Film Stars*, ed. Rebecca Mosely (London: BFI, 2005), 137; Church Gibson, *Fashion and Celebrity Culture*, 55.

30 Church Gibson, *Fashion and Celebrity Culture*; Agins, *Hijacking the Runway*.

31 Agins, *Hijacking the Runway,* location 223 of 5463.

32 Ibid.

33 Stella Bruzzi and Pamela Church Gibson, "Introduction," in *Fashion Cultures Revisited*, eds. Stella Bruzzi and Pamela Church Gibson (London and New York: Routledge, 2013), 5.

34 "Rick Owens," en.vogue.fr, updated November 24, 2015, accessed May 10, 2017, http://en.vogue.fr/vogue-list/thevoguelist/rick-owens/1088.

35 Rick Owens, cited in Holly Shackleton, "step inside rick owens' world," *i-D*, April 2008, posted November 10, 2014, accessed March 21, 2018, https://i-d.vice.com/en_au/article/8xna55/step-inside-rick-owens39-world-aunz-translation.

36 Ruth La Ferla, "Imitate That Zipper," *New York Times*, September 2, 2009, accessed May 10, 2017, http://www.nytimes.com/2009/09/03/fashion/03OWENS.html?pagewanted=all&_r=0.

37 Alexander Fury, "The Lighter Side of Rick Owens," March 2, 2017, *T: The New York Times Style Magazine*, nytimes.com, accessed May 10, 2017, https://www.nytimes.com/2017/03/02/t-magazine/rick-owens-fashion-designer.html?_r=0.

38 Bonnie English, *A Cultural History of Fashion in the 20th and 21st Centuries: From Catwalk to the Sidewalk* (London and New York: Bloomsbury Academic, 2013), Kindle Edition, location 420 of 6620.

39 Ibid., location 268 of 6620.

40 Vinken, *Fashion Zeitgeist*, 35.

41 Ibid., 63.

42 Agins, *The End of Fashion*, location 170 of 6227.

43 Adam Geczy and Vicki Karaminas, *Fashion's Double: Representations of Fashion in Painting, Photography and Film* (London and New York: Bloomsbury, 2016), 123.

44 Vicki Karaminas, "Image: Fashionscapes—Notes Toward an Understanding of Media Technologies and Their Impact on Contemporary Fashion Imagery," in *Fashion and Art*, eds. Adam Geczy and Vicki Karaminas (London and New York: Berg, 2012)," Kindle Edition, location 4169 of 5039.

45 Church Gibson, *Fashion and Celebrity Culture*, 55.

46 Peter Wollen, "The Concept of Fashion in the Arcades Project," *boundary 2* 30, no. 1 (2003): 142.

47 Vachel Lindsay, *The Art of the Moving Picture* (New York: The Macmillan Company, 1916).

48 For a discussion of the reception of popular culture, see Patrick Brantlinger, *Bread and Circuses: Theories of Mass Culture as Social Decay* (Ithaca, NY: Cornell University Press, 1983).

49 Sneja Gunew, "Personal Costs: What Counts as Political?" public lecture, University of Otago, Dunedin, New Zealand, September 28, 2015.

50 John Berger, *Ways of Seeing* (London: British Broadcasting/Penguin Books, 1972), 47.

51 John Carl Flügel, *The Psychology of Clothes* (London: Hogarth Press, 1930), 208. For an example of current usage, see Joanna Bourke, "The Great Male Renunciation: Men's Dress Reform in Inter-War Britain," *Journal of Design History* 9, no. 1 (1996): 23–33.

52 Hilary Radner and Natalie Smith, "Fashion, Feminism and Neo-Feminism: From Coco Chanel to Jennifer Lopez," in *Fashion Cultures* (2nd Edition), eds. Stella Bruzzi and Pamela Church Gibson (London: Routledge, 2013) 275–286.

53 Vanessa Grigoriadis, "Death of One's Own," *New York Magazine*, December 8, 2003, accessed May 12, 2017, http://nymag.com/nymetro/news/people/n_9589/.

54 John T. Molloy, *Dress for Success* (New York: P. H. Wyden, 1975); John T. Molloy, *The Women's Dress for Success Book* (Chicago: Follet, 1977).

55 Dan Schawbel, "Donna Karan: How She Turned Her Passion into a Career," forbes. com, October 13, 2015, accessed May 12, 2017, https://www.forbes.com/sites/danschawbel/2015/10/13/donna-karan-how-she-turned-her-passion-into-a-career/#8747c50733aa.

56 "Donna Karan," "Forbes Profile," forbes.com, updated January 6, 2016, accessed May 12, 2017, https://www.forbes.com/profile/donna-karan/.

57 Eric Wilson, "Now You Know: The Evolution of Donna Karan's Seven Easy Pieces," instyle.com, July 2015, accessed May 12, 2017, http://www.instyle.com/news/history-donna-karan-seven-easy-pieces.

58 For a discussion of "marketplace feminism," see Hilary Radner, "Coda: Feminism *Redux*," in Hilary Radner, *The New Woman's Film: Femme-Centric Movies for Smart Chicks* (London and New York: Routledge, 2017), 190–194; see also Andi Zeilser, *We Were Feminists Once: From Riot Grrrl to CoverGirl®, the Buying and Selling of a Political Movement* (New York: PublicAffairs, 2016).

59 Vanessa Friedman and Jacob Bernstein, "Donna Karan Steps Down, in Major Shift for Fashion," *New York Times*, June 30, 2015, accessed May 12, 2017, https://www.nytimes.com/2015/06/30/fashion/donna-karan-steps-down.html?_r=0.

60 Lynn Yaeger, "On the Eve of the Comme des Garçons Retrospective, the Notoriously Reclusive Rei Kawakubo Speaks Out," vogue.com, April 14, 2017, accessed May 13, 2017, http://www.vogue.com/article/rei-kawakubo-interview-comme-des-garcons-2017-met-museum-costume-exhibit/.

61 Selwa Roosevelt, "The Later the Better," *Washington Post*, March 30, 1997, accessed May 12, 2017, https://www.washingtonpost.com/archive/entertainment/books/1997/03/30/the-later-the-better/953af5b3-8ed6-4be0-9416-4b00718eba5e/.

62 Ibid.

63 Carolyn G. Heilbrun, *Toward a Recognition of Androgyny* (New York: Norton, 1993 [1964]).

64 Grigoriadis, "A Death of One's Own."

65 Yaeger, "On the Eve of the Comme des Garçons Retrospective."

66 Judith Thurman, "The Misfit," *New Yorker*, July 4, 2005, accessed May 13, 2017, http://www.newyorker.com/magazine/2005/07/04/the-misfit-3.

67 Thurman, "The Misfit."

68 "Fresh Heir: Interview with Ann Demeulemeester's New Creative Director Sebastien Meunier," D'Vine, posted May 5, 2014, accessed May 13, 2017, http://www.the-dvine.com/2014/05/fresh-heir-interview-with-ann-demeulemeesters-new-creative-director-sebastien-meunier/.

69 Ruth La Ferla, "In Fashion, Gender Lines Are Blurring," *New York Times*, August 19, 2015, accessed May 13, 2017, https://www.nytimes.com/2015/08/20/fashion/in-fashion-gender-lines-are-blurring.html?_r=0.

70 For a description of Conglomerate Hollywood, see Tom Schatz, "The Studio System and Conglomerate Hollywood," in *The Contemporary Hollywood Film Industry*, eds. Paul McDonald and Janet Wasko (Malden, MA and Oxford: Wiley-Blackwell, 2008), 13–42.

71 Jonathan Romney, "Jim Jarmusch: How the Film World's Maverick Stayed True to His Roots," *Observer*, February 22, 2014, accessed May 8, 2017, www. theguardian.com/film/2014/feb/22/jim-jarmusch-only-lovers-left-alive.

72 Eric Hynes, "Tilda Swinton Lives by Night," rollingstone.com, April 1, 2014, accessed May 13, 2017, http://www.rollingstone.com/movies/news/tilda-swinton-lives-by-night-20140401.

73 Melena Rysik, "This Time, Jim Jarmusch Is Kissing Vampires," *New York Times*, April 3, 2014, accessed May 8, 2017, www.nytimes.com/2014/04/06/movies/this-time-jim-jarmusch-is-kissing-vampires.html.

74 The film is reported to have had a budget of $7 million and a worldwide gross of $2,588,571 million. See IMDb and the-numbers.com, accessed May 8, 2017, http://www.imdb.com/title/tt1714915/business?ref_=tt_dt_bus and http://www.the-numbers.com/movie/Only-Lovers-Left-Alive#tab=box-office.

75 Ryzik, "This Time."

76 Michael Newman, "Introduction," *Indie: An American Film Culture* (New York: Columbia University Press, 2011), Kindle Edition.

77 Todd Gilchrist, "Only Lovers Left Alive's Tilda Swinton talks Playing a Vampire, Working with Tom Hiddleston," dailydead.com, posted November 4, 2011, accessed May 8, 2017, https://dailydead.com/lovers-left-alives-tilda-swinton-talks-playing-vampire-working-tom-hiddleston/.

78 Patricia Garcia, "Dress the Part: *Only Lovers Left Alive*," vogue.com, April 10, 2014, accessed May 8, 2017, http://www.vogue.com/article/dress-the-part-only-lovers-left-alive-fashion.

79 For a discussion of Tilda Swinton's profile as a star, see Jackie Stacey, "Crossing Over with Tilda Swinton–the Mistress of 'Flat Affect,'" *International Journal of Politics, Culture and Society* 28, no. 3 (2015): 243–271; see also Radner, "Transnational Celebrity and the Fashion Icon: The Case of Tilda Swinton."

80 Adam Geczy and Vicki Karaminas, "Lady Gaga, *American Horror Story*, Fashion, Monstrosity and the Grotesque," *Fashion Theory* 21, no. 6 (2017): 715. See also Sue-Ellen Case, "Tracking the Vampire," *Differences: A Journal of Feminist Cultural Studies* 3, no. 2 (1991): 1–20.

81 Bellour "Querelle"; Casetti, *The Lumière Galaxy*.

82 Karaminas, "Image–Fashionscapes," location 4229 of 5039.

83 Ibid., location 4169 of 5039.

Chapter 7

1 Andreas Hepp, "The Communicative Figurations of Mediatized Worlds," *Communicative Figurations* 1 (2013): 3.

2 Gianpietro Mazzoleni, "Changes in Contemporary Communication Ecosystems Ask for a 'New Look' at the Concept of Mediatization," *Javnost—The Public* 2 (2017): 1.

3 The literature on mediatization has rapidly grown over the last seven or so years and cannot all be listed here. However, for some comprehensive discussions of the term, see, for instance, David Deacon, and James Stanyer, "Mediatization: Key Concept or Conceptual Bandwagon?" in *Media, Culture & Society* (2014): 1–13; David Deacon and James Stanyer, "'Mediatization and' or 'Mediatization of'? A Response to Hepp et al.," *Media, Culture & Society* 37, no. 4 (2015): 655–657; Knut Lundby, "Mediatization of Communication," in *Mediatization of Communication*, ed. Knut Lundby (Berlin: De Gruyter, 2014), 3–35; Knut Lundby, ed., *Mediatization: Concept, Changes, Consequences* (New York: Peter Lang, 2009); Friedrich Krotz, "Explaining the Mediatisation Approach," *Javnost—The Public* 2, no. 24 (2017); Stig Hjarvard, *The Mediatization of Culture and Society* (Oxon: Routledge, 2013); Nick Couldry, "Mediatization or Mediation? Alternative Understandings of the Emergent Space of Digital Storytelling," *New Media & Society* 10, no. 3 (2008): 373–391; Andreas Hepp, *Cultures of Mediatization* (Cambridge: Polity, 2013b [2011]); Mazzoleni, "Changes," 136–145.

4 See, for instance, Mikkel Eskjaer, "The Mediatization of Ethical Consumption," *MedieKultur* 54 (2013): 26–46.

5 Eric W. Rothenbuhler, "Continuities: Communicative Form and Institutionalization," in *Mediatization: Concept, Changes, Consequences*, ed. Knut Lundby (New York: Peter Lang, 2009), 279.

6 Hepp, *Cultures*; Lundby, "Mediatization," 3–35.

7 Agnès Rocamora, "Mediatization and Digitization in the Field of Fashion," *Fashion Theory* (2016), online first, http://www.tandfonline.com/doi/abs/10.1080/136270 4X.2016.1173349.

8 Risto Kurnilius and Esa Reunanen, "Changing Power of Journalism: The Two Phases of Mediatization," *Communication Theory* 26 (2016): 369–388; Agnès Rocamora, "The Labour of Fashion Blogging," in *Fashioning Professionals*, eds. Leah Armstrong and Felice McDowell (Bloomsbury, 2018); Mazzoleni, "Changes."

9 Kurnilius and Reunanen, "Changing Power," 372.

10 David Bolter and Richard Grusin, *Remediation: Understanding New Media* (MIT Press, 1999). See Agnès Rocamora, "Personal Fashion Blogs: Screens and Mirrors in Digital Self-Portraits," *Fashion Theory* 4, no. 15 (2011): 407–424.

11 Neil Wrigley and Michelle Lowe, *Reading Retail: A Geographical Perspective on Retailing and Consumption Spaces* (London: Arnold, 2002), 238, citing Christopherson.

12 Kenneth C. Laudon and Carol Guercio Traver, *E-commerce 2016: Business. Technology. Society* (Boston, MA: Pearson, 2017), 731.

13 Wrigley and Lower, *Reading Retail*, 239, citing Reynolds.

14 "Ecommerce in the United Kingdom," Ecommerce News, last modified February 2017, accessed May 10, 2017, https://ecommercenews.eu/ecommerce-per-country/ecommerce-the-united-kingdom/.

15 "E-commerce in the United Kingdom: Facts & Figures 2016," Twenga, 2016, accessed 4 August 2016, https://www.twenga-solutions.com/en/insights/ecommerce-united-kingdom-facts-figures-2016/.

16 "Retail Sales in Great Britain, Apr 2017," Office for National Statistics, 2017, accessed May 9, 2017, https://www.ons.gov.uk/businessindustryandtrade/ retailindustry/bulletins/retailsales/apr2017.

17 Laudon and Traver, *E-commerce 2016*, 93.

18 Ibid., 59.

19 Ibid., 60.

20 See also Anne Friedberg, *Window Shopping: Cinema and the Postmodern* (Berkeley: University of California Press, 1993), Kindle Edition.

21 See Rocamora, "New Fashion Times."

22 Friedberg, *Window Shopping*, 64.

23 Patel, cited in Lisa Lockwood and Sharo Edelson, "Instant Fashion: Salvation of Gimmick," *WWD, Instant Fashion Special Report* (2016), np.

24 Laudon and Traver, *E-commerce 2016*, 734

25 Vikram A. Kansara, "Is the New Style.com Working?" BOF, 2016, accessed January 4, 2017, https://www.businessoffashion.com/articles/digital-scorecard/is-conde-nast-style-com-working.

26 Rocamora, "New Fashion Times."

27 Friedberg, *Window Shopping*.

28 Ibid., 106.

29 Simon, cited in Frank Rose, "The Attention Economy 3.0," *The Milken Institute Review: A Journal of Economic Policy*. Milken Institute, 2015, accessed July 9, 2016, http://www.milkenreview.org/articles/the-attention-economy-3-0; see also Elizabeth A. Wissinger, *This Year's Model: Fashion, Media, and the Making of Glamour* (New York: New York University Press, 2015), 17.

30 See also Rocamora, "New Fashion Times," 70.

31 Alessandra Codinha, "Meet the New Site That Wants to Take the Legwork Out of Instagram-Stalking for You," 2015, accessed May 12, 2016, http://www.vogue.com/ article/semaine-online-magazine-concept-store-launches.

32 Harding, cited in ibid.

33 "Style.com Discontinues, Redirects to Farfetch.com," accessed July 10, 2017, http://www.vogue.co.uk/article/stylecom-discontinued-conde-nast-partnership-consolidates-farfetch.

34 David Altheide and Robert P. Snow, *Media Logic* (London: Sage, 1979).

35 Ibid., 240.

36 Ibid., 9–10.

37 See also David L. Altheide, "Media Logic and Political Communication," *Political Communication* 3, no. 21 (2004): 293–296; Mazzoleni, "Changes."

38 Ibid., 4.

39 See Mark Moss, *Shopping as an Entertainment Experience* (Lanham: Lexington Books, 2007).

40 Christoph Grunenberg, "Wonderland: Spectacles of Display from the Bon Marché to Prada," in *Shopping: A Century of Art and Consumer Culture*, eds.

Christoph Grunenberg and Max Hollein (Ostfuldern-Ruit: Hatje Cantz Publishers, 2002), 18.

41 Ibid., 20.

42 See, for example, Lundby, *Mediatization*; Hjarvard, *Mediatization*.

43 See, for example, Deacon and Stanyer, *Mediatization*; Hepp, *Cultures*; Krotz, "Explaining"; Mats Ekström et al., "Three Tasks for Mediatization Research: Contribution to an Open Agenda," *Media, Culture & Society* (2016): 1–19; Graham Murdock, "Mediatisation and the Transformation of Capitalism: The Elephant in the Room," *Javnost-The Public*, 2017, doi:10.1080/13183222.2017.1290745.

44 Jukka Kortti, "Media History and the Mediatization of Everyday Life," *Media History* 1, no. 23 (2017): 115–129.

45 Agnès Rocamora, *Fashioning the City* (London: I.B. Tauris, 2009), 27; on fashion dolls, see Juliette Peers, *The Fashion Doll: From Bébé Jumeau to Barbie* (Oxford: Berg, 2004).

46 Ekstrom et al., "Three Tasks."

47 Ibid., 9.

48 For early instances of the fashion pages of Sears, see Robin Cherry, *Catalog: The Illustrated History of Mail-Order Shopping* (New York: Princeton Architectural Press, 2008); for histories of fashion plates and of early fashion journals see John L. Nevinson, "Origin and Early History of the Fashion Plate" (1967); Valerie Steele, *Paris Fashion: A Cultural History* (Oxford: Berg, 1998).

49 See Rosetta Brooks, "Sighs and Whispers in Bloomingdales: A Review of a Bloomingdale Mail-Order Catalogue for Their Lingerie Department," in *Zoot Suits and Second-Hand Dresses: An Anthology of Fashion and Music*, ed. Angela McRobbie (Boston, MA: Unwin Hyman, 1989 [1982]).

50 Cherry, *Catalog*, 29.

51 Ulrike Klinger and Jakob Swvenson, "The Emergence of Network Media Logic in Political Communication: A Theoretical Approach," *New Media & Society* 17, no. 8 (2015): 1241–1257.

52 Morten Michelson and Mads Krog, "Music, Radio and Mediatization," *Media Culture & Society* 4, no. 39 (2016): 5, drawing on Deacon and Stanyer.

53 Michelson and Krog, "Music, Radio," 5–6.

54 Bolter and Grusin, *Remediation*.

55 Ibid., 45.

56 Ibid., 50, 200.

57 Ibid., 200.

58 Agnès Rocamora, "Hypertextuality and Remediation in the Fashion Media: The Case of Fashion Blogs, " *Journalism Practice* (2012): 92–106.

59 Knut Lundby, "Introduction: 'Mediatization' as key," in *Mediatization: Concept, Changes, Consequences*, ed. Knut Lundby (New York: Peter Lang, 2009), 13 (drawing on Bolter and Grusin).

60 Altheide and Snow, *Media Logic*, 242.

61 B. Joseph Pine II and James H. Gilmore, *The Experience Economy* (Boston, MA: Harvard Business School Publishing, 2011).

62 See also Niels Ole Finnemann, 'Mediatization Theory and Digital Media', *Communications* 36 (2011): 67–89

63 See also Couldry, "Mediatization"; Andreas Hepp, "Differentiation: Mediatization and Cultural Change," in *Mediatization of Communication*, ed. Knut Lundby (Berlin: De Gruyter, 2009), 139–157; Klinger and Swvenson, "Emergence"; Lundby, "Mediatization."

64 Mazzoleni, "Changes"; Klinger and Svenson, "Emergence."

65 José Van Dijk and Thomas Poell, "Understanding Social Media Logic," *Media and Communication* 1, no. 1 (2013): 2–14.

66 Klinger and Svenson, "Emergence."

67 Mazzoleni, "Changes," drawing on Klinger and Svenson.

68 Rocamora, "New Fashion Times."

69 Couldry, "Mediatization." See also Hepp, "Differentiation"; Stig Hjarvard, "The Mediatization of Society: A Theory of the Media as Agents of Social and Cultural Change," *Nordicom Review* 29, no. 2 (2008): 105–134; Andre Jansson, "Using Bourdieu in Critical Mediatization Research," *MedieKultur* 58 (2015): 13–29.

70 See Sara Butler, "Marks & Spencer Takes Control of Its Online Store from Amazon," *The Guardian*, 2014, accessed February 19, 2014, http://www.theguardian.com/business/2014/feb/18/marks-spencer-control-online-shopping-website-amazon.

71 Jesper Strömbäck and Frank Esser, "Shaping Politics: Mediatization and Media Interventionism," in *Mediatization: Concept, Changes, Consequences*, ed. Knut Lundby (New York: Peter Lang, 2009), 213; but see also Nino Landerer, "Rethinking the Logics: A Conceptual Framework for the Mediatization of Politics," *Communication Theory* 23 (2013): 239–258.

72 See, for instance, Eskjaer, "The Mediatization of Ethical Consumption," 29; Andre Jansson, "The Mediatization of Consumption: Towards an Analytical Framework of Image Culture," *Journal of Consumer Culture* 2, no. 5 (2002): 5–31; Anne Kaun and Karin Fast, *Mediatization of Culture and Everyday Life*. Mediestudier vid Södertörns högskola:1 (Karlstad University Studies, 2014).

73 See also Ekstrom et al., "Three Tasks," 10; Lundby, "Mediatization," 8; Kortti, "Media History," 115.

74 Krotz, "Explaining"; Murdock, "Mediatisation."

75 Murdock, "Mediatisation," 3.

76 Ibid., 4.

77 Christian Fuchs, *Foundations of Critical Media and Information Studies* (London: Routledge, 2011); James Curran, Natalie Fenton, and Des Freedman, *Misunderstanding the Internet* (London: Routledge, 2016).

78 See, for instance, Theresa Cramer, *Inside Content Marketing* (Chicago: Information Today, 2016); Patrick De Pelsmecker, "Introduction," in *Advertising in New Formats and Media*, ed. Patrick De Pelsmecker (Bingley: Emerald Publishing, 2016).

79 De Pelsmecker, "Introduction."

80 See also Jonathan Hardy, "Sponsored Content Is Compromising Media Integrity," April 12, 2017, https://www.opendemocracy.net/jonathan-hardy/sponsored-content-is-blurring-line-between-advertising-and-editorial.

81 Daniel Bô and Matthieu Guével, *Brand Content: Comment les Marques de Transforment on Médias* (Paris: Dunod, 2009).

82 Cramer, *Inside Content*, 6.

83 Pierre Bourdieu, *The Field of Cultural Production* (Cambridge: Polity, 1993).

84 Celia Lury, *Consumer Culture* (Cambridge: Polity, 1996).

85 Jansson, "Mediatization," 6.

86 Ibid., 7.

87 Accessed July 17, 2017, http://www.cdmdiary.com/en/about-cdm/.

88 On transsubstantiation, see Pierre Bourdieu and Yvette Delsaut, 'Le Couturier et sa Griffe. Contribution à une Théorie de la Magie', Actes de la Recherche en Sciences Sociales 1 (1975): 7–36.

89 See Jenkins, *Convergence Culture*.

90 See, for instance, Bô and Guével, *Brand Content*, 138.

91 Butler, "Marks & Spencer Takes Control of Its Online Store from Amazon."

92 Ibid.

93 See Aske Kammer, "The Mediatization of Journalism," *MedieKultur* 54 (2013): 141–148.

94 See also De Pelsmecker, "Introduction."

95 Lundby, "Mediatization," 32.

96 Ibid.

97 Hardy, "Sponsored Content Is Compromising Media Integrity."

98 Ibid.

99 See Rocamora, "The Labour of Fashion Blogging."

100 Ibid.

101 Rocamora, "Personal Fashion Blogs"; Rocamora, "Mediatization and Digitization."

102 Ibid.

103 See Rocamora, "Mediatization and Digitization."

104 See George P. Landow, *Hypertext 2.0* (Baltimore: Johns Hopkins University Press, 1997); Rocamora, "Personal Fashion Blogs."

Chapter 8

1 Sandy Black, "Fashion Is Often Very Old-Fashioned," in *The Sustainable Fashion Handbook*, ed. Sandy Black (London: Thames & Hudson, 2012), 116.

2 Stella McCartney in conversation with Lucy Siegle, London College of Fashion, November 14, 2016.

3 Robert Cordero, "Lidewij Edelkoort: Fashion Is Old Fashioned," at the *VOICES* London conference. Business of Fashion, December 5, 2016, accessed May 17, 2017, https://www.businessoffashion.com/articles/voices/li-edelkoort-anti-fashion-manifesto-fashion-is-old-fashioned.

4 Designer Prabal Gurung speaking at Copenhagen Fashion Summit, Denmark May 11, 2017, focused on accelerating action toward sustainability in fashion.

5 Sandy Black, *Eco Chic: The Fashion Paradox* (London: Black Dog Publishing, 2008); Kate Fletcher, *Sustainable Fashion and Textiles. Design Journeys* (London: Earthscan, 2008).

6 29 percent of total spending online is on clothing and footwear, up from 13 percent in 2011, http://www.britishfashioncouncil.org.uk/pressreleases/The-British-Fashion-Industry–London-Fashion-Week-Facts–Figures February 2016.

7 Global Fashion Agenda and Boston Consulting Group, May 2017, *The Pulse of the Fashion Industry* report p. 10, 2017, accessed May 15, 2017, www.copenhagenfashionsummit.com/pulsereport.

8 Worth £28 billion (including retail) according to figures released by the British Fashion Council and Oxford Economics in February 2017, up from £21bn in 2009, and £26billion in 2013. http://www.britishfashioncouncil.org.uk/pressreleases/London-Fashion-Week-February-2017-Facts-and-Figures.

9 "Clothing Retailing—UK," Mintel, October 2016 report, accessed May 30, 2017. http://store.mintel.com/clothing-retailing-uk-october-2016.

10 DCMS, *Creative Industries Mapping Document* (London: UK Government Department of Culture, Media and Sport, 1998); Centre for Fashion Enterprise, *The UK Designer Fashion Economy: Value Relationships–Identifying Barriers and Creating Opportunities for Business Growth*. Report commissioned by NESTA (London: CFE, 2008); British Fashion Council (BFC) and Oxford Economics, *The Value of the UK Fashion Industry: Economic Considerations for Growth* (London: BFC, 2010).

11 M. Christopher, R. Lowson, and Helen Peck, "Creating Agile Supply Chains in the Fashion Industry," *International Journal of Retail & Distribution Management* 32, no. 8 (2004); Wendy Malem, "Fashion Designers as Business: London," *Journal of Fashion Marketing and Management* 12, no. 3 (2008).

12 Angela McRobbie, *British Fashion Design: Rag Trade or Image Industry?* (London: Routledge, 1998), 69.

13 £12.4 billion spent on fashion online in the UK in 2015, up 16 percent from £10.7 billion in 2014 (Mintel 2015); cited by BFC Press Release February 10, 2017.

14 McKinsey and Business of Fashion report, *The State of Fashion* (London, 2017), 10.

15 Luciano Batista, "New Business Models Enabled by Digital Technologies: A Perspective from the Fashion Sector," *New Economic Models in the Digital Economy*, February 2013, accessed April 30, 2017, http://www.nemode.ac.uk/wp-content/uploads/2013/03/BATISTA-case-study-in-the-fashion-sector-FINAL-Report.pdf; Sandy Black, ed., *Sustainable Fashion Handbook* (London: Thames and Hudson, 2012).

16 See, for example, Estonian-founded fit preference specialists, Fits.me. http://fits.me.

17 Brooke Roberts-Islam, "Martine Jarlgaard's Mixed Reality Show at London Fashion Week—A World First," *Huffington Post*, September 16, 2016, accessed May 30, 2017, http://www.huffingtonpost.co.uk/brooke-robertsislam/martine-jarlgaards-mixed-_b_11919578.html.

18 Lord Young, *Growing Your Business*. A report to HM Government (London: HMSO, 2013).

19 CFE, *UK Designer Fashion.*

20 DCMS, *Creative Industries*, 1998 and 2001

21 Malcolm Newbery, *Conclusions and Recommendations of a Study of the UK Designer Fashion Sector* (London: UK Government Department of Trade and Industry, 2003), 5.

22 Batista, *Business Models.*

23 Sandy Black et al., "Considerate Design for Personalized Fashion," in *Designing for the 21st Century: Interdisciplinary Methods & Findings*, ed. Tom Inns (Aldershot: Gower, 2009). The Considerate Design project was jointly funded by two UK research councils, Engineering and Physical Sciences, and Arts and Humanities: Designing for the 21st century initiative, 2007–2009, led by Sandy Black. http://www.consideratedesign.com/.

24 Funded by the UK Arts and Humanities Research Council, Creative Economy Knowledge Exchange scheme, 2013–2014, led by Sandy Black.

25 Michelle Lowe-Holder, report to FIREup project, March 2014.

26 See www.fire-fashion.uk for links to films about these FIREup projects.

27 Nick Ryan from Worn Again, report to FIREup project March 2014.

28 Funded by Research Councils UK under the NEMODE Network+ scheme—New Economic Models in the Digital Economy, 2015, www.nemode.ac.uk led by Sandy Black and AAM Associates; see also, https://vimeo.com/147929711.

29 A selective survey listing of digital tools and processes is available at https://docs.google.com/spreadsheets/d/1TGeAVXPp-XLh7qLZ1Ga2TCsL0oL-9U9OwgX9wYcL8b0/edit?pli=1#gid=796169669&vpid=A1.

30 Joseph Pine II, *Mass Customization: The New Frontier in Business Competition* (Boston, MA: Harvard Business School Press, 1993).

31 Frank Piller and Mitchell Tseng, eds., *Handbook of Research in Mass Customization and Personalization*, vols. 1 & 2 (Hackensack, NJ: World Scientific Publishing, 2010), 1.

32 Jung-ha Yang, Doris H. Kincade, and Jessie H. Chen-Yu, "Types of Apparel Mass Customization and Levels of Modularity and Variety: Application of the Theory of Inventive Problem Solving," *Clothing and Textiles Research Journal* 33, no. 3 (2015).

33 Philip Treleaven, "Sizing Us Up," *IEEE Spectrum* 41, no. 4 (2004): 28–31, accessed May 10, 2017, http://doi.org/db9tqw.

34 Suzanne Loker et al., "Female Consumers' Reactions to Body Scanning," *Clothing and Textile Research Journal* 22, no. 4 (2004): 151–160; Tasha Lewis and Suzanne Loker, "Trying on the Future: Exploring Apparel Retail Employees' Perspectives on Advanced In-Store Technologies," *Fashion Practice* 9, no. 1 (2017): 95–119.

35 See video demonstration of textiles manufactured using 3D printing technology, *Modeclix*, March 7, 2016, http://www.modeclix.com/making-of/.

36 For early history, see Bradley Rhodes, "A Brief History of Wearable Computing," *MIT Media Lab*, accessed May 25, 2017, https://www.media.mit.edu/wearables/lizzy/timeline.html.

37 Sandy Black, "Trends in Smart Textiles," in *Smart Textiles for Medicine and Healthcare*, ed. Louiva Van Langenhove (Cambridge: Woodhead, 2007), 3–26; Joanna Berzowska, "XS Labs: Electronic Textiles and Reactive Garments as Sociocultural Interventions," in *Fashion Studies*, eds. Sandy Black et al. (London: Bloomsbury, 2013), 456–475; Bradley Quinn, "Technology and Future Fashion: Body Technology," in *Fashion Studies*, eds. Sandy Black et al. (London: Bloomsbury, 2013), 436–455.

38 "Functional Electronic Textiles," accessed May 30, 2017, https://www.fett.ecs.soton.ac.uk

39 Mark Weiser, "The Computer for the 21st Century," *Scientific American*, September, 1991, 94.

40 "WEAR Rationale," Wear Sustain, accessed June 3, 2017, http://wearsustain.eu/about/wear-rationale/.

41 Workshop convened as part of the NEMODE Network+ project led by Sandy Black and AAM Associates on October 25, 2015 at the Photographers Gallery London, with twenty-two attendees. See Sandy Black, Mary Jane Edwards and Gabrielle Miller, "What's Digital about Fashion Design?" a report to RCUK *NEMODE* (New Economic Models in the Digital Economy) 2015, http://issuu.com/aamassociates/docs/whats_digital_about_fashion_design_/1.

42 Workshop participant, taken from "What's Digital about Fashion Design?" workshop transcript October 25th, 2015.

43 Ibid.

44 Ibid.

45 Ibid.

46 See, for example, "Decoded Fashion," accessed May 31, 2017, http://www.decodedfashion.com/.

47 Ben Alun-Jones, co-founder Unmade, in interview with Sandy Black, October 30, 2016.

48 Pine II, *Mass Customization*.

49 Jonas Larsson, Pia Mouwitz and Joel Peterson, "Knit on Demand—Mass Customisation of Knitted Fashion Products," *The Nordic Textile Journal, Special Edition Fashion & Clothing* (2009), 108–121.

50 Marc Bain, "Brands see the future of fashion in customized 3D knitted garments produced while you wait," *Quartz Media*, April 5, 2017, accessed May 25, 2017, https://qz.com/949026/brands-including-adidas-uniqlo-and-ministry-of-supply-see-the-future-of-fashion-in-on-demand-3d-knitting/.

51 "MIXIMALISTE," accessed May 30, 2017, www.MIXIMALISTE.COM.

52 CEO Henri Mura October 17, 2016, Linked-in announcement.

53 Third Wave Fashion: Fashion Tech Startups. "Fashion Tech: Meet Change of Paradigm," March 2016, accessed April 28, 2017, http://thirdwavefashion.com/2016/03/fashion-tech-meet-change-of-paradigm/.

54 Personal communication with Henri Mura, May 24, 2017.

55 Ibid.

56 William McDonough and Michael Braungart, *Cradle to Cradle: Remaking the Way We Make Things* (New York: North Point Press, 2002); Ken Webster, *The Circular Economy: A Wealth of Flows* (Cowes: Ellen MacArthur Foundation, 2017).

57 Sarah Scatturo, "Eco-tech Fashion: Rationalizing Technology in Sustainable Fashion," *Fashion Theory* 12, no. 4 (2008): 469.

Chapter 9

1 Lise Skov and Marie Melchior, "Letter from the Editors," *Fashion Theory* 15, no. 4 (2011): 133.

2 David Gilbert, "From Paris to Shanghai: The changing geographies of fashion's world cities," in *Fashion's World Cities*, eds. Christopher Breward and David Gilbert (Oxford: Berg, 2006), 3–32; Sussanne Anna, "The 'fashion generation' in a fashion city," in *Generation Mode*, eds. Sussanne Anna and Eva Gronbach (Düsseldorf: Hatje Cantz, 2006), 7–11; Eva Gronbach, "Global Local: Movements and Counter-Movements in the 'Fashion Generation'," in *Generation Mode*, eds. Sussanne Anna and Eva Gronbach (Düsseldorf: Hatje Cantz, 2006), 21–33.

3 Susanne Anne and Eva Gronbach, eds., *Generation Mode* (Düsseldorf: Hatje Cantz, 2006).

4 Lidewij Edelkoort, "Anti-fashion," *De Zeen*, March 15, 2015; Karen Webster, "Global Shift: Australian Fashion's Coming of Age," *The Conversation*, November 6, 2013, accessed November 21, 2016, http://theconversation.com/global-shift-australian-fashions-coming-of-age-19237; Shuk-Wah Chung, "Fast fashion is 'drowning' the world: We need a Fashion Revolution!" Greenpeace International, Blogspot by Shuk-Wah Chung posted April 21, 2016, accessed November 21, 2016, http://www.greenpeace.org/international/en/news/Blogs/makingwaves/fast-fashion-drowning-world-fashion-revolution/blog/56222/; Clare Press, "Why the Fashion Industry Is Out of Control," *Australian Financial Review*, April 23, 2016, accessed April 26, 2016, http://www.afr.com/lifestyle/fashion/why-the-fashion-industry-is-out-of-control-20160419-goa5ic; Madeline Veenstra, "The Australian Fashion Community," *Design Online*, State Library of Queensland, published 2012, last modified 2017, accessed August 14, 2017, http://designonline.org.au/content/the-australian-fashion-community/.

5 Skov and Melchior, "Letters from the Editor," 134.

6 Simona Segre Reinach, "National Identities and International Recognition," *Fashion Theory* 15, no. 4 (2011): 267–272.

7 Wendy Larner and Maureen Molloy, "Globalization, Cultural Economy, and Not-So-Global Cities: The New Zealand Designer Fashion Industry," *Environment and Planning D* 25 (2007): 381–400.

8 Síle De Cléir, "Creativity in the Margins: Identity and Locality in Ireland's Fashion Journey," *Fashion Theory* 15, no. 4 (2011): 201–224.

9 Alice Payne, "Inspiration Sources for Australian Fast Fashion Design: Tapping into Consumer Desire," *Journal of Fashion Marketing and Management* 20, no. 2 (2016): 191–207, http://dx.doi.org/10.1108/JFMM-12-2014-0092.

10 Alice Dallabona, "Narratives of Italian craftsmanship and the luxury fashion industry: Representations of Italianicity in discourses of production," in *Global Fashion Brands: Style, Luxury and History*, eds. Joseph H. Hancock et al. (Bristol: Intellect, 2014), 215–228.

11 Grace Lees-Maffei and Kjetil Fallan, eds., *Made in Italy* (London: Bloomsbury, 2014).

12 Gabi Dei Ottati, "A Transnational Industrial Fast Fashion District: An Analysis of the Chinese Businesses in Prato," *Cambridge Journal of Economics* 38 (2014): 1247–1274; Guoheng Zhang, "Made in Italy by Chinese in Prato: The 'carrot and stick' policy and Chinese migrants in Italy, 2010–2011," *CPI Analysis*, October 22, 2015, accessed November 21, 2016, https://cpianalysis.org/2015/10/22/made-in-italy-by-chinese-in-prato-the-carrot-and-stick-policy-and-chinese-migrants-in-italy-2010–11/; Unione Industriale Pratese Confindustria Prato, "Prato textile and fashion centre and the prototype of a manufacturing district," *Evolution of the Prato Textile District*, 2014, accessed November 22, 2016, http://www.ui.prato.it/unionedigitale/v2/english/presentazionedistrettoinglese.pdf.

13 Marie Riegels Melchior, "From Design Nations to Fashion Nations? Unpacking Contemporary Scandinavian Fashion Dreams," *Fashion Theory* 15, no. 4 (2011): 177–200; Marie Riegels Melchior, Lise Skov and Fabian Faurholt Csaba, "Translating Fashion into Danish," *Culture Unbound* 3 (2011): 209–228.

14 Jacob Ostberg, "The Mythological Aspects of Country-of-Origin: The Case of the Swedishness of Swedish Fashion," *Journal of Global Fashion Marketing* 2, no. 4 (2011): 223–234.

15 Ibid., 231.

16 Torbjorn Netlland, "Moods of Norway towards Global Transparency and Happier People," *Better Operations*, February 7, 2013, accessed August 14, 2017, http://better-operations.com/2013/02/07/moods-of-norway-towards-global-supplier-transparency/; Nina Berglund, "Mood Tumbles at 'Mood of Norway'," *News in English*, November 14, 2014, accessed August 14, 2017, http://www.newsinenglish.no/2014/11/14/mood-tumbles-at-moods-of-norway/.

17 Esben Pedersen and Wencke Gwozdz, "From Resistance to Opportunity-Seeking: Strategic Responses to Institutional Pressures for Corporate Social Responsibility in the Nordic Fashion Industry," *Journal of Business Ethics* 119 (2014): 245–264.

18 Nele Bernheim, ed., *Symposium 1: Modus Operandi: State of Affairs in Current Research on Belgian Fashion* (Antwerp: MoMu—Fashion Museum, 2008); Anneke Smelik, ed., *Delft Blue to Denim Blue: Contemporary Dutch Fashion* (London: I. B. Tauris, 2017).

19 Payne, "Tapping into Consumer Desire," 193, 197–198.

20 Lise Skov, "Dreams of Small Nations in a Polycentric Fashion World," *Fashion Theory* 15, no. 4 (2011): 45, 149.

21 Juliette Peers, "Paris or Melbourne? Garments as Ambassadors for Australian Fashion Cultures," in *Generation Mode*, eds. Sussanne Anna and Eva Gronbach (Düsseldorf: Hatje Cantz, 2006) 133–153.

22 Payne, "Tapping into Consumer Desire"; Sally Weller, "Fashion as Viscous Knowledge: Fashion's Role in Shaping Transnational Garment Production," *Journal of Economic Geography* 7, no. 1 (2007): 39–66; Louise Crewe, Nicky Gregson, and Kate Brooks, "The Discursivities of Difference," *Journal of Consumer Culture* 3, no. 1 (2003): 61–82.

23 Lise Skov, "Dreams of Small Nations"; Louise Crewe and Zena Forster, "Markets, Design, and Local Agglomeration: The Role of the Small Independent Retailer in the Workings of the Fashion System," *Environment and Planning D* 11, no. 2 (1993): 213–229; Luciana Lazzeretti, Francesco Capone, and Patrizia Casadei, "The Role of Fashion for Tourism: An Analysis of Florence as a Manufacturing City and Beyond," in *Tourism in the City: Towards an Integrative Agenda on Urban Tourism*, eds. Nicola Bellini and Cecilia Pasquinelli (Switzerland: Springer International, 2017), eBook Edition, 207–220; Nancy Rantisi, "The Prospects and Perils of Creating a Viable Fashion Industry," *Fashion Theory* 15, no. 4 (2011): 259–266.

24 Crewe, Gregson, and Brooks, "The Discursivities of Difference," 73.

25 Ibid., 75.

26 Ibid., 76.

27 Kate Finnigan, "Nordic Chic: 8 Scandi Brands You Need to Know," *The Telegraph*, January 30, 2016, accessed August 14, 2017, http://www.telegraph.co.uk/fashion/brands/nordic-chic-8-scandi-brands-you-need-to-know/.

28 Sally Weller, "Beyond 'Global Production Network' Metaphors: Australian Fashion Week's Trans-sectoral Synergies," *Growth and Change* 39, no. 1 (2008): 104–22.

29 Sally Weller, "Consuming the City: Public Festivals and Participatory Economies in Melbourne, Australia," *Urban Studies*, 50, no. 14 (2013): 2855–2868.

30 Sandra Niessen, Ann Marie Leshkovich, and Carla Jones, eds., *Re-Orienting Fashion: The Globalization of Asian Fashion* (Oxford and New York: Berg, 2003).

31 Lise Skov, "Fashion Flows–Fashion Shows: The Asia Pacific Meets in Hong Kong," in *Rogue Flows: Trans-Asian Cultural Traffic*, eds. Koichi Iwabuchi and Mandy Thomas (Hong Kong: Hong Kong University Press, 2004), 221–247.

32 Maureen Molloy and Wendy Larner, eds., *Fashioning Globalisation: New Zealand Design, Working Women and the Cultural Economy* (Chichester, West Sussex: John Wiley & Sons, 2013); Sally Weller, "Creativity or Costs? Questioning New Zealand's Fashion Success: A Methodological Intervention," *Journal of Economic Geography* 14, no. 4 (2013): 721–737; Rowan Anderson, "10 New Zealand Fashion Designers and Brands You Should Know," *The Culture Trip*, October 31, 2016, accessed November 22, 2016, https://theculturetrip.com/pacific/new-zealand/articles/top-10-new-zealand-fashion-designers-you-should-know/.

33 Jennifer Craik, "Fashioning Australian: Recent Reflections on the Australian Style in Contemporary Fashion," *Journal of Asia-Pacific Pop Culture* 2, no. 1 (2017): 30–52.

34 Maria Claudia Bonadio, "Brazilian Fashion and the 'Exotic'," *International Journal of Fashion Studies* 1, no. 1 (2014): 57–74.

35 Reinach, "National Identities and International Recognition," 267–272.

36 Fashion director of Dublin store, Arnotts, quoted by De Cléir, "Creativity in the Margins," 217.

Chapter 10

1 John Koblin, "Reformation, an Eco-label the Cool Girls Pick," *New York Times*, December 17, 2014.

2 Pedersen and Gwozdz, "From Resistance to Opportunity-Seeking," 247.

3 Simonetta Falasca-Zamponi, *Waste and Consumption: Capitalism, the Environment, and the Life of Things* (New York: Routledge, 2011), 19–22.

4 Alexander Engel, "Colouring Markets: The Industrial Transformation of the Dyestuff Business Revisited," *Business History* 54, no. 1 (2012): 10–29; P. J. Federico, "The Invention and Introduction of the Zipper," *Journal of the Patent Office Society* 28, no. 12 (1946): 855–75; Andrew Godley, "Selling the Sewing Machine around the World: Singer's International Marketing Strategies, 1850–1920," *Enterprise and Society* 7, no. 2 (2006): 266–314; G. J. Pearson, "Innovation in a Mature Industry: A Case Study of Warp Knitting in the UK," *Technovation* 9, no. 8 (1989): 657–679.

5 David Edgerton, *The Shock of the Old: Technology in Global History since 1900* (London: Profile Books, 2007).

6 Roland Barthes, *Système de la mode* (Paris: Seuil, 1967), 330–338.

7 Véronique Pouillard, "Design Piracy in the Fashion Industries of Paris and New York in the Interwar Years," *Business History Review* 85, no. 2 (2011): 319–344.

8 Kathryn K. Sklar, "The Consumers' White Label Campaign of the National Consumers' League 1898–1918," in *Getting and Spending: European and American Consumer Societies in the Twentieth Century*, eds. Susan Strasser, Charles McGovern, and Matthias Judt (Cambridge: Cambridge University Press, 1998), 17–35; Marie-Emmanuelle Chessel, "Women and the Ethics of Consumption in France at the Turn of the Twentieth Century," in *The Making of the Consumer: Knowledge, Power and Identity in the Modern World*, ed. Frank Trentmann (Oxford: Berg, 2006), 81–98.

9 Nancy L. Green, *Ready-to-Wear and Ready-to-Work: A Century of Industry and Immigrants in Paris and New York* (Durham, NC: Duke University Press, 1997).

10 Helen E. Meiklejohn, "Section VI, Dresses—The Impact of Fashion on a Business," in *Price and Price Policies*, ed. Walton Hamilton (New York: McGraw-Hill, 1938), 313–315.

11 Jennifer Le Zotte, *From Goodwill to Grunge: A History of Secondhand Styles and Alternative Economies* (Chapel Hill: University of North Carolina Press, 2017).

12 Véronique Pouillard, "The Rise of Fashion Forecasting and Fashion PR, 1920–1940: The History of Tobé and Bernays," in *Globalizing Beauty: Consumerism and Body Aesthetics in the Twentieth Century*, eds. Hartmut Berghoff and Thomas Kuehne (New York: Palgrave, 2013), 151–169; William R. Leach, *Land of Desire: Merchants, Power, and the Rise of a New American Culture* (New York: Vintage, 1994), 311–313.

13 Brian Hilton, Chong Ju Choi, and Stephen Chen, "The Ethics of Counterfeiting in the Fashion Industry: Quality, Credence and Profit Issues," *Journal of Business Ethics* 55, no. 4 (2004): 350.

14 Diana Crane, *Fashion and Its Social Agendas: Class, Gender and Identity in Clothing* (Chicago: University of Chicago Press, 2000); Jessica Daves, *Ready-Made Miracle: The American Story of Fashion for the Millions* (New York: Putnam, 1967); Claudia B. Kidwell and Margaret Christman, *Suiting Everyone: The Democratization of Clothing in America* (Washington, DC: Smithsonian, 1974).

15 Michèle Ruffat and Dominique Veillon, *La mode des sixties, l'entrée dans la modernité* (Paris: Autrement, 2007).

16 Mary Quant, *Quant by Quant: The Autobiography of Mary Quant* (1965; London: V&A Publications, 2012).

17 Marnie Fogg, *Boutique: A '60s Cultural Phenomenon* (London: Mitchell Beazley, 2003).

18 Paul Stroobant, "La protection de la dentelle à la main," *Im-ex. La grande revue belge pour le développement & l'expansion des industries du vêtement, de la mode et accessoires* (October 1926): 8–9.

19 "Une Conférence technique tripartite du textile aux Etats-Unis," *Textilis* 9, no. 4 (April 1, 1937): 63.

20 Regina Lee Blaszczyk and Véronique Pouillard, "Fashion as Enterprise," in *European Fashion. The Creation of a Global Industry*, eds. Regina Lee Blaszczyk and Véronique Pouillard (Manchester: Manchester University Press, 2018), 24–25.

21 Thierry Charlier, "Un exemple de coopération entre les pouvoirs publics et le secteur privé. Le programme quinquennal de restructuration de l'industrie belge du textile et de la confection en août 1980" (MA thesis in Economics, Université Libre de Bruxelles, Brussels, 1985), 6–7, 12.

22 Ibid., 5; my translation ("ont délibérément laissé périr leur industrie de l'habillement pour devenir la première plaque de transit en matière de commerce de vêtements à bas prix").

23 Lisbeth Sluiter, *Clean Clothes: A Global Movement to End Sweatshops* (London: Pluto Press, 2009).

24 Charlier, "Un exemple de coopération," 16.

25 Ibid., 15.

26 Christopher A. Bayly, "The Origins of Swadeshi (Home Industry): Cloth and Indian Society, 1700–1930," in *The Social Life of Things: Commodities in Cultural Perspectives*, ed. Arjun Appadurai (New York: Cambridge University Press, 2008), 285–321; Lawrence B. Glickman, "'Make Lisle the Style': The Politics of Fashion in the Japanese Silk Boycott, 1937–1940," *Journal of Social History* 38, no. 3 (2005), 586; Geoffrey G. Jones, Kerry Herman, and P. K. Kothandaraman, "Jamnalal Bajaj, Mahatma Gandhi, and the Struggle for Indian Independence," case study no. 807028, Harvard Business School, 2006 (revised 2015), 1–21; Tereza Kuldova, *Luxury Indian Fashion. A Social Critique* (London: Bloomsbury, 2016), 11.

27 An Moons, "To Be (In) or Not to Be (In): The Constituting Processes and Impact Indicators of the Flemish Designer Fashion Industry Undressed," in *Modus Operandi: State of Affairs in Current Research on Belgian Fashion*, ed. Nele Bernheim (Antwerp: Mode Museum, 2008), 69–81.

28 Andrew McAfee, Vincent Dessain, and Anders Sjöman, "Zara: IT for Fast Fashion," case study no. 9–604–081, Harvard Business School, September 6, 2007.

29 Ibid.

30 Sabine Chrétien-Ichikawa, "La réémergence de la mode en Chine et le rôle du Japon" (PhD diss., EHESS, Paris, 2012); Kazunori Takada and Grace Huang, "Uniqlo Thinks Faster Fashion Can Help It Beat Zara," *Bloomberg*, March 16, 2017,

accessed May 15, 2017, https://www.bloomberg.com/news/articles/2017-03-16/uniqlo-turns-speed-demon-to-take-on-zara-for-global-sales-crown.

31 Gilles Lipovetsky, *L'empire de l'éphémère. La mode et son destin dans les sociétés modernes* (Paris: Gallimard, 1987).

32 Teri Agins, *The End of Fashion: How Marketing Changed the Clothing Business Forever* (London: William Morrow, 2000).

33 Susan Strasser, *Waste and Want: A Social History of Trash* (New York: Holt, 1999), 188–189.

34 "Faster, Cheaper Fashion," *Economist*, 5 September 2015, http://www.economist.com/news/business/21663221-rapidly-rising-super-cheap-irish-clothes-retailer-prepares-conquer-america-rivals-should.

35 *The True Cost*, DVD, dir. Andrew Morgan (USA: Bullfrog Films, 2015).

36 Jason Burke, "Bangladesh Factory Collapse Leaves Trail of Shattered Lives," *Guardian*, June 6, 2013; Noemi Sinkovics, Samia Ferdous Hoque, and Rudolf R. Sinkovics, "Rana Plaza Collapse Aftermath: Are CSR Compliance and Auditing Pressures Effective?," *Accounting, Auditing and Accountability Journal* 29, no. 4 (2016): 624–625.

37 Ian M. Taplin, "Who Is to Blame? A Re-examination of Fast Fashion after the 2013 Factory Disaster in Bangladesh," *Critical Perspectives on International Business* 10, no. 1/2 (2014): 77.

38 Enrico D'Ambrogio, European Parliamentary Research Service, "Workers' Conditions in the Textile and Clothing Sector: Just an Asian Affair? Issues at Stake after the Rana Plaza Tragedy," briefing, European Parliament, August 2014, accessed June 26, 2017, http://www.europarl.europa.eu/EPRS/140841REV1-Workers-conditions-in-the-textile-and-clothing-sector-just-an-Asian-affair-FINAL.pdf.

39 Taplin, "Who Is to Blame?" 79.

40 Sinkovics, Hoque, and Sinkovics, "Rana Plaza Collapse Aftermath," 624.

41 Le Zotte, *Goodwill to Grunge*.

42 "Faster, Cheaper Fashion."

43 On the Norwegian media coverage of the Rana Plaza disaster, see Kristin Skare Orgeret, "Cheap Clothes: Distant Disasters. Journalism Turning Suffering into Practical Action," *Journalism* (2016): 1–18.

44 Sluiter, *Clean Clothes*, 20.

45 Ibid., 48–49.

46 Hasia R. Diner, *Roads Taken: The Great Jewish Migrations to the New World and the Peddlers Who Forged the Way* (New Haven, CT: Yale University Press, 2015); David Von Drehle, *Triangle: The Fire That Changed America* (New York: Grove Press, 2003).

47 Green, *Ready-to-Wear*, 80–86, 97–104.

48 Lawrence B. Glickman, *Buying Power: A History of Consumer Activism in America* (Chicago: Chicago University Press, 2009).

49 Glickman, "'Make Lisle the Style,'" 573–608.

50 Albert O. Hirschmann, *Exit, Voice, and Loyalty: Responses to Decline in Firms, Organizations, and States* (Cambridge, MA: Harvard University Press, 1972).

51 Glickman, *Buying Power*, 297–310.

52 Sluiter, *Clean Clothes.*

53 Chessel, "Women and the Ethics of Consumption," 81–98.

54 Naomi Klein, *No Logo: Taking Aim at the Brand Bullies* (New York: Knopf, 1999).

55 Paul Bairoch, *Victoires et déboires: Histoire économique et sociale du monde du XVIe siècle à nos jours*, vol. 3 (Paris: Gallimard, 1997).

56 Laura M. Holson and Rachel Abrams, "For the Trumps, 'Made in U.S.A.' May Be a Tricky Label to Stitch," *New York Times*, December 28, 2016, accessed May 15, 2017, https://www.nytimes.com/2016/12/28/business/donald-trump-ivanka-clothes-global-trade-overseas-manufacturing.html.

57 Daniel Bender and Richard A. Greenwald, *Sweatshop USA: The American Sweatshop in Historical and Global Perspective* (New York: Routledge, 2003).

58 Sluiter, *Clean Clothes*, 71.

59 Taplin, "Who Is to Blame?" 78.

60 Adam Davidson, "Economic Recovery, Made in Bangladesh?," *New York Times*, May 14, 2013, MM16.

61 Green, *Ready-to-Wear*; Bender and Greenwald, *Sweatshop USA*.

62 Sluiter, *Clean Clothes*.

63 Sankar Sen and C. B. Battacharya, "Does Doing Good Always Lead to Doing Better? Consumer Reactions to Corporate Social Responsibility," *Journal of Marketing Research* 38, no. 2 (2001): 240.

64 Taplin, "Who Is to Blame?" 76.

65 Peter Lund-Thomsen and Adam Lindgreen, "Corporate Social Responsibility in Global Value Chains: Where Are We Now and Where Are We Going?," *Journal of Business Ethics* 123, no. 1 (2014): 13.

66 Ibid., 12.

67 McAfee, Dessain, and Sjöman, "Zara."

68 Knut-Erik Mikalsen, "Nordea-sjef: Dette ville en skjorte kostet om fabrikkarbeiderne i Bangladesh skulle fått en levelig lønn," *Aftenposten*, June 2, 2017, accessed June 2, 2017, http://www.aftenposten.no/okonomi/Nordea-sjef-Dette-ville-en-skjorte-kostet-om-fabrikkarbeiderne-i-Bangladesh-skulle-fatt-en-levelig-lonn-622467b.html.

69 Taplin, "Who Is to Blame?" 78; Rina Rafael, "Is This Sewing Robot the Future of Fashion?," *Fast Company*, January 24, 2017, accessed June 2, 2017, https://www.fastcompany.com/3067149/is-this-sewing-robot-the-future-of-fashion.

70 Godley, "Selling the Sewing Machine," 266–314.

71 Tansy Hoskins, "Robot Factories Could Threaten Jobs of Millions of Garment Workers," *Guardian*, July 16, 2016, accessed June 2, 2017, https://www.theguardian.com/sustainable-business/2016/jul/16/robot-factories-threaten-jobs-millions-garment-workers-south-east-asia-women.

72 Taplin, "Who Is to Blame?" 76–78; Glickman, *Buying Power*, 294–296.

73 Falasca-Zamponi, *Waste and Consumption*, 36–39, 42–49.

Chapter 11

1 The Editors of Encyclopedia Britannica, *Y2K Bug*, last modified April 20, 2017, accessed August 26, 2017, https://www.britannica.com/technology/Y2K-bug.

2 Teri Agins, *The End of Fashion, How Marketing Changed the Clothing Business Forever* (New York: Quill, 2000), 15.

3 Ibid.

4 Ibid., 14.

5 Vinken, *Fashion Zeitgeist*, 35.

6 Ibid.

7 Christopher Breward, "Foreword," in *Fashion Studies: Research Methods and Practices*, ed. Heike Jenss (London and New York: Bloomsbury, 2016), xviii.

8 Ibid.

9 Cheryl Buckley and Hazel Clark, *Fashion and Everyday Life, London and New York* (London and New York: Bloomsbury, 2017), 235.

10 Breward, "Foreword," xvii.

11 Lidewij Edelkoort, *Anti_Fashion: A Manifesto for the Next Decade* (Paris: Trend Union, 2014).

12 Rosalind E. Krauss, "Sculpture in the Expanded Field," in *The Originality of the Avant-Garde and Other Modernist Myths* (Cambridge, MA: The MIT Press, 1985), 279.

13 Quoted in Breward "Foreword," xix.

14 Jessica Bugg, "Fashion at the Interface: Designer-Wearer-Viewer," *Fashion Practice* 1, no. 1 (2009): 10.

15 Ibid., 10/11.

16 See Annamari Vänskä and Hazel Clark, eds., *Fashion Curating: Critical Practice in the Museum and Beyond* (London and New York: Bloomsbury), 2017.

17 Bugg, "Fashion at the Interface,"13.

18 See, for example, Lou Taylor, *Establishing Dress History* (Manchester and New York: Manchester University Press, 2004); Valerie Steele and Alexandra Palmer, eds., "Exhibitionism" (Special Issue), *Fashion Theory: The Journal of Dress Body and Culture* 12, no. 1 (2008); Fiona Anderson, "Museums as Fashion Media," in *Fashion Cultures: Theories, Explorations and Analysis*, ed. Stella Bruzzi (London and New York: Routledge, 2000), 371–389.

19 Slavoj Žižek, *Living in the End Times* (London and New York: Verso, 2010).

20 Cheryl Buckley and Hazel Clark, "In Search of the Everyday: Museums, Collections, and Representations of Fashion in London and New York," in *Fashion Studies: Research Methods and Practices*, ed. Heike Jenss (London and New York: Bloomsbury, 2016), 27.

21 Judith Clark and Amy De La Haye, *Exhibiting Fashion: Before and after 1971* (New Haven, CT: Yale University Press, 2014).

22 Amy De La Haye, "*Vogue* and the V&A Vitrine," *Fashion Theory* 10, no. 1/2 (2006): 132–133.

23 Christopher Breward, "Between the Museum and the Academy: Fashion Research and Its Constituencies," *Fashion Theory: The Journal of Dress Body and Culture* 12, no. 1 (2008): 91.

24 Ibid.

25 Ibid. See also Greer Crawley and Donatella Barbieri, "Dress, Time, and Space: Expanding the Field through Exhibition Making," in *The Handbook of Fashion Studies*, eds. Sandy Black et al. (London and New York: Bloomsbury, 2013), 44–60.

26 Valerie Steele, "Museum Quality. The Rise of the Fashion Exhibition," in "Exhibitionism," (Special Issue) *Fashion Theory: The Journal of Dress Body and Culture* 12, no. 1 (2008): 28.

27 Crawley and Barbieri, "Dress, Time and Space," 58.

28 For those seeking more details, Jeffrey Horsely provides a very valuable "Incomplete Inventory" of fashion exhibitions, 1971–2013, in Clark and de la Haye, *Exhibiting Fashion*, 169–245.

29 Alexandra Palmer, "Reviewing Fashion Exhibitions," in "Exhibitionism," (Special Issue) *Fashion Theory: The Journal of Dress Body and Culture* 12, no. 1 (2008): 123.

30 Julia Petrov, "Exhibition and Catalog Review: The Concise Dictionary of Dress," *Fashion Theory: The Journal of Dress Body and Culture* 16, no. 1 (2010): 109–116.

31 Marco Pecorari, *Fashion Remains: The Epistemic Potential of Fashion Ephemera* (PhD diss., Stockholm: Stockholm University, 2015), 258, based on Bruno Latour, *Reassembling the Social: An Introduction to Actor-Network Theory* (Oxford: Oxford University Press, 2007), 79–81.

32 For example, Lesley Ellis Miller, *Balenciaga* (New York: Harry N. Abrams, 2007).

33 N.J. Stevenson, "The Fashion Retrospective," *Fashion Theory: The Journal of Dress Body and Culture* 12, no. 2 (2008): 224, citing Valerie Cumming, *Understanding Fashion History* (London: B.T. Batsford, 2004), 72.

34 Ibid., 226.

35 Ibid., 225.

36 "About the Balenciaga: Shaping Fashion Exhibition," Victoria and Albert Museum, last modified 2017, accessed September 2, 2017, https://www.vam.ac.uk/articles/about-balenciaga-shaping-fashion.

37 Scarlet Conlon, "Inside Balenciaga: Shaping Fashion," UK *Vogue*, published May 24, 2017, accessed August 20, 2017, http://www.vogue.co.uk/article/v-a-museum-balenciaga-exhibition-preview-curator-cassie-davie-strodder.

38 Dana Thomas, "Two Major Museum Exhibitions Celebrate Balenciaga's Fashion Mastery," *Town and Country Magazine*, last modified 2017, accessed August 20, 2017, http://www.townandcountrymag.com/style/fashion-trends/a9178653/balenciaga-museum-exhibitions/.

39 Stevenson, "The Fashion Retrospective," 225.

40 Tina Isaac-Goize, "Star Curator Olivier Saillard Is Headed to J.M. Weston," *Vogue*, June 30, 2017, accessed August 17, 2017, http://www.vogue.com/article/olivier-saillard-weston.

41 Sarah Moroz, "In a New Performance Piece, Tilda Swinton Turns Fashion into Art,"
 T Magazine, *The New York Times*, November 21, 2014, accessed August 19, 2017,
 http://tmagazine.blogs.nytimes.com/2014/11/21/tilda-swinton-cloakroom-paris-festival/.

42 Isaacc-Goize, "Star Curator Olivier Saillard Is Headed to J.M. Weston."

43 For example, *Prada Waist Down,* the exhibition which was originally staged in
 the Prada store in Aoyama, Tokyo (2004–2005) designed by Miuccia Prada, and
 conceived by curator Kayoko Ota of AMO, which subsequently traveled to Prada
 stores in many major international cities. See "Prada Waist Down," 2 x 4, accessed
 Septmeber 15, 2017, https://2x4.org/work/26/prada-waist-down/.

44 Yuli Bai, "Artification and Authenticity: Museum Exhibitions of Luxury Fashion Brands in
 China," in *Fashion Curating: Critical Practice in the Museum and Beyond*, eds. Annamari
 Vänskä and Hazel Clark (London and New York: Bloomsbury, 2017), 213–225.

45 Sarah Scaturro, "Confronting Fashion's Death Drive: Conservation, Ghost Labor, and
 the Material Turn within Fashion Curation," in *Fashion Curating: Critical Practice in
 the Museum and Beyond*, eds. Annamari Vänskä and Hazel Clark (London and New
 York: Bloomsbury, 2017), 22.

46 Maria Luisa Frisa in conversation with Gabriele Monti, "Everybody's a Curator," in
 Understanding Fashion through the Exhibition, Under the direction of Luca Marchetti
 (Geneva: HEAD, 2014), 261.

47 Dobrila Denegri, "When Time Becomes Space," in *Understanding Fashion through
 the Exhibition*, Under the direction of Luca Marchetti (Geneva: HEAD, 2014), 299.

48 "Items: Is Fashion Modern?" The Museum of Modern Art, last modified 2017,
 accessed August 25, 2017, https://www.moma.org/calendar/exhibitions/1638.

49 Ibid.

50 "This Fall, Items: Is Fashion Modern? Highlights 111 Influential Garments and
 Accessories That Are Paragons of Design," The Museum of Modern Art, accessed
 August 26, 2017, http://press.moma.org/wp-content/files_mf/moma_items_
 expandedpressrelease_final38.pdf.

51 Ibid.

52 Natacha Wolinski, "When Fashion Dresses Up the Imagination," *Beaux Arts
 Magazine*, pamphlet for *Dysfashional* exhibition (Luxembourg, 2007).

53 Ibid.

54 "*Dysfashional*," Garage Centre for Contemporary Art, last modified 2017, accessed
 September 1, 2017, http://garagemca.org/en/event/dysfashional.

55 Ilari Laamanen is an independent curator and currently project manager at the
 Finnish Cultural Institute in New York.

BIBLIOGRAPHY

Adorno, Theodor W. "Valéry Proust Museum." In *Prisms*, trans. Samuel and Shiery Weber, 173–186. London: Neville Spearman, 1967.

Adorno, Theodor W. "Cultural Criticism and Society." In *Prisms*, trans. Samuel and Shierry Weber, 17–34. Cambridge, MA: MIT Press, [1981] 1990.

Agins, Teri. *The End of Fashion: How Marketing Changed the Clothing Business Forever*. New York: HarperCollins, 2000.

Agins, Teri. *Hijacking the Runway: How Celebrities Are Stealing the Spotlight from Fashion Designers*. New York: Gotham Books, 2014.

Altheide, David L. "Media Logic and Political Communication." *Political Communication* 21, no. 3 (2004): 293–296.

Altheide, David and Robert P. Snow. *Media Logic*. London: Sage, 1979.

Anderson, Benedict. *Imagined Communities. Reflections on the Origin and Spread of Nationalism*. London and New York: Verso, 1991.

Anderson, Fiona. "Museums as Fashion Media." In *Fashion Cultures: Theories, Explorations and Analysis*, edited by Stella Bruzzi, 371–389. London and New York: Routledge, 2000.

Anderson, Rowan. "10 New Zealand Fashion Designers and Brands You Should Know." *The Culture Trip*, October 31, 2016. Accessed November 22, 2016, https://theculturetrip.com/pacific/new-zealand/articles/top-10-new-zealand-fashion-designers-you-should-know/.

Anna, Suzanne. "The 'Fashion Generation' in a Fashion City." In *Generation Mode*, edited by Sussanne Anna and Eva Gronbach, 7–11. Düsseldorf: Hatje Cantz, 2006.

Appadurai, Arjun. *Modernity at Large: Cultural Dimensions of Globalization*. Minneapolis and London: University of Minnesota Press, 1996.

Ash, Juliette. "Memory and Objects." In *The Gendered Object*, edited by P. Kirkham, 20–21. Manchester: Manchester University Press, 1996.

Bai, Yuli. "Artification and Authenticity: Museum Exhibitions of Luxury Fashion Brands in China." In *Fashion Curating Critical Practice in the Museum and Beyond*, edited by Annamari Vanska and Hazel Clark, 213–225. London and New York: Bloomsbury.

Baird-Murray, Kathleen. "Whatever Happened to the Cleavage?" *Vogue*, UK, 2016.

Bairoch, P. *Victoires et déboires. Histoire économique et sociale du monde du XVIe siècle à nos jours*, 3 vol. Paris: Gallimard, 1997.

Balmain, Army. "What I Wore This Week." *The Guardian*, March 24, 2017.

Barthes, Roland. *Système de la mode*. Paris: Seuil, 1967.

Barthes, Roland. *Mythologies*, trans. Annette Lavers. New York: The Noonday Press. Farrar, Straus & Giroux, 1991.

Barthes, Roland. *The Language of Fashion*, trans. Andy Stafford. Oxford and New York: Berg, 2006.

Batista, Luciano. "New Business Models Enabled by Digital Technologies: A Perspective from the Fashion Sector." *New Economic Models in the Digital Economy*, February 2013. Accessed April 23, 2017, http://www.nemode.ac.uk/wp-content/uploads/2013/03/BATISTA-case-study-in-the-fashion-sector-FINAL-Report.pdf.

Battaglia, M., Testa, F., Bianchi, L., Iraldo, F. and M. Frey. "Corporate Social Responsibility and Competitiveness within SMEs of the Fashion Industry: Evidence from Italy and France." *Sustainability* 6 (2014): 872–893.

Baudrillard, Jean. *Seduction*, trans. Brian Singer. Montreal: New World Perspectives, Culture Text Series, 1991.

Baudrillard, Jean. "Simulacra and Simulations." In *Modernism/Postmodernism*, edited by Peter Brooker, 151–163. London: Longman, 1992.

Baudrillard, Jean. *Simulacra and Simulation*, trans. Sheila Faria Glaser. Ann Arbor: University of Michigan Press, 1994.

Baudrillard, Jean. "Fashion or the Enchanting Spectacle of the Code." In *Fashion Theory. A Reader*, edited by Malcolm Barnard, 462–474. London and New York: Bloomsbury, 2007.

Bellour, Raymond. "Le spectateur du cinéma: une mémoire unique." *Trafic* 79 (2011): 32–44.

Bellour, Raymond. *La querelle des dispositifs*. Paris: P.O.L, 2011.

Bender, D. E. and R. A. Greenwald. *Sweatshop USA. The American Sweatshop in Historical and Global Perspective*. New York: Routledge, 2003.

Benjamin, Walter. *Illuminations*, edited by H. Arendt. New York: Schocken Books, 1968.

Benjamin, Walter. *The Arcades Project*. Cambridge, MA: Harvard University Press, 1999.

Benjamin, Walter. *Selected Writings 1913–1926*, vol. 1, edited by M. Bullock and M. W. Jennings. Cambridge, MA, and London: The Belknap Press of Harvard University Press, 2002.

Benjamin, Walter. *The Work of Art in the Age of Its Technological Reproducibility* (1936) *and Other Writings on Media*. Cambridge, MA: Harvard University Press, 2008.

Benjamin, Walter. *The Work of Art in the Age of Mechanical Reproduction*. London: Prism Key Press, 2012.

Berardi, Franco. *After the Future*, edited by Gary Genosko and Nicholas Thoburn. Oakland, CA, and Baltimore, MD: AK Press, 2011.

Berger, John. *Ways of Seeing*. London: British Broadcasting/Penguin Books, 1972.

Berglund, Nina. "Mood Tumbles at 'Mood of Norway.'" *News in English*, November 14, 2014. Accessed August 14, 2017, http://www.newsinenglish.no/2014/11/14/mood-tumbles-at-moods-of-norway/.

Bernheim, Nele, ed. *Symposium 1: Modus Operandi: State of Affairs in Current Research on Belgian Fashion*. Antwerp: MoMu—Fashion Museum, 2008.

Berzowska, Joanna. "XS Labs: Electronic Textiles and Reactive Garments as Sociocultural Interventions." In *The Handbook of Fashion Studies*, edited by Sandy Black, Joanne Entwistle, Amy De La Haye, Agnès Rocamora, Regina Root, and Helen Thomas, 456–475. London and New York: Bloomsbury, 2013.

Bhachu, P. *Dangerous Designs. Asian Women and the Diaspora Economies*. London: Routledge, 2004.

Bissinger, Buzz. "Caitlyn Jenner: The Full Story" *Vanity Fair*, July 2015. https://www.vanityfair.com/hollywood/2015/06/caitlyn-jenner-bruce-cover-annie-leibovitz.

Black, Sandy. "Trends in Smart Textiles." In *Smart Textiles for Medicine and Healthcare*, edited by Louiva Van Langenhove, 3–26. Cambridge: Woodhead, 2007.

Black, Sandy. *Eco Chic: The Fashion Paradox*. London: Black Dog Publishing, 2008.

Black, Sandy. "Fashion Is Often Very Old-Fashioned." In *The Sustainable Fashion Handbook*, edited by Sandy Black, 116–119. London: Thames and Hudson, 2012.

Black, Sandy. "'Introduction' to Section VI: Science, Technology and New Fashion." In *The Handbook of Fashion Studies*, edited by Sandy Black, Joanne Entwistle, Amy de la Haye, Agnès Rocamora, Regina Root and Helen Thomas, 429–435. London and New York: Bloomsbury, 2013.

Black, Sandy, Mary Jane Edwards, and Gabrielle Miller. "What's Digital about Fashion Design?" A report for *New Economic Models in the Digital Economy*, December 9, 2015. Accessed May 21, 2017, http://issuu.com/aamassociates/docs/whats_digital_about_fashion_design_/1.

Black, Sandy, Claudia M. Eckert, Philip Delamore, Frances Geesin, Steven Harkin, Penelope Watkins, and Fatemeh Eskandarypur. "Considerate Design for Personalised Fashion." In *Designing for the 21st Century: Interdisciplinary Methods & Findings*, edited by Tom Inns, 67–86. Aldershot: Gower, 2009.

Blum, Julia. "Seventeen Magazine: Give Girls Images of Real Girls!" Change.org Inc. Accessed June 7, 2017, https://www.change.org/p/seventeen-magazine-give-girls-images-of-real-girls.

Bô, Daniel and Matthieu Guével. *Brand Content: Comment les Marques de Transforment on Médias*. Paris: Dunod, 2009.

Bocken, Nancy M. P., S. W. Short, P. Rana, and Steve Evans. "A Literature and Practice Review to Develop Sustainable Business Model Archetypes." *Journal of Cleaner Production* 65 (2014): 42–56.

Bolter, Jay David and Richard Grusin. *Remediation: Understanding New Media*. Cambridge: MIT Press, 1999.

Bonadio, Maria. Claudia. "Brazilian Fashion and the 'Exotic.'" *International Journal of Fashion Studies* 1, no. 1 (2009): 57–74.

Bordo, Susan. *Unbearable Weight: Feminism, Western Culture and the Body*. Berkeley, CA: University of California Press, 1993.

Bourdieu, Pierre. *The Field of Cultural Production*. Cambridge: Polity Press, 1993.

Bourdieu, Pierre and Yvette Delsaut. "Le Couturier et sa Griffe. Contribution à une Théorie de la Magie." *Actes de la Recherche en Sciences Sociales* 1 (1975): 7–36.

Bourke, Joanna. "The Great Male Renunciation: Men's Dress Reform in Inter-War Britain." *Journal of Design History* 9, no. 1 (1996): 23–33.

Brantlinger, Patrick. *Bread and Circuses: Theories of Mass Culture as Social Decay*. Ithaca, NY: Cornell University Press, 1983.

Braudy, Leo. *The Frenzy of Renown: Fame and Its History*. Oxford: Oxford University Press, 1986.

Breward, Christopher. "Between the Museum and the Academy: Fashion Research and Its Constituencies." *Fashion Theory: The Journal of Dress Body and Culture* 12, no. 1 (2008): 83–94.

Breward, Christopher. "Foreword." In *Fashion Studies Research Methods and Practices*, edited by Heike Jenss, xvii–xx. London and New York: Bloomsbury, 2016.

Briggs, Adam. "Capitalism's Favourite Child: The Production of Fashion." In *Fashion Cultures Revisited: Theories, Explorations and Analysis*, edited by Stella Bruzzi and Pamela Church Gibson, 186–199. London: Routledge, 2013.

Britannica. The Editors of Encyclopedia Britannica, *Y2K Bug*. Accessed August 26, 2017, https://www.britannica.com/technology/Y2K-bug.

British Fashion Council (BFC) and Oxford Economics. *The Value of the UK Fashion Industry: Economic Considerations for Growth*. London: British Fashion Council, 2010.

Brooks, Rosetta. "Sighs and Whispers in Bloomingdales: A Review of a Bloomingdale Mail-Order Catalogue for Their Lingerie Department." In *Zoot Suits and Second-Hand Dresses*, edited by Angela McRobbie, 183–188. Boston, MA: Unwin Hyman, 1989.

Bruno, Giuliana. "Cultural Cartography, Materiality and the Fashioning of Emotion." In *Visual Cultural Studies*, edited by Marquard Smith, 144–166. Los Angeles and London: Sage, 2008.

Bruzzi, Stella and Pamela Church Gibson. *Fashion Cultures Revisited*. London and New York: Routledge, 2014.

Buckley, Cheryl and Hazel Clark. "In Search of the Everyday: Museums, Collections, and Representations of Fashion in London and New York." In *Fashion Studies Research Methods and Practices*, edited by Heike Jenss, 25–41. London and New York: Bloomsbury, 2016.

Buckley, Cheryl and Hazel Clark. *Fashion and Everyday Life, London and New York*. London and New York: Bloomsbury, 2017.

Bugg, Jessica. "Fashion at the Interface: Designer-Wearer-Viewer." *Fashion Practice* 1, no. 1 (2009): 9–31.

Burke, J. "Bangladesh Factory Collapse Leave Trail of Shattered Lives." *The Guardian*, June 6, 2013. Accessed February 19, 2014, https://www.theguardian.com/world/2013/jun/06/bangladesh-factory-building-collapse-community.

Butler, Sara. "Marks & Spencer Takes Control of Its Online Store from Amazon." *The Guardian*, 2014. Accessed February 19, 2014, http://www.theguardian.com/business/2014/feb/18/marks-spencer-control-online-shopping-website-amazon.

Cachon, G. and R. Swinney. "The Value of Fast Fashion: Quick Response, Enhanced Design, and Strategic Consumer Behavior." *Management Science* 57, no. 4 (2011): 778–795.

Calefato, Patrizia. *Mass moda. Linguaggio e immaginario del corpo rivestito*. Genova: Costa & Nolan (2nd edition, 2007: Roma: Meltemi), 1996.

Calefato, Patrizia. *La moda oltre la moda*. Milano: Lupetti, 2011.

Cartner-Morley, Jess. "Olivier Rousteing on Rihanna, Kim Kardashian and the Balmain Army." *The Guardian*, September 15, 2016. https://www.theguardian.com/fashion/2016/sep/15/olivier-rousteing-on-rihanna-kim-kardashian-and-the-balmain-army.

Casetti, Francesco. "Sutured Reality: Film, From Photographic to Digital." *October* 138 (2011): 95–106.

Cashmore, Ellis. *Celebrity Culture*. London: Routledge, 2006.

Centre for Fashion Enterprise (CFE). *The UK Designer Fashion Economy: Value Relationships–Identifying Barriers and Creating Opportunities for Business Growth*. London, 2008. Report commissioned by NESTA (National Endowment for Science Technology and the Arts).

Change.org Inc. "Raw Beauty Talks: Help Us Create Positive Change for Young Women by Reducing Photoshop in Magazines." Accessed June 7, 2017, https://www.change.org/p/reduce-photoshop-in-magazines-to-create-a-better-world-for girls.

Cherry, Robin. *Catalog: The Illustrated History of Mail-Order Shopping*. New York: Princeton Architectural Press, 2008.

Chessel, M.-E. "Women and the Ethics of Consumption in France at the Turn of the 20th Century." In *The Making of the Consumer. Knowledge, Power and Identity in the Modern World*, edited by F. Trentmann, 81–98. Oxford and New York: Berg, 2006.

Chessel, M.-E. *Consommateurs engagés à la Belle Epoque. La Ligue sociale d'acheteurs*. Paris: Presses de Sciences Po, 2012.

Chow, Rey. *Ethics after Idealism. Theory, Culture, Ethnicity, Reading*. Bloomington, IN: Indiana University Press, 1998.

Chow, Rey. "The Writing Voice in Cinema: A Preliminary Discussion." In *Locating the Voice in Film: Critical Approaches and Global Perspectives*, edited by T. Whittaker, S. Wright. Oxford: Oxford University Press, 2017. DOI:10.1093/acprof: oso/9780190261122.003.0002

Chrétien-Ichikawa, S. *La réémergence de la mode en Chine et le rôle du Japon*. PhD thesis. Paris: EHESS, 2012.

Christopher, Martin, Robert Lowson, and Helen Peck. "Creating Agile Supply Chains in the Fashion Industry." *International Journal of Retail & Distribution Management* 32, no. 8 (2004): 367–376.

Chung, Shuk-Wah. "Fast Fashion Is 'Drowning' the World: We Need a Fashion Revolution!" Greenpeace International, Blogspot by Shuk-Wah Chung, April 21, 2016. Accessed November 21, 2016, http://www.greenpeace.org/international/en/news/ Blogs/makingwaves/fast-fashion-drowning-world-fashion-revolution/blog/56222/.

Church Gibson, Pamela. *Fashion and Celebrity Culture*. Oxford and New York: Berg, 2012.

Church Gibson, Pamela. "Pornostyle: Sexualised Dress and the Fracturing of Feminism." *Fashion Theory: The Journal of Dress, Body, and Culture* 18, no. 2 (2014): 186–206.

Clark, Judith and Amy de la Haye. *Exhibiting Fashion: Before and after 1971*. New Haven, CT and London: Yale University Press, 2014.

Clauss, Elisabeth. "The Re-united States of Fashion." *Business of Fashion*, May 20, 2016. Accessed August 14, 2017, https://www.businessoffashion.com/articles/ author/elisabeth-clauss.

Cline, Elizabeth. *The Shockingly High Cost of Cheap Fashion*. New York and London: Penguin, 2013, Kindle Edition.

Codinha, Alessandra. "Meet the New Site That Wants to Take the Legwork Out of Instagram-Stalking for You." *Vogue*, 2015. Accessed May 12, 2016, http://www. vogue.com/article/semaine-online-magazine-concept-store-launches.

Coen, Jessica. "Here Are the Unretouched Images from Lena Dunham's Vogue Shoot." *Jezebel*, January 17, 2014. Accessed June 7, 2017, http://jezebel.com/here-are-the- unretouched-images-from-lena-dunhams-vogu-1503336657.

Collins, J. L. *Threads. Gender, Labor, and Power in the Global Apparel Industry*. Chicago: University of Chicago Press, 2003.

Collins, Lauren. "Pixel Perfect. Pascal Dangin's Virtual Reality." *The New Yorker*, May 5, 2008. Accessed June 7, 2017, http://www.newyorker.com/magazine/2008/05/12/ pixel-perfect.

Colman, Felicity. "Rhizome." In *The Deleuze Dictionary*, Revised Edition, edited by Adrian Parr, 232–235. Edinburgh: Edinburgh University Press, 2010.

Conlon, Scarlet. "Inside Balenciaga: Shaping Fashion." *UK Vogue*, May 24, 2017. Accessed August 20, 2017, http://www.vogue.co.uk/article/v-a-museum-balenciaga- exhibition-preview-curator-cassie-davie-strodder.

Couldry, Nick. "Mediatization or Mediation? Alternative Understandings of the Emergent Space of Digital Storytelling." *New Media & Society* 10, no. 3 (2008): 373–391.

Craik, Jennifer. "Fashioning Australian: Recent Reflections on the Australian Style in Contemporary Fashion." *Journal of Asia-Pacific Pop Culture* 2, no. 1 (2017): 30–52.

Cramer, Theresa. *Inside Content Marketing*. Chicago: Information Today, 2016.

Crane, D. *Fashion and Its Social Agendas. Class, Gender and Identity in Clothing*. Chicago: University of Chicago Press, 2000.

Crawley, Greer and Donatella Barbieri. "Dress, Time, and Space: Expanding the Field through Exhibition Making." In *The Handbook of Fashion Studies*, edited by Sandy

Black, Amy De La Haye, Joanne Entwistle, Agnès Rocamora, Regina A. Root, and Helen Thomas, 44–60. London and New York: Bloomsbury, 2013.

Crewe, Louise. *The Geographies of Fashion*. London and New York: Bloomsbury, 2017.

Crewe, Louise and Zena Forster. "Markets, Design, and Local Agglomeration: The Role of the Small Independent Retailer in the Workings of the Fashion System." *Environment and Planning D* 11, no. 2 (1993): 213–229.

Crewe, Louise, Nicky Gregson, and Kate Brooks. "The Discursivities of Difference." *Journal of Consumer Culture* 3, no. 1 (2003): 61–82.

Csikszentmihalyi, Mihaly. *Creativity: Flow and the Psychology of Discovery and Invention*. New York: Harper Perennial, 1996.

Curran, James, Natalie Fenton, and Des Freedman. *Misunderstanding the Internet*. London: Routledge, 2016.

Dallabona, Alice. "Narratives of Italian Craftsmanship and the Luxury Fashion Industry: Representations of Italianicity in Discourses of Production." In *Global Fashion Brands: Style, Luxury and History*, edited by Joseph H. Hancock, Gjoko Muratovski, Veronica Manlow, and Anne Peirson-Smith, 215–228. Bristol: Intellect, 2014.

Danesi, M. *La comunicazione al tempo di Internet*. Bari: Progedit, 2013.

Danto, Arthur. *After the End of Art: Contemporary Art and the Pale of History*. Princeton, NJ: Princeton University Press, 1997.

Daves, J. *Ready-Made Miracle: The American Story of Fashion for the Millions*. New York: Putnam, 1967.

DCMS. *Creative Industries Mapping Document*. London: DCMS (UK Government Department of Culture, Media and Sport), 1998.

DCMS. *Creative Industries Mapping Documents 2001: Fashion*. London: DCMS (UK Government Department of Culture, Media and Sport), 2001.

De Cléir, Síle. "Creativity in the Margins: Identity and Locality in Ireland's Fashion Journey." *Fashion Theory* 15, no. 4 (2011): 201–224.

De La Haye, Amy. "*Vogue* and the V&A Vitrine." *Fashion Theory: The Journal of Dress Body and Cult* 10, no. 1/2 (2006): 127–151.

De Pelsmecerk, Patrick. "Introduction." In *Advertising in New Formats and Media*, edited by De Pelsmecker. Bingley: Emerald Publishing, 2016.

Deacon, David and James Stanyer. "Mediatization: Key Concept or Conceptual Bandwagon?" *Media, Culture & Society* (2014): 1–13.

Deacon, David and James Stanyer. "'Mediatization and' or 'Mediatization of'?" A Response to Hepp et al. *Media, Culture & Society* 37, no. 4 (2015): 655–657.

Debord, Guy. *The Society of the Spectacle*, trans. by Ken Knabb. London: Rebel Press, 2004.

Dei Ottati, Gabi. "A Transnational Industrial Fast Fashion District: An Analysis of the Chinese Businesses in Prato." *Cambridge Journal of Economics* 38 (2014): 1247–1274.

Deleuze, Gilles and Félix Guattari. *Mille plateaux*. Paris: Minuit, 1980.

DeMartini-Squires, Brenda. "Now You See It: Disinformation and Disorientation on the Internet." In *A History of Visual Culture: Western Civilization from the 18th to the 21st Century*, edited by Jane Kromm and Susan Benforado Bakewell, 337–346. Oxford and New York: Berg, 2010.

Denegri, Dobrila. "When Time Becomes Space." In *Understanding Fashion through the Exhibition*. Under the direction of Luca Marchetti, 299–301. Geneva: HEAD, 2014.

Derrida, Jacques. *Dissemination*, trans. Barbara Johnson. Chicago: The University of Chicago Press, 1981.

Derrida, Jacques. *A Derrida Reader. Between the Blinds*, edited by Peggy Kamuf. New York: Columbia University Press, 1991.

Derrida, Jacques. *Specters of Marx: The State of the Debt, The Work of Mourning and the New International*, trans. Peggy Kamuf. London and New York: Routledge, 1994.

Derrida, Jacques. "Archive Fever: A Freudian Impression." *Diacritis* 25, no. 2 (Summer 1995): 9–63.

Deurell, Johan and Eide, Hanne, eds. *Utopian Bodies—Fashion Looks Forward*. Stockholm: Liljevalchs Museum, 2015.

Diner, H. R. *Roads Taken. The Great Jewish Migrations to the New World and the Peddlers Who Forged the Way*. New Haven, CT: Yale University Press, 2015.

Edelkoort, Lidewij. "Anti-fashion." *De Zeen*, March 15, 2015.

Edelkoort, Lidewij. *Anti_Fashion: A Manifesto for the Next Decade*. Paris: Trend Union, 2014.

Edwards, Stassa. "New Photographs Show That Zendaya Was Heavily Photoshopped for Magazine Shoot." *Jezebel*, March 11, 2015. Accessed June 7, 2017, https://jezebel.com/new-photographs-show-that-zendaya-was-heavily-photoshop-1740424576.

Edwards, Tim. *Fashion in Focus: Concepts and Practices*. London: Routledge, 2011.

Ekström, Mats, Johan Fornäs, André Jansson, and Anne Jerslev. "Three Tasks for Mediatization Research: Contribution to an Open Agenda." *Media, Culture & Society* (2016): 1–19.

English, Bonnie. *A Cultural History of Fashion in the 20th and 21st Centuries: From Catwalk to the Sidewalk*. London and New York: Bloomsbury, 2013, Kindle Edition.

Entwistle, Joanne. *The Fashioned Body: Fashion, Dress and Modern Social Theory*. Cambridge: Polity Press, 2000.

Entwistle, Joanne. *The Aesthetic Economy of Fashion: Markets and Value in Clothing and Modelling*. Oxford and New York: Berg, 2009.

Enzensberger, Hans Magnus. "Constituents of a Theory of the Media." *New Left Review* 1, no. 64 (November–December 1970): 13–36.

Enrico D'Ambrogio, European Parliamentary Research Service. "Workers' Conditions in the Textile and Clothing Sector: Just an Asian Affair? Issues at Stake after the Rana Plaza Tragedy." Briefing, European Parliament, August 2014. Accessed June 26, 2017, http://www.europarl.europa.eu/EPRS/140841REV1-Workers-conditions-in-the-textile-and-clothing-sector-just-an-Asian-affair-FINAL.pdf.

Eskjaer, Mikkel. "The Mediatization of Ethical Consumption." *MedieKultur* 54 (2013): 26–46.

Evans, Caroline. *Fashion at the Edge*. New Haven, CT, and London: Yale University Press, 2003.

Ewen, Stuart. "All-Consuming Images: Style in the New 'Information Age.'" In *State of the Art: Issues in Contemporary Mass Communication*, edited by David Shimkin, Harold Stolerman, and Helene O'Connor, 195–200. New York: St. Martin's Press, 1992.

Fairs, Marcus. "Interview with Lidewij Edelkoort." *Dezeen*, March 1, 2015. Accessed January 30, 2017, https://www.dezeen.com/2015/03/01/li-edelkoort-end-of-fashion-as-we-know-it-design-indaba-2015/.

Fairs, Marcus. "Lidewij Edelkoort Publishes Manifesto Explaining Why Fashion Is Obsolete." *Dezeen*, March 2, 2015. Accessed January 30, 2017, https://www.dezeen.com/2015/03/02/li-edelkoort-manifesto-anti-fashion-obsolete/.

Featherstone, Mike. *Consumer Culture and Postmodernism*. London: Sage, 2007.

Feldman, Cristine Jacqueline. *We Are the Mods: A Transnational History of a Youth Subculture*. New York: Peter Lang, 2009.

Fidler, Franz. *Portretnaia fotografiia*. Moscow: Vsesoiuznoe kooperativnoe izdatel'stvo, 1960.

Finnemann, Niels Ole. "Mediatization Theory and Digital Media." *Communications* 36 (2011): 67–89.

Finnigan Kate. "Nordic Chic: 8 Scandi Brands You Need to Know." *The Telegraph*, January 30, 2016. Accessed August 14, 2017, http://www.telegraph.co.uk/fashion/brands/nordic-chic-8-scandi-brands-you-need-to-know/.

Fletcher, Kate. *Sustainable Fashion and Textiles. Design Journeys*. London: Earthscan, 2008.

Flügel, John Carl. *The Psychology of Clothes*. London: Hogarth Press, 1930.

Fogg, M. *Boutique: A 60s Cultural Phenomenon*. London: Mitchell Beazley, 2003.

Fox, Alistair, Michel Marie, Raphaëlle Moine, and Hilary Radner, eds. *A Companion to Contemporary French Cinema*. Malden, MA: John Wiley and Sons, 2015.

Foucault, Michel. *Discipline and Punish: The Birth of the Prison System*. London: Penguin Books, 1977.

Friedberg, Anne. *Window Shopping: Cinema and the Postmodern*. Berkeley, CA: University of California Press, 1993, Kindle Edition.

Friedman, Vanessa and Jacob Bernstein. "Donna Karan Steps Down, in Major Shift for Fashion." *New York Times*, June 30, 2015. Accessed 12 May 2017, https://www.nytimes.com/2015/06/30/fashion/donna-karan-steps-down.html?_r=0.

Frisa, Maria Luisa. In conversation with Gabriele Monti, "Everybody's a Curator." In *Understanding Fashion through the Exhibition*. Under the direction of Luca Marchetti, 259–263. Geneva: HEAD, 2014.

Fuchs, Christian. *Foundations of Critical Media and Information Studies*. London: Routledge, 2011.

Fury, Alexander. "The Lighter Side of Rick Owens." *The New York Times*, March 2, 2017. Accessed May 10, 2017, https://www.nytimes.com/2017/03/02/t-magazine/rick-owens-fashion-designer.html?_r=0.

Gamber, Wendy. *The Female Economy: The Millinery and Dressmaking Trades, 1860–1930*. Urbana: University of Illinois Press, 1997.

Garage Centre for Contemporary Art. "Dysfashional." Accessed September 1, 2017, http://garagemca.org/en/event/dysfashional.

Garcia, Patricia. "Dress the Part: *Only Lovers Left Alive*." *Vogue*, April 10, 2014. Accessed May 8, 2017, http://www.vogue.com/article/dress-the-part-only-lovers-left-alive-fashion.

Geczy, Adam and Jacqueline Millner. *Fashionable Art*. London and New York: Bloomsbury, 2015.

Geczy, Adam and Vicki Karaminas, eds. *Fashion and Art*. Oxford and New York: Berg, 2012.

Geczy, Adam and Vicki Karaminas. *Fashion's Double: Representations of Fashion in Painting, Photography and Film*. London and New York: Bloomsbury, 2016.

Geczy, Adam and Vicki Karaminas. "Lady Gaga, *American Horror Story*, Fashion, Monstrosity and the Grotesque." *Fashion Theory* 21, no. 6 (2017): 621–627.

Giannone, Antonella. "La costruzione del senso filmico nell'abbigliamento e nel costume." In *Moda e cinema*, edited by P. Calefato. Genova: Costa & Nolan, 1999.

Gilbert, David. "From Paris to Shanghai: The Changing Geographies of Fashion's World Cities." In *Fashion's World Cities*, edited by Christopher Breward and David Gilbert, 3–32. Oxford and New York: Berg, 2006.

Gilchrist, Todd. "Only Lovers Left Alive's Tilda Switnon Talks Playing a Vampire, Working with Tom Hiddleston." *Daily Dead*, November 4, 2011. Accessed May 8, 2017, https://dailydead.com/lovers-left-alives-tilda-swinton-talks-playing-vampire-working-tom-hiddleston/.

Gill, Alison. "Deconstruction Fashion: The Making of Unfinished, Decomposing and Re-assembled Clothes." *Fashion Theory: The Journal of Dress Body & Culture* 2, no. 1 (1998): 25–49.

Gizmodo Media Group. "Photoshop of Horrors." *Jezebel*, 2017. Accessed June 7, 2017, http://jezebel.com/tag/photoshop-of-horrors.

Gledhill, Christine, ed. *Stardom: Industry of Desire*. London: Routledge, 1991.

Glickman L. B. *Buying Power. A History of Consumer Activism in America*. Chicago: Chicago University Press, 2009.

Granata, Francesca. "Deconstruction Fashion: Carnival and the Grotesque." *Journal of Design History* 26, no. 2 (2012): 182–198.

Green, N. J. *Ready-to-Wear and Ready-to-Work: A Century of Industry and Immigrants in Paris and in New York*. Durham, NC: Duke University Press, 1997.

Greenberg, Clement. *The Collected Essays and Criticism*, Vol. 4, edited by John O'Brian. Chicago and London: Chicago University Press, 1993.

Gregory, Alice. "Has the Fashion Industry Reached a Transgender Turning Point?" *Vogue*, April 21, 2015. Accessed June 8, 2017, http://www.vogue.com/article/andreja-pejic-transgender-model.

Grigoriadis, Vanessa. "Death of One's Own." *New York Magazine*, December 8, 2003. Accessed May 12, 2017, http://nymag.com/nymetro/news/people/n_9589/.

Gronbach, Eva. "Global Local: Movements and Counter-movements in the 'Fashion Generation.'" In *Generation Mode*, edited by Sussanne, Anna and Eva Gronbach, 21–33. Düsseldorf: Hatje Cantz, 2006.

Grunenberg, Christoph. "Wonderland: Spectacles of Display from the Bon Marché to Prada." In *Shopping*, edited by Christoph Grunenberg and Mats Hollein, 17–37. Düsseldorf: Hatje Cantz, 2002.

Hacker Factor. "Fotoforensics." Accessed June 7, 2017, http://fotoforensics.com.

Hansen, Miriam. *Cinema and Experience: Siegfried Kracauer, Walter Benjamin, and Theodor W. Adorno*. Berkeley, CA: University of California Press, 2011.

Hardy, Jonathan. "Sponsored Content Is Compromising Media Integrity." *Open Democracy*, 2017. Accessed April 14, 2017, https://www.opendemocracy.net/jonathan-hardy/sponsored-content-is-blurring-line-between-advertising-and-editorial.

Hegel, G. W. F. *Phänomenologie des Geistes*. Frankfurt am Main: Suhrkamp, 1986.

Hegel, G. W. F. *Vorlesungen über die Ästhetik, Werke* 14. Frankfurt am Main: Suhrkamp, 1986.

Heilbrun, Carolyn G. *Toward a Recognition of Androgyny*. New York: Norton, 1993.

Hepp, Andreas. "Differantiation: Mediatization and Cultural Change." In *Mediatization of Communication*, edited by Knut Lundby, 139–157. Berlin: De Gruyter, 2009.

Hepp, Andreas. "The Communicative Figurations of Mediatized Worlds." *Communicative Figurations* 1. Accessed June 20, 2015, http://www.kommunikativefigurationen.de/fileadmin/redak_kofi/Arbeitspapiere/CoFi_EWP_No-1_Hepp.pdf.

Hepp, Andreas. *Cultures of Mediatization*. Cambridge: Polity Press, 2013.

Herpen, Iris Van. *Iris Van Herpen: Transforming Fashion*. Groninger: Groninger Museum and High Museum of Art, 2015.

Hilton, B., Choi, C. J. and S. Chen. "The Ethics of Counterfeiting in the Fashion Industry: Quality, Credence and Profit Issues." *Journal of Business Ethics* 55, no. 4 (2004): 345–354.

Hirschmann, A. O. *Exit, Voice, and Loyalty. Responses to Decline in Firms, Organizations, and States*. Cambridge, MA: Harvard University Press, 1972.

Hjarvard, Stig. "The Mediatization of Society: A Theory of the Media as Agents of Social and Cultural Change." *Nordicom Review* 29, no. 2 (2008): 105–134.

Hjarvard, Stig. *The Mediatization of Culture and Society*. Oxon: Routledge, 2013.

Hoelzl, Ingrid and Remi, Marie. *Soft Image: Towards a New Theory of Digital Image*. Bristol and Chicago: Intellect, 2015.

Holson, L. M. and R. Abrams. "For the Trumps, *Made in USA* May be a Tricky Label to Stitch." *New York Times,* December 28, 2016. Accessed May 15, 2017, https://www.nytimes.com/2016/12/28/business/donald-trump-ivanka-clothes-global-trade-overseas-manufacturing.html?_r=0.

Horyn, Cathy. "Why Raf Simons Is Leaving Christian Dior." *The Cut,* October 22, 2015. Accessed January 30, 2017, http://nymag.com/thecut/2015/10/raf-simons-leaving-christian-dior.html.

Hoskins, Tansy E. *Stitched Up: The Anti-Capitalist Book of Fashion*. London: Pluto Press, 2014.

Hunt, Elle. "Essena O'Neill Quits Instagram." *The Guardian*, November 3, 2015. https://www.theguardian.com/media/2015/nov/03/instagram-star-essena-oneill-quits-2d-life-to-reveal-true-story-behind-images.

Hynes, Eric. "Tilda Swinton Lives by Night." *The Rollingstone*, April 1, 2014. Accessed May 13, 2017, http://www.rollingstone.com/movies/news/tilda-swinton-lives-by-night-20140401.

Instagram. Post by @Leonardhoespams, September 15, 2016. Accessed June 8, 2017, https://www.instagram.com/p/BKZAe_zgQYl/.

Irvine, Susan. "The Mysterious Cristóbal Balenciaga." *The Telegraph* UK, September 3, 2013. Accessed May 10, 2017, http://fashion.telegraph.co.uk/news-features/TMG10275681/The-mysterious-Cristobal-Balenciaga.html.

Irwin, D. A. *Peddling Protectionism: Smoot-Hawley and the Great Depression*. Princeton, NJ: Princeton University Press, 2011.

Isaac-Goize, Tina. "Star Curator Olivier Saillard Is Headed to J.M. Weston." *Vogue*, June 30, 2017. Accessed August 17, 2017, http://www.vogue.com/article/olivier-saillard-weston.

Jansson, André. "The Mediatization of Consumption: Towards an Analytical Framework of Image Culture." *Journal of Consumer Culture* 2, no. 5 (2002): 5–31.

Jansson, André. "Using Bourdieu in Critical Mediatization Research." *MedieKultur* 58 (2015): 13–29.

Jenkins, Henry. *Convergence Culture: Where Old and New Media Collide*. New York: NYU Press, 2006.

Jennings, Michael W., Brigid Doherty, and Thomas Y. Levin. *The Work of Art in the Age of Its Technological Reproducibility, and Other Writings on Media*. Massachusettes: Harvard University Press, 2008.

Johnstone, Nick. "Dare to Bare." *The Observer*, March 13, 2005.

Joy, A., J. F. Sherry Jr., A. Venkatesh, J. Wang, and R. Chan. "Fast Fashion, Sustainability, and the Ethical Appeal of Luxury Brands." *Fashion Theory: The Journal of Dress, Body and Culture* 6, no. 3 (April 2015): 273–296.

Kammer, Aske. "The Mediatization of Journalism." *MedieKultur* 54 (2013): 141–148.

Kansara, Vikram Alexei. "Is the New Style.com Working?" *BOF*, 2016. Accessed January 4, 2014, https://www.businessoffashion.com/articles/digital-scorecard/is-conde-nast-style-com-working.

Kardashian West, Kim. *Selfish*. New York: Rizzoli, 2015.

Kaun, Anne and Karin Fast. *Mediatization of Culture and Everyday Life*. Mediestudier vid Södertörns Högskola; Karlstad University Studies, 2014.

Kawamura, Yuniya. *The Revolution in Paris Fashion*. Oxford and New York: Berg, 2004.

Kidwell, C. B., and M. Christman. *Suiting Everyone. The Democratization of Clothing in America*. Washington, DC: Smithsonian, 1974.

Klein, Naomi. *No Logo. Taking Aim at the Brand Bullies*. New York: Knopf, 1999.

Klein, Naomi. *This Changes Everything: Capitalism vs. the Climate*. London: Penguin Books, 2015.

Klinger, Ulrike and JaKob Swvenson. "The Emergence of Network Media Logic in Political Communication: A Theoretical Approach." *New Media & Society* 17, no. 8 (2015): 1241–1257.

Kooser, Amanda. "Viral Optical Illusion Asks If These Legs Are Oiled or Painted." *CNET Magazine*, October 26, 2016. Accessed June 8, 2017, https://www.cnet.com/news/viral-optical-illusion-legs-oily-paint-the-dress/.

Kortti, Jukka. "Media History and the Mediatization of Everyday Life." *Media History* 1, no. 23 (2017): 115–129.

Krauss, Rosalind E. "Sculpture in the Expanded Field." In *The Originality of the Avant-Garde and Other Modernist Myths*, 276–290. Cambridge, MA: MIT Press, 1985.

Krotz, Friedrich. "Explaining the Mediatisation Approach." *Javnost—The Public (Journal of the European Institute for Communication and Culture)* 2, no. 24 (2017): 103–118. Accessed May 11, 2017. doi:10.1080/13183222.2017.1298556

Kurnilius, Risto and Esa Reunanen. "Changing Power of Journalism: The Two Phases of Mediatization." *Communication Theory* 26 (2016): 369–388.

Kuspit, Donald. *The End of Art*. Cambridge: Cambridge University Press, 2004.

La Ferla, Ruth. "Imitate That Zipper." *New York Times,* September 2, 2009. Accessed May 10, 2017, http://www.nytimes.com/2009/09/03/fashion/03OWENS.html?pagewanted=all&_r=0.

La Ferla, Ruth. "In Fashion, Gender Lines Are Blurring." *New York Times*, August 19, 2015. Accessed May 13, 2017, https://www.nytimes.com/2015/08/20/fashion/in-fashion-gender-lines-are-blurring.html?_r=0.

Landerer, Nino. "Rethinking the Logics: A Conceptual Framework for the Mediatization of Politics." *Communication Theory* 23 (2013): 239–258.

Landow, George. P. *Hypertext 2.0*. Baltimore: Johns Hopkins University Press, 1997.

Larner, Wendy and Maureen Molloy. "Globalization, Cultural Economy, and Not-so-Global Cities: The New Zealand Designer Fashion Industry." *Environment and Planning D* 25 (2007): 381–400.

Larsson, Jonas, Pia Mouwitz, and Joel Peterson. "Knit on Demand—Mass Customisation of Knitted Fashion Products." *The Nordic Textile Journal, Special Edition Fashion & Clothing* (2009): 108–121.

Lasica, J. D. "Photographs That Lie: The Ethical Dilemma of Digital Retouching." In *State of the Art. Issues in Contemporary Mass Communication*, edited by David Shimkin, Harold Stolerman, and Helene O'Connor, 189–194. New York: St. Martin's Press, 1992.

Laudon, Kenneth C. and Carol Guercio Traver. *E-commerce 2016: Business. Technology. Society*. Boston, MA: Pearson, 2017.

Lazzeretti, Luciana, Francesco Capone, and Patrizia Casadei. "The Role of Fashion for Tourism: An Analysis of Florence as a Manufacturing City and Beyond." In *Tourism in the City: Towards an Integrative Agenda on Urban Tourism*, edited by Nicola Bellini and Cecilia Pasquinelli, 207–220. Switzerland: Springer International, 2017, eBook Edition.

Le Zotte, J. *From Goodwill to Grunge. A History of Secondhand Styles and Alternative Economies*. Chapel Hill: The University of North Carolina Press, 2017.

Leach, W. R. *Land of Desire. Merchants, Power, and the Rise of a New American Culture*. New York: Vintage, 1994.

Lees-Maffei, Grace and Kjetil Fallan, eds. *Made in Italy*. London and New York: Bloomsbury, 2014.

Lewis, Jon, ed. *The End of Cinema as We Know It*. New York: New York University Press, 2001.

Lewis, Tasha and Suzanne Loker. "Trying on the Future: Exploring Apparel Retail Employees' Perspectives on Advanced In-Store Technologies." *Fashion Practice* 9, no. 1 (2017): 95–119.

Library of Congress. "Truth in Advertising Act of 2014–H.R.4341, 113th Congress (2013–2014)." Accessed June 7, 2017, https://www.congress.gov/bill/113th-congress/house-bill/4341.

Lindsay, Vachel. *The Art of the Moving Picture*. New York: The Macmillan Company, 1916.

Lipovetsky, G. *L'empire de l'éphémère. La mode et son destin dans les sociétés modernes*. Paris: Gallimard, 1987.

Lockwood, Lisa and Sharo Edelson. "Instant Fashion: Salvation of Gimmick." *WWD, Instant Fashion Special Report* (2016): 9–11.

Loker, Suzanne, Lora Cowie, Susan Ashdown, and Van Dyk Lewis. "Female Consumers' Reactions to Body Scanning." *Clothing and Textile Research Journal* 22, no. 4 (2004): 151–160.

Lubitz, Rachel. "France Passes Law Requiring Companies to Admit When Models Have Been Photoshopped." *Mic Network Inc.*, 2017. Accessed June 7, 2017, https://mic.com/articles/130789/france-passes-law-requiring-companies-to-admit-when-models-have-been-photoshopped#.Bixi0jWRY.

Ludby, Knut, ed. *Mediatization: Concept, Changes, Consequences*. New York: Peter Lang, 2009.

Lund-Thomsen, P. and A. Lindgreen. "Corporate Social Responsibility in Global Value Chains: Where Are We Now and Where Are We Going?" *Journal of Business Ethics* 123 (2014): 11–22.

Lundby, Knut. "Introduction: 'Mediatization' as Key." In *Mediatization: Concept, Changes, Consequences*, edited by Knut Lundby. New York: Peter Lang, 2009.

Lundby, Knut. "Mediatization of Communication." In *Mediatization of Communication*, edited by Knut Lundby, 3–35. Berlin: De Gruyter, 2014.

Lury, Celia. *Consumer Culture*. Cambridge: Polity Press, 1996.

Lynskey, Dorian. *"Blurred Lines:* The Most Controversial Song of the Decade." *The Guardian*. Accessed November 14, 2013, https://www.theguardian.com/music/2013/nov/13/blurred-lines-most-controversial-song-decade.

Lyotard, Jean-François. *The Postmodern Condition: A Report on Knowledge*, trans. Geoff Bennington and Bryan Massumi. Manchester: Manchester University Press, 1991.

Maffesoli, Michel. *The Time of the Tribes. The Decline of Individualism in Mass Society*. London: Sage, 1996.

Makryniotis, Thomas. *3D Fashion Design: Technique, Design and Visualization*. London: Batsford, 2015.

Malem, Wendy. "Fashion Designers as Business: London." *Journal of Fashion Marketing and Management* 12, no. 3 (2008): 398–414.

Marshall, P. David. *Celebrity and Power: Fame in Contemporary Culture*. Minneapolis: University of Minnesota Press, 1997.

Martinez, Javier Gimeno. "Selling Avant-Garde: How Antwerp Became a Fashion Capital (1990–2002)." *Urban Studies* 44, no. 12 (2007): 2449–2464.

Matlins, Seth. "Ask Dove to Help Protect Our Children from Photoshopped Ads and Beauty." *Change.org Inc*. Accessed June 8, 2017, https://www.change.org/p/dove-make-real-beauty-more-real-and-sign-the-truth-in-advertising-heroes-pledge.

Mazzoleni, Gianpetro. "Changes in Contemporary Communication Ecosystems Ask for a 'New Look' at the Concept of Mediatization." *Javnost—The Public (Journal of the European Institute for Communication and Culture)* 2 (2017): 136–145.

McAfee, A., Dessain, V., and A. Sjöman. "Zara: IT for Fast Fashion." September 6, 2007 Harvard Business School case 9–604–081, 23 p.

McCabe, Maryann, Timothy De Waal Malefyt, and Antonella Fabri "Women, Makeup, and Authenticity: Negotiating Embodiment and Discourses of Beauty." *Journal of Consumer Culture*. Accessed December 9, 2017, https://doi.org/10.1177/1469540517736558.

McDonough, William and Michael Braungart. *Cradle to Cradle: Remaking the Way We Make Things*. New York: North Point Press, 2002.

McRobbie, Angela. *British Fashion Design: Rag Trade or Image Industry?* London: Routledge, 1998.

McRobbie, Angela. *Be Creative: Making a Living in the New Culture Industries*. Cambridge: Polity Press, 2016.

Meikle, James. "Growing Number of Girls Suffer Low Self-esteem, Says Report." *The Guardian*. Accessed November 29, 2013, https://www.theguardian.com/society/2013/nov/29/girls-low-self-esteem-rising-girlguiding-report.

Meiklejohn, H. E. "Section VI, Dresses – The Impact of Fashion on a Business." In *Price and Price Policies,* edited by Walton Hamilton, 313–315. New York: McGraw-Hill, 1938.

Melchior, Marie Riegels. "From Design Nations to Fashion Nations? Unpacking Contemporary Scandinavian Fashion Dreams." *Fashion Theory* 15, no. 4 (2011): 177–200.

Melchior, Marie Riegels, Lise Skov, and Fabian Faurholt Csaba. "Translating Fashion into Danish." *Culture Unbound* 3 (2011): 209–228.

Melly, George. *Revolt into Style: The Pop Arts in Britain*. London: Allen Lane The Penguin Press, 1970.

Mendes, Valerie, and Amy de la Haye. *20th Century Fashion*. London and New York: Thames and Hudson, 1999.

Menkes, Suzy. "The New Speed of Fashion." *T Magazine*. Accessed January 30, 2017, http://www.nytimes.com/2013/08/23/t-magazine/the-new-speed-of-fashion.html.

Michelson, Morten and Mads Krog. "Music, Radio and Mediatization." *Media Culture & Society* 4, no. 39 (2016): 1–16.

Mikalsen, K.-E. "Nordea-sjef: Dette ville en skjorte kostet om fabrikkarbeiderne i Bangladesh skulle fått en levelig lønn." *Aftenposten*. Accessed June 2, 2017, http://www.aftenposten.no/okonomi/Nordea-sjef-Dette-ville-en-skjorte-kostet-om-fabrikkarbeiderne-i-Bangladesh-skulle-fatt-en-levelig-lonn-622467b.html.

Miller, Lesley Ellis. *Balenciaga*. New York: Harry N. Abrams, 2007.

Molenaar, Cor. *Shopping 3.0: Shopping, the Internet or Both*. Farnham: Gower, 2010.

Molloy, John T. *Dress for Success*. New York: P. H. Wyden, 1975.

Molloy, John T. *The Women's Dress for Success Book*. Chicago: Follet, 1977.

Molloy, Maureen and Wendy Larner, eds. *Fashioning Globalisation: New Zealand Design, Working Women and the Cultural Economy*. Chichester, West Sussex: Wiley-Blackwell, 2013.

MoMA. "This Fall, Items: Is Fashion Modern? Highlights 111 Influential Garments and Accessories That Are Paragons of Design." Accessed August 26, 2017, http://press.moma.org/wp-content/files_mf/moma_items_expandedpressrelease_final38.pdf.

Montagné-Villette, Solange. *Le Sentier, un espace ambigu*. Paris: Masson, 1990.

Morgado, Marcia A. "Fashion Phenomena and the Post-postmodern Condition: Enquiry and Speculation." *Fashion, Style, & Popular Culture* 1, no. 3 (2014): 313–339.

Moroz, Sarah. "In a New Performance Piece, Tilda Swinton Turns Fashion into Art." Accessed May 2017, https://tmagazine.blogs.nytimes.com/2014/11/21/tilda-swinton-cloakroom-paris-festival/.

Mosely, Rebecca, ed. *Fashioning Film Stars*. London: BFI, 2005.

Moss, Mark. *Shopping as an Entertainment Experience*. Lanham: Lexington Books, 2007.

Murdock, Graham. "Mediatisation and the Transformation of Capitalism: The Elephant in the Room." *Javnost–The Public (Journal of the European Institute for Communication and Culture)* 2, no. 24 (2017). doi: 10.1080/13183222.2017.1290745.

Netlland, Torbjorn. "Moods of Norway towards Global Transparency and Happier People." *Better Operations*, February 7, 2013. Accessed August 14, 2017, http://better-operations.com/2013/02/07/moods-of-norway-towards-global-supplier-transparency/.

Nevinson, John, L. *Origin and Early History of the Fashion Plate*, https://www.gutenberg.org/files/34472/34472-h/34472-h.htm.

Newbery, Malcolm. *Conclusions and Recommendations of a Study of the UK Designer Fashion Sector*. London: UK Government Department of Trade and Industry, 2003.

Newman, Michael. *Indie: An American Film Culture*. New York: Columbia University Press, 2011, Kindle Edition.

Niessen, Sandra, Ann Marie Leshkovich, and Carla Jones, eds. *Re-Orienting Fashion: The Globalization of Asian Fashion*. Oxford and New York: Berg, 2003.

Nietzsche, Friedrich. *Unzeitgemässe Betrachtungen*. Berlin: Hofenberg, 2016.

Normann, Richard. *Reframing Business: When the Map Changes the Landscape*. Chichester, UK: John Wiley and Sons, 2001.

O'Regan, Tom. "The End of Cinema? The Return of Cinema?" *Metro Magazine: Media and Education Magazine* 124, no. 125 (2001): 64–72, 74–76.

Offer, A. *The Challenge of Affluence*. Oxford: Oxford University Press, 2006.

Ostberg, Jacob. "The Mythological Aspects of Country-of-Origin: The Case of the Swedishness of Swedish fashion." *Journal of Global Fashion Marketing* 2, no. (2011): 223–234.

Palmer, Alexandra. "Reviewing Fashion Exhibitions." In *Fashion Theory: The Journal of Dress Body and Culture. Exhibitionism. Special Issue* 12, no. 1 (2008): 121–126.

Palmer, Alexandra and Hazel Clark, eds. *Old Clothes New Looks: Second Hand Fashion*. Oxford and New York: Berg, 2004.

Paster, Gail K. *The Body Embarrassed: Drama and the Disciplines of Shame in Early Modern England*. Ithaca, NY: Cornell University Press, 1993.

Payne, Alice. "The Knock-on from the Knock-off: Recent Shifts within Australian Mass Market Fashion Design Practice." In *3rd Global Conference Fashion Exploring Critical Issues*. Oxford: Mansfield College, 2011.

Payne, Alice. "Inspiration Sources for Australian Fast Fashion Design: Tapping into Consumer Desire." *Journal of Fashion Marketing and Management* 20, no. 2 (2016): 191–207, http://dx.doi.org/10.1108/JFMM-12-2014-0092.

Pecorari, Marco. *Fashion Remains: The Epistemic Potential of Fashion Ephemera*. PhD diss., Stockholm University, Stockholm, 2015.

Pedersen, Esben and Wencke Gwozdz. "From Resistance to Opportunity-Seeking: Strategic Responses to Institutional Pressures for Corporate Social Responsibility in the Nordic Fashion Industry." *Journal of Business Ethics* 119 (2004): 245–264.

Peers, Juliette. *The Fashion Doll: From Bébé Jumeau to Barbie*. Oxford and New York: Berg, 2004.

Peers, Juliette. "Paris or Melbourne? Garments as Ambassadors for Australian Fashion Cultures." In *Generation Mode*, edited by Sussanne Anna and Eva Gronbach, 133–153. Düsseldorf: Hatje Cantz, 2006.

Petrov, Julia. "Exhibition and Catalog Review: *The Concise Dictionary of Dress*." *Fashion Theory: The Journal of Dress Body and Culture* 16, no. 1 (2010): 109–116.

Piller, Frank and Mitchell Tseng, eds. *Handbook of Research in Mass Customization and Personalization*, vols. 1 and 2. Hackensack, NJ: World Scientific Publishing, 2010.

Pine, Joseph II. *Mass Customization: The New Frontier in Business Competition*. Boston, MA: Harvard Business School Press, 1993.

Pine, Joseph II and James H. Gilmore. *The Experience Economy*. Boston, MA: Harvard Business School Publishing, 2011.

Polhemus, Ted. *Street Style: From Sidewalk to Catwalk*. London and New York: Thames and Hudson, 1994.

Pouillard, V. "Design Piracy in the Fashion Industries of Paris and New York in the Interwar Years." *Business History Review* 85, no. 2 (2011): 319–344.

Pouillard, V. "The Rise of Fashion Forecasting and Fashion PR, 1920–1940. The History of Tobé and Bernays." In Hartmut Berghoff, Thomas Kuehne, *Globalizing Beauty: Consumerism and Body Aesthetics in the Twentieth Century*, 151–169. New York: Palgrave, 2013.

Press, Clare. "Why the Fashion Industry Is Out of Control." *Australian Financial Review*, April 23, 2016. Accessed April 26, 2016, http://www.afr.com/lifestyle/fashion/why-the-fashion-industry-is-out-of-control-20160419-goa5ic.

Proulx, Annie. "Brokeback Mountain. Cowboys and Horses and Long, Lonely Nights in the Wilderness." *The New Yorker*, October 13, 1997. Accessed September 2, 2017, www.newyorker.com/magazine/1997/10/13/brokeback-mountain.

Quandt, James. "Everyone I Know Is Staying Home: The New Cinephilia." *Framework: The Journal of Cinema and Media* 50 (2009): 206–209.

Quant, Mary. *Quant by Quant. The Autobiography of Mary Quant*. London: V&A Publications, 2012.

Quinn, Bradley. *Fashion Futures*. London: Merrel, 2012.

Quinn, Bradley. "Technology and Future Fashion: Body Technology." In *The Handbook of Fashion Studies*, edited by Sandy Black, Joanne Entwistle, Amy De La Haye, Agnès Rocamora, Regina Root and Helen Thomas, 436–455. London and New York: Bloomsbury, 2013.

Radner, Hilary. "Migration and Immigration: French Fashion and American Film." In *France/Hollywood: Échanges cinématographiques et identités nationales*, edited by Martin Barnier and Raphaëlle Moine, 203–223. Paris: L'Harmattan, 2002.

Radner, Hilary. "'This Time's for Me': Making Up and Feminine Practice." *Cultural Studies* 3, no. 3 (2006): 301–322. doi: 10.1080/09502388900490211.

Radner, Hilary. *The New Woman's Film: Femme-Centric Movies for Smart Chicks*. London and New York: Routledge, 2017.

Radner, Hilary and Natalie Smith. "Fashion, Feminism and Neo-Feminism: From Coco Chanel to Jennifer Lopez." In *Fashion Cultures* (2nd Edition), edited by Stella Bruzzi and Pamela Church Gibson, 275–268. London: Routledge, 2013.

Raffoule, François. "Derrida et l'éthique de l'im-possible." *Revue de Metaphysique et de Morale* 53 (2007): 73–88.

Rantisi, Nancy. "The Prospects and Perils of Creating a Viable Fashion Industry." *Fashion Theory* 15, no. 4 (2011): 259–266.

Reich, Charles. *The Greening of America*. New York: Random House, 1970.

Reinach, Simona Segre. "China and Italy: Fast Fashion versus Prêt-à-Porter. Towards a New Culture of Fashion." *Fashion Theory. The Journal of Dress, Body and Culture* 9, no. 1 (2005): 43–56.

Reinach, Simona Segre. "National Identities and International Recognition." *Fashion Theory* 15, no. 4 (2011): 267–272.

Reinecke, J. and J. Donaghey. "After Rana Plaza: Building Coalitional Power for Labour Rights between Unions and (Consumption-based) Social Movement Organisations." *Organization* 22, no. 5 (2015): 720–740.

Reynolds, Jack and Jonathan Roffe. *Understanding Derrida*. New York: Continuum, 2004.

Rhodes, Bradley. *A Brief History of Wearable Computing*. Accessed May 25, 2017, https://www.media.mit.edu/wearables/lizzy/timeline.html.

Rizvi, Jamila. "Will You Help Turn These Numbers Around?" *Mamamia*, August 18, 2013. Accessed June 7, 2017, http://www.mamamia.com.au/fernwood-body-image-survey/.

Rocamora, Agnès. *Fashioning the City*. London: I.B. Tauris, 2009.

Rocamora, Agnès. "Personal Fashion Blogs: Screens and Mirrors in Digital Selfportraits." *Fashion Theory: The Journal of Dress, Body and Culture* 15, no. 4 (2011): 407–424.

Rocamora, Agnès. "Hypertextuality and Remediation in the Fashion Media: The Case of Fashion Blogs." *Journalism Practice* 6, no. 1 (2012): 92–106.

Rocamora Agnès. "How New Are the New Media? The Case of Fashion Blogs." In *Fashion Media: Past and Present*, edited by Djurdja Bartlett, Shaun Cole, and Agnès Rocamora, 155–164. London and New York: Bloomsbury, 2013.

Rocamora, Agnès. "Introduction." In *The Handbook of Fashion Studies*, edited by Sandy Black, Amy De La Haye, Joanne Entwistle, Regina Root, Agnès Rocamora, and Helen Thomas, 159–163. London and New York: Bloomsbury, 2013.

Rocamora, Agnès. "New Fashion Times: Fashion and Digital Media." In *The Handbook of Fashion Studies*, edited by Sandy Black, Amy De La Haye, Joanne Entwistle, Regina Root, Agnès Rocamora, and Helen Thomas, 61–77. London and New York: Bloomsbury, 2013.

Rocamora, Agnès. "Mediatization and Digitization in the Field of Fashion." *Fashion Theory,* 21, no. 5 (2017).

Rocamora, Agnès. "The Labour of Fashion Blogging." In *Fashioning Professionals: Identity and Representation at Work in the Creative Industries*, edited by Armstrong Leah and Felice McDowell, 65–81. London and New York: Bloomsbury, 2018.

Rojek, Chris. *Celebrity*. London: Reaktion, 2011.

Rojek, Chris. *Fame Attack: The Inflation of Celebrity and Its Consequences*. London and New York: Bloomsbury, 2013.

Romney, Jonathan. "Jim Jarmusch: How the Film World's Maverick Stayed True to His Roots." *Observer*, February 22, 2014. Accessed May 8, 2017, https:// www. theguardian.com/film/2014/feb/22/jim-jarmusch-only-lovers-left-alive.

Roosevelt, Selwa. "The Later the Better." *Washington Post*, March 30, 1997. Accessed May 12, 2017, https://www.washingtonpost.com/archive/entertainment/books/1997/03.

Rose, Frank. "The Attention Economy 3.0." *The Milken Institute Review: A Journal of Economic Policy*. Milken Institute. Accessed July 9, 2016, http://www.milkenreview.org/articles/the-attention-economy-3-0.

Ross, R. *Clothing. A Global History*. Cambridge: Polity Press, 2008.

Rothenbuhler, Eric W. "Continuities: Communicative Form and Institutionalization." In *Mediatization: Concept, Changes, Consequences*, edited by Knut Lundby, 277–292. New York: Peter Lang, 2009.

Ruffat, M. and D. Veillon. *La mode des sixties, l'entrée dans la modernité*. Paris: Autrement, 2007.

Ryan, Nicky. "Patronage." In *Fashion and Art*, edited by Adam Geczy and Vicki Karaminas, 155–169. London and New York: Bloomsbury, 2012.

Rysik, Melena. "This Time, Jim Jarmusch Is Kissing Vampires." *New York Times*, April 3, 2014. Accessed May 8, 2017, www.nytimes.com/2014/04/06/movies/this-time-jim-jarmusch-is-kissing-vampires.html.

Sample, Ian. "#TheDress: Have Researchers Solved the Mystery of Its Colour?" *The Guardian*. Accessed June 8, 2017, https://www.theguardian.com/science/2015/may/14/thedress-have-researchers-solved-the-mystery-of-its-colour.

Sastre, Alexandra. "Hottentot in the Age of Reality TV: Sexuality, Race and Kim Kardashian's Visible Body." *Celebrity Studies* 5, no. 1–2 (2013): 123–137.

Scatturo, Sarah. "Eco-tech Fashion: Rationalizing Technology in Sustainable Fashion." *Fashion Theory* 12, no. 4 (2008): 469–488.

Scaturro, Sarah. "Confronting Fashion's Death Drive: Conservation, Ghost Labor, and the Material Turn within Fashion Curation." In *Fashion Curating Critical Practice in the Museum and Beyond*, edited by Annamari Vanska and Hazel Clark, 21–38. London and New York: Bloomsbury, 2017.

Schaltegger, Stefan, Erik G. Hansen, and Florian Lüdeke-Freund. "Business Models for Sustainability: Origins, Present Research, and Future Avenues." *Organization & Environment* 29, no. 1 (2016): 3–10.

Schatz, Tom. "The New Hollywood." In *Film Theory Goes to the Movies*, edited by Jim Collins, Hilary Radner, and Ava Preacher Collins, 8–36. New York: Routledge, 1993.

Schatz, Tom. "The Studio System and Conglomerate Hollywood." In *The Contemporary Hollywood Film Industry*, edited by Paul McDonald and Janet Wasko, 13–42. Malden, MA and Oxford: Wiley-Blackwell, 2008.

Schawbel, Dan. "Donna Karan: How She Turned Her Passion into a Career." *Forbes*, October 13, 2015. Accessed May 12, 2017, https://www.forbes.com/sites/danschawbel/2015/10/13/donna-karan-how-she-turned-her-passion-into-a-career/#8747c50733aa.

Schieren, Mona and Andrea Sich. *Look at Me: Celebrity Culture at the Venice Art Biennale*. Nurnberg: Verlag für Moderne Kūnst, 2011.

Sen, S. and C. B. Battacharya. "Does Doing Good Always Lead to Doing Better? Consumer Reactions to Corporate Social Responsibility." *Journal of Marketing Research* 38, no. 2 (2001): 225–243.

Shackleton, Holly. "Step Inside Rick Owens' World." *i-D*. Accessed May 8, 2017, https://i-d.vice.com/en_au/article/step-inside-rick-owens39-world-aunz-translation.

Shambu, Girish. *The New Cinephilia*. Montreal: Caboose, 2014.

Shin, Eonyou and Fatma Baytar. "Apparel Fit and Size Concerns and Intentions to Use Virtual Try-On. Impacts of Body Satisfaction and Images of Models' Bodies." *Clothing and Textiles Research Journal* 24 (2013): 335–344.

Shin, Eonyou and Fatma Baytar. "Apparel Fit and Size Concerns and Intentions to Use Virtual Try-On." *Clothing and Textiles Research Journal* 32, no. 1 (2013): 20–33.

Simmel, George. "Fashion." *The American Journal of Sociology* 62, no. 6 (1957): 541–558.

Singer, Sally, Sarah Mower, Nicole Phelps, and Allesandra Codinha. "Ciao, Milano! Vogue.com's Editors Discuss the Week That Was." *Vogue.com*, September 25,

2016. Accessed June 7, 2017, http://www.vogue.com/article/milan-fashion-week-spring-2017-vogue-editors-chat.

Sinkovics, N., Ferdous Hoque, S. and R. R. Sinkovics. "Rana Plaza Collapse Aftermath: Are CSR Compliance and Auditing Pressures Effective?" *Accounting, Auditing and Accountability Journal* 29, no. 4 (2016): 617–649.

Sklar, K. K. "The Consumers' White Label Campaign of the National Consumers' League 1898-1918." In *Getting and Spending. European and American Consumer Societies in the Twentieth Century*, edited by S. Strasser, C. McGovern, and M. Judt, 17–35. Cambridge: Cambridge University Press, 1998.

Skov, Lise. "Fashion Flows–Fashion Shows: The Asia Pacific Meets in Hong Kong." In *Rogue Flows: Trans-Asian Cultural Traffic*, edited by Koichi Iwabuchi and Mandy Thomas, 221–247. Hong Kong: Hong Kong University Press, 2004.

Skov, Lise. "Dreams of Small Nations in a Polycentric Fashion World." *Fashion Theory* 15, no. 4 (2011): 45, 137–156.

Skov, Lise and Marie Melchior. "Letter from the Editors." *Fashion Theory* 15, no. 4 (2011): 133–136.

Sluiter, L. *Clean Clothes. A Global Movement to End Sweatshops*. London: Pluto Press, 2009.

Smelik, Anneke, ed. *Delft Blue to Denim Blue: Contemporary Dutch Fashion*. London: I.B. Tauris, 2017.

Sontag, Susan. *On Photography*. Harmondsworth: Penguin, 1979.

Stacey, Jackie. "Crossing Over with Tilda Swinton–the Mistress of 'Flat Affect'." *International Journal of Politics, Culture and Society* 28, no. 3 (2015): 243–271.

Steele, Valerie. "The F–Word." *Lingua Franca* (April 1991): 17–20.

Steele, Valerie. *Women of Fashion*. New York: Rizzoli, 1991.

Steele, Valerie. *Paris Fashion: A Cultural History*. Oxford and New York: Berg, 1998.

Steele, Valerie. "Museum Quality. The Rise of the Fashion Exhibition." In *Fashion Theory: The Journal of Dress, Body and Culture. Exhibitionism. Special Issue* 12, no. 1 (2008): 7–30.

Stein, L. *The Triangle Fire*. Ithaca, NY: Cornell University Press, 1962.

Stenvik, Bor. *Vse my vrem. Kak lozh', zhul'nichestvo i samoobman delaiut nas liud'mi*. Moscow: Alpina Publisher, 2016.

Stern, Carly. "A VERY Stylish Showdown!" *The Dailymail* UK, September 27, 2016. Accessed June 7, 2017, http://www.dailymail.co.uk/femail/article-3809981/A-stylish-showdown-Vogue-editors-aim-pathetic-bloggers-sit-row-Fashion-Week-scathing-article-branding-online-stars-desperate-embarrassing.html.

Stern, Radu. *Against Fashion: Clothing as Art, 1850-1930*. Cambridge, MA: MIT Press, 2004.

Stevenson, N. J. "The Fashion Retrospective." *Fashion Theory: The Journal of Dress Body and Culture* 12, no. 2 (2008): 219–235.

Stokes, Melvin. "Female Audiences of the 1920s and Early 1930s." In *Identifying Hollywood's Audiences: Cultural Identity and Movies*, edited by Melvin Stokes and Richard Maltby, 42–60. London: BFI, 1999.

Stree, Wolfgang. *How Will Capitalism End?: Essay on a Failing System*. London: Verso, 2016.

Strömbäck, Jesper and Frank Esser. "Shaping Politics: Mediatization and Media Interventionism." In *Mediatization: Concept, Changes, Consequences*, edited by Knut Lundby, 205–224. New York: Peter Lang, 2009.

Takada, K. and G. Huang. "Uniqlo Thinks Faster Fashion Can Help It Beat Zara." *Bloomberg*, March 16, 2017. Accessed May 15, 2017, https://www.bloomberg.com/

news/articles/2017-03-16/uniqlo-turns-speed-demon-to-take-on-zara-for-global-sales-crown.

Taplin, I. M. "Who Is to Blame? A Re-examination of Fast Fashion after the 2013 Factory Disaster in Bangladesh." *Critical Perspectives on International Business* 10, no. 1/2 (2014): 72–83.

Taylor, Lou. *Establishing Dress History*. Manchester and New York: Manchester University Press, 2004.

Tenz, Courtney. "The New Antwerp Six: Rising Belgian Designers Shaking Up the Scene." *Papermag*, June 18, 2015. Accessed August 16, 2016, http://www.papermag.com/the-new-antwerp-six-rising-belgian-designers-shaking-up-the-fashion-sc-1427587310.html.

Teunissen, José. "Deconstructing Belgian and Dutch Fashion Dreams: From Global Trends to Local Crafts." *Fashion Theory* 15, no. 4 (2011): 157–176.

Thomas, Brook. *The New Historicism and Other Old-Fashioned Topics*. Princeton, NJ: Princeton University Press, 1991.

Thomas, Dana. "Two Major Museum Exhibitions Celebrate Balenciaga's Fashion Mastery." *Town and Country* Magazine. Accessed August 20, 2017, http://www.townandcountrymag.com/style/fashion-trends/a9178653/balenciaga-museum-exhibitions/.

Thornton, Sarah. *Seven Days in the Art World*. London: Granta, 2008.

Thurman, Judith. "The Misfit." *New Yorker*, July 4, 2005. Accessed May 13, 2017, http://www.newyorker.com/magazine/2005/07/04/the-misfit-3.

Toth, Josh. *The Passing of Postmodernism: A Spectroanalysis of the Contemporary*. Albany, NY: SUNY press, 2010.

Treleaven, Philip. Sizing Us Up. *IEEE Spectrum* 41, no. 4 (2004): 28–31. Accessed May 10, 2017, http://doi.org/db9tqw.

Turker, D. and C. Altuntas. "Sustainable Supply Chain Management in the Fast Fashion Industry: An Analysis of Corporate Reports." *European Management Journal* 32 (2014): 837–849.

Turner, Graeme. *Understanding Celebrity*. London: Sage, 2004.

Twenga. "E-commerce in the United Kingdom: Facts & Figures 2016." Accessed August 4, 2016, https://www.twenga-solutions.com/en/insights/ecommerce-united-kingdom-facts-figures-2016/.

Udland, Myles. "The Internet Is Losing Its Composure over This Dress That Might Be White and Gold or Black and Blue." *Business Insider*, February 26, 2015. Accessed June 8, 2017, http://www.businessinsider.com/white-and-gold-black-and-blue-dress-2015-2.

Ugrina, Luciana. "Celebrity Biometrics: Norms, New Materialism, and the Agentic Body in Cosmetic Surgery Photography." *Fashion Theory* 18, no. 1 (2014): 27–44.

Unione Industriale Pratese Confindustria Prato. "Prato Textile and Fashion Centre and the Prototype of a Manufacturing District." *Evolution of the Prato Textile District*. Accessed November 22, 2016, http://www.ui.prato.it/unionedigitale/v2/english/presentazionedistrettoinglese.pdf.

Vainshtein, Olga. "Digital Beauties: Strategies of Self-Presentation and Resistance." In *Beauty: Exploring Critical Perspectives*, edited by Pierre Wilhelm and Rebecca Nash, 81–93. Oxford: Inter-Disciplinary Press, 2016. Electronic book.

Vainshtein, Olga. "Everybody Lies: Fotoshop, moda i telo." *Teoria Modi* 43 (2017): 201–235.

Van Dijk José and Thomas Poell. "Understanding Social Media Logic." *Media and Communication* 1, no. 1 (2013): 2–14.

Vanska, Annamari and Hazel Clark, eds. *Fashion Curating: In the Museum and Beyond*. London and New York: Bloomsbury, 2017.

Veblen, Thorstein. *Theory of the Leisure Class*. Oxford: Oxford University Press, 2007.

Veenstra, Madeline. "The Australian Fashion Community." *Design Online*. State Library of Queensland. Accessed August 14, 2017, http://designonline.org.au/content/the-australian-fashion-community/.

Victoria and Albert Museum. "About the Balenciaga: Shaping Fashion Exhibition." Accessed September 2, 2017, https://www.vam.ac.uk/articles/about-balenciaga-shaping-fashion.

Vinken, Barbara. *Fashion Zeitgeist: Trends and Cycles in the Fashion System*. Oxford and New York: Berg, 2005.

Von Drehle, David. *Triangle: The Fire That Changed America*. New York: Grove Press, 2003.

Webneel. "What's the Secret of My Beauty? Adobe Photoshop Day Cream – 25 after before Photos." Accessed June 7, 2017, http://webneel.com/webneel/blog/whats-secret-my-beauty-photoshop-after.

Webster, Karen. "Global Shift: Australian Fashion's Coming of Age." *The Conversation*, November 6, 2013. Accessed November 21, 2016, http://theconversation.com/global-shift-australian-fashions-coming-of-age-19237.

Webster, Ken. *The Circular Economy. A Wealth of Flows*. Cowes: Ellen MacArthur Foundation, 2017.

Weiser, Mark. "The Computer for the 21st Century." *Scientific American* September (1991): 94–100.

Weller, Sally. "Fashion as Viscous Knowledge: Fashion's Role in Shaping Transnational Garment Production." *Journal of Economic Geography* 7, no. 1 (2007): 39–66.

Weller, Sally. "Beyond 'Global Production Network' Metaphors: Australian Fashion Week's Trans-sectoral Synergies." *Growth and Change* 39, no. 1 (2008): 104–122.

Weller, Sally. "Consuming the City: Public Festivals and Participatory Economies in Melbourne, Australia." *Urban Studies* 50, no. 14 (2013): 2855–2868.

Weller, Sally. "Creativity or Costs? Questioning New Zealand's Fashion Success: A Methodological Intervention." *Journal of Economic Geography* 14, no. 4 (2013): 721–737.

Whitelocks, Sadie. "Blonde Bombshell Who Cut Off Hair to Work as Male Model Reveals How She and Her Husband Now Get Mistaken for a 'Gay Couple.'" *The Daily Mail*, October 30, 2013. Accessed June 8, 2017, http://www.dailymail.co.uk/femail/article-2480168/Elliott-Sailors-female-works-male-model-gets-mistaken-husband-gay-couple.html.

Willis-Tropea, Liz. "Glamour Photography and the Institutionalization of Celebrity." *Photography & Culture* 4, no. 3 (2011): 261–276.

Willsher, Kim and agencies. "Models in France Must Provide Doctor's Note to Work." *The Guardian*, December 18, 2015. Accessed June 7, 2017, https://www.theguardian.com/world/2015/dec/18/models-doctors-note-prove-not-too-thin-france.

Wilson, Elizabeth. *Adorned in Dreams: Fashion and Modernity*. London: I.B. Tauris, 1985.

Wilson, Elizabeth. "Fashion and Postmodern Body." In *Chic Thrills: A Fashion Reader*, edited by Juliet Ash and Elizabeth Wilson, 3–17. Berkeley, CA: University of California Press, 1992.

Wilson, Eric. "Now You Know: The Evolution of Donna Karan's Seven Easy Pieces." *Instyle Magazine*, July 2015. Accessed May 12, 2017, http://www.instyle.com/news/history-donna-karan-seven-easy-pieces.

Wisler, J. C. "U.S. CEOs of SBUs in Luxury Goods Organizations: A Mixed Methods Comparison of Ethical Decision-Making Profiles." *Journal of Business Ethics* 149, no. 2 (2018): 443–518.

Wissinger, Elizabeth A. *This Year's Model: Fashion, Media, and the Making of Glamour*. New York: New York University Press, 2015.

Wolf, Naomi. *The Beauty Myth: How Images of Beauty Are Used against Women*. New York: HarperCollins, 1991.

Wolf, Naomi. "Emily Ratajowski's Naked Ambition." *Harper's Bazaar*, July 7, 2016.

Wolinski, Natacha. "When Fashion Dresses Up the Imagination." *Beaux Arts Magazine*. Pamphlet for *Dysfashional* exhibition. Luxembourg, 2007.

Wollen, Peter. "The Concept of Fashion in the Arcades Project." *boundary 2* vol. 30, no. 1 (2003): 131–142.

Wrigley, Neil and Michelle Lowe. *Reading Retail: A Geographical Perspective on Retailing and Consumption Spaces*. London: Arnold, 2002.

Yaeger, Lynn. "On the Eve of the Comme des Garçons Retrospective, the Notoriously Reclusive Rei Kawakubo Speaks Out." *Vogue*, April 14, 2017. Accessed May 13, 2017, http://www.vogue.com/article/rei-kawakubo-interview-comme-des-garcons-2017-met-museum-costume-exhibit/.

Yang, Jung-ha, Doris H. Kincade and Jessie H. Chen-Yu. "Types of Apparel Mass Customization and Levels of Modularity and Variety: Application of the Theory of Inventive Problem Solving." *Clothing and Textiles Research Journal* 33, no. 3 (2015): 199–212.

Young, Lord. *Growing Your Business*. *A Report to HM Government*. London: HMSO, 2013.

Yusoff, Kathryn and Claire Waterton. "Indeterminate Bodies." *Body and Society* 3, no. 23 (2017): 3–22.

Zborowska, Agata. "Deconstruction in Contemporary Fashion Design: Analysis and Critique." *International Journal of Fashion Studies* 2, no. 2 (2015): 185–201.

Zeilser, Andi. *We Were Feminists Once: From Riot Grrrl to CoverGirl®, the Buying and Selling of a Political Movement*. New York: PublicAffairs, 2016.

Zellweger, Renne. "We Can Do Better." *Huffington Post, The blog* August 8, 2016. Accessed June 8, 2017, http://www.huffingtonpost.com/renee-zellweger/we-can-do-better_b_11355000.html.

Zhang, Gaoheng. "'Made in Italy' by Chinese in Prato: The 'Carrot and Stick' Policy and Chinese Migrants in Italy, 2010–11." *CPI Analysis*. October 22, 2015. Accessed November 21, 2016. https://cpianalysis.org/2015/10/22/made-in-italy-by-chinese-inprato-the-carrot-and-stick-policy-and-chinese-migrants-in-italy-2010-11/.

Zhang, Michael. "Kate Winslet's Modeling Contract with L'Oréal Has a 'No Photoshop' Clause." *PetaPixel*, October 24, 2016. Accessed June 7, 2017, https://petapixel.com/2015/10/24/kate-winslets-modeling-contract-with-loreal-has-a-no-photoshop-clause/.

Žižek, Slavoj. *Living in the End Times.* London and New York: Verso, 2011.

Internet Sites not already cited

2 x 4. "Prada Waist Down." 2 x 4. Accessed September 15, 2017, https://2x4.org/work/26/prada-waist-down/.

Bubble, Susie. Twitter post by @susiebubble, September 26, 2016 (12:59 a.m.).
 Accessed June 7, 2017, https://twitter.com/susiebubble/status/780315
 796107034624.

De Klerk, Amy. "Kardashians to Blame" in *Harpers' Bazaar* (UK), March 31, 2017.
 Accessed June 3, 2017, http://www.harpersbazaar.co.uk/beauty/news/a40729/
 kardashians-to-blame-for-the-number-of-millennial-women-getting-cosmetic-
 procedures/.

"Donna Karan." In "Forbes Profile." *Forbes*. Accessed May 12, 2017, https://www.
 forbes.com/profile/donna-karan/.

Ecommerce News. "Ecommerce in The United Kingdom." Ecommerce news 2017.
 Accessed May 10, 2017, https://ecommercenews.eu/ecommerce-per-country/
 ecommerce-the-united-kingdom/.http://www.cdmdiary.com/en/about-cdm/.

"Fresh Heir: Interview with Ann Demeulemeester's New Creative Director Sebastien
 Meunier." *D'Vine*, May 5, 2014. Accessed May 13, 2017, http://www.the-dvine.
 com/2014/05/fresh-heir-interview-with-ann-demeulemeesters-new-creative-director-
 sebastien-meunier/.

Hollywood Reporter, March 18, 2015, June 3, 2017, http://www.hollywoodreporter.com/
 news/givenchys-riccardo-tisci-why-he-782524.

Ginsberg, Merle. "Givenchy's Riccardo Tisci on why he dresses Kim Kardashian and
 Kanye West but rejects other stars: 'Why waste time?'" In *Pret–a–Reporter*. The
 Hollywood Reporter, March 18, 2015, May 26, 2017, http://www.hollywoodreporter.
 com/news/givenchys-riccardo-tisci-why-he-782524.

Mad Museum. "fashion after Fashion." April 27, 2017. Accessed June 1, 2017, http://
 madmuseum.org/exhibition/fashion-after-fashion.

"Marc Jacobs Says Fashion Is Not Art," *Los Angeles Times*, November 12, 2007.
 Accessed September 23, 2012, http://latimesblogs.latimes.com/alltherage/2007/11/
 marc-jacobs-say.html.

Medine, Leandra. "Confession: I don't get Vêtements." *Man Repeller*. March 30, 2016,
 http://www.manrepeller.com/2016/03/confession-i-dont-get-vêtements.html.

Office for National Statistics. "Retail Sales in Great Britain, Apr 2017." Accessed May
 9, 2017, https://www.ons.gov.uk/businessindustryandtrade/retailindustry/bulletins/
 retailsales/apr2017/.

"Rick Owens." *Vouge* France. Accessed May 10, 2017, http://en.vogue.fr/vogue-list/
 thevoguelist/rick-owens/1088/30/the-later-the-better/953af5b3-8ed6-4be0-9416-
 4b00718eba5e/.

T Magazine, *The New York Times*, November 21, 2014. Accessed August 19, 2017,
 http://tmagazine.blogs.nytimes.com/2014/11/21/tilda-swinton-cloakroom-paris-
 festival/.

"WWD Overheated!" *WWD*, October 28, 2015, 50–59.

YouTube. "David Bowie: The Stars (Are Out Tonight)." Posted by DavidBowieVEVO,
 February 25, 2013, https://www.youtube.com/watch?v=gH7dMBcg-gE.

http://jezebel.com/new-photographs-show-that-zendaya-was-heavily-
 photoshop-1740424576.

http://www.europarl.europa.eu/EPRS/140841REV1-Workers-conditions-in-the-textile-
 and-clothing-sector-just-an-Asian-affair-FINAL.pdf.

https://mic.com/articles/130789/france-passes-law-requiring-companies-to-admit-
 when-models-have-been-photoshopped#.llGs9KeX3.

https://www.theguardian.com/science/2015/may/14/thedress-have-researchers-solved-
 the-mystery-of-its-colour.

Filmography

Bell, Book and Candle (Richard Quine, 1958)
Funny Face (Stanley Donen, 1957)
Letty Lynton (Clarence Brown, 1932)
Only Lovers Left Alive (Jim Jarmusch, 2013)
Pretty Woman (Gary Marshall, 1990)
Sex and the City (HBO, 1998–2004)
Vertigo (Alfred Hitchcock, 1958)

Interview

Agins, Teri, Interview by Dr. Valerie Steele, 2017 (March 8).

INDEX

Note: Page locators which appears in italics refer to figures.